MAKING MUSEUMS MATTER

MAKING MUSEUMS MATTER

STEPHEN E. WEIL

SMITHSONIAN BOOKS

WASHINGTON

© 2002 by the Smithsonian Institution
All rights reserved
Copyright notices governing individual chapters appear at the beginning of each chapter.

PRODUCTION EDITOR: Ruth Spiegel
DESIGNER: Janice Wheeler

Library of Congress Cataloging-in-Publication Data
Weil, Stephen E.
 Making museums matter / Stephen E. Weil
 p. cm.
 ISBN 1-58834-025-2 (alk. paper)—ISBN 1-58834-000-7 (pbk.: alk.paper)
 1. Museums–Philosophy. 2. Museums–Management. 3. Museums–United States—
 Philosophy. 4. Museums–United States–Management. I. Title.

 AM7.W3925 2002
 069–dc21 2001042037

British Library Cataloguing-in-Publication Data available
Manufactured in the United States of America
09 08 07 06 5 4 3

♾ The paper used in this publication meets the minimum requirements of the American
National Standard for Information Sciences—Permanence of Paper for Printed Library
Materials ANSI Z39.48-1984.

For permission to reproduce the cover illustration, please correspond directly with the
owner of the work. Smithsonian Books does not retain reproduction rights for this illustra-
tion or maintain a file of addresses for photo sources.

Contents

Foreword

I don't think I've ever before thought of myself as a "museum worker," but the truth is that I have been working in the museum field (or should I say "fields" to stretch the metaphor) for nearly twenty-seven years, so the term fits. It is a phrase Steve Weil tosses in, almost as an aside, in one of his wonderful essays included in this collection, and it seems to me typical of the way he surprises the reader by skipping the pieties and inviting calm, clear reflection on a world that has rather treasured its mysteries and exceptionalism.

What then would I label myself? Certainly I'm not a museologist, a term reserved for those who don't necessarily *do* but theorize about doing museum work. Steve would qualify for the honorific as that most rare of all beings, doer and thinker, but he doesn't use it here to describe himself or others and may find it a bit self-important. I think I might have gone with curator or expert or historian or even, because of a lapse from curatorial grace about twelve years ago, museum official. But whatever the term, it would have implied a special involvement in a world apart, a world with special obligations and, it must be admitted, privileges. That is why we all put up with the relatively bad pay, all the while considering ourselves the luckiest of individuals.

In the end, I think, whatever the terminology we use, those of us in the field would consider the opportunities and challenges we confront a calling, aware of the religious overtones. And what would Steve, the self-described

"museum worker," say to that? It's worth asking because, I propose, understanding his likely response is a good way to understand his carefully considered worldview.

Steve's response might go something like this—and here I am taking the opportunity to oversimplify the elaborate and cogent arguments that follow in the essays, exercises, articles, provocations, and lectures of one of the museum world's most articulate and impassioned critics and advocates: The notion that the museum world, and in particular the world of art museums, is a sacred, special place that is ipso facto wonderful and deserving of the world's support and adoration is not only outdated but pernicious. What people who work within it need to do, those who are still stuck in the exhausted paradigm, is to realize that the modern world is asking tough questions of museums and of their management, and that they are appropriate questions. To greet those questions with outrage or lamentation, as an assault on the temple, or at least as presumptuous ignorance, is not only to threaten the survival of museums but, worse, to miss an opportunity to make them fulfill a responsibility to society too long deferred.

Simply put, museums, in the Weil perspective, need to spend less time gazing at their navels. He advocates—backing up that advocacy with examples—that museums not only question some beloved assumptions but simply allow themselves to think for a while like those who use museums, or who are asked to support museums, or who wonder why society needs museums at all. Steve knows that some of those "external" viewpoints might be motivated by a know-nothing attitude to the world, but he asks his colleagues in many different ways not to dismiss all questioning because some is baseless or even dangerous.

In among his most disarming passages he even remembers moments when he used arguments treasured by the museum world but which he considers wrong-headed because his museum—the Hirshhorn in Washington in the years he was deputy director—was beset by critics who challenged the right of the museum to show certain works or budget reviewers who felt that museum holdings and purpose could be measured as though simply an enterprise like others. In those pragmatic moments, in the face of complete misunderstanding, Weil admits he adopted the defensive posture. He is very concerned that his colleagues not use those moments they all face as an excuse to wall off the world, to caricature its legitimate inquiry. The museum world is not above criticism or evaluation. If the criticism is not to be destructive or the evaluation clumsy, then we need to help shape le-

gitimate standards. He would go even further. Reasonable criticism and the demand for evaluation provide the opportunity for museums not simply to survive (what's the point of simple survival?) but *to matter*.

If there is one simple way to differentiate Steve Weil from those in the museum community—his prime audience for these speeches and essays—whom he seeks to persuade, it might be to say that from their perspective the phrase "making museums matter" is an absurd tautology. *Of course* museums matter. In two of the most remarkable and telling essays in this volume, "Courtly Ghosts and Aristocratic Artifacts" and "Reduced to Art," Steve uses the instance of what might be called "the religion of art" or "aestheticism" to analyze and deconstruct what he considers the most egregious form of museum worship. In the first, the historian and polemicist in Weil (in other essays we meet the lawyer and strategist) trace almost the exact moment, in the early twentieth century, when two of America's leading art museums changed their focus from education as the reason for the existence of the institutions they shepherded to the sanctification of art. The shift was everything in the modern history of museums, because it represented a change from the nineteenth-century (enlightenment-based) justification of museums for a social purpose outside themselves to an attitude similar to that in a luxury goods store: "If you have to ask, you can't afford it." It was now art for art's sake and collections for collections' sake.

Weil's arguments about the reason for the shift are merciless. The whiff of piety he sees as nothing less than perfume to cover up the smell of self-interest by America's emerging elites. Establishing an aesthetic hierarchy justified a social hierarchy. It is not a theme he continuously pursues throughout the collection because the argument about the "elitist" nature of museums can be overdone and because many in modern museums are not remotely cynical in their faith in the idea of art for art's sake. But in his arsenal of arguments against the aestheticism he sees as the enemy of the museum that matters, he wants us to realize that the notion is not eternal but rooted in a particular time and place, and that if it *ever* served a useful purpose (which he doubts) that usefulness to an increasingly democratic society is over.

The second essay, "Reduced to Art," finds another way to remind us that the art-for-art's-sake argument is not eternal and universal, but time and place bound. In it, we are introduced to an argument by a representative of another culture—it would be wrong to spoil the impact of Weil's argument by giving too much away here—which turns on its head our notion of art

as the highest designation we can give a created object. There is something wonderfully sly in the way Weil uses this instance to challenge our certainties and to build his larger case for the transformation of the modern museum.

Having demolished our false gods, Weil sets out—it is really the overriding point and "feeling" of this volume—to argue for the museum that truly matters. It's a simple premise, but one he makes us understand is hard won. Museums *deserve* the support of the community when they truly serve the community. It is not enough to say that they serve art; it is not enough to say that they collect and preserve objects (indeed in some cases their collections may be spare); it is not enough that they stand *for* something. They matter if they consult not only the muses but the masses; if they see themselves as democratic institutions; if they stress not their authority but their social value.

What infuriates the Steve Weil we meet in these pages, and he can seem at times very angry indeed, is the extent to which the "old attitude" of the arts community contributes to its marginalization in America. He looks around and notices that today "few artists, if any, play prominent roles in our public life," that we have experienced a "deepened rift between the fine arts and American society." Museums can play a role in changing this—and in fact at the end of the twentieth century and beginning of the twenty-first have begun to do so—by recognizing that they *do* have a calling, but not the calling that decades of self-reference have articulated.

To find the basis for a better ideal Weil first looks back to the nineteenth century and sees a time, as described by a colleague, Martha Woodmansee in 1994, when "works of art were . . . valued not for what they looked like but for the things that they were able to do—inspire, instruct, incite, inform, and more." Weil sees this only as a starting point for the museum of the future, because that earlier understanding of the uses of museum collections also harbored within it, as he writes in another of his essays, a patronizing notion of purpose: "Museums were created and maintained by the high for the low, by the couth for the uncouth, by the washed for the unwashed, by those who knew for those who didn't but needed to know and who would come to learn."

What Weil asks the transforming museum world of today to do, and he sees this happening in many places, is to regain that earlier notion of the social usefulness but to lose the attitude. He asks, in short, for a greater vision of democratic purpose in the museum of the twenty-first century. At

the heart of the new museum is a respect for its public and a concern for their needs. Museums too often try to "sell" the public on its traditional offerings rather than to inquire into their needs and interests. This can be caricatured by those who resist public consultation as "only" giving the public what it wants, thereby giving up the obligation to surprise and inform. Weil's vision rejects this oversimplification. Public need can be assessed at many levels. The point is to get out of the mode of smug indifference and to focus on social effect and value.

Read in certain ways, Weil may come across as simply a pragmatist who asks museums to get off their high horse. But that would be the most superficial of readings. There is great faith in museums at the heart of his exhortations. "Museums," he writes at one point, "are quintessentially places that have the potency to change what people may know or think or feel, to affect what attitudes they may adopt or display, to influence what values they form." The effect they have may be the enhancement of an individual's life or of the cohesion of a social community. And then Weil asks us to consider the "larger notion—that museums might play an important role in determining how well or poorly the citizens of a democratic society succeed in governing themselves."

So Weil's message to "museum workers" is simple and direct. The "romantic" age of the untouchable, unaccountable, unchallengeable, perhaps even ineffable museum is over. The world is asking tough questions of us, questions we need to answer. We *are* accountable to our publics. But we must shape the terms of that accountability by clearly articulating the institutional ends by which we ask to be judged. Each museum must ask itself what it is for, and more than that must ask itself how to determine its own success or failure. We must marry practicality with clear public purpose. Only then, and finally, will we be worthy of our calling.

Marc Pachter

Director, National Portrait Gallery, Smithsonian Institution

THE MUSEUM IN PURSUIT OF EXCELLENCE

Organization-wide Quality

A THEORY OF MUSEUMS AND IMMODEST PROPOSAL

Museums are not mysteries, nor are those most closely associated with them the keepers of mysteries. Museums are, or at least ought be, rationally organized institutions directed toward articulable purposes—institutions that, at their most excellent, both can and do accomplish those purposes with maximum effect and with minimum waste. What follows—immodest insofar as it attempts to define institutional excellence in more precise terms than has previously been attempted among museums—is a proposed framework within which any museum might be examined in its entirety and assessed for its overall quality in a demonstrably objective way.

Underlying this proposal is the premise (which may certainly be disputed by many) that a museum may be judged as better or worse independently of whether one considers its purpose to be beneficial or malign, its subject matter to be significant or trivial, or its communal role to be useful or redundant.[1] Just as the physical well-being of an individual may be evaluated separately from a consideration of that individual's morals, politics, or taste, so may an institution's organizational well-being be evaluated separately.

Also underlying the proposal are four other and somewhat overlapping premises with which most of those responsible for the funding, leadership,

This text was delivered at a meeting of the International Committee on Management (INTER-COM) of the International Council of Museums (ICOM), held at the Museum of London in September 1994.

governance, and operation of museums (hereinafter referred to collectively as "museum people") might agree: First, notwithstanding whatever difficulty they may have in articulating the basis on which they make such distinctions, museum people have a gut sense that all museums are not of equal quality, that some museums are better than others. At issue here is not mere personal preference, but an instinctive sense that—in common with every other human activity—not everybody is just as good as everybody else at operating a museum. If such variability were not the case, museum people might spare themselves considerable effort. Grant making could be simplified to an entitlement-like formula. Accreditation and assessment could be phased out as no longer serving any practical purpose. Program evaluation would become superfluous. Manifestly, however, those most familiar with museums do not believe that all museums are equally good. Their customary behavior points to precisely the opposite conclusion: that they believe some museums to be better than others. How else could the museum field's incessant efforts at self-improvement, through training, meetings, courses of study, publications, and other means, be justified unless those efforts were premised on the notion that there were such things as "better" and "worse" museums and also were motivated by a determination to see museums made more "better" and less "worse"?

Second, notwithstanding their distinctive emphasis on the artifacts and specimens they preserve, study, and interpret, museums are not fundamentally different from other organizations of the not-for-profit sector. Like them, their quality is ultimately judged by the public service they provide, not by the economic results they achieve. There is, accordingly, no apparent reason why museums may not be examined and evaluated in ways that are closely akin to those that have been developed for other parts of this sector. Within the past decade, there has been substantial evolution in the evaluative techniques available to not-for-profit organizations.[2] The museum community has thus far been slow to adopt these for its own use.

Third, notwithstanding the belief of those who work in museums that the work they do is of intrinsic value, the establishment and operation of a museum is not an end in itself but is only justifiable by the museum's dedication to one or more public purposes. This posits that the answer to the question, Why is your community better off because it has a museum? must necessarily be something more than, Because otherwise it wouldn't. Museums matter only to the extent that they are perceived to provide the

communities they serve with something of value beyond their own mere existence.

Fourth, notwithstanding that those who govern museums may sometimes believe that their primary duty is institutional preservation, the success or failure of a museum is directly related not to its survival but the degree to which it is able to accomplish its purpose. In a not-for-profit organization, survival does not necessarily equate with success. As Peter F. Drucker has ruefully observed in this regard, not-for-profit organizations are at a disadvantage in comparison with for-profit organizations. "In the business world, the market puts you out of your misery by not buying your products.[3]

COMPARED WITH WHAT?

The comedian Henny Youngman used to respond to the question, "How's your wife?" with the counterquestion, "Compared with whom?" Behind this quip lay an idea articulated by David Hume some two centuries earlier: that such evaluative words as "good" or "bad" are not meaningful in themselves but only acquire their meaning in a comparative context. As Hume wrote in his essay *Of the Standard of Taste,* "By comparison alone we fix the epithets of praise or blame, and learn how to assign the due degree of each."[4] Can the merits of any one museum then be measured simply by comparing it directly with another?

Experience suggests not. As every museum person knows, museums are so extraordinarily varied in their origin, discipline, scale, governance, structure, collections, sources of funding, endowment, staffing, facilities, and community setting that meaningful comparisons between one and another are rarely possible. That a particular big-city art museum is better attended or more richly endowed, has a larger facility, or is open for longer hours than a particular small-town history museum might be demonstrated by a series of one-on-one comparisons. To determine which on an allover basis is the "better" museum might require something else entirely.

The "something else entirely" proposed here is the composition of a model (albeit highly abstracted) not-for-profit organization that might be used as a standard of comparison, not only by museums of every discipline and scale but by other not-for-profit entities as well. To the extent that museum people could agree upon the criteria that would be essential to com-

pose this model and the relative weight that each included criterion ought be assigned, there would thus be available a means by which any two or more museums might be indirectly compared by first measuring them against a common standard and then comparing the resulting measurements.

Beyond its use as a means of comparison, such a model might serve as a diagnostic tool to indicate in what ways a museum that measures as only passable or worse could be made into a better institution. It could also provide a means of measuring an institution's performance over time. As such, it might be a useful supplement to the several assessment programs offered by the American Association of Museums (AAM), with the additional advantage that it could, optionally, be self-administered.

Inevitably, some museum people will disagree with the criteria chosen for the proposed model and/or with the relative weights these have been assigned. That should not invalidate the basic scheme. An infinity of alternative models employing different criteria might serve equally well, so long as those rested on some reasonable premises and their criteria were consistently applied.

Other museum people may take the position that museums—because, perhaps, of their infinite variety—are ultimately incommensurable. Because museums cannot be compared, these people would argue, they also cannot be evaluated in any truly comparative way. Museums ought be appreciated and valued for the unique things they are. They ought not to be dragged into an essentially degrading and meaningless competition with one another.

Given the ever-growing scrutiny under which the not-for-profit sector now finds itself, that appears to be a dangerous position. It can only undermine confidence in the museum community as a whole to argue that there are no objective standards by which the operation of a museum can be judged and that those who are called upon to fund museums must accept purely as a matter of faith that they are being operated properly. Every museum is unique, but so too is every person, every persian kitten, and every pineapple soufflé, and all may find themselves, from time to time and for one or another reason, required to stand up and be judged. If no such time should ever come for museums, fine. But if it should, then it would arguably be better if the museum community already had in place some mechanism for judgment of its own design than if it had to submit to whatever device some less-knowledgeable group of judges was able to cobble together.

SOME CRITERIA OF GOOD

By what criteria then might museum people recognize a "good" museum? Not surprisingly, they are just those same criteria that one would expect to find in highly regarded public-service organizations of every kind throughout the not-for-profit sector. Such organizations are *purposive* (they have a clear sense of what purposes external to themselves they are seeking to accomplish), *capable* (command the means required to accomplish those purposes), *effective* (are demonstrably able to accomplish the purposes they seek to accomplish), and *efficient* (are able to accomplish those purposes in a maximally economic way).

What may be at once apparent is that the sequence in which these criteria are stated—purposiveness, capability, effectiveness, and efficiency—is precisely the same sequence of considerations through which a not-for-profit organization might best be methodically evaluated. Each criterion is thus a hurdle that must be cleared before the next one is addressed. If an organization is unable to define what it seeks to accomplish, any further inquiry into its merit may be moot. There will never be a way to know whether it has accomplished its purpose and, per se, it can never be an effective organization. Likewise, if an organization can clearly define what it seeks to accomplish but cannot command the means to do so, any further inquiry into its effectiveness or efficiency would again be moot. Lacking means, it cannot accomplish anything. If an organization can both clearly define what it seeks to accomplish and command the required means to do so, but nevertheless—for whatever reason—is chronically unable to accomplish its purposes, it must still be deemed to have failed. Under those circumstances, any inquiry into whether it is or is not an efficient organization would be wholly irrelevant.

Less apparent is that the level within an organization at which each of these criteria—purposiveness, capability, effectiveness, and efficiency—is customarily addressed moves generally downward as this sequence moves forward. Overarching questions of purpose are quintessentially those that must be addressed by an organization's governing authority. Assembling the required resources to carry out the organization's designated purposes is most often a task shared by the governing authority and senior staff. The day-to-day effectiveness of a not-for-profit organization is most frequently

a staff concern, subject only to periodic review by the governing authority. As much or even more, the case may be the same with respect to questions of efficiency, which principally involve staff and which the governing authority may address only infrequently

This analysis in turn suggests that the remedies for organizational deficiencies that relate to the first and second criteria in this sequence (lack of purposiveness and/or lack of capability) may require a more fundamental organizational adjustment than would the remedies for those that relate to the third and fourth (ineffectiveness and/or inefficiency). To instill purposiveness into an otherwise purposeless not-for-profit organization may require a profound change within its governing authority. By contrast, to introduce greater efficiency into an otherwise less efficient organization may in many cases require little more than an improved management, expanded training, and/or the occasional use of consultants. The scheme proposed here reflects this distinction by assigning a substantially greater weight to the combined criteria of purposiveness and capability than it does to those of effectiveness and efficiency.

WHAT WEIGHS WHAT?

An ideal organization—one that qualified for the highest possible grades with respect to the criteria of purposiveness, capability, effectiveness, and efficiency—would be awarded a total of 100 points, made up of a maximum of 35 points for purposiveness, 30 points for capability, 25 points for effectiveness, and 10 points for efficiency. For its overall evaluation, an organization awarded a total of 91–100 points would be rated first-class, one awarded 71–90 points would be rated passable, one awarded 61–70 points would be rated marginal, and one awarded 60 points or less would be rated a failure.

Concerning the rationale through which these numbers and ratings have been calculated, it should be evident that, as a consequence of the 35 points assigned to the criterion of purposiveness, an organization fundamentally lacking in purpose could never be rated as more than marginal. In practice, such an organization would have to be deemed less than marginal, that is, a failure, because—as a corollary to its purposelessness—it could not be awarded any of the possible 25 points for effectiveness (that being defined as the ability to accomplish a proposed purpose). A highly purposive or-

ganization that was unable to command the resources required to accomplish its purpose—thereby suffering a loss of 30 points—would be, its high purpose notwithstanding, similarly rated; at best it would be marginal. In practice, the lack of resources would cripple its effectiveness, and the loss of those points as well would (as in the case above) reduce its status to failure.

Lack of effectiveness and lack of efficiency—even taken together and at their most extreme (25 points for the former, 10 points for the latter)—would reduce an otherwise top-rated organization to a marginal status but not necessarily to outright failure. These deficiencies might be more readily cured by the governing authority already in place than could a lack of purpose or lack of capability. Some relatively minor adjustment might bring such an organization at least up to the passable level. Least damaging, because most readily corrected, would be a lack of efficiency. At worst, inefficiency might prevent an organization that was exemplary in all other respects from being rated first-class.

On a practical level, these criteria do not form so neat a set of watertight compartments as the foregoing might suggest. A deficiency in one criterion would most likely create reciprocal deficiencies with respect to others. The public perception that a given not-for-profit organization was deficient in defining a fundamental purpose might ultimately reduce the resources made available to it, thus adversely affecting its capability. The public perception that the organization was ineffective could have a similar impact; so might the public perception that the organization was wasteful, that is, not efficient. Conversely, a clearer projection of purpose, a better demonstration of effectiveness, or greater evidence of efficiency might each serve to increase the flow of resources to an organization, with a consequent increase in its capability. Among museums, as among organizations of every kind, rarely is there only one thing right or wrong at a time. Virtues, like defects, tend to come in clusters.

PURPOSIVENESS

As the appendix to *The Board Members Book,* his 1985 guide to the governance of not-for-profit organizations, Brian O'Connell composed a set of make-believe minutes for a make-believe board meeting of a make-believe and thoroughly dysfunctional not-for-profit organization.[5] These culminated with the report of the board's evaluation committee: "Any organization

made up of such bright people, who are so dedicated and who have worked so hard, must be doing a great deal of good."

If we were to conceive of the degree of purposiveness to be found in museums as occupying a spectrum, then this kind of organization would certainly lie at the nether end. Infused with the earnest enthusiasm and benevolent aspirations of a largely amateur board and staff, what such a museum principally seeks to accomplish is to keep that board and staff feeling good. In this, its purpose is basically social, not museological. Whatever success it may have as a kind of cultural country club for those who cluster around it (and who may even provide its ongoing financial support), its purposiveness in museological terms must be ranked at or near zero.

Though O'Connell's "feel-good" organization is imaginary, in practice some museums may still be encountered where institutional purposes are expressed so ambiguously that these all-too-real museums must also be consigned to the lower end of this spectrum. Ambiguity is inevitably fatal to the excellence of a museum or other not-for-profit organization, for several reasons. First, it undermines accountability. If it is not clear what an organization is seeking to accomplish, then nobody can be held accountable for its failure to do so. There is simply no test by which an observer can determine whether or not resources have been applied for their intended purposes. Second, there are no means by which the effectiveness of such an ambiguously purposed organization can be evaluated. Supporters of the organization can claim that whatever outcomes were achieved were deliberate and constituted success. Detractors of the organization may equally well claim that those outcomes were purely accidental and constituted failure.

Museum people are frequently reluctant to acknowledge that feel-good organizations and organizations of ambiguous purpose are more likely to be encountered in the museum field than nearly anywhere else in the not-for-profit sector. Hospitals, schools, social-service agencies, and community improvement groups are generally established to meet a perceived need. Museums, by contrast, are frequently self-initiated. No more than a single individual with the necessary determination and means is required to establish a museum and start it operating. That such a museum will ever serve any purpose beyond providing gratification to its creator is not a given. Some do, but many do not.

Something else that museum people are frequently reluctant to acknowledge is the degree to which museums may evolve into what Philip M. Nowlen has called "federations of self-interest." In such institutions, the

professional satisfaction and advancement of the staff may—in the absence of strong governance—in time overwhelm any external focus as the museum's dominant (if unstated) purpose. So long as the staff is able to procure some means of support, such museums may continue in this mode indefinitely. In terms of purposiveness, these too must be rated at the bottom of the spectrum.

If a lack of purpose, ambiguity, and a propensity toward self-interest are the hallmarks of museums that rank at the lower end of this spectrum, what might we expect to find in those at the upper end? Some of the attributes one might expect to find in museums that measure most successfully (at the 35-point level) against this criterion of purposiveness would be:

Purposes (necessarily plural) that embrace (in whatever proportions) all three of the museological imperatives of preservation, scholarship, and object-based public programming (through interpretive exhibitions and otherwise). Though museums may have purposes beyond these (to increase tourism, to serve as a community center, to perpetuate the memory of a founder, to reflect a government's benevolence), a narrower array of purpose will not do.[6] An organization that only preserves may be a good archive; one that engages primarily in scholarship may be a good academic center; one that concerns itself all but exclusively with public programs—even object-based public programs—may be a good art or natural-history center; but they are all inadequate as museums.

Purposes that are expressed in sufficiently concrete and time-bound ways that they can serve as a basis for accountability. These are something less than the grand (and perhaps ultimately elusive) aspirations of mission; they nestle inside mission and consist of attainable objectives. They look to results rather than to distant horizons. Ideally, purposes ought to be expressed in terms of the concrete outcomes sought rather than—as has been more traditional—of programmatic outputs ("to present exhibitions of") or of communal needs ("to bridge the existing gap between"). Moreover, the outcomes sought should be potentially observable. Museums need not confine themselves to seeking quantifiable results, which are not always possible or even desirable, but some evidence of accomplishment beyond the good faith or enthusiasm of the staff is necessary if the museum is to be judged (as this scheme contemplates) on its effectiveness as well as its purposiveness.

Purposes that can reasonably be expected to be achieved with the current resources that the museum has or anticipates to be available. Unless

there is some realistic fit between a museum's aspiration and its capability, the likelihood is that the museum's available energies will be largely consumed by fund-raising rather than programmatic considerations. Just as survival is not the measure of the good museum, neither is growth. By concentrating on the use of current resources, a museum can achieve what Regina Herzlinger has called "intergenerational equity"—neither sacrificing its utility to future generations by spending down its accumulated resources on the present one nor, conversely, setting aside a disproportionate share of its current income to benefit future generations at the cost of the present one.[7]

And *purposes* that are demonstrably reflected in the museum's actual programming and, like well-made rules, can be projected clearly, are consistent with one another, and can be maintained with relative constancy over time.[8]

Beyond this, the museum that aspires to first-class rank will supplement its clearly projected purposes with an equally clear definition of the successful accomplishment of those purposes. As Richard F. Larkin has pointed out, the failure or inability to define what might be considered success has long been a persistent problem across the entire range of not-for-profit organizations.[9] The question is not simply of what outcomes the organization hopes to produce, but among how many people, in what area, over what time period, and to what degree.

An inability to define successful performance is akin to a lack or ambiguity of purpose. It defeats accountability. Absent some means to determine what would constitute a successful performance, no organization can fail. Moreover, in the absence of some definition of success, no organization may ever be considered to be either fully grown or adequately funded. Whereas the community might be best served by a mature and stable organization, the failure or inability of an organization to define a successful level of performance may set it on a path of insatiable need and ill-considered growth. The first-class museum will define for itself how much is enough.

Those who cannot accept the first premise of this proposal—that the merit of a museum may be judged independently of what one thinks of the beneficence, importance, or necessity of what it seeks to accomplish—may wish to impose additional tests in determining how the 35 points allotted to purposiveness are to be awarded. Indeed, at one extreme, they might choose to make what they consider the correctness (or incorrectness) of a museum's purpose the principal factor in the allocation of these points. Thus approached, and no matter what its excellence otherwise, a museum that

advocated a particular cause—that took a stance, for example, on an issue such as capital punishment, the moderate use of alcohol, abortion, or polygamy—could never be rated as more than a marginal institution by an evaluator who disagreed with its position.

Although powerful arguments can be offered both for and against the imposition of such ideological tests in evaluating institutions, this is not the place to rehearse those. Suffice it to say that the scheme here proposed is flexible enough either to accommodate or to exclude such tests. In some instances they might be considered permissible and/or appropriate (determining the recipients of one's own private philanthropy). In others (allocation of public funds) they might not.

CAPABILITY

The highest purposes notwithstanding, nothing can be accomplished in a museum without the means and the determination to do so. Purposiveness and capability are the twin pillars by which the successful museum is supported.

We tend to think of resources as interchangeable, but in fact it is far more practicable to convert fiscal resources into facilities, collections, and staff than is the converse. Accordingly, one of the most immediately evident hallmarks of the successful museum will be that it regularly has in hand the fiscal resources required to accomplish its purposes on an ongoing and sustainable basis. Unpalatable as some may find the thought, money does matter in museums. The measure is not "how much" in absolute terms— more is not necessarily better—but how much in relation to need.

In rare instances, this fiscal underpinning may be supplied by an endowment that, judiciously managed, permits an annual draw adequate to meet a museum's basic expenses. In other instances, governmentally related museums may receive some annual and reasonably predictable appropriation through which to meet those expenses. Most often, however, a museum will have to raise some substantial portion of the funds to meet its basic expenses through voluntary contributions, membership campaigns, and other external means. As many commentators have pointed out, the alternative— to try to earn the required funds through admissions, shop sales, and other auxiliary activities—poses the very real danger that marketing considerations may dilute or even overwhelm considerations of purpose. Whatever may be gained in terms of one may concurrently be lost in terms of the other.

For most museums, then, the excellence that may accrue through the availability of fiscal resources is directly linked to two other aspects of capability: the goodwill of potential supporters and a leadership and governance structure that is sufficiently dynamic to convert that goodwill into a steady stream of contributions, volunteer services, and other forms of support. In tandem with such tangible resources as facilities, collections, and staff, the intangibles of goodwill, dynamic leadership, and wise governance as manifested in the ability to motivate support must also be considered among those resources that, taken in their totality, provide a museum with the capability to carry out its purposes.

Two very different competencies may be required for the successful operation of a museum: that of accomplishing the museum's mission-derived purposes and that of converting the public's goodwill into actual support. This difference has not always been clearly articulated in discussing the operation of nonprofit organizations. Drucker uses the same word, "customers," to refer both to those who attend the museum (the clients, or recipients of its services) and those who support it by donating money, property, or time. An organization can only succeed, he argues, if customers of both sorts are satisfied with and value what they receive from the organization.[10]

In many privately funded museums, at least—and the case is possibly similar for other kinds of nonprofit organizations—there is the difficulty that what visitors seek may be altogether different from what donors hope to receive. Visitors may be seeking some combination of edification and entertainment. The interests of contributors or donors, by contrast, may be related to the establishment or maintenance of a web of social and/or business connections, the achievement of status, and/or the opportunity to participate in a range of what might be considered glamorous activities.[11]

Some may find these conflicting expectations regrettable. Others may simply accept them as the realistic price of maintaining a private organization. What appears clear, however, is that capability must first and foremost depend upon the ongoing availability of fiscal resources. When those resources cannot be provided through endowment or regular government support, they can only be engendered by, first, the cultivation and maintenance of goodwill and, second, the leadership and management skills necessary to convert that goodwill into regular support.

Beyond these, what other resources might be considered critical in evaluating a museum's capability? Intuition suggests that either its collection or

its facility might be of next importance, but analysis suggests otherwise. Given sufficient funds and the proper leadership and governance, a museum can acquire collections and a facility with relative ease over time. Not so readily acquirable, and more critical by far, would be the presence of a stable and well-motivated staff of demonstrated managerial and technical competence. Only through such competence can the capability latent in the museum's resources—a sound fiscal base, goodwill, dynamic leadership, and wise governance—be translated into actual museological achievements.

Museums perceived as successful will customarily contain a dazzling variety of managerial skills within their upper-management levels. To a remarkable degree, these required skills do not differ from museums of one discipline to another. They do, however, differ with respect to scale, complexity in general being directly proportional to the relative size of budget and/or staff. To be highly ranked for this aspect of capability, the non-subject-matter areas in which a museum's management would need to demonstrate competence would include strategic and tactical planning, budgeting and other aspects of financial planning and control, operations, development, human resources, facilities preservation and management, public relations, service delivery, marketing, legal affairs, and information technologies.

To examine and evaluate each of these managerial capabilities may require input from technical specialists. To take but one example, to review the management of human resources in a large museum would by itself be a substantial undertaking. The considerations—always with due regard to issues of diversity and upward mobility—would necessarily range from salary and benefit administration through training and grievance procedures to hiring and promotion practices, including some consideration in each case of whether or not these practices complied with local and national laws and regulations. Without the development of comprehensive checklists in this and other areas, estimates of managerial competence may continue to be more a matter of visceral response than careful investigation.

Staff capability must, of course, extend beyond management. In the successful museum, managerial competencies will be combined with an equally imposing array of skills that may actually vary among museums of different disciplines. In the front rank of those exercising these skills—at least as seen by the public—will be the disciplinary specialists: curators, historians, scientists, and educators. Supporting their efforts will be exhibition and graphic designers, editors, registrars, preparators, conservators, taxi-

dermists, photographers, craftspersons, information and media specialists, librarians, and more. Lending further support will typically be a security force and a building-maintenance staff. The overall assessment of a museum in terms of capability must necessarily include some estimate as to the skills of all these staff members considered as a group.

Still another aspect of capability is the museum's ability to secure the cooperation of other institutions in obtaining loans, circulating exhibitions, and exchanging expertise. Such cooperation may depend upon the perception that the requesting museum adheres to the standards of conduct and performance prescribed for the field by its various professional associations. At their most extreme, these may require that a nonadhering museum be boycotted with respect to future loans or traveling exhibitions.[12]

Finally, such an overall assessment must also take into account a museum's collections and facilities. These are not left to the last because they are least important but, rather, because they are the two aspects of capability whose inadequacies might most easily be remedied. To try to create a fine museum out of nothing more than a good collection or a fine building—a museum with no fiscal support, capable leadership and governance, competent management, or technical ability—is an exercise in futility. By contrast, a museum that has those prerequisites in place ought to be in a position to acquire a collection and/or the necessary facilities. As in the relationship between purposiveness and capability, it is a matter of getting the sequence right, of understanding which hurdle needs to be cleared before the next one can be addressed. It's like a footrace—the finish line may be the goal, but it cannot be where you start.

EFFECTIVENESS

Although it has been allotted only 25 points, effectiveness is in a sense all that really matters. It is the same sense in which the only real criterion of an airline's performance is not luggage handling, food service, or staff courtesy but the fact that its aircraft arrive safely at their destinations. A museum, in the end, is worth no more than what it is able to accomplish.

Of the four criteria under discussion—purposiveness, capability, effectiveness, and efficiency—effectiveness appears to be the most difficult to evaluate. As Herzlinger and Robert M. Anthony have written of not-for-profit organizations generally (and the case holds true for museums): "The

absence of a satisfactory, single, overall measure of performance that is comparable to the profit measure is the most serious management control problem in a nonprofit organization. (It is incorrect to say that the absence of the profit motive is the central problem; rather, it is the absence of the profit measure.)"[13]

Compounding this problem for museums is the inevitable multiplicity of their purposes and the further complication that their effectiveness in achieving each of their several purposes may require a different means of evaluation. Of the three central museological imperatives—preservation, scholarship, and object-based public programming (through interpretive exhibitions and otherwise)—preservation and scholarship appear to present fewer problems of evaluation than does public programming.

Preservation (which, except in museums with static collections, necessarily includes acquisition as its first step) could, for example, be judged against a museum's own internal collections-management policy. Of the universe of "stuff" that the museum has identified as important to preserve, what progress has been made in actual acquisitions? Is the museum devoting resources to preservation commensurate with its stated importance among the museum's purposes? What level of conservation care (as evidenced by, for example, a conservation survey) is being given to the existing collection? Does the museum have an adequate internal capacity for necessary restoration or, absent that, a satisfactory means of outsourcing such work? In what condition is the museum's climate-control system? Is an adequate pest-control program in place? What disaster plans are in place with respect to the collection? Is there adequate staff training in the handling of collection objects? And more.

Scholarship as well might be judged against a museum's own expressed intentions. In museums of some disciplines (art museums, for example), scholarship may be pursued principally in connection with collection objects (already owned or contemplated for acquisition) and exhibitions. To the extent that such scholarship is disseminated to the public, it will most likely be in the form of wall labels, gallery handouts, and exhibition catalogs. In museums of other disciplines (larger natural history museums, for example), scholarship may be aimed at producing articles for peer-reviewed journals, monographs, and other professional publications. Whether the staff of such a museum is succeeding in its scholarly efforts can be determined in much the same way (regrettably or not) that colleges and universities today evaluate the scholarly accomplishments of their faculties. In mu-

seums of all disciplines, however, the same "integrity" test as for preservation might be applied. Is the museum devoting resources to scholarship commensurate with the importance assigned to it as one of its purposes? That such resources are available will not, of course, guarantee the effectiveness of the activity, but lack of the necessary resources will almost assuredly doom the activity to failure.

By far the most difficult area in which to evaluate effectiveness is public programming. Temporary exhibitions, and temporary art exhibitions particularly, constitute possibly the worst case. All too often, such exhibitions have come to be regarded as ends in themselves, with little or no regard for how they might affect visitors. As such they become terminal phenomena to be judged for their originality, thoroughness, aesthetic excellence, or intellectual rigor rather than instrumentalities to be evaluated for their impact on a target audience. Although several pioneer researchers (mostly with a grounding in sociology) have sought to break through this barrier over the past two decades, a great deal of resistance among museum people remains to be overcome if this work is to go forward. Too often the survey researcher wanting to investigate the outcome of an exhibition will find the question, "What exactly are you trying to accomplish?" scornfully answered with, "It's a museum thing. If you have to ask, you just won't get it."

"Summative evaluation"—the process of measuring a program's results by its stated goals and objectives—requires something more forthcoming, something that museums have been slow to furnish. It requires an ability to articulate just what result the public program is intended to accomplish. Vague claims of "educational" intent are simply not enough. This is an area in which museum people need to drill themselves with tougher questions: Why is this exhibition (or other program) being presented? What precisely is the result being sought? How is a visitor intended to be affected by participating in the program? By learning something? Feeling something? Being sensitized to something? Made more curious about something? Motivated to take action about something? Entertained or given pleasure? The answers sought need not be quantitative, but they do need to be susceptible to survey research and they do need to be discussable. Ambiguity in programmatic purpose is in many ways parallel to ambiguity in institutional purpose. It undermines accountability. If there are no expected outcomes, failure becomes impossible. So does any kind of real evaluation.

It should follow that any museum that is both highly purposed and highly capable ought, per se, to be highly effective as well. Experience suggests,

though, that this is not always the case. In the otherwise purposeful and capable museum that lags in effectiveness, the mode of assessment suggested here might serve as a useful diagnostic tool in understanding where a malfunction is occurring and how it might be corrected. Lacking effectiveness, such a museum can scarcely be more than marginal. By addressing that lack, it could become solidly passable or even aspire to be first class.

EFFICIENCY

Because efficiency is so major a consideration in the operation of for-profit enterprises—a context in which it tends to merge with effectiveness, both ultimately relating to the enterprise's all-critical economic outcome—representatives of the business community first joining the governing boards of not-for-profit organizations sometimes tend to give it an exaggerated importance, perhaps because it is frequently the particular aspect of a not-for-profit organization with which they are most familiar.

Efficiency is not unimportant, and waste cannot be condoned. In a not-for-profit organization, inefficiency does not represent anywhere near so grave a problem as might a failure of purpose, a lack of capability, or an inability to be effective. Of all such malfunctions, it would have the least impact on the organization's operations and is the one that could be most readily corrected. Thus, only 10 points have been allocated to this fourth and last criterion. Also motivating so small an allocation is the need to make sure that aspects of effectiveness (worth 25 points) are not sacrificed in the name of efficiency. The trade-off is intended to be a poor one.

If those outside the not-for-profit organizations sometimes put too much stress on efficiency, those inside these organizations sometimes confuse the fact that they are not in a business (an enterprise the success of which will be defined by an economic outcome) with a belief that they are therefore free of any obligation to be "businesslike" in their day-to-day operation. That belief is more than wrong. Those who work in not-for-profit organizations serve as the stewards of resources entrusted to them to carry out a public purpose. That obligation alone should impose an even greater than average duty to see that those resources are used carefully. Their constant object should be to get the largest possible museological bang from the available bucks or, conversely, to maintain the same museological bang with the expenditure of fewer bucks. The owners/operators of a small business are

fully entitled to squander their own money. The managers of a comparably sized not-for-profit organization have no such privilege.

Unlike questions of effectiveness, which may require evaluators who are reasonably familiar with the practice and subject matter of the museum to be evaluated, questions of efficiency tend to be generic. Whether a particular piece of paper is being handled by too many people; whether a different kind of insurance policy might give greater protection against liability; whether the current HVAC system is optimally efficient; or whether the museum would not be better off leasing than purchasing a particular vehicle—all are matters that can be addressed by management experts with a wide range of experience. Moreover, there are many issues relating to efficiency for which quantitative performance indicators might readily be developed and/or external benchmarks might be already available for use.[14]

EVALUATED BY WHOM?

How might an overall organizational quality assessment such as that sketched out here best be performed? The answer will largely depend upon why such an assessment is being made and how it is to be used.

If such assessments were initiated by a museum as a regular part of its management practice, there would be good reason to perform these from inside. Immense amounts of effort (time and cost) might be saved by not having to educate outside evaluators from the ground up concerning the details of organizational operation. Moreover, the process of evaluation could be linked—ideally on a continuing basis—with the organization's own strategic and tactical planning processes. Through a process of continuing feedback and diagnosis, such a museum might hope to embark on a simultaneous course of continuing improvement.[15]

If such an assessment were to be connected to the distribution of public funds or other benefits, however, it is arguable that those who work within an organization lack the objectivity that would ideally be required in making such an assessment. Moreover, given the public scrutiny to which such an assessment might be subject, as well as the many and vastly different criteria and subcriteria involved, an array of outside specialists might be necessary if an organization of any real scale were to be thoroughly evaluated in all of its relevant aspects.

A third possibility might arise if a museum opted for only an occasional—perhaps once every five years—check on itself. The high cost of such an assessment might be mitigated if a pair of museums (located in different parts of the country and in no way competitive with one another) were to appoint task forces composed of board and staff members to evaluate each other's institutions.

CODA

Some encountering this proposal will agree that museums do vary in excellence and that some museums are clearly better than others, but they will nevertheless object to this system of assessment as an effort to define the undefinable. Quality in museums, they may argue, is like quality in art. As Supreme Court Justice Potter Stewart once memorably said of obscenity, "You know it when you see it."[16]

That argument may or may not be true for art and/or obscenity, but in neither case does it offer useful guidance to the museum in which the leadership, governing authority, and staff members aspire to institutional improvement. By contrast, what is here proposed (and whether or not one is willing to accept the possibility of an overall assessment) is an approach that might help to identify institutional deficiencies and suggest some means by which they could be remedied. It is an approach that might also prove useful in indicating how a weakness with respect to one aspect of an organization might be reflected by reciprocal weaknesses elsewhere and how these might be addressed in a coordinated way.

Much still needs to be done if this skeleton is to be fleshed out into a full-scale scheme of assessment. Like any such scheme, it can only be polished through actual use and accumulated experience. The process needs to be started, though, and preferably too early than too late. As Richard A. Smith, national executive director of the Support Centers of America, observed in 1994, what the not-for-profit field really needs are "methodologies that document what an organization accomplishes (preferably in terms of specific outputs and outcomes) at what total cost."[17] The question before the museum field is this: Who might better develop such methodologies? Those who know museums best, or those who scarcely know them at all?

NOTES

1. This is the recurring paradox of formalism. If one can conceive of a beautifully made painting of an ugly subject (late Goya, for example), why might one not just as readily conceive of an excellently operated museum dedicated to an odious purpose? Museum work, viewed thus, might be seen as a technology—in essence, a particular way to get things done. Consider the analogy to radio broadcasting, where the quality of a station might be considered wholly apart from either the ideological stance of its management or the content of any particular program.

2. See, for example, Brian O'Connell, *Evaluating Results,* Nonprofit Management Series, no. 9 (Washington, D.C.: Independent Sector, 1988); Peter Szanton, *Board Assessment of the Organization: How Are We Doing?* NCNB Governance Series, no. 14 (Washington, D.C.: National Center for Nonprofit Boards, 1992); *The Drucker Foundation Self-Assessment Tool for Nonprofit Organizations,* consisting of Constance Rossum, "How to Assess Your Nonprofit Organization," and Peter F. Drucker, "The Five Most Important Questions" (San Francisco: Jossey-Bass, 1993).

3. Drucker, 41.

4. Quoted in George Dickie et al., eds., *Aesthetics: A Critical Anthology* (New York: St. Martin's Press, 1989), 248.

5. Brian O'Connell, *The Board Members Book: Making a Difference in Voluntary Organizations* (New York: Foundation Center, 1985), 204.

6. To be kept in focus is that the evaluation here proposed is of museums as museums. An institution might, for example, be rated only marginal as a museum but be considered a first-class community center. In some contexts the distinction might not be important. In others—such as the distribution of public funds earmarked for museums (or community centers)—it might be critical.

7. "Effective Oversight: A Guide for Nonprofit Directors," *Harvard Business Review,* July–August 1994, 52.

8. It is a commonplace of the museum literature that the preservation of objects and their use in public programming are to a degree in conflict with one another. For the purposes of this proposal, however, preservation and object-based public programming are not deemed inconsistent purposes. The tension and need to balance between them is simply a given in the operation of museums.

9. See Stephen E. Weil, "Performance Indicators for Museums: Progress Report from Wintergreen," *Journal of Arts Management, Law and Society* (winter 1994): 341.

10. Drucker, 21.

11. According to a survey published in *Chronicle of Philanthropy* for September 20, 1994 (p. 12), wealthy donors to museums (defined as those with liquid assets of at least $1 million who had contributed $25,000 or more in the preceding three years) were

more than twice as apt (22.7 percent v. 10.8 percent) to be motivated by the social opportunities offered than were wealthy donors to not-for-profit institutions generally. They were also more than twice as likely (19.8 percent v. 8.3 percent) to have come from "old money" with a family tradition of philanthropy. For an analysis of donor motivations in these terms, see Russ Alan Prince, *The Seven Faces of Philanthropy* (San Francisco: Jossey-Bass, 1994).

12. This, for example, is the policy of the Association of Art Museum Directors with respect to certain breaches of the standards promulgated by its ethics and standards committee and set forth in its publication, *Professional Practices for Art Museums.*

13. Brian O'Connell, *Management Control in Nonprofit Organizations*, 9.

14. For an extended discussion of the use of performance indicators and benchmarks in museums, see Weil, "Performance Indicators."

15. Such a linkage between assessment and planning is strongly urged by Drucker, 50–52.

16. In *Jacobellis v. Ohio,* 378 U.S. 184, 197 (1964).

17. Richard A Smith, letter to the editor, *Chronicle of Philanthropy,* March 8, 1994, 52–54.

(F)FeTMu

The (Famous) Ferd Threstle Museum—generally known as (F)FeTMu—owns and occupies a rambling, forty-thousand-square-foot (thirty-six-hundred-square-meter) building in what has become a heavily built-up commercial area on the outskirts of Tulsa, Oklahoma. It was established some fifty years ago by a more-than-generous bequest from Ferd Threstle (in fact, it was every last penny he owned), the retired assistant manager of a local grocery store, who had several years earlier won the multimillion-dollar first prize in a magazine subscription contest. Its sole mission, as mandated by Mr. Threstle's will, was to make Mr. Threstle's name famous.

Nowhere can the narrow focus of (F)FeTMu's mission be better understood than through a videotaped interview—regularly shown in its orientation gallery—with the lawyer who had drafted Mr. Threstle's will. She recalls how she tried to convince him to adopt some broader purpose. She suggested that the museum might present Mr. Threstle's life as lens or prism through which visitors could catch a glimpse of everyday twentieth-century life, or savor the special ambience of northeastern Oklahoma, or trace out

This was the second of three "warm-up exercises" that were published in *Museum News* (November–December 1996) under the collective title "To Help Think about Museums More Intensely." Reprinted with permission, from *Museum News* (November–December 1996). Copyright 1996, the American Association of Museums. All rights reserved.

a typical career in the grocery trade. Alternately, he might be shown as the quintessential common man, a universal type.

Mr. Threstle was adamantly opposed. He had not the slightest interest, he said, in being understood as a lens or a prism. Nor did he want to be recalled as a common or even as an uncommon man. Certainly, he said, he'd never done anything more noteworthy than buy, shelve, inventory, advertise, and sell a bunch of groceries. No, all he wanted was to be famous. Robert Brustein once defined a celebrity as somebody who was well known for being well known. Mr. Threstle's ambition was to take that one step higher: He wanted to be famous for being famous.

(F)FeTMu has been singularly fortunate in the handling of its endowment by successive boards of trustees. With an average 12 percent annual return and 5 percent annual drawdown for operations, the museum has been able to double the value of its principal at roughly ten-year intervals. Mr. Threstle's original bequest of $10 million for the initial endowment has by now multiplied thirty-two times, to a value of $320 million with a current operating draw of $16 million annually. In another ten years the endowment should be worth considerably more than half a billion dollars. The museum has negligible admissions income, loses money on its restaurant (Ferd's Place) and sales shop (although undergraduates at the University of Tulsa once made a fad out of collecting coffee cups with the Ferd Threstle logo, and the shop enjoyed a few years of very good sales), attracts no private support, and has never received a single municipal, state, or federal grant. The endowment income provides virtually all of the museum's support.

Following some early years of confusion, when there were several biographically oriented exhibitions of account books, office furnishings, and other artifacts associated with Mr. Threstle, the museum undertook to cleave more closely to its founder's purist intention: that it celebrate not his life but only his name. (F)FeTMu's Tulsa-based and tightly integrated public programming has been organized around three series of exhibitions generated by the phrase "Ferd Threstle Writ." One of these, *Ferd Threstle Writ Small,* is an annual, juried exhibition in which lapidary artists compete in engraving Ferd Threstle's name on the heads of pins and other small objects. Frequently, several of these are acquired for the collection. A second, *Ferd Threstle Writ Large,* is a triennial invitational that furnishes installation artists with the opportunity to use various sites around the city for billboards, plantings, ornamental ironwork, and similar efforts that incorporate Ferd Threstle's name in innovative or amusing ways. Finally, *Ferd Threstle*

Writ Well is an annual exhibition for calligraphers, who compete head-to-head for several awards based on an international jury's determination of the "most beautiful," "most original," and "most playful" way of writing Ferd Threstle's name.

In an effort to make Ferd Threstle's name famous beyond the Tulsa area, (F)FeTMu has launched a number of outreach initiatives. Using the considerable economic clout provided by its endowment, it has induced a software manufacturer to produce a screen saver for computer monitors that consists entirely of the words "Ferd Threstle" scrolling endlessly downward in the successive colors of the rainbow; convinced (with the help of a timely loan) an educational publisher to include the letters that form "Ferd Threstle" as part of an exercise book for grade-school handwriting classes; and paid fees to various Hollywood studios to have "Ferd Threstle" appear on signs as part of film backgrounds. Future projects contemplate the use of the Ferd Threstle signature as a wallpaper design; the repeated recitation of his name in an anti-insomnia, sleep-inducing CD; and an (F)FeTMu home page on the World Wide Web at http://www.Ferd@forever.edu.

Few museums in the United States or elsewhere have progressed as far as (F)FeTMu in linking assessment so directly to mission. Though this may in part be caused by the narrowness of its mandate ("to make Ferd Threstle a famous name"), the results are nonetheless noteworthy. The principal tool that (F)FeTMu has used for evaluation is a name-association questionnaire, in which randomly chosen respondents are provided with a first name and then asked to report the second name that most immediately occurs to them. More often than not, "Elvis" will elicit "Presley," "Newt" will summon up "Gingrich," "Woodrow" will trigger "Wilson," and "Mickey" will produce either "Mouse" or "Mantle." Although "Ferd" only rarely produces "Threstle" as a response, (F)FeTMu's management considers the trend to be more important than any absolute result.

And the trend is impressive. Twenty years ago, when this kind of evaluation began in earnest, the percentage of "Threstle" responses to "Ferd" was 6 percent in Tulsa, 2.8 percent in Oklahoma generally, and 0.013 percent nationally. All of those figures are higher today, and they continue to climb steadily. In terms of an institutional goal, the management of (F)FeTMu will consider itself successful when 20 percent of Tulsans, 10 percent of Oklahomans, and 0.5 percent of all U.S. residents will immediately associate "Threstle" with "Ferd." The goal thereafter will be to maintain this level of recognition as one generation succeeds another.

But there have been ominous signs. Notwithstanding the demonstrable success of (F)FeTMu in achieving its mission, several developments have been upsetting. These include: an effort by a Tulsa city council member to have (F)FeTMu's real-estate tax exemption repealed, on the grounds that such exemptions are intended for organizations providing truly charitable services and that, as he argued in a recent speech, "as a charity, (F)FeTMu ain't worth spit." Second, some younger members of the state museum association tried to expel (F)FeTMu, on the grounds that it does not make the requisite contribution to the advancement of society that ought be the hallmark of a museum. Some of those same young members are also mounting a parallel campaign within the American Association of Museums to have (F)FeTMu's accreditation withdrawn. Finally, Carlyle Threstle III— Ferd Threstle's great-grandnephew and soon-to-be-inheritor of the single (F)FeTMu board seat reserved for family—is expected to seek a court-ordered amendment to the terms of the Threstle bequest to permit the museum to pursue more socially relevant goals. Alternately, he would like to see $200 million of the $320 million now held in (F)FeTMu's endowment turned over to a newly established organization intended to assist abused children, on the grounds that the current and prospective value of the endowment is "grotesquely disproportionate" to what is necessary to carry out the museum's mandate. "It's a disgrace to my family and its good name," he told the press, "that the dead hand of my cooty great-granduncle should still be pushing this outworn agenda after all these years. Enough is enough. (F)FeTMu is too much."

Ponder this: What do you think we owe the dead? What do you think we owe the living? What arguments can you comfortably make in favor of (F)FeTMu maintaining its present course? What arguments do you find yourself tempted to make in opposition? If it were wholly in your power to decide (F)FeTMu's future, what decisions might you make? Why?

From Being *about* Something to Being *for* Somebody

THE ONGOING TRANSFORMATION OF THE AMERICAN MUSEUM

At the end of World War II, the American museum—notwithstanding the ringing educational rhetoric with which it was originally established and occasionally maintained—had become engaged primarily in what my Washington colleague Barbara Franco once called the "salvage and warehouse business."[1] It took as its basic tasks to gather, preserve, and study the record of human and natural history. Any further benefit, such as providing the public with physical and intellectual access to the collections and information thus accumulated, was simply a plus.

Fifty years later, caught up in the confluence of two powerful currents—one flowing throughout the worldwide museum community, the other specific to the United States—the American museum is being substantially reshaped. In place of an establishment-like institution focused primarily inward on the growth, care, and study of its collection, emerging instead is a more entrepreneurial institution that—if my vision of its ultimate form should prove correct—will have shifted its focus outward to concentrate

This was originally written for the special issue of *Daedalus,* vol. 128, no. 3 (summer 1999) devoted to "America's Museums." A briefer version under the title "When the Audience Takes Stage Centre" also served as the text for the October 1998 Margaret Manion Lecture at the University of Melbourne and subsequently appeared under that title in *Melbourne Art Journal.* Published with permission of *Daedalus,* journal of the American Academy of Arts and Sciences.

on providing primarily educational services to the public and will measure its success in that effort by the overarching criterion of whether it is actually able to provide those services in a demonstrably effective way.

This prognostication makes no distinction between museums and museumlike institutions in terms of their funding sources, scale, or discipline. It applies equally to a large statewide historical society, a campus-based natural history museum, and a small, private art gallery. So-called private museums require particular mention. Even the most ostensibly private of American museums—through the combined effects of its own tax exemption and the charitable-contribution deductions claimed by its donors—receives a substantial measure of public support. Given the nature of that support, such private museums are inevitably expected not only to provide a level of public service comparable to that required of so-called public institutions but also to maintain similar standards of accountability and transparency.

Among workers in the field, the response to this ongoing change in the museum's focus has been mixed. Some—a minority, certainly—view it with distress. They argue that the museum—if not at the height of its salvage and warehouse days, then not long thereafter—was already a mature, fully evolved, and inherently good organization in no compelling need of further change. Particularly troublesome, in their view, would be to tamper with the centrality of the collection—even to entertain the notion that the collection might no longer serve as the museum's raison d'être but merely as one of its resources.

A far larger number of museum workers are sympathetic to the museum's evolution from a collection-based organization to a more educationally focused one, but they nevertheless tend to retreat from making institutional effectiveness so exclusive a test of institutional failure or success. Characterizing the museum as analogous in some measure to the university, they argue that the museum's traditional activities of preservation (which may include collecting), interpretation (which may include exhibiting), and scholarly inquiry (above all) are not merely instrumental steps toward an ultimately external outcome but should also be valued in their own right, as ends as well as means. From that moderate position, many still share the vision of an emerging new museum model—a transformed and redirected institution that can, through its public-service orientation, use its very special competencies in dealing with objects to improve the quality of individual human lives and to enhance the well-being of human communities.

Vague as those purposes may at first appear, so multifarious are the potential outcomes of which this emerging museum is capable that to use terms any more specific than "quality of life" or "communal well-being" would be unnecessarily exclusive.

Finally, at the other extreme are those museum workers who question whether the museum truly is an inherently good organization (or whether it has any inherent qualities at all) and whether the traditional activities of preservation, interpretation, and scholarship have any value in a museum context, apart from their capacity to contribute to an outcome external to the museum itself. Rejecting any analogy with a university, they argue that museum work might better be understood instead as a value-neutral technology and the museum itself as neither more nor less than a highly adaptable instrument that can be employed for a wide range of purposes.

What follows will consider the American museum from this last point of view, examining the currents that now press against it as well as suggesting several possibly unanticipated consequences that may well follow in the wake of those currents. It is based on the twin premises that, first, those pressures now reshaping the museum will continue unabated for the foreseeable future, and second, that in yielding to those pressures nothing innate or vital to the museum will be lost or even compromised. As Adele Z. Silver of the Cleveland Museum of Art wisely observed, "Museums are inventions of men, not inevitable, eternal, ideal, nor divine. They exist for the things we put in them, and they change as each generation chooses how to see and use those things."[2]

THE MUSEUM AS PUBLIC SERVICE

In a reflection on the recent history of museums, written for the fiftieth-anniversary issue of the UNESCO magazine *Museum International*, Kenneth Hudson—perhaps the museum community's most astute observer—wrote: "The most fundamental change that has affected museums during the [past] half century . . . is the now almost universal conviction that they exist in order to serve the public. The old-style museum felt itself under no such obligation. It existed, it had a building, it had collections and a staff to look after them. It was reasonably adequately financed, and its visitors, usually not numerous, came to look, to wonder and to admire what was set

before them. They were in no sense partners in the enterprise. The museum's prime responsibility was to its collections, not its visitors."[3]

Among the several factors to which Hudson points in seeking to account for this change is the enormous increase during the postwar period in both the number and the magnitude of museums. By his count, at least three-quarters of the world's active museums were established after 1945. In no way has the level of direct governmental assistance to these museums kept pace with that growth. In some countries it has remained stagnant; in others—the United States, for one—its vigorous growth in the 1960s and 1970s has been followed by actual decline. The result, almost worldwide, has been the same: to change the mix in the sources of support for museums, with a decrease in the proportion coming directly from governmental sources and a corresponding increase in the proportion that must be found elsewhere.

It seems clear, at the most elementary level, that the greater the degree to which a museum must rely for some portion of its support on "box office" income—not merely entrance fees but also the related funds to be derived from shop sales and other auxiliary activities—the greater will be its focus on making itself attractive to visitors. Likewise, the greater the extent to which a museum might seek corporate funding—particularly for its program activities—the more important will be that museum's ability to assure prospective sponsors that its programs will attract a wide audience. Under such circumstances, it should hardly be surprising that museums are increasingly conscious of what might be of interest to the public. The consequence is that museums almost everywhere have, in essence, shifted from a "selling" mode to a "marketing" one. In the selling mode, their efforts were concentrated on convincing the public to "buy" their traditional offerings. In the marketing mode, their starting point instead is the public's own needs and interests, and their efforts are concentrated on first trying to discover and then attempting to satisfy those public needs and interests.

Hudson argues—correctly, I think—that something more profound than mere box-office appeal is involved in this change of focus. He suggests that the museum's growing preoccupation with its audience also may be attributable to the tremendous increase of professionalism within the museum community during the postwar years. The impact of that development—and, as a principal consequence, the equally tremendous growth in the scale, influence, and variety of professional associations—should not be

underestimated. The policy positions taken by those professional associations—and the insistent repetition of those policies over time—have played a compelling part in shaping the mind-set and expectations of new practitioners in the field and the larger public as well. As the sociologists Walter W. Powell and Rebecca Friedkin point out in their analysis of the sources of change in public-service organizations, beyond such changes in focus as may be attributable to changes in the sources of an organization's support—for museums, the box-office factor—institutional change may frequently represent "a response to shifts in the ideology, professional standards, and cultural norms of the field or sector in which an organization is situated."[4]

That would appear to be the case for the museum. A broad range of national and local professional organizations have influenced the ideological reshaping of the American museum. Earliest among these was the AAM, founded in 1906 as something of a parallel to the United Kingdom's Museums Association, which dates back to 1889. Narrower in focus but also with considerable impact have been the more recently established Association of Science-Technology Centers (ASTC) and the Association of Youth Museums (AYM). Of perhaps lesser consequence for the American museum—but of enormous influence elsewhere—has been the International Council of Museums (ICOM). Descended from the International Museums Office founded under the auspices of the League of Nations in 1927, ICOM was established in 1946 as a UNESCO-affiliated nongovernmental organization, headquartered in Paris.

The publications and program activities of these associations amply document the degree to which they have changed their emphasis over the past several decades, from collections and preservation to public service. Within the AAM, that shift can be attributed directly to the growing influence that museum educators have exercised over the association's public-policy positions. That influence can be traced on an ascending curve, beginning in June 1973 when a group of prominent museum educators threatened to secede from the organization. In June 1976, as a gesture of conciliation, a change in the AAM's constitution granted a committee of educators together with other disciplinary groups a role in the association's governance. With the publication of *Museums for a New Century* in 1984, education was declared to be a "primary" purpose of museums.[5] This upward curve reached its zenith in May 1991, when the association's governing board adopted the educator-prepared position paper *Excellence and Equity* as an official statement of the association's policy.[6] Woven throughout *Excellence*

and Equity are the linked propositions that a commitment to public service is "central to every museum's activities" and that "education—in the broadest sense of that word—[is] at the heart of their public service role."[7]

A similar shift of focus can be traced in the AAM's program of institutional accreditation, first proposed in 1968 and put into operation in 1971. In its earliest phase, accreditation was primarily concerned with how an institution cared for its collection and maintained its facilities. With the passage of time, the scope of accreditation has steadily broadened to consider not only the institutional care of collections but also, as importantly, the programmatic use of those collections. Consider the contrast between the types of concern expressed in the AAM's first accreditation handbook of 1970 and in its most recent one, published in 1997. In the 1970 publication, among the positive traits that might support a museum's accreditation were avoidance of "crude or amateurish" exhibits, evidence that exhibit cases were dust- and vermin-proof, and a demonstration that the exhibits themselves were "selected to serve [some] purpose and not just [as] 'visible storage.'"[8] Regarding special exhibitions, it suggested that the better practice was to offer exhibitions that appealed to the interest of the general public and not simply to that of an "antiquarian or dilettante" audience. In the AAM's 1997 publication, the emphasis shifted entirely. Suggested areas of inquiry include whether the "museum effectively involves its audiences in developing public programs and exhibitions," whether it "effectively identifies and knows the characteristics of its existing and potential audiences," and whether it "effectively evaluates its programs and exhibitions" in terms of their audience impact.[9]

Contrasting quotations from two other AAM publications may suggest how far the rhetoric—if not yet all of the operational practices—of the museum community has evolved during this period. Consider the 1968 *Belmont Report*—a mostly forgotten document that was once thought (wrongly, in the event) to offer an irrefutable argument for the increased federal funding of American museums. Those who produced the report were certainly aware that "education" would prove the most likely heading under which increased funding could be justified, but they seemed reluctant to relinquish entirely the old-fashioned satisfaction ("pleasure and delight") that museum collections were traditionally thought to provide.[10] "Art museums," they explained, "aim to provide the aesthetic and emotional pleasure which great works of art offer. This is a primary purpose of an art museum. It is assumed that a majority of the people who come regularly to art museums come to

be delighted, not to be taught, or preached at, or "improved" except by the works of art themselves. An art museum, especially, is—or ought to be— a place where one goes to get refreshed."[11] Never adequately explained in the *Belmont Report* was why so much refreshment (particularly in the case of the art museum, where that refreshment was disproportionately consumed by the more affluent members of society) should properly be provided at public rather than private expense.

The escalation in rhetoric is suggestive. Over three decades, what the museum might be envisioned as offering to the public has grown from mere refreshment (the museum as carbonated beverage) to education (the museum as a site for informal learning) to nothing short of communal empowerment (the museum as an instrument for social change). Describing the growth of museums in rural Brazilian communities seeking to discover their roots and preserve a unique history, Maria de Lourdes Horta wrote in a 1997 AAM publication:

> A museum without walls and without objects, a true virtual museum, is being born in some of those communities, which look in wonder to their own process of self-discovery and self-recognition. . . . For the moment, in my country, [museums] are being used in a new way, as tools for self-expression, self-recognition, and representation; as spaces of power negotiation among social forces; and as strategies for empowering people so that they are more able to decide their own destiny.[12]

ICOM, like the AAM, has put increasing emphasis on the public-service role of museums. Going still further, it has advanced toward a view—similar to that from Brazil—that museums can play a powerful role in bringing about social change. To some extent, that conviction has grown almost in tandem with the number of developing countries included within its membership base. Given that change in its membership, as well as its ongoing relationship with UNESCO, ICOM's emphasis on social activism must be understood as more than simply a passing phase. It permeates virtually every aspect of ICOM, beginning even with its membership requirements. In contrast to the AAM, which continues to take the more traditional approach of defining museums primarily in terms of their activities—to present essentially educational programs that use and interpret objects for the public—ICOM's statutes were amended in 1974 to redefine "eligible" museums as those that have among their characteristics the purpose of serving (in an earlier iteration) "the community" or (in ICOM's current definition) "society and . . . its development."[13]

Among the clearest articulations of ICOM's evolving position was a resolution adopted by the membership in 1971 at its ninth general conference. Rejecting as "questionable" what it called the "traditional concept of the museum," with its emphasis "merely" on the possession of objects of cultural and natural heritage, the conference urged museums to undertake a complete reassessment of the needs of their publics, so that the museums could "more firmly establish their educational and cultural role in the service of mankind." Rather than prescribing any monolithic approach to this task, individual museums were urged to develop programs that addressed the "particular social environment[s] in which they operated."[14]

At an April 1998 meeting in San José, Costa Rica, "the first summit of the museums of the Americas," organized by the AAM in collaboration with some of ICOM's national and other committees, the proposition that museums might play a useful role in social development was taken a step further. In a three-tiered finding that amounted to a syllogism, the 150 delegates representing 33 Western countries took the position that the museum was not merely a potential or desirable instrument for sustainable social advancement but, in effect, an essential one. The logic of that position went as follows: "First, sustainable development is a process for improving the quality of life in the present and the future, promoting a balance between environment, economic growth, equity and cultural diversity, and requires the participation and empowerment of all individuals; second, culture is the basis of sustainable development; and third (and, in effect, ergo), museums are essential in the protection and diffusion of our cultural and natural heritage."[15]

This emphasis on social service is the first of the two currents that are pushing the American museum out of the salvage, warehouse, and soda-pop business and toward a new line of work. It is powered both by economic necessity—the box-office factor—and by the museum field's changing ideology as transmitted not only through such major professional associations as the AAM, ASTC, AYM, and ICOM but through countless smaller ones as well. It is coupled with the reality that for many of the more recently founded museums in newly populous parts of this country, it will never be possible—because of scarcity-driven market prices, international treaties and export/import controls, or endangered species and similar legislation—to amass the in-depth and universal collections that were built many years ago by the longer-established institutions. For those older museums, public service may nevertheless be their more viable future. For younger

ones, without important collections or any great prospect of ever acquiring them, public service may be their only future.

EVALUATING THE PERFORMANCE OF NONPROFITS

The second current pushing against American museums is a local one. Its source is in the not-for-profit or "third" sector of this country's economy, the organizational domain to which the largest segment of those museums belongs and by which all of them are profoundly influenced. Comprising more than a million organizations—museums accounting for less than 1 percent—and generally estimated to include about 7 percent of the nation's wealth, jobs, and economic activity, the third sector itself is in the midst of profound change as to how it evaluates its constituent organizations as worthy of funding. Increasingly, the principal emphasis of such evaluations is being put on organizational performance—on the results that an organization can actually achieve.

The genesis of this change may be found in the long-simmering sense that the managers of governmental agencies as well as third-sector organizations—both lacking the reality checks of a competitive marketplace as well as the operational discipline required to demonstrate consistent profitability—have rarely been required to apply their resources with the same effectiveness and efficiency that would be demanded of them in a for-profit context.[16] In the case of federal government agencies, Congress's desire to ensure greater effectiveness culminated in the Government Performance and Results Act (GPRA), which was passed with strong bipartisan support in 1993 and which became fully effective in 2000. GPRA requires every federal agency to establish—preferably in objective and measurable terms—specific performance goals for each of its programs and to report annually to Congress on its success in meeting those goals. For the third sector, where nothing so draconian as GPRA has yet to be proposed, this new emphasis on organizational performance nevertheless constitutes a sharp break with past practice.

Two events can be singled out as having accelerated this growing emphasis on performance. One was the "social-enterprise" model of third-sector organizations developed by Professor J. Gregory Dees at Harvard Business School during the early 1990s.[17] The other was the United Way of America's development and advocacy of outcome-based evaluation as the

appropriate means of evaluating the effectiveness of the health and human-service agencies to which it provides funds.[18]

The impact of Dees's social-enterprise model can best be understood by considering some of the ways that third-sector organizations have previously been viewed. As recently as the end of World War II—a time when museums were still in their establishment stage and when survival (as contrasted with accomplishment) was widely accepted as a perfectly reasonable indicator of institutional success—the three adjectives most commonly used to describe such organizations were "philanthropic," "benevolent," and "charitable." Remarkably, none of these referred either to what those organizations actually did or to what impact they might hope or expect to make on some target audience. Their reference instead was to the high-minded motives of the individuals responsible for their establishment and support: philanthropic (from the Greek for a "lover of humankind"), benevolent (from the Latin for "somebody wishing to do well"), and charitable (from the Latin also: *caritas,* or "with loving care"). In the years since, those adjectives have largely been replaced by the terms "nonprofit" and "not-for-profit," notwithstanding the repeated criticism that the third sector is far too large and its work far too important to define it so negatively in terms of what it is not, instead of positively in terms of what it is.[19]

What is particularly striking about Dees's social-enterprise model is its way of cutting through earlier methods of evaluating these third-sector institutions and concentrating instead on "organizational outcomes," "impacts," or "results." In the long run, says Dees, it is those outcomes that matter—not goodwill, not an accumulation of resources, not good process, and not even highly acclaimed programs, but actual outcomes, impacts, and results. In essence, those are the organization's bottom line. Thus envisioned, the social enterprise can be seen as at least partially parallel to the commercial enterprise—similar in having achievement of a bottom line as its ultimate operational objective, yet wholly different because of the way that bottom line is defined. The commercial enterprise pursues a quantifiable economic outcome; the social enterprise pursues a social outcome that may or may not be quantifiable but that, in any event, must certainly be ascertainable.

Dees points to a second important difference between the commercial enterprise and the social enterprise. He calls this the "social method." Whereas the commercial enterprise must rely on "explicit economic exchange relationships, contracts, and arm's-length bargains" to obtain resources and to distribute its product, the social enterprise operates in a dif-

ferent environment. At the input end, it may rely on the voluntary contri-
bution of funds, goods, and/or labor; at the output end, it typically pro-
vides its services to the public without charge or at a price below the cost
of producing those services. Those differences aside, in the social-enterprise
model—just as in the commercial-enterprise one—the ability to achieve
an intended bottom line is what distinguishes organizational success from
failure.

For the American museum, this is a fresh challenge. To the extent that
it has ever accepted that its performance might be legitimately subject to
overall and possibly comparative evaluation, its worst-case scenario was that
such an evaluation would—like the AAM's accreditation program—be
wholly internal. What constitutes a good museum? At one time, it might
have been defined in terms of the loyalty and generosity of its benefactors.
Later, "good" might have referred to the magnitude of its resources and the
excellence of its staff: a fine collection, a highly regarded and well-
credentialed group of curators, an appropriately large endowment, and a
substantial building. Among government-related museums, a good museum
might be one that adhered to the best practices and highest professional
standards in the field, one that did things "by the book." Or—as was the
case during the heyday of the National Endowments for the Arts and the
Humanities, with their emphasis on program funding—it might be a mu-
seum at which exhibitions and other programs were considered exemplary
by knowledgeable colleagues who worked in peer organizations. What
seems so extraordinary, at least in retrospect, is that not one of those ap-
proaches took into the slightest account the museum's external impact, on
either its visitors or its community.

Curiously, a rigorous bottom-line evaluation, with its primary weight on
just such considerations, would not really eliminate any of those other,
inner-directed approaches. It would simply incorporate and supersede
them. For a museum to achieve a consistently solid bottom-line result, it
would still need the ongoing support of generous donors and a spectrum
of tangible and intangible resources. It would still need to establish and ad-
here to sound working practices and to produce high-quality programming.
In the social-enterprise model, all the factors are necessary but not—in
themselves or in combination—sufficient. The museum that aspires to be
successful must still manage to combine these elements with whatever else
may be necessary to render the specific public service that it has identified
(for itself and for its supporters) as its own particular bottom line.

And what, for museums, might such a bottom line be? Here, I think, the museum community can find useful guidance in the evaluation model that the United Way of America formally adopted in June 1995. Before, the United Way had centered its evaluation process around the programs of its applicant health and human-service agencies. In 1995 it determined that it would henceforth concentrate instead on the results of those programs— on the identifiable outcomes or impacts that those agencies were able to achieve through those programs.

The key concept in the United Way's newly adopted approach is *differ-ence*. To qualify for funding, the United Way's applicant agencies are called upon to demonstrate their ability to make positive differences—differences in knowledge or attitude or values—in the quality of individual or communal lives.

There are, I think, few people working in the museum field today who doubt for a moment that museums can meet such a standard. Museums quintessentially have the potency to change what people may know or think or feel, to affect what attitudes they may adopt or display, to influence what values they form. As Harold Skramstad, president emeritus of Henry Ford Museum and Greenfield Village, asked in 1996 at the Smithsonian's 150th anniversary symposium in Washington, D.C., unless museums can and do play a role relative to the real problems of real people's lives, then what is their point?

The answer is, with the considerable funding that they receive directly and indirectly from public sources, American museums must embrace such a role. As I have written elsewhere,

> If our museums are *not* being operated with the ultimate goal of improving the quality of people's lives, on what [other] basis might we possibly ask for public support? Not, certainly, on the grounds that we need museums in order that museum professionals might have an opportunity to develop their skills and advance their careers, or so that those of us who enjoy museum work will have a place in which to do it. Not certainly on the grounds that they provide elegant venues for openings, receptions and other glamorous social events. Nor is it likely that we could successfully argue that museums . . . deserve to be supported simply as an established tradition, as a kind of ongoing habit, long after any good reasons to do so have ceased to be relevant or have long been forgotten.[20]

With the ongoing spread of outcome-based evaluation, however, two cautions seem in order. First, museums need to observe a certain modesty as

they identify their bottom lines, lest they overstate what they can actually accomplish. Grand proclamations, such as those made at the first summit of the museums of America, may be important in highlighting the museum field's overall capability to contribute meaningfully toward social development. The individual museum that declares "denting the universe" to be its bottom line may be setting itself up for failure unless and until it can produce a perceptibly dented universe to demonstrate its accomplishment. Museum workers need to remind themselves more forcefully than they generally do that museums can wonderfully enhance and enrich individual lives, even change them, and make communities better places in which to live. But only rarely—and even then, more often than not in synergy with other institutions—do they truly dent the universe.

Second, museums must ensure that the need to assess the effectiveness of their public programs does not distort or dumb down the contents of those programs to the point of including only what may have a verifiable or demonstrable outcome and excluding everything else. The problem is parallel to that faced by the nation's school systems with respect to nationally standardized tests. For all its promise, outcome-based evaluation—like any system—requires a wise and moderate application. Taken to an extreme, it can damage the very institutions that it was designed to benefit.

As part of the worldwide museum community, the American museum is under pressure to make public service its principal concern. Because the museum is also part of the American not-for-profit sector, the nature of the public service it will be expected to provide can be defined in more specific terms: demonstrably effective programs that make a positive difference in the quality of individual and communal lives. Recast in marketing terms, the demand is that the American museum provide some verifiable added value to the lives of those it serves in exchange for their continued support. Recast in blunter terms, the museum is being told that, to earn its keep, it must be something more important than just an orderly warehouse or popular soda fountain.

RIPE FOR CHANGE:
EXHIBITING THE LIVING CULTURE

Traditional wisdom holds that an organization can never change just one thing. So finely balanced are most organizations that change to any one ele-

ment will ultimately require compensating and sometimes wholly unantici-
pated changes to many others. As the focus of the worldwide museum com-
munity continues to shift, from the care and study of collections to the de-
livery of a public service, I want to examine at least two other aspects of
American museums that may be considered ripe for compensating changes.
One is the way that they are divided along disciplinary lines by the types of
collections they hold—most typically art, history, and science. The other
is the way they are staffed and how museum workers are trained. In both
respects, the overwhelming majority of American museums and museum-
training programs continue to operate as if World War II had only just
ended and as if collections were still at the center of the museum's concerns.

With regard to the division of museums by discipline, let me start with
an anecdote. During a visit to British Columbia in 1997, I learned of an ex-
hibition mounted earlier that year by the Nanaimo District Museum on Van-
couver Island, *Gone to the Dogs.* The exhibition not only traced the history
of dogs in the community back to their pre-European roots but also took
into account the various ways in which dogs—"as companions and cowork-
ers"—continued to relate to the community today: from tracking preda-
tors for the Royal Canadian Mounted Police to acting as Seeing Eyes for the
visually handicapped to serving as pets. In a Doggy Hall of Fame, local resi-
dents were invited to post photographs of favorite dogs as well as brief,
typed statements as to why they thought them special. A free film series—
Dog Day Afternoons—presented feature films about dogs. Supplementary
programs addressed local dog-related businesses such as pet grooming and
veterinary services and highlighted the work of the SPCA.[21] By all accounts,
the exhibition was an enormous success. It brought many first-time visitors
to the museum, its popularity required the museum to transfer the exhibi-
tion to another local venue and extend the closing date, and, above all, it
appeared to have left behind the palpable sense of a public enriched by its
recognition of a common bond. In the end, the exhibition proved not to
have been so much about dogs as it was about the shared concerns and in-
terconnectedness of a community.

Almost as striking as the novelty of that exhibition, however, was the
recognition of how few communities in the United States might ever hope
to see a similar exhibition in their own local museums, notwithstanding the
ease with which it might be replicated. The mission of the Nanaimo Dis-
trict Museum was defined by geography, not by discipline: It was established
to serve the city of Nanaimo and its surrounding district. In seeking to il-

luminate that region's cultural heritage and link that heritage to its present-day development, no restrictions limited the range of materials that the museum could employ to illustrate such links. In the United States, most museums are confined to specific disciplines. In the 1989 *National Museum Survey*—the most recent broad-based statistical information available—only 8.6 percent of American museums classified themselves as general museums not tied to a particular discipline.[22] If children's museums, generally multi-disciplinary, are counted as well, the total is still barely above 15 percent.

For the remaining 85 percent of American museums, to present an exhibition such as *Gone to the Dogs* would generally be considered as beyond their disciplinary boundaries. When collections were at the center of a museum's focus, that disciplinary exclusivity might have made sense. From a managerial perspective, at least, it limited the number of such narrowly trained specialists as discipline-specific curators and conservators who had to be kept on staff. With the refocus of the museum on its public-service function, strong arguments can be advanced for releasing the museum from this disciplinary straitjacket—most particularly in communities that have only a single museum or, at best, two. Why should those museums not try to broaden their disciplinary scope? Staffing problems could readily be dealt with through collaboration with local colleges, universities, and research institutions, by outsourcing, or through the use of consultants. In the words that James Smithson used to describe his expectations of the institution that was to bear his name—that it be for "the increase and diffusion of knowledge"—the public-service-oriented museum might well conclude that, rather than pursue both goals with equal vigor, it would make better sense to emphasize "diffusion," where the museum's unique competencies lie, and to leave the "increase" to possibly more competent academic institutions, with which it could closely collaborate.[23]

Easing the disciplinary boundaries of museums would not be as radical a step as it might first appear. A separation into disciplines was never inherent to the museum as an institutional form, even in its origin in those sixteenth- and seventeenth-century cabinets of curiosities. Such a separation was a later development. The Tradescant collection—the founding collection for the Ashmolean Museum at Oxford—comfortably combined natural-history specimens and what its first catalog of 1656 called "Artificialls"—objects that ranged from works of art, weapons, and coins to ethnographic materials and Egyptian and Roman antiquities.[24] Many continental European *wunderkammers* were similar. In the United States, the first

museums—such as the one Charles Willson Peale opened in Philadelphia in 1786—held equally eclectic collections. Peale's museum included not only portraits of American Revolutionary War heroes but also fossils, shells, models of machinery, and wax figures of Native North Americans.[25] Throughout the twentieth century, the case for multidisciplinary museums was advanced by museum practitioners as diverse in their views as John Cotton Dana in the first quarter of the century and by the proponents of the ecomuseum in more recent years.[26]

Contemporary museum practice provides ample room to envision museums organized along other than disciplinary lines. One immediate example is the children's museum. In her 1992 survey of children's museums across the United States, Joanne Cleaver credits Michael Spock and his staff—who revived the Boston Children's Museum, starting in 1961—with having pioneered the idea that "the museum was for somebody rather than about something."[27] An alternative institutional form—a museum that is about something but nevertheless is nondisciplinary—is the community or neighborhood museum. One well-established type is the *heimat* ("homeland") museum, an institution that began to appear throughout Germany during the latter part of the nineteenth century and, after some twists and turns, still survives today.[28]

Although *heimat* museums were intended originally to document rural life and popular culture, particularly in their preindustrialized forms, the potential role of these museums in education and community development was recognized by the turn of the century. Under the Nazi regime, it was only a short step from education to propaganda. The *heimat* museums were employed to disseminate a pseudoscientific message of Aryan superiority and to preach a nationalist gospel of blood and soil. Notwithstanding that dark episode, there is something remarkably prescient of current museological thinking in these 1936 observations by a German curator writing about a *heimat*-like museum in Cologne: "The *heimatmuseum* must not be a kingdom of the dead, a cemetery. It is made for the living; it is to the living that it must belong, and they must feel at ease there. . . . [T]he museum must help them to see the present in the mirror of the past, and the past in the mirror of the present . . . and, if it fails in that task, it becomes no more than a lifeless collection of objects."[29]

In the contrasting attitudes that German museum workers take toward its postwar continuation, the *heimat* museum can be seen as providing a litmus test by which to separate those who still believe in the primacy of col-

lections from those who now see the museum primarily in terms of public service. Some German colleagues dismiss the contemporary *heimat* museum as beyond the boundaries of the field because, in addition to holding objects, it also serves as an active cultural and social center. For exactly that same reason, other German colleagues consider it to be an especially valuable and viable kind of museum. Outside of Germany, the *heimat* concept has taken on a life of its own. With its emphasis on everyday life and ordinary objects, for example, the Museum of London—which opened in 1976 and which Kenneth Hudson has acknowledged to be "one of the finest city-biography museums in the world"—might simply be seen as the *heimat* museum writ large.[30]

With regard to neighborhood museums, perhaps the best-known model in the United States is the Anacostia Neighborhood Museum, opened by the Smithsonian Institution in 1967. As an institutional type, the neighborhood museum was described by the late John R. Kinard, Anacostia's founding director: "[It] encompasses the life of the people of the neighborhood—people who are vitally concerned about who they are, where they came from, what they have accomplished, their values and their most pressing needs. Through the various media of its exhibits the museum reflects the priorities already determined by neighborhood people and other community agencies and is, thereby, able to present the issues that demand attention."[31] Just as few American museums might have had the flexibility to mount the Nanaimo Museum's *Gone to the Dogs,* few might have had the inclination to undertake so bold and neighborhood-specific an exhibition as *The Rat: Man's Invited Affliction,* an early Anacostia project generated by local children and the concern they expressed about the problem of rat infestation in their neighborhood.

Kinard later wrote that it was the *Rat* exhibition that convinced him and his staff that the museum could no longer afford to deal only with life in the past. Its exhibitions, he said, "must have relevance to present-day problems that affect the quality of life here and now."[32] That conviction notwithstanding, the museum's focus on its immediate neighborhood was eventually to change. Scarcely more than a decade after the founding of the museum, Anacostia's board of trustees adopted a new mission statement pursuant to which it was to offer a more generalized but still multidisciplinary program dealing with African American history, art, and culture.[33] In essence, it was now to be a community rather than a neighborhood museum, with the understanding that the community it served was to be a na-

tional one. In 1987, two years before Kinard's death, the Anacostia Museum officially dropped the description "neighborhood" from its name and moved from its first site in a converted movie theater to a new, purpose-built facility in a nearby park. In recent years, with additional space at its disposal, its name was changed again to the Anacostia Museum and Center for African American History and Culture.

Neighborhood museums—following the original Anacostia model—have generally been considered in connection with the economically depressed inner city or similar locations, but there appears to be no reason why their use should be so limited. One example of the wider application of the neighborhood museum concept—particularly in its concentration on contemporary issues that affect its constituents—is the remarkable metamorphosis that has occurred at the Strong Museum in Rochester, New York. It was founded as a salvage and warehouse museum almost by default; Margaret Woodbury Strong, its patroness, left it more than three hundred thousand objects after her death in 1969, nearly twenty-seven thousand of them dolls. Several decades into its life and after extensive and even painful consultation with its community, the museum decided to change its original focus and become instead a museum that had special appeal to local families.

From its previous emphasis on life in the Northeast before 1940—a concentration well supported by Mrs. Strong's collection—it has turned instead to what its director calls "history that informs civic discourse about contemporary issues."[34] Since 1992 the topics examined by its exhibition program have included the cold war, AIDS, bereavement, racism, drug abuse, and health care. It has entered into joint ventures with the Children's Television Workshop for an exhibition built around *Sesame Street* and with the Rochester public library system to integrate a branch library into the museum.

Some observers argue that museums can only achieve this organizational breadth by sacrificing the depth with which they were previously able to address a narrower range of subjects. Others—my Smithsonian colleague Robert D. Sullivan, for one—respond that, whether or not museums are or ever were the most appropriate places for learning in depth, an emerging electronic information environment is rapidly reshaping how information is distributed, and breadth-based learning, typified by the Internet's capacity to provide infinitely branched linkages, will be its hallmark. "In the same way," Sullivan says, "that the printed word as a medium of diffusion encouraged linear, sequential, and vertical ways of thinking, the Internet

encourages non-linear, non-sequential, horizontal ways of thinking and con-necting knowledge. The instantaneous horizontal connectivity of the In-ternet collapses time and space and evaporates and/or challenges all efforts by information and knowledge rich institutions to remain isolated, frag-mented, walled chambers."[35]

For the "knowledge-rich" American museum to abandon its old scavenger-warehouse business would seem fully synchronous with such a change. All the same, many in the American museum community—and not merely the moderates of whom I spoke earlier—would be reluctant to see museums lose their capacity to deal with knowledge in depth as well as breadth.

NEW SKILLS FOR MUSEUM MANAGEMENT

The second unintended consequence of the American museum's shift in focus away from the care and study of its collections involves the way mu-seums are staffed and how museum workers are trained. Here we enter un-charted territory, but one thing seems clear: Tomorrow's museums cannot be operated with yesterday's skills. Although museums will still require the expertise of the discipline-centered specialists who today hold many of their senior positions, the successful operation of public-service museums will require that those specialists at least share these positions with museum workers of a different orientation and expertise—museum workers who will bring to their institutions a new combination of skills and attitudes.

Along these lines, Leslie Bedford—for many years with the Boston Chil-dren's Museum and more recently associated with the Museum Leadership Education Program at the Bank Street School in New York—has proposed the establishment of a training institute that would prepare museum work-ers for careers in public programming.[36] In her view, a thoroughly trained public programmer would be a "creative generalist" who combines differ-ent specialties now scattered both inside and outside the museum. These would include an ability to work directly with community members to as-sess how the museum might appropriately meet their needs; practical knowledge of how to establish productive collaborations with other com-munity organizations, both for-profit and not-for-profit; understanding of how best to use all the myriad means—exhibitions, lectures, films, con-certs, programs of formal education—through which the museum may in-

teract with the community; and knowledge of how to make appropriate use of audience research and various forms of program evaluation.

Going beyond Bedford's proposal, this last skill ought to be in the curriculum of museum-training programs at every level. Its neglect—particularly in management training—may be caused in part by the tangency of such programs with graduate schools of business. In the for-profit sphere, where at least short-term success or failure can be determined from financial and other periodic reports, evaluation simply does not perform the same critical function of measuring effectiveness and distinguishing success from failure that it does among governmental agencies and not-for-profit organizations.

Critical to understand here is the changing standard of not-for-profit accountability. As effectiveness becomes more firmly established throughout the third sector as the overarching criterion of institutional success, accountability will eventually boil down to a single, hard-nosed question: Is this institution demonstrably using the resources entrusted to it to achieve what it said it intended to achieve when it requested and was given those resources? Peter Swords, of the Nonprofit Coordinating Committee of New York, has referred to this enhanced standard as "positive accountability": being able to show that the resources entrusted to an institution were in demonstrable fact used to accomplish its intended purpose.[37] This positive standard is in contradistinction to what he calls "negative accountability": being able to show that no financial improprieties have occurred and that all of an institution's funds can properly be accounted for. An organization without the capacity to monitor its outcomes regularly and credibly—unable, that is, to render a positive account of its activities—may no longer be fundable. Nor will meeting such a requirement simply be a matter of appropriate staffing; it will also be a matter of budget. Monitoring program impacts is costly, but it will be no more a dispensable frill tomorrow than filing tax returns or tending to workplace safety are today.

The work that needs to be done is daunting. In many instances it may start with something so basic as getting a museum's leadership to articulate what it hopes or expects its institution to accomplish. That so many museums continue to be so unfocused about their purpose—avoiding any reference to outcomes at all and/or mistakenly defining them in terms of organizationally controllable outputs—is only the beginning of the problem. Compounding it are, first, the extraordinarily wide range of potential museum

outcomes—educational, experiential, recreational, and social—and, second, the difficulty in ascertaining the achievement of those outcomes, a difficulty far greater than in ascertaining the frequently quantifiable results that can be achieved by health and human-service agencies.

Museums may sometimes provide anecdotally recoverable and even life-transforming "Oh Wow!" experiences.[38] More often, though, the impact of museums on their communities—on their visitors and nonvisitors alike—is subtle, indirect, cumulative, and intertwined with the impact of such other sources of formal and informal educational experiences as schools, religious bodies, and social and affinity groups. Museum management must not only become educated as to how the museum's impact can be captured and described; they must also educate those to whom they are accountable as to what may or may not be possible in rendering their accounts. In no way do these complexities make evaluation any less essential. On the contrary: Because the value that the museum can add to a community's well-being may not be nearly so self-evident as that provided by an emergency room or a children's shelter, credible evaluation will be all the more critical to the museum's survival.

At the level of institutional leadership, the most important new skill will be the ability to envision how the community's ongoing and/or emerging needs in all their dimensions—physical, psychological, economic, and social—might be served by the museum's particular competencies. The museum has tremendous technical facility in assembling, displaying, and interpreting objects, and a well-interpreted display of those objects may have enormous power to affect what and how people think or know or feel. What then can the museum contribute? Can it be a successful advocate for environmentally sound public policies? In what ways might it help the community to achieve or maintain social stability? Or energize and release the imaginative power of its individual citizens? Can it serve as a site for strengthening family and/or other personal ties? Can it trigger people's desire for further education or training, inspire them toward proficiency in the creative arts or the sciences?

For the newly reshaped American museum to achieve its public-service objectives, even those new skills may not be sufficient. Needed as well may be some attitudinal changes—two in particular. First, museum workers must learn to relax their expectations as to why the public visits their institutions and what it may take away from those visits. Exhibition curators

may sometimes imagine a far greater congruence than is really the case between the intensity with which they have prepared an exhibition and the interest that the public may take in the educational content of that exhibition. The public is not a monolith. People come to museums for many different reasons and take many different things out of that experience.

In *Speak to My Heart,* an exhibition opened by the Anacostia Museum and Center for African American History and Culture in 1998, a label text described the community role of the contemporary African American church as "a safe place to be . . . a haven from the stressful workaday world, a place for personal growth and community nurture, and an outlet for the development and use of natural talents." How pertinent might such a description be to the museum? Is the museum only important as a place in which to receive the authorized curatorial word, or might it have other legitimate uses as well?[39] That so many different visitors may choose to use the museum in so many different ways should not matter. That it is so open textured as a destination, so adaptable to various public uses should not—at least in the emerging and visitor-centered museum—be regarded as a defect. Rather, it should be understood as one of its greater glories.

The other attitude in need of change involves the museum's relationship to the community. The emerging public-service-oriented museum must see itself not as a cause but as an instrument. Much of the cost of maintaining that instrument is paid by the community: by direct support, by the community's forbearance from collecting real estate, water, sewer, and other local taxes, and by the considerable portion of every private tax-deductible contribution that constitutes an indirect public subsidy from the community. For that reason alone, the community is legitimately entitled to have some choice—not the only choice, but some choice—in determining how that instrument is to be used.

In the emerging museum, responsiveness to the community—not indiscriminate, certainly, but consistent with the museum's public-service obligations and with the professional standards of its field—must be understood not as a surrender but as a fulfillment. The opportunity for museums to be of profound service, to use their competencies in collecting, preserving, studying, and interpreting objects to enrich the quality of individual lives and to enhance their community's well-being, must certainly outdazzle any satisfactions that the old salvage, warehouse, or soda-pop business could ever have possibly offered.

NOTES

1. Notwithstanding that museums throughout all of the Americas might appropriately be so designated, the phrases "American museum" and "American museums" are used here to refer solely to museums in the United States. Barbara Franco is director of the Historical Society of Washington, D.C. Her observation was made in conversation with the author, June 1998.

2. Barbara Y. Newsom and Adele Z. Silver, eds., *The Art Museum as Educator: A Collection of Studies as Guides to Practice and Policy* (Berkeley and Los Angeles: University of California Press, 1978), 13.

3. Kenneth Hudson, "The Museum Refuses to Stand Still," *Museum International* 197 (1998): 43.

4. Walter W. Powell and Rebecca Friedkin, "Organizational Change in Nonprofit Organizations," in *The Nonprofit Sector: A Research Handbook,* ed. Walter W. Powell (New Haven: Yale University Press, 1987), 181.

5. American Association of Museums (AAM), *Museums for a New Century: A Report of the Commission on Museums for a New Century* (Washington, D.C.: American Association of Museums, 1984).

6. AAM, *Excellence and Equity: Education and the Public Dimension of Museums* (Washington, D.C.: AAM, 1992).

7. *Ibid.*, 7.

8. AAM, *Museum Accreditation: A Report to the Profession* (Washington, D.C.: AAM, 1970).

9. AAM, *A Higher Standard: The Museum Accreditation Handbook* (Washington, D.C.: AAM, 1997).

10. AAM, *America's Museums: The Belmont Report* (Washington, D.C.: AAM, 1968).

11. *Ibid.*, 2.

12. From a presentation made during the Smithsonian Institution's 150th anniversary symposium, Washington, D.C., September 5–7, 1996. The full text appears in *Museums for the New Millenium: A Symposium for the Museum Community* (Washington, D.C.: Center for Museum Studies, Smithsonian Institution, and AAM, 1997); the quoted passage is found on pp. 107–108.

13. ICOM Statutes, sec. 2, art. 3.

14. ICOM *News* 71 (September 1971): 47.

15. Taken from the May 1998 interim report to the AAM board of directors and the ICOM executive committee on the summit meeting of the museums of the Americas, "Museums and Sustainable Communities," San José, Costa Rica, April 15–18, 1998.

16. See, for example, Judge Richard A. Posner's observation in *United Cancer Council v. Commissioner of Internal Revenue,* 165 F3d 1173 (7th Cir 1999): "Charitable organizations are plagued by incentive problems. Nobody owns the rights to the profits and therefore no one has the spur to efficient performance that the lure of profits creates."

17. J. Gregory Dees's views can be found in two published Harvard Business School "notes": *Social Enterprise: Private Initiatives for the Common Good,* N9-395-116 (November 30, 1994) and *Structuring Social-Purpose Ventures: From Philanthropy to Commerce,* N9-396-343 (April 15, 1996).

18. For a basic description of the United Way's approach, see *Measuring Program Outcomes: A Practical Approach* (Arlington, Va.: United Way of America, 1996).

19. Nancy R. Axlerod, former president of the National Center for Nonprofit Boards, suggested that these negative descriptions of third-sector organizations were no less inappropriate than that offered by the father who, on being asked the gender of his three children, responded that "two were boys and one was not."

20. Stephen E. Weil, keynote address to the annual meeting of the Mid-Atlantic Association of Museums, Rochester, New York, November 13, 1997.

21. Information about *Gone to the Dogs* and about the Nanaimo District Museum generally was kindly supplied by Debra Bodner, the museum's director-curator.

22. All figures are from the data report for the 1989 *National Museum Survey* (Washington, D.C.: AAM, 1992).

23. In his 1826 will, through which the Smithsonian Institution was ultimately established, Smithson specifically mandated that it be "for the increase and diffusion of knowledge among men."

24. Arthur MacGregor, "The Cabinet of Curiosities in Seventeenth-Century Britain," in *The Origins of Museums: The Cabinet of Curiosities in Sixteenth- and Seventeenth-Century Europe,* ed. Oliver Impey and Arthur MacGregor (Oxford: Clarendon Press and Oxford University Press, 1985), 147–158.

25. Germain Bazin, *The Museum Age* (New York: Universe Books, 1967), 242.

26. The writings of John Cotton Dana (1856–1929)—beyond question this country's most original thinker about museums—were out of print until the publication in 1999 of *The New Museum: Selected Writings of John Cotton Dana,* by the Newark Museum and the AAM. For an overview of his life, see Edward P. Alexander, "John Cotton Dana and the Newark Museum: The Museum of Community Service," in *Museum Masters: Their Museums and Their Influence* (Nashville: American Association for State and Local History, 1983). For a selected bibliography of Dana's museum-related writings, see *Newark Museum Quarterly* (spring/summer 1979): 58. For a description of the ecomuseum movement, see Nancy J. Fuller, "The Museum as a Vehicle for Community Empowerment: The Ak-Chin Indian Community Ecomuseum Project," in *Museums and Community: The Politics of Public Culture,* ed. Ivan Karp, Christine Mullin Kreamer, and Steven D. Lavine (Washington, D.C.: Smithsonian Institution Press, 1992), 327–365.

27. Joanne Cleaver, *Doing Children's Museums* (Charlotte, Vt.: Williamson Publishing, 1992), 9.

28. For a brief history, see Andrea Hauenschild, "'Heimatmuseen' and New Museology" (paper delivered at the Third International Workshop on New Museology, Toten, Norway, September 14–19, 1986).

29. Quoted in Alfredo Crus-Ramirez, "The *Heimat* Museum: A Perverted Forerunner," *Museum* 48 (1985): 242–244.

30. Kenneth Hudson, *The Good Museums Guide: The Best Museums and Art Galleries in the British Isles* (London: Macmillan, 1980), 102–103.

31. John R. Kinard and Esther Nighbert, "The Anacostia Neighborhood Museum, Smithsonian Institution, Washington, D.C.," *Museum* 24, no. 2 (1972): 203.

32. *Ibid.,* 105.

33. Zora Martin-Felton and Gail S. Lowe, *A Different Drummer: John Kinard and the Anacostia Museum 1967–1989* (Washington, D.C.: Anacostia Museum, 1993), 37.

34. Scott G. Eberle and G. Rollie Adams, "Making Room for Big Bird," *History News* 51, no. 4 (autumn 1996): 23–26.

35. Robert D. Sullivan is the associate director for public programs at the Smithsonian's National Museum of Natural History. The quoted language comes from "The Object in Question: Museums Caught in the Net" (unpublished essay presented at the annual meeting of the Visitor Studies Association, Washington, D.C., August 7, 1998).

36. Letter to the author, December 14, 1997.

37. Peter Swords discusses this in "Form 990 as a Tool for Nonprofit Accountability" (paper delivered at the "Governance of Nonprofit Organizations: Standards and Enforcement" conference, New York University School of Law, National Center on Philanthropy and the Law, October 30–31, 1997).

38. For a report of one such experience and an argument that such experiences should be given greater weight in visitor studies, see Anna M. Kindler, "Aesthetic Development and Learning in Art Museums: A Challenge to Enjoy," *Journal of Museum Education* 22, nos. 2 and 3 (1998): 12–15.

39. I am grateful to Camilla Boodle, a London-based museum consultant, for her suggestion that visitors may find a museum rewarding without necessarily accepting its authority. Conversation with the author, August 1998.

4

Fantasy Islands

Imagine two great and distant islands, as remote from one another (and from every place else) as Earth is from Mars or Venus. Imagine further that—in every respect save one—these two islands are uncannily alike. Each has all the necessary natural and human resources to support a stable and self-sufficient way of life. Each is self-contained to the point that none of its citizens has ever felt (or ever will feel) any necessity or even any great desire to reach out very far beyond its immediate shores. Until early in this century, these two islands even had virtually identical histories. The only difference between them lies in this: Some fifty years ago, the citizens of one of these islands—the one that we now call "Musalot"— began to establish a large and thriving variety of museums, exhibition centers, and related venues (hereinafter all called "museums") of almost every imaginable discipline and in a variety of scales. These museums have been maintained at a consistently high standard (and will continue indefinitely to be so).

In stark contrast to Musalot, not a single museum has ever been established on the other of these islands—the one that will always be known to us as "Naughtamuse"—nor will there ever be one. Because of an odd and

This was the third of three "warm-up exercises" that were published in *Museum News* (November–December 1996) under the collective title "To Help Think about Museums More Intensely."

ineradicable genetic quirk (some might actually think it a defect), the citizens of Naughtamuse are simply unable to conceive of or even comprehend the notion that they might derive some benefit from the assemblage and public exhibition of groups of objects. It is a thought that has never occurred to any of them, nor can it. Whereas the citizens of Musalot have chosen to dedicate a considerable portion of their public resources to the operation of their museums, the no less well-intentioned citizens of Naughtamuse have chosen to dedicate a comparable share of their public resources to enhancing the island's already excellent family services, educational systems, and health-care capabilities.

Push your imagination still further. Leap three or four generations ahead. Consider the following questions concerning the impact that Musalot's museums or, alternately, Naughtamuse's lack of them may possibly have made on the lives of their respective inhabitants.

Do you think that life on these two islands will have continued to evolve in just as parallel a way as it did before either island had museums?

If they are no longer quite so parallel, in what specific ways (aside from the fact that one island does have museums and all that goes with them: museum visits, museum workers, museum associations, museum training courses, museum chat on e-mail, and more) do you envision that life on Musalot may have become different from life on Naughtamuse?

Do you consider these differences to be entirely positive for Musalot, or do you think that to some extent they represent trade-offs? Are there some differences that you can sense but have difficulty in articulating? Are there some differences between life on Musalot and life on Naughtamuse that you think might be attributable to the presence of one kind of museum (art, history, science, natural history) and others that you think might be attributable to the presence of other kinds? Can you specify which might be which?

How significant do you consider the passage of time? Do you think that any differences you sense after the passage of three or four generations would have been as pronounced after only one or two? Do you think that they might be even more pronounced after five or six?

Given what you personally know, feel, and think about museums and their value, would you prefer to live on Musalot or Naughtamuse? Might your answer to that be different if you felt yourself in some urgent and substantial need of family services, scholarship help, or publicly funded medical assistance? Might your answer be different if you knew, felt, or thought about museums a great deal less than you actually do?

Museums

"So here it is at last: the distinguished thing!!"

These words came to the great Anglo-American novelist Henry James after he suffered a stroke in December 1915, an episode that James took as signaling that his death was imminent (he did in fact die some twelve weeks later). In considering the most fundamental of questions concerning museums—Do museums really matter? Can and do museums make a difference?—we could more than appropriately echo James's words: So here they are at last: those distinguished—or, at least, those persistent—questions. Here are what Phil Nowlen of the Museum Management Institute has for many years referred to as the ultimate "so what" questions. So what difference did it make that museums were ever here? So what difference would it have made if they hadn't been?

Posed in a variety of ways—sometimes as questions about a museum's impact, outcomes, or results, at other times as inquiries into institutional effectiveness—these are also the in-your-face, bottom-line, hard-nosed questions that the museum community has, for the past several decades or more, struggled mightily to keep safely locked in the closet and out of public view. With some haughtiness, J. P. Morgan once observed that if you needed to ask what the annual cost of operating a yacht was, then you

This text was presented as the keynote address at the fiftieth anniversary celebration of the Mid-Atlantic Association of Museums in November 1997 in Rochester, New York.

probably couldn't really afford one anyway. Too frequently, all too many of us working in museums have assumed a not dissimilar haughtiness: If you needed to ask the value of a museum, if you needed to ask whether it mattered, then you probably wouldn't understand the answer anyway.

That time has gone. Those ultimate "so what" questions are finally here and with us. With us as well are some postultimate questions that must invariably follow in their wake. If museums do matter, if they can make a difference, to whom do they matter, and what are the differences that they might make? Who determines, and when, and how, whether they are, in fact, making those differences? And, perhaps thorniest of all, how much of a difference must any particular museum make, and over what length of time, for some well-informed observer—a donor or an influential legislator—to consider a museum to be successful, to consider it as having demonstrated itself worthy to receive ongoing support?

When James sighed "at last," he thought he was facing his end. By contrast, our "at last" might just as readily signal a beginning. What will be argued here is that rather than being intimidated by these long-deferred questions, the museum community ought to encourage and even warmly welcome them. Subject to our willingness to take two major steps—one a bold conceptual step forward, the other a more strategic step off to the side—these are questions to which we can properly respond clearly, persuasively, and positively.

The first necessary step, the bold one, requires that we publicly face up to the reality—and face up to it with a forthrightness that hitherto has been lacking—that all museums are not equally good and that, in fact, some museums that manage to remain solvent and go about their day-to-day business might really be no good at all. Such an admission will require, first, that we reach some consensus as to what constitutes a "good" museum and, second, that we be prepared to acknowledge that a museum that fails to meet our consensus definition of a good museum should be considered, by reason of that failure, to be a "bad" museum.

The second necessary step, the strategic one, is concerned with articulating the potential outcomes that museums can achieve. We must be able to sort out—with far greater facility and somewhat more systematically than we generally do now—the full range of public-service roles that museums have the capacity to play. All too frequently, museums are characterized—sometimes even by themselves—as being important principally as sites for informal education and/or self-directed learning. They are cer-

tainly important for that, but they are also important for a very great deal more than that. To conceive of museums in so narrow and constricted a way is to omit entirely—or, at least, to greatly obscure—the many other rich and important ways beyond the educational in which they are able to provide a range of public benefits.

REACHING A CONSENSUS ON MERIT

In approaching the first step—achieving some consensus as to what might constitute a good museum—I propose that these questions cannot be answered in any generic way. To think that there might be a single set of answers applicable to all museums, or even to the museums of a single discipline, is simply not realistic. This country's eight thousand museums vary enormously in terms of the purposes to which they aspire, the resources that they have available, and the infinitely different contexts in which they operate, and it would defy common sense and every statistical expectation to think that all museums, regardless of how evaluated, would be found equally meritorious. What seems clear at the outset is that these questions can only be answered on an institution-by-institution basis.

Approaching museums in that way has several consequences. It renders obsolete—in fact, wholly nullifies—that perverse (but also pervasive) bit of logic that might (for lack of a better name) be called "museology's secret syllogism." It's that superbly self-serving syllogism that goes: All museums are good per se. My institution is undeniably a museum. Ergo, my institution is undeniably good. In the face of these long-deferred questions about whether and in what ways museums can make a difference, individual institutions will no longer have the abstract cloak of their museum status in which to wrap themselves protectively. On the multiple judgment days to come, every museum will have to stand and answer for itself.

A second consequence—almost a comic one—of approaching museums on an institution-by-institution basis is that it allows us to enrich our discourse by including a phrase that has hitherto remained largely unspoken. That phrase is "bad museum." I have scarcely ever heard or even seen that unusual combination of two such otherwise common words—"bad" and "museum"—used in any public setting, not at twenty-eight consecutive annual meetings of the AAM, not at innumerable meetings of state and regional museum organizations, not in the pages of *Museum News*. It is almost

as if we are all the children of some great museological mother who taught us early on that "if you can't say something nice about another museum, then it's better to say nothing at all." Or, more fancifully, it's as if museum workers constitute some kind of a tribe and that this is one of our taboos. "Bad museum" simply is not something to be said in public. It's like the "F-word"—not polite.

Considered less fancifully, the fact that we so rarely hear or read about "bad museums" may touch on several important issues. First, to some people within the museum field and beyond whom I've described elsewhere as "romantics," the concept of the museum is an inherently positive one. These are the people who embrace the first and major premise of that secret syllogism. Museums, from their viewpoint, are good organizations per se. The notion of a bad museum would, accordingly, be an oxymoron—like an ugly baby or too much ice cream. Even the worst of museums, like the worst of ice creams, would still be pretty good.

Second, the failure to talk publicly about bad museums may also be an unfortunate by-product of the museum field's long and generally successful quest to professionalize itself. Although most observers regard the process of professionalization as generally positive or at least benign—a means of raising the standards in a particular field—others have seen it as having a distinctively negative aspect. As long ago as 1776, Adam Smith noted in *The Wealth of Nations* that "people of the same trade seldom meet together, even for merriment and diversion, but the conversation ends in a conspiracy against the public, or in some contrivance to raise prices." One of the characters in George Bernard Shaw's 1911 play *The Doctor's Dilemma* puts it more succinctly. "All professions," he says, "are conspiracies against the laity." To some extent, our almost congenital avoidance of open references to bad museums may simply rest on an understandably collegial and even sympathetic desire to protect one another.

Finally, and perhaps most likely, there appears to be a deep reluctance across the museum field to believe that any judgment about a museum's overall merit could possibly have any validity beyond being merely "one person's opinion." For those inside an institution, this can be almost as marvelously self-protective as the secret syllogism. If no objective judgment of the institution's overall performance is possible, then objective judgments about the performance of its key staff members may be equally impossible. I had a somewhat heated discussion about this with a senior Smithsonian scientist who claimed that any effort to judge a museum must be, at best, a

matter of subjective speculation. Thinking to clinch the argument that some museum might genuinely be a terrible place, I asked what he would think of an institution in which the collections were deteriorating, the pertinent records were either missing or inaccurate, the endowment money was long since wrongfully squandered, and the little information provided to the dwindling handful of visitors was almost invariably wrong. After sucking his pipe for a few moments he said, "Sounds like it could stand some improving."

This avoidance of virtually any public discourse concerning bad museums might be merely amusing if it did not also have one serious consequence. Because the museum community has never been willing to grapple openly with what might make any particular museum a "bad" one, by the same token it has failed to address in any sustained and productive way the question of what might make some other museum a "good" one. The closest it has come is through the AAM's accreditation process. Accreditation, however—and, in a membership organization like AAM, there may well be no alternative—simply works on a pass/fail basis. It does not grade museums; it does not award a truly superb one an A+ and a less than superb but still more than minimally acceptable one a B–. The museum that is outstanding by every possible measure and the museum that can simply squeak past the current accreditation standard fall into the same category. Museums that fail to achieve accreditation at all are largely protected by silence.

By facing up to these questions of whether museums matter and whether they can and do make a difference, and by acknowledging that these questions can only be addressed institution by institution, we can begin to provide ourselves with a basis on which to make sound, open, and credible judgments about which museums might be good ones and which ones might not. In doing so, we can also begin to provide ourselves with some meaningful ways of comparing the actual performance of any particular museum with its aspirations, and—when making the comparisons that must inevitably be made when museums compete for limited resources—to reach some reasonably objective conclusions concerning their relative merit and their relative worthiness to receive ongoing support.

ATTRIBUTES OF A GOOD MUSEUM

On what basis might we judge whether a museum is a good or bad one? What can we identify as the attributes of a good museum? I propose using

some of the materials developed over the past few years by the Alexandria, Virginia, headquarters of the United Way of America as a model. United Way has exerted an enormous—even seismic—influence throughout the health and human-service field by its formal adoption in June 1995 of outcome-based evaluation as the primary basis on which it would thereafter allocate its grant funds. As succinctly described in one of its publications, this constituted a shift from a previous focus on the programs of its applicant agencies to an emphasis instead on their results, that is, on the measurable outcomes or impacts that these agencies were able to achieve through those programs.

In the course of that shift, United Way developed a simplified vocabulary with which to discuss its new approach. In lieu of asking applicant agencies to describe their goals in such conventional organizational terms as "mission," or "vision," or "mandate," it suggested that they focus instead on two key words: "hope" and "expect." "Given the immense amount of work that your organization proposes to undertake, what do you ideally hope to accomplish?" And, "realistically, what do you expect to accomplish?" Those questions are not meant to be answered in programmatic terms, but rather by describing how a proposed program is intended to make a "positive difference" in the quality of people's lives.

This last requirement—that the intended outcome of the programs that United Way funds must be a positive difference in the quality of people's lives—is the cornerstone on which United Way's entire scheme of outcome-based evaluation is built. As for what, in that context, United Way means by "outcomes," these were defined in a program manual as: "benefits or changes for individuals or populations during or after participating in program activities. . . . Outcomes may relate to behavior, skills, knowledge, attitudes, values, condition, or other attributes. They are what participants know, think, or can do; or how they behave; or what their condition is, that is different following the program."

I would argue that these United Way concepts can be directly imported from their health and human-service context into the world of cultural institutions, and specifically into that of museums. I would further argue that United Way's cornerstone—to make a positive difference in the quality of people's lives—ought to be consciously adopted as our cornerstone as well. And I would argue still further that, at least at their best, museums operate today in the hope and expectation that they will make a positive difference in the quality of people's lives. And I would argue finally that we form,

preserve, and study collections today not because we think that those activities are appropriate ends in themselves but because we hope and expect that those collections will be used in ways that will, to quote United Way, "provide benefits . . . for individuals or populations."

In one sense, we have no alternative but to rest our definition of the "good museum" on just such a cornerstone. For publicly supported institutions, it is conceivably the only such definition that we can afford. If our museums are not being operated with the ultimate goal of improving people's lives, on what alternative basis might we possibly ask for public support? Not, certainly, on the grounds that we need museums so that museum professionals might have an opportunity to develop their skills and advance their careers, or so that those of us who truly enjoy museum work will have a place in which to do it. Not because they provide elegant venues for openings, receptions, and other glamorous social events. And not on the argument that museums—collectively, a humongous enterprise involving in this country alone the expenditure of billions of dollars annually and the dedicated efforts of tens of thousands of individuals—deserve to be supported simply as an established tradition or an ongoing habit, long after any good reasons to do so have ceased to be relevant or have long been forgotten.

What about our existing collections? Could their continued preservation provide a rationale for the ongoing support of museums? Reverting to a tribal mode, might we successfully argue that the objects in these collections are like fetishes, that they embody such potent values that their indefinite preservation is warranted regardless of any relevance or use that they might ever have to lives now in being or yet to be? At best, such an argument might justify warehousing those objects in some distant and bare-bones storage, but not in the costly museums where we keep them today. Again, we have no real alternative but to argue that museums are at their best when they seek to improve the quality of people's lives.

Following in the wake of United Way, we can begin to identify the initial attribute of a good museum: It is an institution that is operated with the hope and expectation that it will make a positive difference in the quality of people's lives. Before we move on, two ancillary issues must be addressed. First, as for making a difference, will any differences do, or is it only intended differences with which we are concerned?

In terms of accountability, it must surely be the latter. A museum's program, like any complex institutional activity, may produce a range of outcomes, both intended and unintended. Nevertheless, the core question of

positive accountability—in carrying out its program, has this organization made effective use of its resources?—can only be answered in terms of the program's *intended* consequences. Concerning this first attribute, then, some further refinement is needed. The good museum is one that is operated with a clearly formulated purpose, describable in terms of the particular and positive outcomes that it hopes and expects to achieve.

The second ancillary issue concerns the qualifier "positive." In various degrees, museums are ideological or at least reflective of particular points of view. Equally varied in ideology or point of view are those who may be called upon the evaluate them. Setting aside the case of any diehard museographical technocrats, who might elect to judge a museum by the skill with which it was managed rather than by the outcomes it was seeking to achieve, those who argue that all value judgments concerning museums are inherently subjective have at least part of a valid point. Whether the difference that any particular museum is hoping to make is a positive one is a judgment that will necessarily vary from one observer to the next. The observer who regards the Macho City Museum of Male Supremacy with great enthusiasm is not likely to be equally enthusiastic about the newly founded National Museum of Gender Equity, and vice versa. How can we cope with this? Best, perhaps, is simply to acknowledge that there may be no universally accepted positions with regard to certain issues. To the extent that some ideological differences may be truly irreconcilable, any judgment as to whether or not the difference that a museum is trying to make is a positive difference must be always be understood to be in some degree subjective.

What further attributes must we add to this initial one—that the good museum is one that has a clearly formulated and worthwhile purpose? As an old English proverb has it, if wishes were horses, beggars might ride. In the case of museums, resources—those at a level commensurate with the outcomes that they hope and expect to achieve—are what provide the horsepower that enables the well-intentioned ones to achieve their worthwhile purposes. Except for those romantics who view all museums as inherently good, it ought be evident that a museum seriously lacking in the resources required to achieve its purpose—whether that lack is in dollars, collections, trained staff, equipment, and/or facilities—cannot be evaluated as a good museum and must accordingly be considered a bad museum. A "bad museum" is not an oxymoron. If anything is oxymoronic in our field, it is the belief of national and local funding sources that they can reduce the resources available to museums and still expect them to maintain their prior

level of quality. Resources are not a frill. Adequate resources are what well-intentioned museums must consume if their good intentions are ever to be realized.

Those are two attributes of the good museum: a clear and worthwhile purpose and the resources necessary to achieve that purpose. In order to respond positively to our basic question—do museums matter?—two more attributes must be considered. One relates to leadership. Within its governance and its own senior staff, the good museum requires a leadership fiercely determined to see that the achievement of its purpose is established and unblinkingly maintained as the institution's highest priority. The good museum is neither a survival-driven institution nor a process-driven one. The good museum is a purpose-driven institution. Its leadership understands and makes manifestly clear that other and more conventional measures of success—a balanced budget, approbation of peers, high staff morale, acquisition of important collections—all have to do with means, and not with ends. They may be necessary to the good museum—adequate resources certainly are—but in and of themselves they are not sufficient to make a museum a good one. The things that make a museum good are its purpose to make a positive difference in the quality of people's lives, its command of resources adequate to that purpose, and its possession of a leadership determined to ensure that those resources are being directed and effectively used toward that end.

The last attribute concerns feedback. With purpose, resources, and leadership all in place, how does a museum go about determining whether its purposes are being achieved? The museum, as a nonprofit organization, rarely gets the same feedback from the competitive marketplace that a for-profit organization relies upon for guidance. In this connection, United Way's otherwise useful model offers little help. The outcomes pursued by health and human-service organizations are far more susceptible to quantification than are those generally pursued by museums. Moreover, such outcomes can often be presented in far more vivid, concrete, and dramatic terms—emergency rooms or shelters for battered children—than may ever be possible for museums.

Museums are not unique in this disadvantage. That museums cannot report their results as measurable outcomes or plot them against statistical data bases are problems that they share with a host of other socially important organizations, ranging from liberal-arts colleges to advocacy groups to religious denominations. Churches, to name one of these, argue per-

suasively that they cannot be expected to report their success in terms of "souls saved per pew-hour preached." With outcomes that tend to be so much more elusive, imprecise, and indirect than, for example, drug rehabilitation programs or a blood drive, perhaps the best that these organizations can hope to do—rather than to measure—is simply to ascertain or approximate.

For museums, even that looser requirement presents difficulties. In general, the impact of museums on their visitors is not of the one-shot or "Eureka!" kind but something far more subtle, cumulative over repeated visits, and quite possibly ascertainable only after many years. Nor can a museum's long-term impact on its visitors always be wholly isolated. It will be found intertwined with the impact that other community-based educational and cultural organizations may have made on those same visitors. Notwithstanding those complexities, the good museum must be able to devise the means to assure itself on some regular, reliable, and ongoing basis that its programs are having their intended effect—or, if they are not, that it is in position to recognize that fact and to make whatever corrections are necessary. To the extent that the outcome-based evaluation that United Way advocates continues to spread through the nonprofit sector and become a norm for other grant makers, the need for such feedback mechanisms will become all the more urgent.

The foregoing list by no means exhausts the attributes of the good museum—efficiency, responsiveness, and accessibility might easily be added— but it should suffice when we return to our original, basic question: whether and how museums make a difference. We must turn to the second of the two steps that need to be taken if that question is to be answered positively. We must look at the full range of public-service roles that museums might play to see whether these could be usefully sorted into a pattern.

ENTERTAINMENT, EDUCATION, AND EXPERIENCE

Museums are most frequently characterized today as sites for informal education and/or self-directed learning. *Excellence and Equity,* for example, argues that museums ought to place "education—in the broadest sense of the word—at the center of their public service role." Let me begin, though, by considering education in *less* than its broadest sense—by considering it as a process by which the specific knowledge that visitors gain through a mu-

seum visit is congruent with the knowledge that the museum intended that those visitors acquire. That would be what my Smithsonian colleague Zahava Doering refers to as the "baby-bird" theory of museum education. The museum, as the great all-knowing mother bird, carefully chews up what the fledgling visitor will need for sustenance and then doles it out beakful by careful beakful. Looking at visitor studies done over the past several decades, some museum people clearly thought this was the proper direction.

If you glance through Chandler Screven's seminal 1974 study of museum education, *The Measurement and Facilitation of Learning in the Museum Environment: An Experimental Analysis,* you will encounter a vocabulary of instructional technologies and specific learning outcomes. A learning outcome would include, says Screven, "the specification of what the learner (museum visitor) is expected to *do* as a result of exposure to the exhibit in terms of *action verbs* such as: *name, arrange, compare, order, list, distinguish, identify, solve.*" An exhibition of Greek and Roman pottery, for instance, might have the following instructional objective: "Given six pairs of color slides of pottery, presented one pair at a time in a test machine, each pair containing an example of one Greek and one Roman piece, the visitor will correctly identify the Greek (or Roman) example in five out of six pairs."

To determine how much of a visitor's postvisit knowledge may be attributable to the visit itself, Screven envisions various schemes of pretesting and posttesting. To increase an exhibition's effectiveness as an instructional mechanism, he discusses how visitors might be induced to spend more time on such productive behaviors as reading labels and making comparisons, as contrasted with less productive behaviors such as "random gazing" or careless generalization.

Imagine some hypothetical visitors to Screven's hypothetical exhibition of Greek and Roman pottery. One is a recent immigrant from Greece for whom the exhibition triggers a profound sense of pride in the achievements of her ancestors. Two others are brothers who lately lost their younger sister and find it somehow comforting that the arts and beauty can endure even though life may be short. Another is an amateur potter who regularly visits ceramics exhibitions of every kind in search of new ideas. Still another, a recent tourist to Rome, finds that the exhibition revives pleasant memories of his trip. Finally, two young lovers amuse themselves by making up their own funny and mythlike stories to explain the amorous and other episodes depicted on some of the pottery.

The point is that a visitor might derive considerable personal enrichment

from this hypothetical exhibition without ever improving by one bit his or her ability to distinguish a Greek vase from a Roman one. Unless we are to adopt some puritanical point of view that denounces as illegitimate all of a visitor's responses to a museum visit beyond those narrow, didactic ones intended by its program staff, we have to acknowledge that the totality of what goes on in a museum—the myriad interactions between visitors and objects, the equally myriad interactions of visitors with one another—is a far headier mixture than much of our museum literature suggests. Should museums ignore or reject those many interactions as a kind of static that interferes with the main educational messages that they are trying to send? Do these myriad interactions simply come, in Screven's language, from "random gazing" or careless generalization? Or, from an opposite point of view, might we not accept these as appropriate museum behaviors or even, beyond merely accepting them, actually embrace them as providing important insights into the real riches that museums can provide to their communities? It would be a wonderful irony if all those distractions, which the more narrowly education-minded among us think of as static, turned out instead to be some of the museum's most important and memorable music.

In considering how we might better sort out and consider the full range of public-service roles that museums might play, an article appearing in the *New York Times* by music writer Paul Griffith suggested an interesting framework. In analyzing what the presenters of classical music concerts believed themselves to be providing to their audiences, Griffith referred to what he called "the three Es of music: entertainment, education, and experience."

With some slight modification—principally, the addition of the museum as a place for socialization—I would argue that Griffith's three Es also describe what museums in their public-service role can provide to their communities: entertainment, education, and experience. That the museum may, for a great number of its visitors, function primarily as a place of entertainment is sometimes a bitter pill for many museum people to swallow. Having prepared for their museum careers through the long and arduous study of a discipline, they would prefer to see visitors take an interest in that discipline with at least some of the same seriousness that they do. And yet, undeniably, for a great number of regular museum visitors, museum going is a pleasurable leisure-time activity, a way to relax, a form of diversion competitive with film, theater, dance, and other modes of entertainment. Past school age, cultural participation is not mandatory, and the

people who participate in cultural events—any questions of conspicuous cultural consumption aside—do so mostly for pleasure, not out of duty.

Where the museum differs significantly from film, theater, dance, and those other modes of entertainment is in its relative informality. Contrast the fluidity of a museum visit with the rigid routine of attending a theater: a fixed starting time, a predetermined duration, a preassigned place to sit, and a socially enforced rule of silent participation. Because of its relative informality, museum going—in addition to the three Es—is almost unique among cultural activities in providing the opportunity for valuable social interactions. On occasion, these interactions may even be wholly separate and apart from those educational and experiential encounters of visitor and object that the traditional museum literature treats as central to a museum visit. Although museum workers tend to see these interactions as peripheral, to visitors they may be anything but.

Some figures concerning attendance at the Smithsonian are striking. Of sixteen thousand visitors interviewed between 1994 and 1996—visitors who had come on their own, not as part of any organized school or other tour—only 14 percent had come by themselves. For the other 86 percent, their museum visits were interwoven with a social experience. As Deborah Perry, Lisa Roberts, Kris Morrissey, and Lois Silverman have pointed out (*Journal of Museum Education,* fall 1996), "People often come [to museums] with their families and other social groups, and they often come first and foremost for social reasons. Although visitors say they come to museums to learn things, more often than not the social agenda takes precedence. Quality family time, a date, something to do with out-of-town guests, a place to hang out with friends: these are some of the primary reasons people choose to go to museums."

In a 1986 article in UNESCO's magazine *Museum,* Sheldon Annis wrote in a similar vein. Watching groups of visitors move through a museum, he suggested, was to see them "playing to and against each other. For most, nothing is more interesting than acting out and within the social roles of their own lives." In all, he concluded, "Museum-going is usually a happy and social event. Being there in some particular social union is both purpose and product. It does not really matter whether the coins were Roman or Chinese."

Some commentators have seen the socializing potential of museums in still broader terms than that. They argue that, beyond their capacity to enrich already existing relationships, museums might also contribute to the creation of important new relationships. In the statement of principles that

accompanies its strategic agenda for the years 1998 to 2000, the AAM refers to museums as institutions that can help to build community. In that view, the museum may be considered as a distinctive public space, in which diverse elements of the community might intermingle in ways not readily available elsewhere. Some have suggested that museums to an extent have replaced churches in that respect. Museum consultant Elaine Heumann Gurian has argued (*Daedalus,* summer 1999) that—because of the high degree of public trust they enjoy—museums should also be recognized as one of the few institutions within a community that can function as a safety zone, a place to which parents might comfortably send their children or in which members of a minority group might hope to socialize without fear of intimidation. Others see the museum as one of the few community institutions that can provide an antidote to urban loneliness, a place where individuals can safely satisfy a basic need to be in the company of other people.

Moving along to the second of Griffith's three Es—education—there is little to add to the voluminous literature already generated concerning the museum in its educational function. As before, and *Excellence and Equity* notwithstanding, I would like to continue to treat museum education in less than its broadest sense, as referring primarily to the visitor's acquisition of the particular knowledge that the museum intended to impart. By doing so, we can leave maximum scope for what may be the most interesting and distinctive of Griffith's three Es: experience. Beyond providing diversion and entertainment, beyond their role as a site for social interaction, beyond whatever educational functions they may choose to assume, museums are also places that indisputably provide their visitors with an almost infinite range of experiences. Quoting again from Perry, Roberts, Morrisey, and Silverman:

> While visitors may have a primary social agenda, they also want and expect to learn something new, have their curiosity piqued, see something they've never seen before, or in some cases revisit an old favorite. However, the learning occurs not only through traditional methods, but through social mediation, dialogue, and joint construction of meanings. By listening to visitors, museum professionals have realized that they are not—and should not be—in the business of teaching. Instead they are in the business of creating environments that facilitate the construction of appropriate meanings, that engage people in the stuff of science, art and history.

Recent visitor research supports this notion of the museum as an environment for the construction of meaning—a meaning that may well (or indeed

most likely will) differ from one visitor to the next. In 1996, Russell J. Ohta of Arizona State University West studied visitor responses to the highly controversial exhibition *Old Glory: The American Flag in Contemporary Art* when it was shown at the Phoenix Art Museum. Although each of the visitors he studied experienced "rich moments filled with deep personal meaning," none of those meanings resembled any other. The meaning in each case was forged from the visitor's own personal identity. What they experienced had nothing to do with either the American flag or its use in art. Their experiences, he concluded, were primarily about themselves.

"In essence," Ohta writes, "the exhibition became a looking glass for visitors. They experienced what they were capable of experiencing. They experienced who they were." He concludes by quoting anthropologist David Pilbeam's dictum that, in looking at things, we tend not to see them as they are but as we are. Ohta is not the first to have used the imagery of the museum as a looking-glass experience. In his 1986 article, Sheldon Annis concludes that neither museums nor objects are possessed of intrinsic meanings. "Rather," he says, "they accept and reflect the meanings that are brought to them."

A similar conclusion was reached in a study of informal education in Holocaust museums by Zahava Doering and another of my Smithsonian colleagues, Andrew Pekarik. Arguing that museums, upon close examination, turn out to be "not particularly effective in accurately conveying detailed, factual knowledge," they argue that the single most powerful determinant of a visitor's response to a museum exhibition is what they refer to as his or her "entrance narrative." Constituting that entrance narrative is a basic framework, or the fundamental way in which the visitor construes and contemplates the world; previously acquired information about the exhibition's topic, organized according to that basic framework; and the sum of the visitor's personal experiences, emotions, and memories that verify and support this understanding. What their model suggests, they argue, is that "the most satisfying exhibitions for visitors are those that resonate with their experience and provide new information in ways that confirm and enrich their view of the world." Rather than communicating new information, they say, the greatest strength of museums may be in confirming, reinforcing, and extending the existing beliefs of their visitors.

Lois Silverman has reached a similar conclusion, albeit by a different route. In a widely cited article published in *Curator* in 1995, she argues from a postmodernist perspective that museum objects are like texts that lack

any fixed or inherent meaning until they have been "completed" through the act of reading. In the case of the text, there will be as many versions—all equally correct—as there are readers. A similar "meaning making" process—by which an object acquires meaning for a particular visitor—occurs in the museum. In common with Doering and Pekarik's entrance narrative, such meaning making will in every case involve the totality of specific memories, expertise, viewpoint, assumptions, and connections that the particular visitor brings to the museum. Silverman is critical of current museum practice for its failure to take better advantage of what she thinks is the essentially experiential nature of museum visiting. "Hindered," she says, by their "historical focus on a nearly exclusively educational mission, other potentialities of museums lie seriously underutilized in exhibitions and institutions alike. Museums in a new age can become places that actively support and facilitate a range of human experiences with artifacts and collections—social, spiritual, imaginal, therapeutic, aesthetic [experiences], and more."

One final note with respect to experience: In arranging the several hundred very diverse objects included in the Smithsonian's 150th anniversary touring exhibition, the organizers consciously sought to elicit three distinct kinds of response. In contrast to those somewhat dry and distant actions suggested by Screven's list of action verbs—to name, arrange, compare, order, list, distinguish, identify, or solve—what visitors to the Smithsonian's exhibition were asked to do was infinitely more personal. The exhibition invited them to remember, to discover, and—perhaps above all—to imagine.

Venturing only a little way beyond Paul Griffith's three Es, we can generate a rich pattern of purposes—none of them unimportant—that museums might pursue in their public-service role. Given that these are all good purposes, the question remains: Is one as good as another, or—without wholly neglecting any—might the museum community be wise to single one out for special emphasis? Curiously, that seemingly theoretical question may have an intensely practical answer. In his presentation at the Smithsonian's 150th anniversary symposium, Harold Skramstad argued that not only was the museum a wholly pointless institution unless it helped to solve people's real problems, but also that—if it was to survive—it had to do so in some way that was unique to itself and not redundant with what other kinds of organizations might have to offer.

If we apply Skramstad's test to the range of public-service possibilities, it seems clear that only with regard to the fourth and last of these—its ca-

pacity to provide visitors with an experience-rich environment—is the museum's true uniqueness to be found. The museum that conceives of itself primarily as a tourist destination—that seeks to increase its recreational appeal in order to attract visitors who might, in turn, bring economic benefits to the surrounding community—is constantly vulnerable to the danger that Disney or some Disney clone will come along and, through the magic of its checkbook, create an even larger and more attractive tourist destination. Similarly, museums have no natural monopoly as sites for social interaction or as the providers of education. The very notion that these activities even require a physical site may be at risk. Distance learning is already with us. Can distance socialization be far behind?

What museums have that is distinctive is objects, and what gives most museums their unique advantage is the awesome power of those objects to trigger an almost infinite diversity of profound experiences among their visitors. Nor are those responses limited to visitors; museum workers may be equally susceptible. At the April 1997 annual meeting of the Texas Association of Museums in Midland, Hal Ham of Texas A&M's Conner Museum gave a wonderfully provocative presentation about nanotechnology. Nanotechnology is an anticipated twenty-first-century technology that will permit its practitioners to make exact, molecule-for-molecule reproductions of any object—a way to do for inanimate things what cloning can do for living ones. Teasingly, Ham asked his audience members how they would feel about providing every art museum—or perhaps, even, every household—with a *Mona Lisa* replica that was in every last molecular respect identical to the original.

One museum director immediately rose to argue. Those replicas were not and could never in every way be identical to the original because Leonardo himself had never personally touched them. Ham stood his ground. Was the *Mona Lisa* important as a work of art? If so, more should be better, and perhaps one in every home (or why not two?) would be best of all. Or was it also important as a relic, important because of its association with Leonardo, important like the things in history museums? There was no show of hands at the end, but my guess is that the overwhelming majority of museum people there—myself included—did not honestly believe at any gut level that these molecule-for-molecule replicas really were the same thing as the *Mona Lisa*. They lacked the power to send our imaginations soaring in the same way that the original could.

Do we fully understand the depth and workings of this power? Do we re-

ally know why, during the Smithsonian's 150th anniversary touring exhibition, visitors stood in long, uncomfortable lines to see Abraham Lincoln's top hat or, more wondrously still, although there never really was such a person as Dorothy, to look at Dorothy's ruby slippers? Some, like the German cultural critic Walter Benjamin, talk about the authentic original as possessing an "aura." Others liken such originals to those objects that Melanesian natives say are imbued with mana, an inherent supernatural power. More prosaically, we might hypothesize that—to filch the title from one of Leo Steinberg's essays—the eye is a part of the mind, and looking and seeing are not the end of what happens to a visitor in a museum but only the starting points of an ultimately holistic experience.

Standing squarely in front of one of fifty million exact replicas of the *Mona Lisa,* and knowing it to be nothing more than that, a visitor might at the most think it a somewhat amusing application of modern technology or, at the least, might actually find it boring. But standing squarely in front of the original in the Louvre, that same visitor might have a far richer response. Such a response might, for example, blend the uniqueness of the moment— the wonder of being, at that instant, the only creature in the entire galaxy to be standing in front of that one real thing—with a sense of awe that she and Leonardo were somehow linked across nearly five centuries; that she might perhaps be standing at precisely the same distance from the *Mona Lisa* that the artist himself stood at that moment in 1506 when—backing just slightly away from the painting for a moment—he finally said to himself, "*Basta,* enough, *finito,*" and launched it out into the world.

This almost unparalleled ability of objects to stimulate so diverse a range of responses seems to me the greatest strength of museums. Nor does there seem to be any limit to what the range of those responses may be. Some museums are celebratory, others seek to console. Some try to stimulate a sense of community, others to capture memory. And some simply offer the important refreshment to be found in breaking the grip of everyday routine. As Nelson Graburn wrote, among the various needs of their visitors that museums can meet is one that he termed the "reverential." It was, he said, "the visitor's need for a personal experience with something higher, more sacred, and out-of-the-ordinary than home and work are able to supply. . . . The museum may provide a place of peace and fantasy, where one can be alone with one's thoughts and make of the objects and exhibits what one will."

In the opening of *Anna Karenina,* Leo Tolsoy writes, "Happy families are

all alike; every unhappy family is unhappy in its own way." In a sense, all good museums can be said to be alike. Common to every good museum is a clear sense of the worthwhile things it hopes to do, the resources together with the determination necessary to get those things done, and such feedback or other mechanisms as may be needed to determine that those things are, in fact, getting done. In contrast to good museums, bad museums—like unhappy families—may be bad in a number of very specific ways.

If we continue to define a "bad museum" in the simplest and most straightforward way—a museum that is not a good museum—it seems apparent that a museum may be bad because, first, it lacks any clearly articulated and worthwhile purpose; or second, having such a purpose, it nevertheless has failed or is unable to attract the resources necessary to accomplish that purpose; or third, having both such a purpose and the necessary resources, it nevertheless lacks the will, the determined leadership, to achieve that purpose; or last, with appropriate purpose, resources, and leadership all in place, it smugly and erroneously assumes that it is doing its job when in reality it is not doing any such thing.

Bad museums should be of greater concern to the community of good museums than has generally been the case. They tie up old resources and divert new ones, and they tend to diminish the high esteem in which museums ought be held. It should be the business of good museums to help those bad museums that can change to become good ones, and to help move those that cannot change toward a quiet and dignified exit. Deficiencies of purpose, resources, and feedback generally can be addressed without thoroughly overturning an organization. By contrast, museums that are bad because their leadership lacks the determination to make them good present a more difficult case. Paradoxically, it is frequently just such museums that are—because of their weak leadership—the most reluctant to put a quick and decent end to themselves so that the valuable public resources they still hold might be released for more productive use by other organizations.

And so at last, we return to the first questions: Do museums matter? Can and do they make a difference? The answer should be self-evident. At the other pole from the secret syllogism, we have now reached a tautology. Some museums matter. Good museums matter, good museums make a difference, and they matter and make a difference because that is exactly how we have defined them. The very things that make a museum good are its intent to make a positive difference in the quality of people's lives and, through its skillful use of resources and under determined leadership, its

demonstrable ability to do exactly that. Other museums don't matter. Bad museums don't matter, and the reason that they don't matter is also definitional: Either they have no real desire to make a positive difference in the quality of people's lives or, notwithstanding such a desire, they lack the capacity and/or the leadership to do so.

What remains most remarkable to me is how broad a range of purposes the good museum has available to choose from in shaping its public-service efforts. Within the broad categories of entertainment, socialization, education, and experience, innumerable subcategories remain to be identified and named. As most good museums ultimately arrive not at just one purpose but at some mixture of purposes, the number of possible combinations of these categories and subcategories is virtually endless. Having said that all good museums are in one sense alike, we can also say that, in another sense—in the mix of purposes they pursue—they almost all differ from one another. It is that variability, it seems to me, that makes museum work so exciting, even magical. So long as a dedication to public service is its driving force, a museum can be a good one in an almost infinite number of ways. The constructive ways in which museums can innovate and explore new dimensions are almost endless. In everything museums do, they must remember the cornerstone on which the whole enterprise rests: to make a positive difference in the quality of people's lives. Museums that do that matter—they matter a great deal. And their crowning glory is that they can matter in so many marvelous ways.

6

New Words, Familiar Music

THE MUSEUM AS SOCIAL ENTERPRISE

In back of every museum—profoundly affecting both how its staff goes about organizing its work and what expectations the public may have of it— lies one or more models. In the two hundred years since the museum was first recognized as a distinctive type of institution, these models have been in almost constant flux. As new ones have arisen, old ones have sometimes lost their power, sometimes disappeared entirely. At other times, new and old have accommodated one another, sometimes overlapped, even blended.

Within my own working lifetime, I have followed with fascination the emergence—particularly in this country, perhaps less so abroad—of a new and potentially dominant model for museums. Because it puts so extreme an emphasis on an organization's outward rather than inward focus, it is a model that seems strikingly different from most of the earlier ones that museums have followed. Applicable across the entire spectrum of nonprofit organizations, it is called the "social enterprise" model, so named by J. Gregory Dees. Before turning to consider what the museum as social enterprise might be like, let me mention several older models that it could

In November 1977, to mark the twenty-fifth anniversary of its Katherine Coffey Award, the Mid-Atlantic Association of Museums published a festschrift entitled *Making a Difference* to honor the award's recipients for the years 1972 through 1996. As the award's 1990 recipient, the author was asked to contribute an essay. This text was his contribution. Reprinted with permission of the Mid-Atlantic Association of Museums.

supplement or even displace, as well as some of the factors that appear to account for this new model's emergence over the past two or three decades.

I first began museum work in 1967. Still to be found then (and perhaps even now) were some hardy remnants of different models that had been used to shape museums through and even after World War II. Perhaps the most awesome of these was the Museum as Establishment. Conceived around the most privilege-bestowing of paradigms, this was the majestic and deeply founded museum whose legitimacy was unquestionable, whose entitlement to ongoing public support was simply taken as a matter of course, whose authority was absolute, and whose inner workings were of no proper concern to anybody beyond its walls. Like some institutional version of the royal family, it was what consultant Will Phillips has called an "aristocratic" organization.

Other models of which sturdy survivors could be found included the Museum as Treasure House, the Museum as Philanthropy, the Museum as Process, and the Museum as Presenter. In the Treasure House model, the measure of the museum was the magnitude and/or excellence of its physical and human resources: collections, facilities, endowment, trustees, and staff. "More and better" were the museum's twin and constant goals. The Museum as Philanthropy, by contrast, was concerned with the benevolence of those who had established and maintained it. It was the museum created by well-meaning "haves" to confer a benefit on culturally deprived and otherwise less fortunate "have nots." It measured its success by the degree of goodwill that permeated its public programs. With enough of that goodwill, important and valuable consequences were almost certain to follow.

The Museum as Process was the museum that prided itself above all on having in place an up-to-date and consistently enforced policy or protocol to cover every imaginable activity or contingency. It did things by the book. The Museum as Process was (in the early days; not recently) the darling of the AAM's accreditation program: first kid on the block to have a collections management policy or an emergency evacuation procedure, impeccable records, impeccable storage. The Museum as Presenter was meanwhile centered on its exhibition and other public programs. What its curators cherished above all was the approbation of their peers (and, most especially, of those peers who served on the NEA and other grant-review panels). Quality was its daily watchword.

What has been weakening the power of these older models and driving museums toward the adoption of a more recent one? Some of the pressure

has come from within the museum field itself. Technological advances and resource shortages have compelled museums to consider more carefully what their priorities might be and where their efforts might best be concentrated. Museum educators—within their own institutions as well as through their strength in the AAM and many state and regional museum organizations—have prompted museums to move away from their inward focus to their far more outward-looking orientation. Critics within and outside the field have also played a key role by persuasively attacking one or another segment of the museum community for its elitism, insularity, or failure to practice the inclusiveness that it preaches.

From a broader perspective—regardless of whatever shortcomings might be attributable to museums in the past—the major impetus for the emergence of the social-enterprise model has had very little to do specifically with museums themselves. Museums have simply been caught up, almost as innocent bystanders, in a profound change that is making its way inexorably through this country's entire nonprofit sector, the sector of America's public life to which the majority of them belong. To understand more fully the emergence of this social-enterprise model, one must look beyond museums to the great sprawling universe of nonprofit organizations generally.

At least four factors can be singled out as being crucial. First, and of earliest importance—it was virtually fatal to the Museum as Establishment—was the widespread acceptance beginning in the 1970s of the "tax expenditure" concept as propounded by the late Harvard Law School professor (and also U.S. Treasury official) Stanley Surrey. Embodied in this concept was the argument that the tax dollars forgone by government in the case of tax-deductible charitable contributions constituted cocontributions that came just as surely out of the government's coffers as if those same amounts had been directly appropriated by Congress. Viewed through this lens, there was really no such thing as a purely private nonprofit organization. At best, "private organizations" were a public-private hybrid. Nor was there any longer a persuasive argument that the internal operations of such organizations were properly beyond the bounds of public scrutiny.

There has also been a growing acceptance of the argument of the highly regarded management expert Peter Drucker that it is socially irresponsible for any organization to exercise control over always-limited resources unless it is able to utilize those resources to produce some outcome commensurate with their magnitude. Wastefulness, as Drucker envisions it, is a near cousin to slothfulness—one of the original seven deadly sins. In a

business enterprise, Drucker's "commensurate" outcome might be a profit, equivalent at least to the interest that might otherwise have been earned on the invested capital as well as some premium for risk. The nonprofit is not, in Drucker's view, substantially different. Although the outcome attributable to the organization's contributed capital may not be measurable in fiscal terms, some result (or outcome or consequence) commensurate with its magnitude is nevertheless expected. Otherwise, the organization may be deemed to have acted in a socially irresponsible manner by its failure to have made appropriate use of the resources under its control.

Drucker contrasts his own result-based approach with that of those who would (mistakenly, he argues) evaluate nonprofits by their good intentions (as in the case of the Museum as Philanthropy). He is also critical of nonprofits—particularly social-service organizations—that seek to be evaluated solely by the severity of the problems that they intend to address (for example, XYZ is a dreadful disease, our organization fights XYZ, ergo our organization must be a good one). For Drucker, the ultimate test of a nonprofit organization is whether it is able to employ its resources to provide adequate value both to its "primary customers" (such as a museum's visitors) and to its "secondary" ones (its volunteers, donors, staff members, and trustees).

Drucker's use of "value" in this context provides a bridge to a third factor driving the nonprofit world toward the social-enterprise model: its slow, reluctant (and, among cultural organizations, even sometimes grumpy) acceptance of the bundle of concepts that together constitute "marketing." Only in the past decade or so have nonprofits been prepared to recognize that these concepts might have broad application in understanding the relationships between their organizations and those many others with which they interact.

Within the nonprofit sector (and among museums especially), marketing's antithesis, the Better-Mousetrap Theory, has had a long if not productive history. Build one, the theory went, and—regardless of whether anyone had the slightest need or want for any such contraption; regardless, even, if there were still any mice to be found—the world would beat a path to your door. Frequently, of course, the world did not. It seems far better understood today that if a nonprofit organization has genuine expectations of others—if it expects those others (be they visitors, volunteers, donors, or staff) to pay entrance fees, volunteer their leisure time, donate their money, or accept below-private-sector salaries—then it must in return be

able to satisfy their individual needs and wants. When marketeers refer to an "exchange of values," it is the provision of such satisfaction that constitutes one side of the exchange.

The fourth and perhaps most important factor responsible for the emergence of the social-enterprise model is an expanded notion of accountability. Thirty years ago, accountability consisted primarily of what Peter Swords has called "negative accountability." It was making sure that nobody had a hand in the cookie jar, whether directly, through embezzlement, bribes, or kickbacks, or indirectly, through conflict of interest or the use of insider information. In the years since, these cookie-jar problems have been alleviated to some degree by the increasing sophistication of accounting standards as well as together with the imposition of governmentally imposed record-keeping and reporting requirements that have opened up most nonprofit organizations to allow for an unprecedented degree of public inspection.

Today, nonprofit organizations are being asked to move even further toward what Swords has called "positive accountability"—the ability to assure providers that the resources they have provided are being used both effectively and efficiently to accomplish the purposes for which they were intended. Underlying such positive accountability, of course, is the necessity that organizations and their supporters begin with a clear and shared understanding both of what results they are seeking to achieve and of what means will be used to ascertain whether or not they are achieving those results. In this context, clarity of purpose becomes key. Without such clarity, an organization's effectiveness cannot be ascertained or a proper accounting rendered.

Turning finally to Dees's concept of the social enterprise, it is precisely on this basis—the capability to achieve a desired outcome, to reach a bottom line—that he classifies nonprofit organizations as a form of enterprise. In their entrepreneurship, nonprofits are only parallel to—not identical with—business enterprises. According to Dees, two critical differences separate them. One is the nature of their bottom lines. Whereas a business enterprise seeks a financial outcome as its bottom line, a social enterprise seeks instead to bring about a particular social outcome. Implicit in such an effort (and in synchrony with the requirements of positive accountability, as described by Swords) is that such an outcome—the achievement of the organization's underlying purpose—has been clearly understood and defined in advance.

The second critical difference between the social and the business enterprise is what Dees refers to as "social method." Whereas the business enterprise obtains its resources through "explicit economic exchange relationships, contracts, and arms-length bargains," a social enterprise may rely to some degree on donated funds, goods, and services as resources while, correspondingly, providing its own services to the public either without charge or at a price below their fair market value. Those differences aside, nothing in the social-enterprise model suggests that the striving-to-be-successful social enterprise should not manage its affairs in a manner very similar to that of a successful business enterprise. An enterprise need not be a business to be businesslike.

In conclusion, then: how might the Museum as Social Enterprise compare with some of the museums that we have known in the past? In contradistinction to the Museum as Establishment, the Museum as Social Enterprise would draw its legitimacy from what it does rather than what it is, would seek public support not as a matter of right but by offering to provide the public with value in exchange, might be open to challenge as a matter of course, and—equally as a matter of course—would expect to be held accountable for every aspect of its operations. In contradistinction to the Museum as Treasure House, it would regard its collections and other resources as means toward the accomplishment of its entrepreneurial goals, not as ends in themselves. In contradistinction to the Museum as Philanthropy, it would measure itself by the results that it achieved, not merely by its good intentions. In contradistinction to the Museum as Process, it would—in Drucker's phrase—"seek not just to do things right, but also to do the right things." Less dramatic might be its distinction from the Museum as Presenter. The Museum as Presenter might once have concentrated on the quality of its public offerings, but the Museum as Social Enterprise would look first and principally at their impact.

The Museum as Social Enterprise: the words may be new, but the melody—like a rising tide—has been swirling up and around us for a good many years now. For those who have yet to embrace it, it seems (at least to me) like a Museum that deserves to be warmly welcomed. Welcomed or not, however, it may well prove to be not only an inevitable Museum but, as I suggested at the beginning, the Museum that provides us with a dominant model for a long time to come.

Transformed from a Cemetery of Bric-a-brac

Among the perennially favorite American stories is Washington Irving's tale of Rip Van Winkle, the amiable New York farmer who fell into a profound sleep as a loyal subject of George III, woke up some twenty years later, and was astonished to find that he had become a citizen of an entirely new country called the United States of America. What had happened while he slept, of course, was a revolution. If we could shift that frame just slightly and conjure up instead an old-fashioned curator in a New York museum—a tweedy Rip Van Recluse—who dozed off at his desk some fifty years ago and woke up today, would his astonishment at the museum in which he found himself be any less? I think not.

During the past half century, not just one but two distinct revolutions have occurred in the American museum. The first—a revolution specific to the museum—was in its focus. When Rip Van Recluse began his long sleep, the American museum, just as it had been since early in the twentieth century, was oriented primarily inward on the growth, care, study, and

This text was presented as the keynote address at the 1999 annual meeting of the British Museums Association in Edinburgh in September 1999. A slightly edited version was subsequently included by the Institute of Museum and Library Services in a publication entitled *Perspectives on Outcome Based Evaluation for Libraries and Museums* that was initially distributed in the summer of 2000. Published with permission from the Institute of Museum and Library Services, a federal agency serving the public by strengthening the nation's museums and libraries.

display of its collection. By the time he awoke, that focus had been completely reversed. The museum in which he found himself was now an outwardly oriented organization, engaged primarily in providing a range of educational and other services to its visitors and, beyond its visitors, to its community. The collection, once its raison d'être, was now simply one of a number of resources to be used for the accomplishment of a larger public purpose.

This change of focus, as Rip would quickly discover, was in no way peculiar to the American museum. Common virtually everywhere is the conviction that public service is central to what a museum is all about. How that is expressed may differ from one country to another, but almost nowhere does anybody still believe—as did many of Rip's colleagues before his long sleep—that the museum is its own excuse for being.

The second revolution—a revolution that is still in progress—is considerably more complicated. By no means specific to museums, it is a revolution raging across the entire not-for-profit or "third" sector of American society—that sprawling conglomeration of more than one million privately governed cultural, educational, religious, health-care, and social service organizations to which most American museums belong. Whereas the first revolution involved a change in institutional focus, this second revolution has to do with public expectations.

At its core is a growing expectation that, in the discharge of its public service obligations, every not-for-profit organization will carry out its particular work not only with integrity but with a high degree of competence as well and, moreover, that it will employ that competence to achieve an outcome that—regardless of what kind of a not-for-profit organization it may be—will demonstrably enhance the quality of individual lives and/or the well-being of some particular community. Under the pressure of this second revolution, what had once been a landscape dotted with volunteer-dominated and often amateurishly managed charities—the realm of stereotypical bumbling vicars, fluttering chairladies, and absent-minded professors—is being transformed into a dynamic system of social enterprises, in which the ultimate institutional success or failure of each constituent enterprise is judged by its capacity to articulate the particular results it is seeking to achieve and by its ability, in day-to-day practice, to achieve the results it has so articulated.

To translate that second revolution into museum terms: the institution in which Rip Van Recluse fell asleep was generally regarded as an essentially

benevolent or philanthropic one. It was imbued with a generous spirit, its supporters were honorable and worthy people, and it was, above all, respectable. During the years that Rip slept, other ways of looking at the American museum began to surface. For some observers, resources replaced respectability as the measure of a museum—a good museum, in their view, was one with a fine collection, an excellent staff, an impressive building, and a solid endowment. For others a museum was better measured not by what resources it had but by what it did with those resources—by its programming. For still others it was processes and procedures that mattered—what made a museum admirable was its mastery of museological techniques, its ability to do things "by the book." With the coming of this second revolution, all of those other measures are being subsumed into two overarching concerns. These are, first, that the museum has the competence to achieve the outcomes to which it aspires—outcomes that will positively affect the quality of individual and communal lives—and, second, that the museum employs its competence in such a way as to assure that such outcomes, in fact, are demonstrably being achieved on some consistent basis.

Among the forces driving this second revolution has been the emergence, primarily in the graduate schools of business, of the new organizational concept of the "social enterprise," pursuant to which a socially driven enterprise and a profit-driven one can best be understood as being basically similar entities that differ mainly in the nature of the bottom lines that they pursue, how they price the products and/or services that they distribute, and how they acquire replacement resources to make up for those depleted through distribution. In the end, however, "managing for results"—to use a Canadian phrase—is no less essential to one form of enterprise than to the other.

As this theoretical model was being polished in the business schools, a complementary group of ideas was finding practical expression in the work place. Two instances are noteworthy here: in the private sector, the adoption of new evaluation practices in 1995 by the United Way of America and, in the public sector, the passage of the Government Performance and Results Act (GPRA) in 1993. For those not familiar with the United Way, a brief description may be in order. Originally organized as the Community Chest movement, the United Way is perhaps the largest and certainly one of the most influential not-for-profit undertakings in the United States. A federation of some fourteen hundred community-based fund-raising organizations that derive roughly 70 percent of their contributed income from direct payroll deductions, it collected some $3.5 billion dollars in 1998, its

most recent reporting year. That money, in turn, is then distributed to tens of thousands of local organizations throughout each community. Although each United Way chapter has full autonomy to determine how its share of this immense pool of money will be distributed, uniform standards are set by its national office in Alexandria, Virginia. In 1995 that office officially announced a radical change in those standards.

Previously, United Way had based its funding decisions on an evaluation of its applicant programs. If an organization applied to a United Way chapter for funding an adult literacy program, for example, the criteria for making or denying that grant would have been based on such program-related questions as whether the curriculum was soundly conceived, whether the instructors were well qualified and whether the proposed classroom materials were appropriate for the expected participants. No longer, said United Way in 1995. Henceforth the focus would be on the recipients of services, not their providers. Henceforth the test would be outcomes, results, program performance. By what percentage had the reading scores of those participants improved? How did that improvement compare with the improvement recorded in earlier years? How did it compare with the record of other literacy programs in similar circumstances? Put bluntly: not, Was the program well designed or highly regarded? but: Did it really work?

Central to the United Way's new approach were such concepts as *change* and *difference*. A 1996 publication suggested how flexibly those concepts could be applied without violating the boundaries of what might still might be strictly defined as outcomes. Outcomes might relate to the acquisition of knowledge or skills, but they could also include intended changes in attitude or values. Intentionality was also key. It was not enough that a program had made *some* difference; what mattered was an *intended* difference.

Although United Way's funding was directed primarily toward social-service agencies, its full-scale embrace of outcome-based evaluation has had a pervasive influence throughout the entire American funding community, among foundations, corporate donors, and government agencies. To a greater degree than ever, funders are asking applicants of every kind—cultural organizations as well as social-service agencies and health services—detailed questions about what outcomes they hope or realistically expect to achieve through a proposed program and about how they intend to determine whether or not those outcomes have been achieved.

Meanwhile, that identical question—What is it that you hope or expect to accomplish with the funds for which you are asking?—is today being for-

mally posed on an annual basis to every federal agency. Under the GPRA, legislation that was scarcely noticed when it was passed on a bipartisan basis in 1993 but which is now beginning to loom large, each such agency will be responsible, first, for establishing—preferably in objective and quantifiable terms—specific performance goals for every one of its programs and, second, for reporting annually thereafter in meeting those goals.

GPRA raises the level of public accountability to a new height. Before GPRA came into effect, U.S. government agencies were already responsible under earlier legislation for controlling fraud and abuse. Professor Peter Swords of the Columbia University Law School has referred to this lower level of scrutiny as "negative accountability"—making sure that nobody was doing anything wrong. With GPRA the government will be ratcheting itself up a notch to what Swords has called, by contrast, "positive accountability"—making sure that government programs actually work to achieve their intended outcomes and that federal money is being spent not only honestly but also effectively.

Although this enhanced standard of accountability will affect only a handful of museums directly, it is certain to serve as a model for various state, county, and municipal governments and for some private funding sources as well. In confluence with the other forces driving this second revolution, the implementation of such standards is radically changing the climate in which American not-for-profit organizations operate—museums included. This new climate is distinctly more hard-nosed. All but gone are the traditional trust and leniency that not-for-profit organizations enjoyed when yesterday's public still looked upon them as genteel charities. In their place is the heightened degree of accountability on which the public now insists.

Nothing on the horizon suggests that this climate is likely to change or that what we are witnessing is merely some cyclical phenomenon, something to be survived until museums can once again hunker down around their collections. In earlier and more trusting days, the museum survived on the faith that it was an important institution per se and that its mere presence in a community would somehow enhance the well-being of that community. The second revolution has undermined that faith by posing questions about competence and purpose that, like genies released from a bottle, cannot readily be corked up again.

As museums in the United States seek to cope with this second revolution, a number of misconceptions have emerged. Many American museum workers seem to believe that what is primarily being asked of them is to be-

come more efficient, to adopt "lean and mean" practices from the business sector that would enable them and their museums to achieve a more positive and self-supporting economic bottom line. Although nobody is condoning inefficiency in museums, the goal that the proponents of social-enterprise theory are pursuing—the United Way and GPRA, each in their own way—is not merely efficiency but something far more difficult to attain and considerably more important as well: effectiveness.

In this context, the distinction between *efficiency* and *effectiveness* is critical. "Efficiency" is a measure of cost; "effectiveness" is a measure of outcome. "Efficiency" describes the relationship between a program's outcome and the resources expended to achieve that outcome. Efficiency is clearly important—the more efficient an organization, the more outcome it can generate from the same expenditure of resources—but it is always subsidiary to effectiveness. "Effectiveness" describes the relationship between a program's outcome and the expectation with which that program was undertaken in the first place—it is the measure of "Did it really work?" In the for-profit commercial enterprise, efficiency and effectiveness overlap substantially. Waste can undermine profit, the basic point of the enterprise. Not so in the social enterprise, where efficiency and effectiveness remain distinct. A museum might conceivably be effective without necessarily being efficient.

A related misconception is that the pursuit of effectiveness is analogous to benchmarking. "Benchmarking"—as that term is generally used in the United States—is something else: an effort to improve how you perform a particular task by seeking out the most exemplary practice in some other organization with the intention, so far as may be practical, of then adopting that practice for yourself. Specific procedures within a museum—making timely payment to vendors, performing a conservation survey, processing outgoing loans—can certainly be approached in this way, but scarcely ever could the overall operation of the museum itself be benchmarked. Museums are so extraordinarily varied in their discipline, scale, governance, collections, sources of funding, endowment, staffing, and community setting that one can hardly serve as a model or even the basis of any meaningful comparison for another. That is particularly the case with respect to effectiveness. A museum's effectiveness can only be determined in relationship to what it is trying to accomplish—not in terms of what some other museum is trying to accomplish.

Finally, there are those who think that in these combined revolutions American museums are being asked to do something wholly novel or unprecedented.

From almost its very beginning, however, the mainstream museum movement in the United States has had running beside it a slender but vigorous alternative movement—a countercurrent—that envisioned the museum not in terms of such inward activities as the accumulation, care, and study of its collections, but rather in terms of what impact it might have on its community.

For more than a century, many of the most eloquent voices within the American museum community have argued strenuously for the outwardly directed and publicly accountable museum. Here, for example, is how George Brown Goode—an early assistant secretary of the Smithsonian—made the case during a lecture at the Brooklyn Institute in 1889: "The museum of the past must be set aside, reconstructed, transformed from a cemetery of bric-a-brac into a nursery of living thoughts. The museum of the future must stand side by side with the library and the laboratory, as part of the teaching equipment of the college and university, and in the great cities co-operate with the public library as one of the principal agencies for the enlightenment of the people."

Nobody has made these arguments more pungently, however, than John Cotton Dana, the early champion of community museums and the founder, in the early 1900s, of one America's most notable examples: the Newark Museum. In a 1917 essay, written as the Metropolitan Museum of Art and other East Coast museums were accelerating their quest for the previously unobtainable works of fine art flowing out of Europe, Dana was scornful of what he called "marble palaces filled with those so-called emblems of culture,—rare and costly and wonder-working objects." Such museums, the kinds of museums, he said, "which kings, princes, and other masters of people and wealth had constructed" would give the common people neither pleasure not profit. Nor could such museums accomplish what Dana took to be the first and obvious task of every museum: "adding to the happiness, wisdom and comfort of members of the community."

Most remarkably of all, Dana understood as early as 1920 that the public's support of a museum was, at bottom, an exchange transaction—that the public was due a measure of value in return. Museums, he said, had to be both useful and accountable. This once-alternative countercurrent is now in the course of becoming the mainstream itself. Astonishing as the concept of the museum as a positively accountable public-service organization may be to the newly awakened Rip van Recluse, that concept does have deep roots in the American museum tradition.

Among the several consequences that these two revolutions may have for

American museums, one—a consequence that our time-traveler Rip Van Recluse may not find so congenial—is internal. It pertains to how museums are staffed and how their operating budgets are allocated. When collections were at the core of the museum's concern, the role played by those in charge of the collection was dominant. In American museums, curators were the resident princes. With the evolution of the outwardly focused public-service museum, curators have been forced to share some of their authority with a range of other specialists: first with museum educators, and more recently with exhibition planners, with public programmers and even with marketing and media specialists. As with their authority, so with their budgets. As the museum's focus is redirected outward, an increasing share of its operating costs, particularly salaries, must concurrently be diverted away from the acquisition, study, and care of collections and toward other functions. In many American museums this has sometimes been a bumpy transition—power is not always relinquished graciously, even by otherwise gracious museum people—with still some distance to go.

A second of these consequences also has budgetary consequences. It is the urgent need for museums to develop and implement new assessment techniques by which to evaluate the overall impact of their programs on individuals and communities. Not only will this be expensive, but museums also begin with a tremendous handicap. Because outcome-based evaluation has its roots in the social-service area where results can usually be quantified, this evaluation presents particular problems, not only to museums but also to certain other public service organizations—religious bodies, liberal arts colleges, environmental lobbyists—whose program outcomes may not be readily susceptible to statistical or other measurement.

In contrast, for example, to a drug rehabilitation program or a prenatal nutrition program—both of which might produce clearly measurable outcomes within less than a year—the impact of museums is of a very different kind, frequently subtle, rarely pure, and often requiring the passage of years to become apparent. Museums will not only have to educate themselves as to how their impact can be captured and described, they will also have to educate those to whom they may be accountable, as to what may and may not be possible in rendering their accounts. Daunting as those tasks may be, they will be essential. It is precisely because the value of what a museum can add to a community's well-being may not be as self-evident as is that provided by the drug or prenatal program that developing a credible means to report that value is so important.

Another of these consequences is—to my mind—the most critical. It is the need to define institutional purposes more clearly and, having once defined them, consistently make those purposes the backbone of every activity that the museum undertakes. The logic here is basic. Under the impact of these two revolutions, institutional effectiveness will be the key to continued public support. In the absence of some clear sense of what a museum intends to achieve, it is impossible to assess its effectiveness—impossible to evaluate how its actual achievements compare with its intended ones. That a clear sense of purpose was basic to a museum's organizational well-being was already understood—if only instinctively—by the early proponents of the outwardly directed museum. In a paper presented to the United Kingdom's Museums Association when it met in Newcastle in 1895, the Smithsonian's George Brown Goode made that very point. "Lack of purpose in museum work," he said, "leads in a most conspicuous way to a waste of effort and to partial or complete failure."

One source of difficulty for American museums has been a tendency to confuse museum purposes with museum functions. In her 1998 AAM book on mission statements, Gail Anderson points out that a museum that describes its intentions solely in terms of the activities it plans to undertake—that it will collect, preserve, and interpret X or Y or Z—cannot possibly be qualitatively evaluated. In the absence of any sense of what it hopes to accomplish and whom it hopes to benefit through those activities, such a museum simply appears to be spinning in space with no goal but its own survival. This is where Rip Van Recluse might find himself most puzzled. When he fell asleep in his museum all those years ago, its purpose wasn't a question. In the mainstream formulation, a museum didn't need a reason to be. It just was. Not any more: This second revolution is establishing purpose as every institution's starting point—the first promise from which every institutional argument must hereafter proceed.

When we finally do turn to see what the possible purposes of museums might be, what we find shining through is the incomparable richness of this field in which we work. In the range of purposes that they can pursue—and the range of the community needs which they can meet—educational needs and spiritual ones, social and physical needs, psychological and economic ones—museums are among the most remarkably flexible organizational types that a modern society has available for its use. Museums can provide forms of public service that are all but infinite in their variety. They can inspire individual achievement in the arts and in science; serve to strengthen

family and other personal ties; help communities achieve and maintain so-
cial stability; act as advocates or play the role of mediator; inspire respect
for the natural environment; generate self-respect and mutual respect; pro-
vide safe environments for self-exploration; and be sites for informal learn-
ing. In every realm, museums can truly serve as places to remember, to dis-
cover, and to imagine.

In 1978 the AAM elected Dr. Kenneth Starr, then the head of the Mil-
waukee Public Museum, as its president. Earlier in his career, Starr had been
a scholar of Chinese art, and almost invariably in the course of a public ad-
dress, he would remind his listeners that the Chinese ideogram for "crisis"
was a combination of the symbols for danger and opportunity. If these revo-
lutions turn a museum from an inwardly focused to an externally focused
one, from an institution whose worth might be accepted on faith to one re-
quired to demonstrate its competence and render a positive account of its
achievements—if these revolutions can in any sense have triggered a cri-
sis, then we might ask the two questions relevant to every crisis: Where is
the danger? Where is the opportunity?

For the American museum, I think, the danger is that it may slide back
into its old Rip Van Recluse, collection-centered ways and thereby render
itself irrelevant. In our American system of third-sector, privately governed
not-for-profit organizations, there are no safety nets for worn-out institu-
tions. Museums can fail, and they will fail if and when nobody wants to sup-
port them any longer. And the opportunity? The opportunity, I think, is for
the museum to seize this moment and to use it, first, as the occasion to think
through and clarify its institutional purposes and then, second, to go on to
develop the solid managerial techniques and strategies that will assure its
ability to accomplish those purposes in a demonstrable and consistent way.

Before he fell asleep, Rip Van Recluse may well have felt some pride
about the good place in which he worked, the important people who sup-
ported it, perhaps even about its fine collection and imposing building.
Today, though, two revolutions later, the pride that museum workers can
take is of a different and, I think, a higher order. It is the pride of being as-
sociated with an enterprise that has so profound a capacity to make a posi-
tive difference in the quality of individual lives, an enterprise that can—in
so many significant ways and in so many remarkably different ways—enrich
the common well-being of our communities. Those are the possibilities that
these two revolutions have released to us. It is up to us now to make the
most of them.

THE MUSEUM
AS WORKPLACE

8

The Distinctive Numerator

Those of us with the good fortune to work in museums have long been engaged—in my own case, for some twenty-five years—in a conversation about the fundamental strengths of the museum as a social institution and about what the individual museum can contribute—and also what it cannot—to its several publics and to its community, however these may be defined.

Most museum workers have what could be described as "hyphenated" interests. On one side of the hyphen is our disciplinary interest: art, history, science, and their variants. On the other is our institutional interest, our concern with the museum as a highly specialized and distinct means of cultural transmission. Put otherwise, except for any surviving McLuhanites who still believe the medium is the message, most of us are inevitably involved both with a disciplinary message and with the institutional medium by which that message is disseminated. Rarely, though, are any of us equally involved with both.

In 1967, when I first went to work for the Whitney Museum of American Art, my primary interest was in the disciplinary side of the hyphen.

At the annual meeting of the American Association of Museums in Philadelphia in May 1995, the author received the association's Distinguished Service Award. This text was his acceptance speech. An edited version subsequently appeared in *Museum News* (March–April 1996) under the title "The Distinctive Numerator." Reprinted, with permission, from *Museum News* (March–April 1996). Copyright 1996, the American Association of Museums. All rights reserved.

Having worked the previous four years in a remarkably aggressive commercial gallery, I thought that the museum would provide a more sympathetic and even dignified setting in which to expand my involvement with contemporary art and with New York City's bustling art scene. The museum as an institution was something to which I'd scarcely ever given even a moment's thought.

What was shortly to swing me over to the other side of the hyphen—to an abiding interest in the museum as a medium—was the series of assaults launched against New York City's art museums in the late sixties and early seventies by a number of loosely organized and overlapping groups of artists. Those groups—in particular, the Art Workers Coalition—seemed convinced that their local museums truly had the power to stop the war in Vietnam, to convince the federal government to release its "political prisoners," and to put an end to racial, sexual, and other inequalities of every kind. One of the most dramatic of these assaults occurred at the first AAM meeting I ever attended, the annual meeting that opened at the Waldorf-Astoria Hotel in New York City on June 1, 1970.

The meeting was a riot—literally. Early on the first morning, some thirty artists wearing T-shirts stenciled "Art Strike against Racism, Sexism, Repression, and War" infiltrated the meeting, rushed the speakers' platform, and commandeered the microphone. They demanded that a spokesperson from their ranks be given precedence over the scheduled program and that, in lieu of other business, the AAM members in attendance take action on a series of demands intended to be binding on their respective institutions. These demands were cast in a rhetoric typical of the time. Number three, for example, was that "all urban museums . . . devote 15 percent of their funds the first year, 20 percent the second year, increasing to 40 percent of their total funds toward decentralizing museum facilities and services" for various categories of "oppressed people." Demand number four was that "the AAM declare as inseparable from the freedoms under which the arts flourish the immediate release of the Black Panthers and all political prisoners in this country." Amidst considerable chaos, the meeting was abruptly adjourned. More trouble followed that evening when the participants reconvened at the Brooklyn Museum, and there was a third outburst two days later when Nelson Rockefeller, governor of New York, came to address the membership and found himself instead in a noisy confrontation with the artists.

Disruptive as those tactics may have been, one of their positive—if un-

intended—consequences was to force those of us who were charged with countering these assaults into thinking far longer and harder about our institutions than we might otherwise have done. The initial questions were short and blunt. How did museums benefit the public? Why were they worthy of continued support? Were art museums, as one of the leaders of the Art Workers Coalition said, merely part of an establishment that "sees artists as social lackeys, maneuvers consistently to deny [them] a voice in the institution and policies that shape their lives, and confines them to the position of being amusing hustlers for the capitalist class," or might such museums and others as well be something considerably more? Of necessity, we found ourselves beginning to talk with one another in far more probing ways than we had in those halcyon days when it seemed all but self-evident that museums were entities precious in themselves—fully as worthy of preservation and even reverence as the objects held in their collections.

Those assaults have long since faded but, thankfully, the conversation they triggered goes on. Central to it has been the very question to which those rioting artists of 1970 assumed that they knew the answer: What kinds of positive changes can museums really effect in the world beyond their doors? Were those artists of 1970 correct to think that museums could be the agents of such sweeping and dramatic change, that they could single-handedly stop a war, end injustice, or cure inequality? Most of us then and today would answer no; museums cannot really do those things. But we might, by contrast, answer yes to the related question of whether particular museums can make substantial contributions toward those ends. To say that an individual museum does not have a lever to move the world, that it cannot be a compelling agent of fundamental social change, is not to deny that it can be a powerfully effective source of influence. Through the personal enrichment of its visitors and by the part it plays in helping to form an educated, informed, sensitive, and aware citizenry, the individual museum can make an enormous contribution toward the most important task that any of us face—the task of building a just, stable, abundant, harmonious, and humane society.

Where we continue to encounter difficulty is in describing more precisely the contributions that museums make toward these ends. Two things do seem clear. First, we must acknowledge that no single contribution is common to all museums. Notwithstanding our craving for definitional simplicity, the spectrum of contributions that museums make to society is as broad and as richly varied as are museums themselves. And second,

notwithstanding recent demands that we begin to quantify the value of those various contributions, they may not prove susceptible to such neatly quantitative modes of measurement.

Concerning the first point, the glue that holds our field together in its aspiration to professionalism consists of those aspects of museum work that serve as our common denominator: the maintenance, documentation, and study of collections and their use in public programs. We come to annual and regional meetings to talk about techniques, about methods, about process. These are necessary, of course, but we must always remember that they are not sufficient. What each of our institutions contributes to its community derives not from its common denominator but from its distinctive numerator—from what it can contribute, uniquely in its community and perhaps uniquely among all the museums in this country or the world, to the well-being of a specific group of people in a specific time and place. Back in our communities, what matters is not process but product— the results we accomplish, the outcomes we achieve. In short, our distinctive numerators. No one numerator is necessarily more right for a particular museum than another. Many are possible. The question is one of choice. As a social institution, the museum can accommodate a multitude of different and even potentially conflicting purposes: it can focus on heritage, on community building, on public education, on preservation, on scholarship, on providing important experiences. If rightness is to be judged at all, it lies not in the purpose chosen but in firmly choosing a purpose and making that choice publicly and consistently clear.

The demand that we be able to measure a museum's contribution to its community quantitatively—to show, more exactly, how much value it has added in exchange for the support it has been given—is like the demand being made today upon colleges and universities. It may even be a by-product of the repeated assertion that museums are primarily educational. Whereas there may be some validity in asking a university to demonstrate its institutional effectiveness through the achievement of its students, museums cannot do that. The parallel is not nearly exact. The changes that museums can effect upon their visitors and in their communities are far different and subtler. These changes often can only be ascertained—not measured—cumulatively and their manifestations are rarely dramatic and frequently indirect.

Short-term economic impact studies aside, many museums find themselves hard-pressed to show what tangible benefits they are able to provide

to their communities. If museums are to be accountable—which no longer seems a matter of choice—we will have to work together to clarify and better articulate the long-term impact and importance of the different outcomes that museums produce. We must develop the means to ascertain and demonstrate these effects. That we must do so against a confusing and constantly shifting background of changing demographic patterns, accelerating technological development, and evolving social structures does not excuse us from that effort. It simply means that we must accept the frustrating reality that what we are finally able to clarify about museums and their contributions today will almost certainly become cloudy again by tomorrow.

Our conversation about museums and the values they provide has been productive and has taken us far, but it has not been conclusive. Perhaps that is as much as can be hoped for. Our situation may well be like that described in the anonymous quotation with which Kast and Rosenzweig concluded their 1985 book on organizational management: "We have not succeeded in answering all our questions. Indeed, we sometimes feel that we have not completely answered any of them. The answers we have found only serve to raise a new set of questions. In some ways we feel we are as confused as ever. But we think we are confused on a higher level and about more important things."

When I heard that I was to receive the AAM's 1995 Distinguished Service Award, it struck me as a kind of a capstone—a personal culmination of all those years of conversation about museums. More recently, though, I've found myself hoping that it might prove to be not so much a capstone as a stepping stone—that in becoming a distinguished member of our museum community, I don't yet have to be an extinguished one, and that I might participate in this conversation for a bit longer. I hope so. It is a conversation that none of us can afford to abandon. Not one of us would, I think, continue in this business if we thought that those museums with which we're most familiar were nothing more than a source of entertainment or recreation, or if we thought that the principal value of a museum to its community was as an economic stimulus, or finally if we thought that, regardless of whatever importance they might once have had, the museums that we know best have become irrelevant.

The case is the opposite. That our conversation continues in so animated a way bears witness to our continuing belief in the importance and vitality of the museum as an institution. What we lack is not confidence but a more useful vocabulary, not a visceral sense of the good things that a museum can

make happen but a better means to make that sense articulate. If, as we go, this conversation still leaves us to some degree confused, we can at least have confidence that our confusion will be at a higher level and about more important things.

9

A Parable of Rocks and Reasons

It's the first Saturday morning in November, bright but brisk. You pass an open field where some thirty or so sweat-streaked men and women are loading a truck with rocks. You pause to watch them at work. While you watch, a person who appears to be their leader walks over to ask if you might care to lend a hand. Before responding, you will naturally want to know why these people are making such an enormous effort to gather such a big load of rocks. And so you ask: Why are you doing this?

Consider the answers that follow, and make up as many others as you'd like. Which responses to your questions might least incline you to be helpful? Which responses might most so incline you?

> It's an old tradition in our community. The first Saturday in November all the young people go out and move a bunch of rocks from one field to another. The next year we move them back again. We've always done it. My uncle thinks it came from Europe. He thinks it's like a Druid thing, only with rocks.
>
> This is a piece of unused land that we're hoping to transform into a public garden. A local nursery agreed to give the town some plants and labor if we could first

This was the first of three "warm-up exercises" that were published in *Museum News* (November–December 1996) under the collective title "To Help Think about Museums More Intensely." Reprinted, with permission, from *Museum News* (November–December 1996). Copyright 1996, the American Association of Museums. All rights reserved.

clear out these rocks. It'll be great when it's finished. The people in town really need something like this.

We're a local body-building group. Sometimes we find that it's more fun to do stuff like this instead of working out in the gym. The object's the same, though: personal development. Strength is joy, they say, and this can certainly be joyful.

Tomorrow's our annual Shirley Jackson ceremony. If you remember her story "The Lottery," it's the time when we get together in the town square to stone one of our neighbors to death. Helps the next year's crops, they say. You might find it interesting, but there's a rule against strangers attending.

We've got an annual contest going with the next town down the road to see which of us can hoist the most rocks in two hours. The winner gets a trophy. We've won the last two times. If we win again, we get to retire the trophy.

The town's old wooden schoolhouse for kindergarten through fifth grade burned down last month. This time the supervisors will be smarter and have the new one built out of stone. We're some PTA volunteers who agreed to help out.

It's a question of prestige. You can't just come out to this field to pick up rocks. It's private. You have to be asked, and not everybody is. Around here it's considered an honor. In this case, we decided to ask you because you looked like our kind of person, if you know what I mean.

We're all graduate students from the Climatology program at State University. Later this semester we'll be analyzing these rocks in the lab for scratches, impurities, and other physical evidence of glacial activity in this area.

We're here to help the 4-H Club. There's a local contractor who needs some rocks to decorate an upscale condo he's building downtown. He promised the club a good contribution if we brought him a couple of truckloads.

We're a social club. It's real fun to do things together. Exactly what we do isn't half as important as being with each other when we do it. Sometimes, like this time, the dumber the better. We just like to go out, work up a real sweat together, and then cool off with some good local brew.

Change your focus. These people are not picking up rocks. These people are doing something even more arduous: they are operating a museum. And you are not a passerby; you are a foundation, a municipal council, or some other potential public or private funding source. When the leader of the group asks if you would care to lend a hand, you will naturally have the same question: Why are you doing this? Consider some of the different reasons you might be given. Might some of them parallel the reasons that were given

for picking up rocks? In which instances might you be least inclined to be helpful? In which instances most? And to what extent, if any, might your inclination tend to be different depending upon what kind of a public or private funding source you were?

Romance versus Realism

A REFLECTION ON THE NATURE OF MUSEUMS

Within the museum community today are two competing and profoundly different conceptions concerning the nature of a museum. Although rarely articulated explicitly, the implicit adoption of one or the other of these conceptions has important consequences in determining how those who support, govern, and staff any particular museum may go about establishing its priorities and evaluating its performance. The first of these conceptions (which, for convenience more than dead-on accuracy, will be referred to as the "romantic") rests on the notion that a museum is per se an institution of universal and positive value. The premise of the second (which, for a similar reason, will be referred to as the "realistic") is that a museum is a value-neutral organizational instrument with the capability to be used for a wide range of purposes that—depending upon the perspective of those making such a judgment—may or may not be considered of universal and/or positive value.

Traces of the romantic conception can be found in such pronouncements as the ICOM definition of a museum (an "institution in the service of society and of its development") or UNESCO's 1960 "Recommendation Concerning the Most Effective Means of Making Museums Accessible to Every-

Reprinted, with permission, from *Museum News* (March–April 1997). Copyright 1997, the American Association of Museums. All rights reserved.

one." On the assumption that every museum—regardless of its merit—effectively contributes to the mutual understandings of people by preserving works of art and scientific material and by presenting those to the public, UNESCO promulgated a blanket recommendation that the general public be encouraged to visit museums, and that for this purpose all museums should be made readily accessible.

For those inside museums, the romantic view that they are inherently "good" organizations is intuitively sympathetic. It follows that if a museum is a "good" organization, then so too must be those who are involved in its support, governance, and operation. Beyond that, the romantic view has the practical advantage of permitting a museum's management to focus on efficiency as the principal performance measure by which the organization's operations can be evaluated. Because the work that the organization is doing is, by definition, already good, the only remaining question is whether, in doing that work, the museum is maintaining a maximally positive relationship between the resources it consumes and the outputs it generates from those resources. Except in rare instances, when external benchmarks may be employed for the sake of comparison, that determination can be made from within the organization itself and without any need to give more than passing consideration to such uncontrollable and frequently elusive factors as visitor response or long-range community impact. Adding to the appeal of this approach is that, to those members of a museum's governing board who come from business backgrounds, efficiency is a mode of evaluation that may seem readily familiar.

The romantic view of museums has a second practical advantage as well. It permits a museum to define success in terms of its own institutional survival. Again, because the organization is already defined as "good," then it would clearly be more beneficial to the community it serves if it continued to exist than if it became extinct. So long as the museum is able to secure the resources (whether earned or contributed) necessary to meet its operating costs, it can be considered successful. If there ever comes a time when it is unable to do so (regardless of whether that inability is caused by a diminution of resources or an increase in expenditures), it will then be a failure. In the relative simplicity of the ways in which they measure organizational performance and success, managing for efficiency and managing for survival largely overlap. The well-managed museum, conceived in the romantic mold, would be both externally strong in its fund-raising and other developmental activities and internally proficient in its utilization of

budgetary and other controls to monitor expenses and maximize staff productivity.

Concealed within the romantic conception of museums, however, is a logical problem, or at least a paradox. In reference to ICOM's definition of a museum, this is the problem: Within any single country and certainly among different countries, there is scarcely any universal agreement as to what might or might not be of service to a given society and/or what might contribute appropriately to such a society's development. Situations may even arise in which the driving motive behind a museum's program activities might well be the very converse of that envisioned by UNESCO—consider the situation in the history museums of former Yugoslavia, or in a military museum in Iraq. Rather than contribute to the mutual understandings of peoples, such a museum might deliberately seek to foster a profound misunderstanding by one people of another.

What objects a museum chooses to collect and exhibit, and how it does so, invariably reflect a point of view. To the extent that points of view can and do differ sharply, the possibility that museums might serve as agents of universal understanding seems illusory. How much "mutual understanding" might be generated, for example, by an Invisible Empire Museum located in Louisiana or Tennessee, dedicated to glorifying the immediate post–Civil War activities of the Knights of the White Camellia or the Ku Klux Klan? More grotesquely, consider how things might be if the Axis Powers had triumphed in World War II and the National Socialist Party, undiminished in its virulence, still held absolute power in Germany. Is it not conceivable that Berlin might today boast a Museum of the Final Solution, a museum that looked and functioned in every respect like the U.S. Holocaust Memorial Museum, except in reverse?

For those who had the opportunity to spend time in the history museums of Eastern Europe before the collapse of its communist regimes, such a possibility is not so far fetched. The Marxist-Leninist version of history encountered in those museums appeared, at least from the perspective of Western visitors, to be not only at variance with the truth but to be deliberately calculated to arouse in museum visitors a deep hostility toward the West and its most deeply held values. In a world of conflicting interests, a museum that serves one community beneficially may, when considered from the perspective of some other community, appear to be anything but inherently benign.

Accepting the reality that such institutions cannot serve as universal

agents of mutual understanding, those advancing the alternative conception of museums propose a view based on a different set of premises entirely. It is, in many senses, a distinctly unromantic view. To start, they envision museum work as something akin to the practice of a technology rather than as an activity that might be considered virtuous in itself. Museum workers, they say, are fundamentally technicians. They have developed and passed along to their successors systematic ways to deal with the objects (and with information about those objects) that their museums collect and make accessible to the public. Through training and experience they have developed a high level of expertise as to how those objects ought properly to be collected, preserved, restored, classified, cataloged, studied, displayed, interpreted, stored, transported, and safeguarded.

From there, proponents of this view go on to argue that—notwithstanding the frequent references to its educational function—the museum in its public interactions is more closely analogous to a broadcasting station than it is to any traditional school. Like such a station, it disseminates information and provides experiences to a largely self-selected audience—an audience that it encounters in relatively unstructured and informal circumstances and that may process the information provided in wholly unpredictable ways. And as with such a station, a museum's true significance lies not merely in its technical capacity to survive at a certain level of activity, just as the station has the technical capacity to maintain itself on the air, but in its program content—what it disseminates and, more important, why it does so. The focus of a museum conceived in the realistic mode is not on survival but on purpose, the basic *why* of what it does. What does such a museum hope or expect to accomplish through its program activities? How does it anticipate that those accomplishments will make a positive difference to the community it intends to serve?

Because the crucial relationship in a realistically conceived museum is between intention and outcome, the principal measure of its operations will not be efficiency—as is the case for the romantically considered museum—but effectiveness. To what extent is the organization able to accomplish its goals in terms of results or outcomes? In such a museum, questions with respect to efficiency are not unimportant, but they are subordinate. Unless and until the museum is demonstrably able to accomplish its purpose, questions as to its efficiency or inefficiency may simply be irrelevant. When, but only when, such a museum *can* demonstrate its effectiveness, questions of efficiency may become central. The greater such a museum's efficiency, the

more it can accomplish with the same resources; alternatively, it may require fewer resources to maintain the same level of accomplishment.

Just as the romantic view of museums offers several practical advantages, the realistic view is conversely burdened with several practical difficulties. For many in the museum community, defining institutional purpose in terms of intended outcomes has proven problematic. Museum workers are far more accustomed to casting statements about institutional mission either in terms of function ("to collect, preserve, and interpret") or of program activities ("to provide the community with a comprehensive program of exhibitions that . . ."). For institutional purposes to be recast in terms of intended outcomes, those responsible for such a formulation will have to step well away from their daily work to ask themselves some fundamental questions as to just why that work is being done, and for whom. How will the community we serve be positively different as a result of our effort? How much difference would it make if we had never undertaken such an effort to begin with?

A second and perhaps greater practical difficulty for realistically conceived museums has to do with ascertaining—if not actually measuring—outcomes. These museums' impact on individuals and communities tends to be subtle, cumulative, difficult to disentangle from the influence of schools and other cultural organizations, and—in comparison with such high-drama, life-saving organizations as shelters for abused children or Alpine rescue squads—incremental rather than critical. Organizations that regularly deal with issues of life and death can frequently cite hard statistical evidence to support their value. Organizations whose primary purpose is not to save lives but to enhance them may have to find more qualitative or even anecdotal ways to determine and describe their accomplishments.

Only by developing the means required to ascertain whether and to what extent it is actually accomplishing its goals—beyond question a daunting task, but also essential—can the management of a purpose-driven museum make sound judgments with respect to its present and future program activities. Only by demonstrating the positive difference that such a museum can make in the life of its community can its management make the strongest case for continued support. Whereas the hallmarks of the well-managed museum in the romantic mode are a strong developmental capacity and sound internal controls, a well-managed museum conceived in the realistic mode must possess not only both those attributes but also a strongly articulated sense of purpose and the feedback mechanisms neces-

sary to determine, on a continuing basis, whether and to what extent that purpose is being accomplished.

Proponents of the realistic conception of museums do not argue that there is any one outcome that every museum ought pursue. They do argue, however, that a museum must be able to articulate the logical connection between its primary program activities and the positive difference it believes those activities are likely to make to its community. Whether the museum focuses its efforts on preserving particular collections; educating the public with respect to a specific subject; reinforcing and perpetuating the community's heritage; providing its visitors with an aesthetic or other experience; serving as a catalyst for the community's social development; advancing scholarship in a particular field; or boosting the community's economy through its attraction as a tourist or leisure destination, the point is the same: Its programs must make a positive and intended difference to its community. *Difference* is the key.

Must one of these conceptions ultimately prevail over the other, or might there be some middle ground where the romantic and realistic conceptions of museums could be harmonized? Finding the latter seems unlikely. Each conception focuses on a different performance measure as the principal means by which a museum ought evaluate itself—efficiency in the case of the romantic conception, effectiveness in the case of the realistic one. In an organization working at its fullest potential, efficiency and effectiveness might for a time be synchronous. In a less optimal situation, their combination would not be sustainable. When hard choices had to be made, a museum's governance and management would find that they had to give either efficiency or effectiveness priority over the other. What seems more likely than harmonization is that one of these conceptions will eventually become dominant throughout the museum community. What also seems likely is that it will be the funding community, rather than either the museum community or any compelling logic, that ultimately determines which. And what seems likeliest of all is that it will be the realist conception that will prevail.

Beginning with human services, outcome-based evaluation is becoming a commonplace of the nonprofit sector across the United States. Foundations and other experienced funders are shifting their focus from activities to results, from programs to performance. Whether such an approach is as appropriate to museums and other cultural organizations as it is to human-service organizations may be a moot point. Funding sources are becoming

increasingly accustomed to inquiring into what real differences in real lives an applicant organization is making—not simply, as once was the case, wanting to be assured that their grant funds were properly used. Museums may have little choice but to adopt the realistic conception. In the long run, that might prove a benefit. Viewed from outside their own sometimes-insular world, museums might find themselves more highly regarded than ever when they are consistently able to present themselves as organizations that warrant support through their demonstrable effectiveness in accomplishing well-articulated and worthwhile purposes that can logically be shown to make a positive difference to their communities.

Museum Publishing

In the preface to the second edition of his *Lyrical Ballads* (1800), William Wordsworth suggested that poetry takes its origin from "emotion recollected in tranquility." Among the great range of emotions that Wordsworth recollected in his later tranquility was the extraordinary exultation that he and other like-minded members of his generation had felt during the earliest days of the French revolution. "Bliss," he wrote, "Bliss was it in that dawn to be alive, / But to be young was very heaven!"

For those engaged in museum publishing, this must be—at least for the young in heart—a time of nothing less than triple bliss. The worldwide museum community is awash with revolutions. I will limit my discussion here to three.

First, in the years since World War II we have seen the now almost-complete metamorphosis of the museum from an institution that was primarily turned inward and concerned with the preservation and study of its collection into an institution that is now predominantly turned outward and whose stated purpose is to provide services to its various publics.

Second, as a consequence of that first revolution, we can now begin to see the slow but inexorable crumbling of all those self-constructed barriers by

This text was delivered at a symposium on museum publishing held in Ottawa in July 2000 and organized by the Publishing Program of the University of Chicago's Graham School of General Studies.

which museums and other essentially preservative organizations have traditionally separated themselves from the rest of the social-services sector.

Third and finally, independent of those other two revolutions but concurrent with them (like a tidal wave riding on the back of two other tidal waves), we have technological innovations—some already here, some soon to arrive, and some still in gestation—with the potential to transform the means by which a museum may communicate with its various publics. One aspect of this third revolution that will have an enormous impact on museum publishing is what I call "dematerialization" of the book.

The first of these revolutions—the decentering of collections as the museum's raison d'être—has not been wholly bloodless. In many North American museums, battles over budget allocations and/or program priorities have pitched curators—the traditional champions of collections—against a sometimes unlikely alliance of museum educators, marketeers, and even development officers. The trend toward public service has, though, been irreversible.

The impact of this change from one museum to another has varied enormously. At the conservative end of the spectrum are some old-line natural-history and art museums that continue to give pride of place to the individually remarkable objects that constitute their collections. Notwithstanding stronger emphasis on education and outreach, a greater generosity in providing information to visitors through object labels and handouts, and even an expanded use of media, many of these museums seem little changed from their former selves. At the far other end of the spectrum are more recently established institutions, such as the Experience Music Project in Seattle, the U.S. Holocaust Memorial Museum in Washington, D.C., and the Newseum in Arlington, Virginia, in which individual collection objects have been subordinated to the larger experiences that these museums are seeking to provide or are otherwise incorporated into the stories that they are trying to tell.

Among museum commentators, perhaps the most radical position with respect to the role of objects is that taken by my former Smithsonian colleague Elaine Heumann Gurian. She has argued not only that collections and their constituent objects may no longer be necessary in order for an entity to be classified as a museum but also that they never have been as essential as generally claimed by the mainstream museum literature (*Daedalus*, summer 1999). Answering her own question—"If the essence of a museum is not to be found in objects, then where?"—she writes: "I propose that the

answer is in being a *place* that stores memories and presents and organizes meaning in some sensory form. It is both the physicality of a place and the memories and stories told therein that are important." In Gurian's formulation, objects may still play a role—she likens them to props that can make "an implicit thesis visible and tangible"—but they are not at the heart of the museum enterprise. What is at its heart is a place in which people can congregate to experience stories told in "tangible sensory form"—a place for inquiry into the memories of the past, a forum for consideration of the present, and a site from which to aspire for the future.

In the United States, Gurian's rejection of the use of objects as the museum's defining characteristic echoes a long-standing theme—albeit for many years a countermelody, rather than the principal one—in American museological thinking. As far back as 1889, George Brown Goode, an early assistant secretary of the Smithsonian Institution, was warning that the museum that failed to make living thoughts rather than inanimate things its central concern might in the end be little more than—in his wonderful phrase—"a cemetery of bric-a-brac."

The most widely known advocate for this point of view was the pioneering museum and social theorist John Cotton Dana, the founder and for nearly three decades the director of the Newark Museum. In a series of self-published pamphlets that began to appear in 1917, Dana inveighed against what he took to be a fundamental error in the organization of museums in the United States, namely their slavish reliance on foreign—primarily European—models and their consequent enchantment with the kind of rare and expensive objects with which those foreign models were typically filled. Scornful of what he called "marble palaces filled with . . . so-called emblems of culture—rare and costly wonder-working objects," he called on the museums of his own country to confine themselves to what he repeatedly described as their "one and obvious task." And that, he said, was to add "to the happiness, wisdom and comfort of members of the community." How might the museum best do this? "Learn what the community needs," Dana said, and "fit the museum to those needs."

What particular implications did this new way of thinking about museums have for museum publishing? I use the word "publishing" in its broadest possible reach: to cover not only the preparation, production, and distribution of printed materials of every variety but also the preparation of wall texts, slides, video tapes and disks, recorded audio tours, Web sites, and every other means by which a museum might regularly communicate

information, ideas, or opinions to one or another of its publics. That museum publishing has undergone, over this past century, a metamorphosis nearly as complete as that which has transformed the museum itself will not, I think, come as a surprise to anybody. By whatever measure, the volume and variety of museum publications has expanded exponentially. Equally dramatic has been the change in focus. Glancing through Laurence Vail Coleman's 1939 *The Museum in America,* one has the clear impression that much of what museums published before World War II was material relating directly to their own collections. These included collection catalogs and guides, as well as serial publications—typically designated as "bulletins," "journals," "studies," or "proceedings"—in which an in-house curator or other expert would discuss in some scholarly depth one or more objects from the collection or otherwise address some theme reflected by the collection.

Publications of this latter type first became widespread early in the twentieth century. One of the most popular was the American Museum of Natural History's magazine *Natural History,* which began to appear in 1900. Among more scholarly efforts, the bulletins of the Museum of Fine Arts in Boston and the Metropolitan Museum of Art in New York date from 1903 and 1905. Although many of these serials continue to be published today, they have long since been eclipsed by the far more glamorous special-exhibition catalogs that many museums—art museums particularly—now produce almost as a matter of course.

Before the war, special-exhibition catalogs had been ugly ducklings. Few included illustrations, and even those few illustrations that did appear were almost always in black and white. Writing of these catalogs in 1939, Coleman acknowledged that some small number might provide useful reference matter or even have permanent value. For the most part, he thought that such publications provided "hardly a helpful or enlightening word beyond the customary listing of works and the names of the artists."

Since World War II, that situation has changed entirely. Museums still publish collection catalogs and guides, of course, but judging at least by the entries to the AAM's annual Museum Publications Design Competition— a competition begun in 1983—by far the larger part of museum publishing appears to involve materials related to special exhibitions: catalogs, gallery handouts, invitations, posters, press kits, and marketing materials. Collection-related materials don't even take second place. That seems to belong to the vast spectrum of printed materials intended to win and retain

membership and other forms of support: annual reports, newsletters, calendars, fund-raising pieces, and membership brochures. Of the sixteen submission categories established for the AAM's competition, three at most appear to be collection related. The remainder are all intertwined with the museum's new identity as an active participant in the public sphere.

In the second of these three revolutions—the crumbling of those self-constructed barriers by which museums have traditionally isolated themselves from other organizations of virtually every kind—what should be clear is the degree to which this second revolution is rooted in the first. So long as museums were tightly focused on the maintenance and preservation of their collections, they had little in common with other organizations beyond that small handful—archives, zoos, and arboreta—that were also engaged in preservation activities. With the museum's reorientation toward a primarily public-service role, that isolation no longer makes the same sense. The range of organizations with which the reoriented museum might share a common goal—to enrich the quality of individual lives and to enhance the community's well-being—has expanded significantly. In theory, at least, there are virtually no entities operating within either the not-for-profit or the governmental sectors with which museums do not have some overlapping interest, virtually no entity with which some museum might not undertake a cooperative effort toward the accomplishment of some common goal.

For the museum, this expanded potential to work with other organizations could not have come at a more propitious time. Institutions are exploring new ways in which to work cooperatively. Across the for-profit sector, unprecedented couplings have begun to emerge: manufacturers with their suppliers, manufacturers with their customers, competitors with one another and unions with management. Typically slower to innovate, the not-for-profit sector nevertheless is beginning to follow that trend.

The depth of commitment in these cooperative arrangements can vary enormously. At one end of the spectrum may be a joint venture, limited in scope and duration to the completion of a single short-term project. At the other end could be the deep collaboration in which two and two might actually make five—collaborations with an outcome potentially greater than the sum of what each of the collaborators might ever have created by acting on its own.

Deep collaboration—in which the potential risks may expand in tandem with the potential rewards—goes much further. Describing such collabo-

rations among individuals, Martin Schrage—a science writer and sometime associate of MIT's Media Lab—writes: "The goal of collaboration is the creation of value, not merely the sum of individual efforts but, more importantly, value born from the exponential product of the collective interactions among the collaborators. Collaboration describes a process of value creation that our traditional structure of communications and teamwork cannot achieve."

Still largely unexplored is whether and to what degree collaborative interactions between institutions must, to be successful, follow the same pattern—such as the need for mutual respect, tolerance, and trust—that characterizes collaborations between individuals.

For museums, the most likely partners for cooperative projects have generally been thought to be schools and libraries. In the United States, one particularly fertile field for cooperation between museums and schools has proven to be the charter school, a form of educational experiment first authorized in Minnesota in 1991 that has spread to at least thirty-five other states. Museums are among those eligible to sponsor charter schools, and many have chosen to do so.

No single formula dominates how these projects work. The museum's contribution may vary enormously from case to case. It may be expertise in providing informal learning: Consider the Chrysalis Charter School in Redding California, jointly established in August 1996 by the Carter House Natural Science Museum and a local public-school district. Tuition free and serving ninety-five students in grades kindergarten through eight, the Chrysalis Charter School operates on the theory that a "powerful hybrid" can be created by combining the best aspects of formal and informal learning. As described by Paul Krapfel, one of the school's founders, in the *Journal of Museum Education*, the formal part of this mix provides at least two attributes that museum learning generally lacks. "The first," he says, "is an interacting mentor. The presence of a mentor can help a learner work through a difficult concept that the learner, if left lone, might abandon. . . . The second attribute lacking in museums is long-term engagement with the learner. . . . A long-term relationship with a learner develops a network of friendship, confidence and inter-connections that can be used to guide the learning into deeper territory."

At the New York City Museum School—a collaboration between that city's board of education and a group of museums in Brooklyn and Manhattan that opened in 1994 and that works with adolescents starting in grade

six—the contribution of the participating museums is characterized in almost diametrically opposite terms. These museums bring to the project their methodology—the disciplined and objective scientific method through which they conduct their inquiries. As described by Sonnet Takahisa, one of its founding codirectors, the school "models the pattern of learning that is practiced by museum professionals—learning that is intellectually rigorous, uses authentic and primary sources, and requires scholarly training, an innate sense of curiosity, and the ability to synthesize and evaluate information from a variety of sources. . . . [The New York City Museum School] seeks to apply this process of museum learning to all aspects of the mandated city and state curriculums."

With respect to libraries—especially in the United States—nothing could better symbolize the growing interaction between museums and libraries than the 1996 decision by Congress to merge the two federal government agencies that had previously provided separate support to these organizations into the single Institute of Museum and Library Services (IMLS). In the years since, IMLS has emphasized the commonality of museums and libraries: how together they provide "a continuum of invaluable resources for further growth through knowledge and self-discovery" and how they act as "focal points in their community's cultural landscape."

Among the projects IMLS funds is a three-way partnership in Pittsburgh among the Carnegie Mellon University Libraries, the Carnegie Museum of Natural History, and the School of Computer Sciences at Carnegie Mellon. One aim of this project is to develop "Smart Web" exhibits by which museum visitors and others will be able to learn about objects on display in far greater depth than they could from traditional and often simplified object labels. The starting point is to be the museum's dinosaur collection, and the Web site will permit users either to follow a prescribed path or to choose their own way through a range of relevant research materials: unpublished correspondence, field notes, published popular and scientific articles, and photographs documenting various related discoveries. For visitors to the Carnegie, access to these Smart Web sites will be through its library or through kiosks in the galleries. Nonvisitors will have access through the World Wide Web.

Another museum and library have gone even further—they have all but merged. Through a partnership created at the invitation of the Strong Museum in Rochester, New York, the local library system operates a branch within the museum itself. Instead of the customary branch library configu-

ration—a central reading room lined with bookcases or with stacks off to one side—the books in the museum's branch are available for browsing or borrowing in a series of "book nooks" scattered throughout the galleries and generally containing material pertinent to whatever exhibitions are then on view in those particular galleries. As a further convenience for visitors, books borrowed during a museum visit can later be returned to any other branch library in the system.

Restating the question posed earlier—what implications might these changes have for museum publishing?—the answer seems clear. As museums increasingly engage themselves in joint ventures and other partnership arrangements, the range of materials that they are called upon to originate can only become correspondingly broader. That appears to be particularly the case with regard to educational materials for use in conjunction with school programs.

As one measure of change, consider the recently issued bibliography of the Victoria and Albert Museum's publications from 1852 to 1996. In 1996, the last year covered, the museum published eight separate handbooks for teachers. In 1896 the V & A did not publish a single one—its publishing activities were almost entirely restricted to catalogs and guides to its own collections. A similar trend might also be discerned in the AAM's Museum Publications Design Competition. When that competition began in 1983, such educational materials were not among the categories for which prizes were awarded; today, they are conspicuously so. Some of these materials have become quite elaborate. Among the years winners in the 2000 AAM competition was a resource pack for teachers who work with the Metropolitan Museum of Art's twentieth-century collection. Packaged in a tote box—and presumably made up by combining newly created pedagogic materials with museum shop products already on hand—it included background information on the art, a binder of images, source materials, and a discussion strategy as well as slides, a poster set, a video tape, and a CD-ROM.

For those engaged in museum publishing, these first two revolutions— the transformation of the museum from a collection-centered to a public-service institution and the concomitant reduction of isolation from other organizations, which had all too often given the traditional collection-centered museum an unworldly, ivory-tower aspect—must pale beside the third: the technological revolution that can transform almost entirely the means by which museums communicate with their various publics.

The aspect of that revolution that will have the greatest impact on mu-

seum publishing is the dematerialization of the book—that series of ongoing technical developments through which the ink-on-paper and distinctly material book, which has been the principal focus of publishing for these past five hundred years, is being transformed—some might even say transfigured—into something far less corporeal, perhaps as incorporeal as a disembodied string of ones and zeros. To be examined along the way are three phenomena—Books-on-Demand, the e-book, and Web sites—that might eliminate certain books altogether.

Books-on-Demand—the phrase is a registered trademark of Bell and Howell's Information and Learning Division—is a Horatio Alger story of how a technology originally developed more than sixty years ago for use in a scholarly context has mutated until it is on the verge of becoming a key technology in popular publishing as well. The idea that scholarly books might profitably be produced in editions as small a single copy seems to have originated in the mid-1930s with Eugene Power, a young employee at a printing firm in Ann Arbor, Michigan. In 1938, with underwriting from the Rockefeller Foundation, he went to England to microfilm a series of early English books in the British Museum. The following year, he began to microfilm a series of doctoral dissertations, and the company he founded—University Microfilms Incorporated—has continued to disseminate them ever since.

University Microfilms has flourished mightily since 1939. In 1962, nearing retirement age, Power sold the business to Xerox. In 1985 Xerox in turn sold it to Bell and Howell, which changed the divisional name from UMI to Information and Learning. Despite these changes, the company's principal focus—aside from the traditional role in disseminating doctoral dissertations and master's theses—has been on making out-of-print material available to the scholarly community. Working with some eight thousand publishers, Bell and Howell claims to have more than 150,000 volumes on its list of out-of-print and/or hard-to-find titles, and its archives are said to hold close to 6 billion pages of material.

Bell and Howell's Books-on-Demand moves with a certain academic stateliness. For a book to be ordered, reproduced xerographically, trimmed, bound, and shipped can take up to three or four weeks. This concept is about to expand from academic publishing to include popular publishing as well, through the introduction of new equipment—digitally based printers and high-speed binding equipment—intended to accomplish the production part of those tasks in fifteen minutes or less. Three of the biggest

U.S. booksellers—Barnes and Noble, Borders, and Amazon.com—have invested in or otherwise teamed up with more technologically sophisticated partners to begin offering a Books-on-Demand service. In the case of Barnes and Noble and Borders, one vision is that this equipment (which will almost certainly become smaller, cheaper, and faster) could eventually be installed in individual bookstores.

As a correspondent for Reuters put it, "In the time it takes to drink a cup of bookstore cappuccino, customers can order a single volume and then have it in their hands, fresh from an in-store printer and binder, at the publisher's list price." This is no longer fantasy. Majors—a bookstore in Houston that specializes in scientific texts—began offering just such an in-store Books-on-Demand service in March 2000. Borders will be working with the same equipment to produce books at the point of sale.

Two points seem noteworthy in terms of museum publishing. First, the Books-on-Demand concept is evolving beyond out-of-print or hard-to-find books—the University Microfilms model—to include books never in print in the first place. Worthy books that might never command enough of a market to be publishable by conventional ink-on-paper means might nevertheless be published this way. For most museums, that would have to be a plus.

The Books-on-Demand concept is also attractive because of the savings it might offer in both space and expense. With a Books-on-Demand printing and binding kiosk installed on its premises, an organization—museum or otherwise—ought be able to recapture much of the space now used to store its book inventory. Beyond that, it should be able to save some of the costs of carrying that inventory, not to mention the dollars it wastes just carting that inventory back and forth between the printer, the warehouse, and the point of sale. The biggest saving of all might come from not having to print and ship more copies of a book than are needed. By one estimate, 30 to 40 percent of all books printed are never sold. Inevitably, part of the cost of producing and handling those unsold copies must be reflected in the price charged for the 60 to 70 percent that are sold.

Even those savings may appear insignificant next to the emerging technology of e-books and the handheld electronic devices through which they can be accessed. As defined by the American Council of Learned Societies—working under a $3-million Mellon Foundation grant to sponsor high-quality electronic monographs in the field of history—an e-book is "a text or text-and-image based publication in digital, i.e., computer-

generated, presented and readable form." Beyond their accessibility in electronic form, e-books also differ from conventional books by their internal searchability and by their capacity to be electronically linked to other sites.

The e-book is already here. Not quite yet here, though, is the ideal e-book reader: a lightweight, handheld device available at modest cost that would provide a text image virtually indistinguishable in size, color, clarity, and texture from a printed page; that would permit readers to scribble freely in the margin and underline key words and sentences; that could tolerate dog-earing and other traditional book abuse; and that would—finally—have the physical rigor to withstand what somebody once called the "three critical Bs of book reading": bed, beach, and bath. Detractors of the e-book question whether such a device can ever be produced. Enthusiasts think it only a matter of years, or perhaps even months.

Meanwhile, an extraordinary amount of consolidation, positioning, and maneuvering is under way. The first two dedicated electronic e-book readers to attract widespread attention—SoftBook and Rocket e-Book—came on the market in 1998. In separate transactions in January 2000, both were acquired by Gemstar International Group, the West Coast licensor of electronic program guide services to television networks. Emerging rapidly as Gemstar's chief competitor for the dedicated reader market is Microsoft, which introduced its new ClearType display technology in early 2000. Competing with both Gemstar and Microsoft are the makers of such personal digital assistants as the Palm Pilot, devices that have the capacity to download and display e-book texts.

On the supply side, Gemstar and Microsoft are both pursuing arrangements with publishers to give them access—sometimes exclusive, more often not—to print materials on their backlists, their current lists, and their future lists. Meanwhile, looking for greater distribution, Microsoft has concluded a contract with Barnes and Noble to set up an e-book superstore that will feature titles to be read on the Microsoft reader. Gemstar has entered into what it calls a "strategic alliance" with Thompson Multimedia to pursue the digital electronic book market worldwide.

For the consumer, among the most striking aspects of these dedicated E-book readers is their capacity. Softbook has an extended memory that can store some one hundred thousand pages of text—the equivalent of 250 books at an average of four hundred pages each. Consider the advantage of such capacity to a long-distance airline traveler, a guidebook-addicted tourist, or even a college student temporarily out of reach of a library.

E-books are also flexible, portable, and practical. The reader can change font size with the push of a button, converting text easily to a large-type format. The Rocket e-Book weighs in at 22 ounces (616 grams), and an upcoming new model will come in at less than a pound (less than half a kilogram). Advanced battery technology will permit some of these readers to operate for as long as thirty-five consecutive hours without the need for a recharge. As a final convenience, e-books can be downloaded to these readers directly from the Internet in less than three minutes per volume.

The e-book offers unprecedented creativity to its makers. It can incorporate not only still images but also moving ones—and even audio—directly into a text, and it provides the possibility of links to other sources. A book about discus throwing could include not only film clips of athletes in action but also links to relevant publications about the Olympics and to books on physiology. A book about Beethoven could include audible music, not just printed notation, together with links to historical materials about nineteenth-century Vienna. Just as many of the earliest motion pictures were little more than filmed versions of stage plays, the earliest e-books may be little more than electronic versions of printed publications. Assuming that the e-book may in time develop as an independent medium of expression, its possibilities seem unlimited.

Still, unlimited convenience and unlimited creativity are not the full story. The e-book's biggest impact might actually be economic. We saw earlier the potential space and cost savings offered by Books-on-Demand. The e-book does these one better. Beyond getting rid of the cost of printing books that will never sell, and gaining the savings in warehouse, shipping, and distribution costs, the e-book—by releasing the text entirely from its enslavement to a paper support—eliminates in a single stroke one of the major costs of publishing, the cost of endlessly moving piles of paper from one publishing player to another. Assuming that e-book readers can be further improved—and assuming that a pervasive nostalgia for old-fashioned ink-on-paper publishing can be overcome (which may not be so easy as it sounds)—the e-book might well become the dominant publishing form in the twenty-first century.

E-books deal primarily with texts that are authoritative and fixed. What about books with changing texts—such reference works as manuals, encyclopedias, or dictionaries? Here we come to our final instance of dematerialization: the possibility that in some circumstances a Web site might be a more than fully adequate substitute for any kind of a book: ink-on-paper,

a Book-on-Demand, or even an e-book. To begin with a nonmuseum example, *Harrison's Principles of Internal Medicine* is one of the most widely used and respected medical texts in the world. In 1998 McGraw-Hill published the fourteenth edition of this work. In its printed form, it was 2,784 pages bound into either one or two volumes. Alternately, it was available as a CD-ROM, and now *Harrison's Principles* is also available on-line. Not only is the on-line version updated daily, but it is also fully searchable, includes updated therapies, provides links to other relevant research and publications, and provides space for comment and discussion by users. It costs the individual practitioner $89 per year, approximately half the hard-copy cost on a one-time basis.

Assume for a moment that no fifteenth edition of *Harrison's* should ever appear—that, rather than bumping it awkwardly forward every three or four years in a revised print version, McGraw-Hill abandons the notion of the periodic "edition" altogether and lets it live on as a continually updated Web site instead. As that fourteenth and last printed edition from 1998 slowly sinks into obsolescence, who would ultimately stand to lose, who to gain? Among the biggest losers, of course, would be all of those business entities that revolve around the physical rather than intellectual aspects of publishing: the papermakers, the printers, the warehousers, the shippers, the distributors and—this time somebody else—the retailers. Not necessarily economic losers but possibly unhappy as well might be the historians and archivists deprived of any single, fixed, and authoritative version of *Harrison's* to which to refer or which to safeguard. Librarians might also have the disquieting sense that the preservation of this text—and of its integrity as well—was out of their hands and that it could be altered or even obliterated by forces beyond their control.

But consider who might gain. The publisher could have radically reduced production and distribution costs. The doctor might have access to far more, and far more up-to-date, information. Perhaps most important, the quality of care available to the doctor's patients might be enhanced. Ask yourself honestly: Even taking into account all those gloomily predicted glitches that can bollix up any technological scenario—yes, there could be power outages; yes, the computer could crash; yes, some madman might blow up the server; and yes, some hacker could break into the site and corrupt its contents—wouldn't you rather, everything else being equal, be treated by a physician working with up-to-date medical information than by one whose information was already a few years old?

If that example seems too dramatic, let's ratchet down to something less fraught: fund-raising. Here, the publication in question is *The Foundation Directory*—one of the standard reference works used by virtually every development office in the United States. Comparable in heft with *Harrison's*—its 2000 edition runs to 2,640 pages and lists some ten thousand foundations with detailed information about their grants—the directory announced that an advanced on-line version would be unveiled in the summer of 2000. The on-line version has many advantages: It will be updated quarterly; it will be searchable in ways that are simply impractical in the print version; it will have direct links to some six hundred foundation Web sites; and—for the economy-minded—it offers the option of a monthly lease ($19.95 in the plain version, $29.95 in the advanced) for those who only need it intermittently. The question once more: If your development office raises any significant funds for your publications program, then—again, the possibility of technical glitches notwithstanding—wouldn't you prefer that office to have access to the most, and the most up-to-date, information possible?

Many museums are already using the Web as a means to introduce themselves to the public and to show a sampling of their collections. Some—the Canadian Museum of Civilization here in Ottawa, for one—have gone further and constructed virtual museums on the Web. These continually updatable Web sites suggest another potential use of the Web by museums: a site for their collection catalogs. Some museums—see, for example, the Tate Gallery's recently revamped Web site—already seem headed in this direction. The logic seems compelling. Printed catalogs have always suffered from the same weakness as the print versions of *Harrison's* and *The Foundation Directory:* notwithstanding the enormous effort invested in their production, they are generally out of date before the ink dries on the first copy off the press.

Substituting an on-line format would allow tremendous improvements. New acquisitions could be incorporated immediately, exhibition histories could be kept current, and additional provenance information could be added as it became available. Scholarly references could be kept up to date, and, immeasurably enhancing the usefulness of these catalogs to students and scholars alike, links to other sites could make the full texts of those references immediately available.

Whether these on-line applications are simply a fantasy or whether they might make eminently hard-headed sense may depend on the numbers. Certainly, the cost savings in some areas could be substantial: savings on

travel, paper, printing, storage, shipping, and distribution. Whether those savings would be substantial enough to cover the costs of establishing and maintaining this part of a larger museum Web site is not certain. Also unclear is the revenue side: At this still-early stage of the Internet's development, what kind of a business or other model might work best with respect to such an on-line catalog? Intertwined here, with such practical matters as money and copyright, are policy questions as well, particularly with regard to encryption. As rapidly evolving systems of encryption offer Web-site owners an ever greater degree of control over the ways their sites can be used, museums will have to determine whether, and if so to what extent, they can or should—consistent with their public-service role—use that technology to regulate access to information about their collections.

To a great extent these questions—and questions about Books-on-Demand and e-books as well—are all likely to be questions for the future. To begin with, museums are notoriously risk averse and are not likely be among the earliest adaptors of these new technologies. Second, many of these new technologies have yet to extend themselves to four-color reproduction—a staple of many museum publications. Although they undoubtedly will offer that eventually, the focus of their developers is presently elsewhere. And finally, some of the means by which museum publications are distributed are different from those of the larger publishing world. Nevertheless, those who work in museum publishing might do well to be taking a harder look at this ongoing dematerialization of the ink-on-paper book and to consider what it might mean for them. In my own view—reflected perhaps by the suggestion with which I began, that this might truly be an appropriate moment for bliss—this revolution poses for those in museum publishing very little in the way of risk and a great deal in the way of opportunity.

As former Random House editor Jason Epstein has pointed out (*New York Review of Books,* April 2000), these new technologies may change many of the mechanical ways that books are produced and distributed but they will not, in the end, change the basic ways they come into being. "The decision to accept or reject a manuscript," he writes, "the strategies of revision and publicity, the choice of art work and typography when a satisfactory manuscript is finally produced, the emotional and financial support of authors: this can only be done by human beings endowed with the peculiar qualifies that a successful publisher or editor needs, no matter how the technological environment transforms the rest of the publishing process."

If technology per se does not pose a threat to museum publishing—editorial, design, and marketing skills being no less necessary in an electronic setting than in ink-and-paper—those in museum publishing should be aware of at least one related pitfall. The danger is that when electronic publishing does finally emerge in the museum, it may become a source of contestation with electronic information specialists and/or others attempting to claim it as rightfully a part of their own turf.

In a fascinating paper delivered at the first "Museums and the Web" international conference, held in Los Angeles in March 1997, Stephen Alsford of the Canadian Museum of Civilization traced the development of that museum's extraordinarily wide-ranging Web site. Posing to himself the question "Whose baby is it?" he reflected on the potential for infighting among the museum's traditional departments over the control of the site and warned of what he called the "risk . . . that any given department . . . may impose on the Web project the local paradigm governing its own operations." Critical to understand, he said, was that the Web site "is not a book, not a magazine, not an exhibition, not a database, not a media kit." Whose baby, then, did he think it should be? Unless a museum had deep enough pockets to establish a new department to maintain its Web site, then—as was the case in his own museum—he suggested that it be run as a special project out of the director's office.

Whether or not you accept Alsford's view with respect to Web sites, the question remains as to whether the rest of electronic publishing should be dealt with in some parallel fashion. I would answer that it should not, that the situation is not the same. Arguably, a Web site is a new medium—one that is still in its earliest stages of exploration and development. As such, it might best be mastered by individuals who come to it fresh and without the baggage of other creative media. Not so with electronic publishing. The underlying qualities that make for a good printed book are the same qualities that will make for a good e-book, even if the e-book should prove to be the more useful book with its built-in capacity to search and link. Museum publishing people will have to learn additional skills, but those skills must be grafted onto that solid core of expertise that museum publishing has been accumulating over the past several decades.

Which brings me to my final point: training. Assuming that these technologies will play an ever-increasing role in museum publishing, then those who now work in that field will most certainly need appropriate training to make the best use of those technologies—indeed, I think they are entitled

to it. The responsibilities are joint. Employees must be prepared to invest the effort required to upgrade their skills, and employers, in turn, must be prepared to give them the necessary time and the financial assistance. In the view of many—a view reflected in the Code of Professional Ethics of the International Council of Museums—employers have an ethical obligation to provide their employees with opportunities for professional development. Not to do so is to waste—and to waste in the most irresponsible manner imaginable—the capacities of those employees. In this new, twenty-first-century working environment, employees—even museum employees—have a right not to be drained of their usefulness, then crumpled up and thrown away. In that context, training is a necessary prophylactic, not a discretionary frill.

This, then, is an invitation to enjoy a triple and revolutionary bliss. First, to savor the excitement of working in museums at a time when they have so essentially changed their focus, from static and inward to dynamic and outward; second, to be working in museums at a time when—consonant with that new focus—they are beginning to explore so many promising and innovative partnerships with a broad range of like-minded institutions; and third and finally, to be engaged in an area of museum work that will see—perhaps far more than in any other—so many dramatic changes over the next few years. Beyond mere bliss, it might indeed—as Wordsworth said so ringingly—be "very heaven."

If Content Is Out, Aesthetics Must Be In

When Curtis Carter asked me to join the meeting of the American Society of Aesthetics in Washington, D.C., in October 1999, it was neither as a philosopher nor as an aesthetician. It was, rather, as somebody with two decades and more of experience in Washington on that gritty and frequently contentious border where government and the visual arts encounter one another. Wearing two hats—first, that of a sometime attorney with a long and ongoing interest in the legal aspects of the museum and visual-arts worlds, and second, that of a former federal museum official (I was deputy director of the Smithsonian's Hirshhorn Museum and Sculpture Garden from its opening in 1974 until my retirement in 1995)—I want to describe some of the battles fought along that border. In connection with the Hirshhorn Museum, I will also explore the aesthetic stance that we eventually came to take in fighting those battles.

In a less contentious setting, works of art might be regarded as indivisible wholes in which what they depict and how that *what* is depicted are inextricably fused. Consider, for example, this description of Caravaggio's *The Taking of Christ* by the University of Chicago's Ingrid Rowland: "Caravaggio

This text was delivered at the annual meeting of the American Society for Aesthetics, held in Washington, D.C., in October 1999.

also conveys [Jesus'] obedience by showing how [he] sways with the crush of the people moving in on him from the painting's right, a rush that reaches its climax in the screaming, fleeing disciple on the left. . . . Jesus sways, but he also stand his ground amid the knot of grasping hands, the cloying intimacy of Judas' kiss, and his beloved disciple's panicked desertion; the victim of this drama is also its strongest character."

In a governmental context, though, works of art are invariably regarded as containing two entirely separate and readily severable elements: an amalgam of subject matter and point of view that might, in shorthand, be called "content," and something consisting of everything else that might—also in shorthand—be called "artistic quality." Although "artistic quality" may frequently include aesthetic merit as one of its components, the term as it is generally used is far broader. It also takes into account such characteristics as originality, authenticity, and condition. Moreover, many works of visual art—works of the twentieth century in particular—may be described as having a positive artistic quality although the artist's intentions were fundamentally anti-aesthetic.

This distinction between content and artistic quality is particularly important in situations that involve the First Amendment's prohibition of governmental interference with the right of free speech. Not widely recognized is how recently the visual arts have, for constitutional purposes, been considered to be a form of speech. It is only since the 1960s that a string of federal court decisions made it clear that "speech"—as used in the Constitution—is not limited to forms of verbal expression but can also be applied to such nonverbal and even potentially abstract forms of expression as dance, music, and the visual arts. For the visual arts, two areas of continuing legal concern in which the First Amendment plays a significant role are obscenity and government funding.

Regarding the former, the Supreme Court has consistently held obscenity to be an exception to the First Amendment's otherwise prevailing regime of free speech. Accordingly, in the absence of such constitutional protection, obscenity may be subject to regulation at the federal, state, and local levels. Nested within that exception, however, is another exception—a counterexception. It provides that speech that might, on the basis of its content, otherwise be deemed obscene cannot be so classified if it also possesses some degree of artistic value, that is, artistic quality.

The definition of "obscenity" in use throughout our judicial system was first formulated by the Supreme Court, ruling in 1973 on a cluster of five

cases generally referred to as the "Miller Quintuplets" in refrence to the first of these, *Miller v. California*. In *Miller,* the Court prescribed a three-part test to determine whether a work of art was obscene. The first two parts dealt with content. First, whether the average person, applying contemporary community standards, would find that the work, taken as a whole, appeals to prurient interest; and, second, whether the work depicted or described, in a patently offensive way, sexual conduct as specifically defined by the applicable state or local law.

Completely different—in fact, startlingly so—was the third part of this test. It asked whether the work, taken as a whole, lacked serious literary, artistic, political, or scientific value. Absent such value—but only absent such value—it might be declared obscene. Particularly to be noted here is the difference between the first part of this definition, with its community standard—a standard that might conceivably vary from one locality to another—and the third part, with its suggestion that, in contrast, artistic value is a universal constant. In the Supreme Court's formulation, artistic value is a fact about a work of art, a fact as susceptible to proof as might be any other fact concerning, for example, its length or weight or location.

What follows then is that—in this obscenity context—the question of whether a work of art possesses artistic value is not one of law, which a court might itself decide, but one of fact, to be decided by the trier of facts, most typically by a jury. No clearer and certainly no more dramatic example of how such fact-finding might work in practice could be provided than the 1990 obscenity trial of Dennis Barrie. Barrie, the director of the Contemporary Arts Center in Cincinnati, was indicted on criminal charges in connection with the display at the Arts Center of a touring exhibition of Robert Mapplethorpe's photographs organized by the University of Pennsylvania's Janet Kardon under the title *The Perfect Moment.*

Although *The Perfect Moment* included some of Mapplethorpe's most notorious sadomasochistic images, Kardon's catalog—written long before any legal action became a threat—made clear that her own interest in those and other images was in their formal artistic qualities, not in whatever content they might convey. She describes Mapplethorpe's models as "stultified by symmetrical, frontal, canonical poses, and removed from real life by dramatic light of high contrast." Rather than realistic depictions of actual situations, his scenes, she writes, "appear to be distilled from real life; when elevated to an unnatural innocence, they create a frisson between the li-

centious subject of the photograph and its formal qualities that purifies, even cancels, the prurient elements."

Called as a witness at the trial, Kardon reiterated the nature of her interest. She testified that she had chosen to do a Mapplethorpe exhibition because she thought him to be the most important artist then working in a formalist manner. Pressed in court to define what a "formalist" was, she said it was one "who makes . . . subject [matter] secondary to a particular vision in the mind, and makes composition and light and form and color, if that's appropriate, the primary expressive devices of the photograph." When the defendant, Barrie himself, was questioned on the witness stand about certain images in the exhibition, his responses also adhered to this rigorous formalist line:

> PROSECUTING ATTORNEY: This is a photograph of a man with a finger inserted in his rectum, what is the artistic content of that?
> DENNIS BARRIE: It's a striking photograph in terms of light and composition.

In the end, after only two hours of deliberation, the eight-person jury acquitted Barrie on the grounds that the prosecution had failed to meet the third part of the *Miller* definitional test: to show that Mapplethorpe's photographic images lacked serious artistic value. Although their backgrounds were far removed from the fine arts, the jurors had been readily able to grasp the notion that a distinction could be made between the repugnance they felt over the content of Mapplethorpe's photographs and the "serious artistic value" with which those photographs had been imbued.

In the case of governmental funding for the arts, the First Amendment's free speech provision comes into play in a different manner. Its impact is not so much on what art the government may choose to fund as it is on what art the government may choose not to fund, and why. Illustrative is the fracas in which Mayor Rudolph Giuliani of New York City withdrew city funding from the Brooklyn Museum because the museum refused to take down a painting the content of which the mayor found offensive. The city of New York is not, as the mayor forcefully pointed out, under any obligation at all to fund museums that are resident there. Depending upon the basis used to make its choices, the city might also choose to fund some of those museums but not others. But what—as a governmental entity—it cannot do,

the Brooklyn Museum argued, is to choose which museums it will or will not fund based on the content of the art that they hang on their walls. Underpinning the Brooklyn Museum's argument is the relatively little known concept of "unconstitutional conditions."

At the heart of that concept is the assertion that government—acting in the role of patron—cannot bring about a particular result that the Constitution would have forbidden it from bringing about when it is acting in its role of policeman. As phrased by a leading commentator in this field— Kathleen M. Sullivan, formerly of the Harvard Law School and now at Stanford—"In a free society, the government may no more purchase orthodoxy by power of the purse than compel it by power of the sword. . . . [G]overnment may not grant benefits such as money, space or jobs in exchange for the surrender of constitutionally protected expression, even if the recipient was free to go elsewhere, and the government was free never to have offered the benefit at all."

At the federal level, this question of whether government—specifically the National Endowment for the Arts—might take content into account in making grants or whether it must confine itself wholly to artistic quality as a criterion was central to the case of the "NEA Four." As the endowment was coming to birth in 1965, it was clear from the outset that the grant applications it could be expected to receive would far exceed the funds that it would have available and that some basic standard would be required by which it could choose between these competing applications. As set forth in the 1965 report of the Senate Labor and Public Welfare Committee, which shaped the endowment's establishing legislation, that standard was to be artistic excellence. Acknowledging that evaluations in terms of such a seemingly abstract and subjective standard would necessarily vary, the Senate committee believed that such a standard was nevertheless "sufficiently identifiable to serve the broad purposes of the act." Similar references to "excellence" appeared throughout the legislation itself and continued to appear in the various reports that the NEA submitted to the Congress during its first twenty-five years.

In 1990, however, following the Robert Mapplethorpe controversy and others (the Mapplethorpe exhibition for which Dennis Barrie was indicted had been funded by the Arts Endowment), that standard was temporarily modified. In appropriating the NEA's annual budget for fiscal year 1991, Congress added language specifying that, in addition to using "artistic excellence" as its criterion for decision making, the agency was also to take

"into consideration general standards of decency and respect for the diverse beliefs and values of the American public." Shortly thereafter a group of artists—Karen Finley, John Fleck, Holly Hughes, and Tim Miller, thereafter to be known as the "NEA Four"—commenced a lawsuit in which they claimed that this qualifying language constituted an unconstitutional condition and violated their First Amendment free-speech rights.

After an eight-year journey through the federal courts, where they were successful at both the district and circuit court levels, the NEA Four were finally rebuffed by a June 1998 decision of the U.S. Supreme Court. With only Justice David Souter dissenting, the Supreme Court reversed the lower courts and held the decency provision not to be unconstitutional, at least on its face. In part, this was through something of a weasel: Writing for the majority, Justice Sandra Day O'Connor stressed that the language in question only required that "decency and respect" be "taken into account"—it did not mandate that those standards be considered dispositive. Concerning the question of unconstitutional conditions, four of the justices apparently agreed with Justice O'Connor's argument that Congress might have more latitude—the case leaves unanswered just how much more—in deciding what it will support than in deciding what it will regulate. Clearly, though, Congress could no more vote to pay a fifty-dollar bonus to all registered Republicans than it could vote to impose a fifty-dollar fine on all registered Democrats. Nor is it likely that Justice O'Connor's language could be stretched so far as to cover Mayor Giuliani's assault on content he finds offensive.

Compounding the Brooklyn Museum's argument is the fact that the painting at which the mayor took offense is one depicting the Virgin Mary. Beyond the fact that blasphemy—unlike obscenity—is a protected form of speech, still another provision of the First Amendment may be applicable: the clause that provides that "Congress shall make no law respecting an establishment of religion." In *Lynch v. Donnelly*—the only instance where the Supreme Court dealt with how this provision might apply to the display of religious art at government expense—the content–artistic quality distinction was again called into play. In a 1984 decision, the Court held by a 5 to 4 margin that the city of Pawtucket, Rhode Island, had not violated the First Amendment's ban on the establishment of religion by erecting a Christmas crèche on the grounds of its city hall. Writing for the majority, Chief Justice Warren Burger argued that the separation between church and state in this country was in no way as complete as the plaintiffs claimed it to be.

In support of that argument, he referred to the "more than two hundred" paintings on exhibit in the National Gallery of Art in Washington, D.C.—an institution maintained, he noted, with government support—depicting the "Birth of Christ, the Crucifixion, and the Resurrection, among many other [subjects] with explicit Christian themes and messages."

In his dissent, Justice William Brennan neatly skewered this suggested analogy between the exhibition of art in a museum and the lawn display in Pawtucket. A more appropriate analogy to the museum setting, he said, would be the college classroom. In such a setting, the emphasis in studying religiously inspired materials—for example, Milton's *Paradise Lost* or a Gothic cathedral—might not be at all on "the religious beliefs which [they] exalt, but rather upon the 'aesthetic consequences'" that those beliefs may have engendered. As true of Raphael's *Alba Madonna* as of Milton's *Paradise Lost,* what justifies their presence in a governmentally sponsored institution is that they can be appreciated "primarily for [a]esthetic or historical reasons," not principally for religious ones. Notwithstanding Professor Rowland's gloss on Caravaggio's *The Taking of Christ* as a unified whole, if that painting should ever come to Washington on loan to our National Gallery, we can be assured that the Supreme Court, at least, would be able to separate its content from its artistic excellence and permit it to hang in the gallery on that latter basis alone.

Now to put on my museum hat, I knew scarcely a single season during my twenty-one years at the Hirshhorn when we were not engaged in some controversy—most minor, a few more serious—concerning the appropriateness of one or another particular work of art for acquisition by, and/or public display in, a taxpayer-funded institution. Almost invariably artistic quality would be the grounds on which we chose to fight these controversies. Frequently cited in the voluminous correspondence that these controversies generated was what Alfred H. Barr Jr. had many years earlier prescribed as the principal task of New York's Museum of Modern Art: "The conscientious, continuous, resolute distinction of quality from mediocrity." Generally coupled with this was the assertion that the Hirshhorn Museum's professional staff was better qualified to hold opinions on matters of artistic quality than was the other party to the controversy.

The contexts in which this argument would play out were amazingly diverse. In one memorable incident, the museum was under a routine investigation by the Smithsonian's Office of the Inspector General—a modern-day analogue to the Spanish Inquisition—to determine whether there had

been any waste, fraud, or abuse in its purchases of art works. Things began badly when we answered his initial question—"How do you know that you're paying the right price for a work of art?"—with "There is no right price. There's only a price, take it or leave it." Art, we went on to explain, was not like a manufactured product, priced on the basis of its production cost and/or utility. It was like a commodity, priced by the interplay of supply and demand. After some weeks of this, and considerable research, the IG finally conceded that the works of some artists appeared to be in greater demand than those of others and that they might, accordingly, command higher prices. At that point, though, everything derailed.

Within a very short period, the Hirshhorn had both sold a painting by the artist Clyfford Still at auction in New York and purchased another work by the same artist from a commercial art dealer. Both paintings were of the same year, of approximately the same size, and painted in Still's characteristically spiky abstract style. The difference was that the one we bought cost four times what we got for the one we sold. The IG was incredulous, convinced that something improper had occurred. Not at all, we tried to assure him; the difference was in their relative quality. The one we had purchased was, by a wide margin, a far superior painting. In the end, after more weeks and more research, he came to agree: first, that the presence or absence of some innate characteristic or set of characteristics encapsulated in the word "quality" was an appropriate justification for the expenditure of public funds, and second, that the museum's staff was an appropriate group to judge whether and in what degree such "quality" subsisted in a particular work of art.

With one difference, comparable scenarios were played out with museum visitors who took exception to various works of art on display in the galleries. The difference—and here the content–artistic quality distinction comes back into play—was that it was not the price but the ostensible content of these works that the visitors found offensive. The painter Larry Rivers was a multiple offender. His free rendition of Jacques-Louis David's full-length portrait of Napoleon—which Rivers titled *The Greatest Homosexual*—aroused expressions of pain at the French Embassy. One diplomat called it an insult. The Soviet Embassy, in its turn, expressed indignation over Rivers's massive assemblage *The Russian Revolution: From Marx to Mayakovsky*. Particularly offensive, it said, was its suggestion that the poet Vladimir Mayakovsky's suicide in 1930 might have been attributable to the repressive policies of the Soviet government.

Another perennial offender was Robert Arnason's glazed ceramic and bronze sculpture *General Nuke*. It consists of the grimacing bust of a three-star general, his sharpened teeth dripping with blood and his nose shaped like a streaking intercontinental ballistic missile, the whole sitting atop a bronze column depicting a maze of charred and entangled corpses. Incised into the general's helmet are such words and phrases as "Fireball," "Armageddon," and "mutually assured destruction." Of the various complaints received about this sculpture, perhaps the most extreme was from a retired military officer who suggested that, by undermining public confidence in the more beneficial aspects of nuclear warfare, the Hirshhorn was serving as either a witting or unwitting tool of the USSR.

No written complaint went unanswered. Over and over again, we would patiently explain that we were an art museum, that our primary interest was in the artistic excellence and/or originality of the works we displayed, and that whatever content the artist might have incorporated into those was, from our very special point of view, a matter of indifference. As the person primarily responsible for framing these responses, I was repeatedly confronted by the question of just how this artistic excellence—by no means self-evident to the person who raised the question—could be recognized.

The answer that eventually evolved was that such recognition came through a consensus of informed opinion over time. Each word of that formulation was carefully selected and each one counted. A "consensus," not a "unanimity," so that the argument could not be undercut by producing somebody, somewhere, who did not agree. Not just any opinion, but an "informed" opinion, which provided maximum flexibility in determining whose opinions might be taken into account and whose might be ignored. "Opinion" was a trickier word. It was not meant to suggest that the determination of excellence was in any way subjective, but that—like the defense of mental illness in a criminal trial—it was a fact that might require the testimony of an expert witness in order to be fully understood. Finally, saying that it was only "over time" that these informed opinions mattered provided us the opportunity to invoke Vincent Van Gogh or the Armory Show or whatever other instances we could offer of widely acclaimed art that was not appreciated when first shown.

To this last thought, we sometimes appended Albert Elsen's observation that one of the indicators of quality in a work was its "aesthetic durability," that such a work did not quickly wear out what he called "its intellectual and emotional welcome." Implicit here as well—and here are echoes of the

charge to the jury in the Mapplethorpe case—was the notion that the excellence perceived by the holders of these informed opinions was in no way something of their own construction. It was, rather, a fact—an actual, real, and palpable characteristic of these works of art, a fact available to be discovered by any properly informed observer.

Now retired and looking back at those old controversies at the Hirshhorn, I think that what gradually emerged as a workable theory was something remarkably close to art historian Lorenz Eitner's position that artistic quality is universal and absolute, that it "resides in the object and endures as long as its physical substance." Whatever the temptation to think Eitner's position simplistic, a reminder is in order: Washington is at bottom a political city, a city in which—of necessity—complex issues are frequently framed in large and readily understood terms. Every letter the Hirshhorn sent to a disgruntled visitor was potentially a letter to the staff of that visitor's congressman or -woman or senator as well. With such Capitol Hill staffers as our real audience, subtlety and nuance were not refinements that we could readily afford.

In managing what was, in effect, the nation's official museum of contemporary art, one of our primary objectives was to provide the public with the widest possible access to the work of contemporary artists. To defend that access against the incursions periodically threatened by Congress or by one or another part of the bureaucracy, what was needed was a robust and straightforward theory of excellence that could withstand the rough and tumble encounters of this most contentious city. How well or how poorly such a theory might also withstand a rigorous academic scrutiny was really beside the point. What proved indispensable in the end was this combination of, first, that same distinction between content and artistic quality already described in the legal context; second, a wholly objective theory, untainted by even a hint of relativism, as to what might constitute such artistic excellence; and third, the successful assertion that the museum's staff had—or otherwise had access to—an informed opinion that possessed in ample measure the capacity to recognize that excellence. In combination and over the years, those ideas provided us with a remarkably stable basis on which to wage our battles successfully.

If that adds up to aesthetic pragmatism, make the most of it.

13

The Museum at the End of Time

To: Members of the Staff
 Metropolitan Museum of Life
From: Office of the Director
 Metropolitan Museum of Life

As all of you must be aware by now, it has been established beyond any possible doubt that the universe will cease, abruptly and without a trace, a few seconds after 11:43 P.M. Greenwich mean time on August 16, 2125. At its most recent meeting, the museum's board of trustees asked me to be in touch with various of the museum's stakeholders (including the staff) to solicit their views as to how this impending cessation of the universe might impact the museum's operations during the interim and also to inquire as to what changes in its programming, budget allocations, staffing, and so forth they might think appropriate in the light of this unprecedented situation. Responses may be sent directly to my attention. For the sake of brevity, you may refer to the date of cessation as "C-Day."

Responses to the C-Day Memo

FROM A HISTORY CURATOR: Humankind will never again be the same. As the clock ticks toward its final tock, people, communities, and nations will behave toward one another in entirely unpredictable ways. These

new relationships will be reflected in works of art, architecture, the design of household objects, the content of publications of every kind, and more. I am proposing (a) that we immediately establish *apocalyptica* as a major new collecting category that would cut across all previous departmental boundaries and (b) that we undertake a series of exhibitions to be given at regular intervals (perhaps once a decade through 2100, and at five-year intervals after that) documenting the ways—sometimes somber, sometimes amusing—in which various communities are coping with their anticipated nullification. To provide just a touch of drama, the last of these might be timed to close on C-Day.

FROM THE ASSISTANT DIRECTOR FOR FINANCE AND ADMINISTRATION: Now that the "Big Gnab" theory has finally been verified, I have two principal concerns: the endowment and the impact of end-time inflation. Concerning the endowment, it would clearly be absurd if any of this were left unspent on C-Day. How and when we can get the court's permission to spend the restricted part is something we'll need to consider. Given the freedom to do so, ought we treat it as an annuity and plan to have it run out just as our own time expires? Complicating this is the prospect of an inflation that will certainly rise to ever-more-hyper dimensions as C-Day approaches and the future value of money sinks toward nil. In those final days, what will induce our employees to come to work when their wages are no longer meaningful? The availability of canned food and bottled water might well be the answer. One of the things I hope we can commission somewhere down the line is a computer simulation indicating how and when we might optimally begin to shift parts of the endowment from securities to edibles.

FROM A RECENTLY HIRED AND JUNIOR MEMBER OF THE REGISTRAR'S DEPARTMENT: One of my museum studies classmates argues that registration work will start to slacken off as C-Day gets closer. He says that, in the end, nobody will care. I think that's wrong. If I were here, I would care. Even if the work weren't finished until the very afternoon of C-Day, I'd want to know that there's not a single object in this collection that hasn't been properly measured, photographed, and cataloged. It's a matter of duty. If something's the right thing to do, it's the right thing to do no matter what the circumstances. I hope that you and your suc-

cessors will agree and maintain a fully staffed registrar's department right up to the very last minute.

FROM THE CURATOR OF FILM AND VIDEO: Being a frustrated artist myself, I can envision exactly what I'd like to have on view in our new video gallery if I were still to be around when toodle-oo time comes along. What I see is a huge, floor-to-ceiling globe with the world's twenty-four time zones clearly marked. Inside each time zone, a television monitor would be mounted. Displayed on each of these twenty-four monitors would be real-time images televised in each case from the pertinent time zone. These would be selected so that adjacent monitors showed contrasting images of tumultuous urban life and placid natural beauty. As the countdown to C-Day nears its end, and as the constraints of civilized behavior begin first to loosen and then finally to fall away entirely, the juxtapositions and multiple ironies would be remarkable. Imagine images of Shanghai in the throes of a Saturnalian revelry, played off against images of the Pacific's steady roll as it heaves itself westward. Think of a bacchanalian festival sweeping through the streets of Buenos Aires, while the next monitor over shows images of the Andes in all their cold, unearthly beauty; orgiastic London, and the night-shadowed fjords of Norway; San Francisco, and the imperturbable Rockies. As humankind hurtles back toward a state of nature, mute nature itself will be blindly marching down the path to its own oblivion. All right there on the screen, all right here in the museum. Oh, how I would like to live long enough to see it. I greatly envy my remote successor, who most likely will.

FROM THE HEAD OF SECURITY: People are motivated to obey the law primarily by their fear of the consequences that may follow from breaking it. As C-Day approaches, the consequences that follow anything will become increasingly unlikely, and we can almost certainly expect to see a gradual increase in crime. This will pose a threat to our collection, our visitors, and our building. Although we would normally plan to counter this threat with a corresponding increase in the size of our guard force, the approach of C-Day may also prove to be a disincentive to work. If our collection, visitors, and building are to be properly protected until the end, priority must be given to the acquisition and development of a fully automated security system that would not only apprehend potential perpetra-

tors but might actually put them on trial and, if it found them to be guilty, carry out their sentences as well.

FROM THE DEPUTY ASSISTANT DIRECTOR FOR FINANCE AND ADMINISTRATION: If the museum is to make the maximum possible use of its resources, what will be required is a strategic plan pursuant to which those resources can be gradually redeployed from future-focused activities to present-oriented ones, most particularly to public programming. By crunch-time on C-Day, every last vestige of infrastructure should have been phased out. Whatever remaining resources we've still got should (at least ideally) by then have been dedicated to active public use. In terms of space, this will mean converting our various working spaces (the conservation laboratory, the library, the registrar's area, the carpentry and other shops, and ultimately even our executive offices themselves) to gallery and/or special-events spaces. Likewise, collections storage must eventually be converted to open storage. The timing will be tricky. On the one hand, we don't want to terminate vitally important activities prematurely. On the other, it would be important to do this before terminal inflation makes the work prohibitively costly.

FROM THE HEAD OF DEVELOPMENT: Tempting as it may be to concentrate on last things first—to wring our hands and complain that the glass is already half empty—the fact is that C-Day is more than a century and a quarter away. That's a half-full glass if I've ever seen one. Important now is not to brood about how we'll end our days but to exult over what we can be doing in the meanwhile to make them better. Development-wise, I think we can do well—not just well, but very well. How do we turn this oblivion thing to good use?

Well, for instance, since we won't be able to celebrate any anniversaries after the event, why not celebrate them before? I could see a benefit dinner dance to be held every August 16 with a regular recurring theme like "The Last Supper? Not Quite Yet, but Still Counting." If the curators weren't too finicky, a highlight of the evening might be an auction of some things from the collection. The idea would be to get an up-front payment for some future delivery (for example, on C-Day minus ten). In the same vein, since our costume collection no longer has to be preserved indefinitely, why couldn't we rent out some of the more famous items for people to wear to

these events? Ditto the jewelry collection? Samuel Johnson once said that the knowledge that one was shortly to be hanged "concentrates [the] mind wonderfully." Well, if that's so, then the end of the universe should *really* get our creative juices flowing!!!

Assignment

Think about your own museum. Assume the contrary of what was imagined above. Assume that the "Big Gnab" theory has been discredited, and that the universe is *not* going to cease without a trace on August 16, 2125, or at any other time soon. To what extent has your museum articulated a distinct obligation to future generations? To what extent is that obligation explicitly reflected in its day-to-day operations? To what extent is it implicit? Are you satisfied with the extent to which future obligations are reflected in the operation of your museum? If not, what would you change?

14

Collecting Then, Collecting Today

It is astonishing to me to realize how great a gulf has opened up during the past twenty-five years or so between private collecting by individuals and institutional collecting by museums. Private collecting today is pretty much as it has always been. Although every collector has a distinctive style, all of those styles still combine a unique mix of passion, instinct, and impulse, on the one hand, and caution, deliberation, and calculating connoisseurship on the other. In sharp contrast, the nature of institutional collecting has changed almost completely during the years that I've been involved with museums.

Three factors, I think, primarily account for that change: First, it was only since the 1960s and with the introduction of more modern management methods that museums began to recognize the exponential rate at which their collections were tending to grow and the enormous economic burden represented by those collections, at least to the extent that they included indiscriminately acquired objects in quantities vastly greater than the institutions responsible for their care might ever conceivably use. Second, during this same period, the legal rules applicable to a variety of objects—

This text was delivered at the conference "Collecting the Twentieth Century—Tiffany to Pokemon," held in Cooperstown, New York, in October 2000 and cosponsored by the Cooperstown Graduate Program and the Cooperstown Graduate Association in cooperation with the New York State Historical Association.

particularly objects of foreign origin—proliferated enormously. Virtually all of these new rules had the effect of limiting the lawful import of such objects into the United States. Third, and most important, the very nature of museums themselves underwent an almost complete transformation, in which their focus changed from an inward concentration on their collections to a newly articulated outward concentration on the various publics and communities that they served.

Perhaps the earliest systematic effort to calculate the rate at which museum collections tend to grow was a study in the mid-1970s at the Smithsonian's dozen-plus museums. Although not definitive, it did suggest an average growth rate of between 1 and 2 percent annually. Offering some confirmation of that figure was a subsequent study of sixty-one British museums conducted by Gail and Barry Lord and their associate John Nicks (*The Cost of Collecting*) in 1988–1989. Their average figure was about the same: 1.5 percent.

Although 1.5 percent may sound like a relatively benign figure, it becomes less so when calculated as a compound rate, meaning that a collection's size could double every fifty years and increase fourfold over a century, and considering that the expense of storing, guarding, and caring for collections, in the aggregate and over time, comes to a great deal more than even the most sophisticated of museum workers generally realize.

The pioneering work on collection-storage costs was done by the architect George Hartman of the Washington-based firm Hartman-Cox. In 1983, building on some work done several years earlier at the Institute of Archaeology and Anthropology at the University of South Carolina, Hartman developed a series of formulas that sought to take into account the "specific costs of such elements as accessioning, cataloguing, periodic inventory, maintaining accessible records, environmental and pest control, storage hardware, security, conservation, insurance, and general overhead including management and building expense."

In its May–June 1988 issue, *Museum News* applied Hartman's formulas to a hypothetical 100,000-square-foot (9,000-square-meter) museum building with an annual operating budget of $3 million. The results were startling. The annual operating cost allocable to an object kept in storage came—in 1988 dollars—to $30 per square foot (78 square centimeters). Hartman's numbers indicated that the average stored museum object—an average made up of coins, locomotives, beetles, and elephants—required not just 1 but 2 square feet (1.5 square meters) of storage, so the total cost

per object was $60 per year. Using the consumer price index to adjust for the intervening inflation, that would translate into slightly more than $86 per object per year in today's dollars. For a stored collection of 1,000 objects, you might be looking at $86,000 of annual expense attributable to storage; for 10,000 objects, $860,000. From 11,600 objects upward, the annual cost of storage can average $1 million or more. Note, too, that those are only operating expenses and don't take into account the original capital expended to construct such storage in the first place.

Using a different methodology, the Lord and Nicks study arrived at a similar cost for British museums. They also found that close to two-thirds of all museum operating expenses were attributable directly or indirectly to the cost of managing and caring for collections, those on public display as well as those maintained in storage.

What has been the impact as museums have come to a better understanding of those numbers? In some instances, institutions have responded by becoming far more selective about what they will acquire, particularly as gifts. In others they have even resolved not to accept gifts—especially gifts of large groups of objects—unless such gifts are accompanied by sufficient funds to endow their future care. Finally, in some museums—primarily in the United States, not in Europe—systematic deaccessioning programs have been established as a routine aspect of collections management. Many feel that collections, no less than forests or herds of elk, can benefit from periodic thinning. For most institutional collectors, whatever their approach, collecting has become a far more deliberate and purposive activity than it was in the past.

Compounding this new deliberateness are many of the changes in the legal—and also the ethical—climate in which museums operate. The most dramatic of these relate to objects originating in other countries. Until the early 1970s, the prevailing rule in American law had been that it was not illegal per se to import an object into the United States solely because it had been illegally exported either from its country of origin or some intermediate jurisdiction. In practice this meant that museums were basically free to acquire anything that appeared on the market in this country after satisfying themselves, at a minimum, that their potential acquisitions had not been smuggled into the country, that is, that they had entered the United States under a lawful declaration of their origin and value. Buying things outside the country was a little trickier, to the extent that there might be complications pertaining to their export.

The first crack in this rule came in 1970 when the United States and Mexico signed a treaty providing for the recovery and return of stolen archaeological, historical, and cultural properties. Just two years later, similar protection was extended to a larger geographic area when Congress passed a statute regulating the import of pre-Columbian monumental and architectural sculptures and murals from (alphabetically) Bolivia, British Honduras (now Belize), Honduras, Costa Rica, the Dominican Republic, El Salvador, Guatemala, Mexico, Panama, Peru, and Venezuela.

What was eventually to prove the most significant event of the early 1970s was the U.S. ratification in 1972 of the UNESCO 1970 Convention on the Means of Prohibiting and Preventing the Illicit Import, Export, and Transfer of Ownership of Cultural Property. I say "eventually" because the convention was not self-executing. Implementing legislation was required to give it domestic force within the United States, and eleven more years passed before the Reagan administration was finally able to push such legislation through Congress in the form of the Convention on Cultural Property Implementation Act. Only now, nearly twenty years later, is the full force of that act beginning to be felt.

The Cultural Property Implementation Act (CPIA) was originally administered by the U.S. Information Agency, now a part of the U.S. Department of State. It is a massive and complex piece of legislation—suffice it to say that it provides in several ways for the imposition of import restrictions on various categories of cultural property originating from other state parties to the UNESCO convention. The state parties whose patrimonies are in one degree or another subject to an import restriction under the CPIA include Bolivia, Cambodia, Canada, Cyprus, El Salvador, Guatemala, Italy, Mali, Nicaragua, and Peru.

To understand the impact of the CPIA on museum collecting, consider the case of Peru. In an effort to prevent any further looting of the newly discovered and much-publicized Mocha tombs in its Sipan region, Peru successfully requested that the United States impose an import restriction on pre-Columbian archaeological materials originating from that area. Such a restriction, initially imposed by executive order, became effective on May 7, 1990. It provided that no such material could enter the United States unless either there was proof that it had been exported from Peru before the effective date or it was otherwise accompanied by documents indicating that its export from Peru had been in compliance with Peruvian law. In June 1997 that protection was folded into a more comprehensive regulatory

scheme. Under a bilateral agreement between the United States and Peru, dated June 11, 1997, restrictions were extended to cover all pre-Columbian archaeological materials from Peru, wherever found, as well as colonial-era ethnographic materials, particularly those taken from churches.

Faced with the possible acquisition of a Peruvian-originated object—a Mocha gold ornament, say, or a carved wooden Santos figure—a museum in the United States may act at its peril unless it can establish on what date and, in some cases, under what circumstances the object left Peru. Failure to do so may result in the object's seizure and return to its country of origin.

While Congress and the State Department were following this UNESCO-based approach, the U.S. Department of Justice and the Customs Service were developing an alternative one of their own. Underpinning their approach is a four-step argument. First, they argue that the patrimony-protecting legislation of countries around the world actually operates to vest the legal title to protected patrimonial objects in the governments of those countries. Second, they argue that to remove such objects from those countries without the approval of their governmental owners would thus be tantamount to theft. Third, they argue that, consequently, any such object so removed might rightly be characterized as stolen property. Fourth and finally, they argue that any effort to bring such stolen property into the United States would render it subject to seizure under the customs laws. Worse still, anybody found dealing with such an object might be subject to criminal prosecution under the National Stolen Property Act.

The Justice Department first unveiled this theory in the late 1970s in *United States v. McClain*, a case that involved smuggled Mexican antiquities. Following a rigorous examination of the pertinent Mexican statutes, to determine whether these truly vested ownership of all such antiquities in the Mexican government, the federal Fifth Circuit Court of Appeals upheld the smugglers' convictions. The theory surfaced again in the widely discussed Steinhardt case—*United States v. An Antique Platter of Gold*—involving a fourth-century-B.C. antiquity that New York collector Michael Steinhardt had purchased in 1991 for some $1.2 million and which, following a request from the government of Italy, the Customs Service seized from Steinhardt's Fifth Avenue apartment in 1995. In the district court case that followed, the presiding federal judge ruled that, under a 1939 Italian cultural patrimony law, the platter was ostensibly the property of Italy and, accordingly, an object of "stolen property" for purposes of applying U.S. domestic criminal law. Although the Court of Appeals for the Second Cir-

cuit subsequently affirmed the lower court's decision upholding this seizure in July 1999, it did so on a different ground—the case also involved a false customs declaration.

Meanwhile, the museum community—which had filed an amicus brief on Steinhardt's behalf—was left with the frightening possibility that, under this legal theory, other antiquities taken out of Italy since 1939 might also be deemed someday to have been stolen and could become subject to seizure and/or the basis for a criminal prosecution. Any museum collecting Italian antiquities today will certainly do so in a very different and far more circumspect manner than it might have done in earlier years.

Beyond legal restrictions with respect to collecting foreign-source objects, some museums have also subjected themselves to voluntary ethical constraints. The Smithsonian Institution is one example. The Smithsonian has had a rule in place since 1973—roughly the time that the United States approved the UNESCO convention—that forbids any of its museums to acquire, by gift or purchase, any material that was unlawfully removed from its country of origin after the date on which that rule went into effect.

Another area of collecting in which legal and ethical considerations come into play involves "Nazi-era" objects: in general, works of art and other artifacts that were created before 1945 and acquired after 1933. In reviewing their collections, most major art museums are engaged in an effort, through Web-site postings or otherwise, to track down whatever provenance information for that period they may be missing. Beyond that, both the AAM and the AAMD have issued detailed guidelines for the use of their memberships. These not only apply to their existing collections and material borrowed for exhibitions but refer to future acquisitions as well. These guidelines provide broad coverage. Issued late in 1999, the AAM's apply not only to objects that may have been unlawfully appropriated during the period 1933–1945, as a result of actions in furtherance of the Holocaust or taken by the Nazis or their collaborators, but also to "objects that were acquired through theft, confiscation, coercive transfer, or other methods of wrongful expropriation." Museums are urged by these guidelines not only to resolve the Nazi-era provenance status of objects before acquiring them but also—if credible evidence of unlawful appropriation without subsequent restitution should be discovered—to notify the donor or seller and all other interested parties of any such findings. Whatever merit "Don't ask; don't tell" may have in other spheres of life, it is emphatically not the rule with respect to Nazi-era objects.

For other kinds of objects, still other rules apply. Museums that collect Native American materials must, of course, be mindful of NAGPRA—the Native American Graves and Repatriation Act, under which objects they acquire may be subject to claims for repatriation. Museums that collect firearms—automatic ones, particularly—may have to be mindful of the federal Bureau of Alcohol, Tobacco and Firearms regulations concerning their ownership and/or interstate shipment. Museums that collect objects that include parts of animals—ivory chess sets or feather headdresses—must be aware of endangered species legislation and make sure that they are in compliance. Although private collectors are subject to many of these same rules—from those covering imports to those dealing with animal parts—they neither operate in the same kind of public fishbowl as do museums nor live under the perpetual threat that any perception of wrongdoing may jeopardize their funding.

Copyright can also present an increasingly tricky hurdle, particularly for art museums. Collage and "appropriation art"—to the extent that these may incorporate original work by others—can be especially troublesome. Both the Whitney Museum of American Art in New York City and the Museum of Contemporary Art in Los Angeles are defendants in a lawsuit involving an untitled 1990 artwork by the well-known feminist collage artist Barbara Kruger. The work—copies of which are in both of their collections and which both museums have frequently reproduced—depicts a young woman peering through a magnifying glass. Emblazoned across the image is the slogan IT'S A SMALL WORLD BUT NOT IF YOU HAVE TO CLEAN IT. The plaintiffs are a photographer, who claims to own the image—he alleges that Kruger copied it out of a 1960 German photography magazine without his permission—and who is suing for infringement, and the young woman depicted in the photograph, who is suing for invasion of privacy. This case involves only a single image. For museums that collect in the area of media—the Museum of the Moving Image in Queens, the Museum of Television and Radio with its branches both in New York and Los Angeles, or the Experience Music Project in Seattle—problems such as this may be compounded a thousand times over.

Ultimately, the most important change in the nature of institutional collecting is rooted in the changing nature of the museum itself from a focus on collection to a focus on public service. This decentering of the collection as the museum's raison d'être has by no means been uniform from one institution to another.

In a large number of instances, that change has meant that a museum's collections—which might once have been thought of as its "end"—can now be seen as a "means," as an instrument for the achievement of a larger end and simply one among a number of resources that the museum can employ to carry out its service obligations to the public. It is precisely at this point, at which the collection is no longer an end but a means, that institutional collecting is at its greatest distance from individual collecting. For a museum today, the question that hovers over every potential acquisition is not the one that a private collector might well have asked in the past and still asks today: "Is this a truly remarkable and intrinsically desirable object?" The question for the institutional collector is, instead, a question of utility: "How might this object be useful to the museum in carrying out its institutional mission?"

If that distinction needs an underline, it can be found in the AAM's *Handbook for Accreditation Visiting Committees* (2000). In listing the principal characteristics of an accreditable museum, the handbook notes that a museum's collections "are appropriate to the mission." Strongly implied is the proposition that—in a mature and functioning museum—it is the mission that shapes the collection and not the converse: that the collection can forever be accumulated willy-nilly and the mission subsequently reshaped from time to time to somehow fit around it.

That the latter alternative—to shape a mission around an existing collection, no matter how oddly formed or misshapen that collection might initially be—might well be the formula for a dysfunctional museum is not simply theoretical. In two notable and curiously parallel instances, both rooted in the late 1960s but played out in the 1990s, we have been able to witness the actual consequences of such an approach. One case involved Canadian lawyer Eric Harvie's entirely eccentric collection of more than a million objects, nearly another million photographs, and twenty-four thousand works of art; the other, the Eastman Kodak heiress Margaret Woodbury Strong's almost equally eccentric accumulation of some three hundred thousand artifacts including twenty-seven thousand dolls. In both cases it was assumed that a very large private collection could be readily converted into an effective museum collection. In both instances as well, the museums that were thus created—the Glenbow Museum in Calgary and the Strong Museum in Rochester—eventually found it necessary to reconceptualize themselves, and these massive collections were subordinated to a larger vision of the museum's role in the community. In the case of the Strong Mu-

seum, this involved turning itself into an entirely different kind of institution—a family and children's museum instead of the history museum that it started out to be.

My personal participation in the reshaping of a private collection for the use of a public institution happened during my years at the Hirshhorn Museum and Sculpture Garden, from its opening in 1974 to my retirement in 1995. Although Joseph H. Hirshhorn gave the museum some twelve thousand works of art—roughly half during his lifetime and the balance at his death—it was understood from the very beginning of his conversations with the Smithsonian in the 1960s that the museum was not to serve as a memorial to Hirshhorn's personal predilections as a collector—the Smithsonian had already been "burned" once by agreeing to that in the case of Charles Lang Freer. Instead, it would function as an educationally oriented institution, intended to develop a broader public understanding and appreciation of modern and contemporary art.

The reshaping of the Hirshhorn collection involved pruning away, primarily by disposition at auction, the excesses of Hirshhorn's sometimes glaring ebullience—he had collected more than fifty paintings by Milton Avery, more than eighty sculptures by Henry Moore, and more than four hundred paintings by Louis Eilshemius—and using the proceeds from those dispositions to begin to fill the equally glaring gaps in the collection—major movements in twentieth-century art in which he had little or no interest. It also involved the transfer to other museums within the Smithsonian of entire subcollections—Benin bronzes, Eskimo carvings, Middle Eastern antiquities—that had nothing to do with modern and contemporary art. Twenty years after Hirshhorn's death, this process of pruning and gap filling continues. My own guess is that it may take another twenty or thirty years to complete.

The museum has always tried to make clear that this reshaping process should in no possible way be interpreted as critical or disrespectful of Hirshhorn's activities as a private collector. He did what the private collector has always done and remains uniquely and gloriously privileged to continue to do: He collected not only for his own deep pleasure but also—as Francis Henry Taylor once pointed out with respect to individual collectors in general—"as a complex and irrepressible expression of the inner individual" that he was. Hirshhorn the mighty hunter and Hirshhorn the proud possessor were both wonderfully reflected in the collection he amassed.

If once upon a time museums—or at least museum directors or senior

curators acting on their behalf—could collect in such a passionate, vital, and self-expressive way, collect with that same bravado and zest that typifies the private collector in hot pursuit of his or her quest, such a time has long since gone. Museum collecting today, for all these reasons—the burden of caring for collections, the necessity to negotiate a labyrinth of legal considerations, and the need for acquisitions to be carefully related to mission—has become something else. Still exciting, still rewarding, but—to a great degree—it is stately, sober, and deliberate as well. It is said that blondes have more fun. So too, I think—and it's a rueful thought—do private collectors.

Twenty-One Ways to Buy Art

You are the director of a municipally funded museum of twentieth-century art in a small Midwestern city. Your board of trustees has asked that you draft a brief policy statement providing guidance as to how the museum's acquisition funds might best be spent over the next several years. These funds are projected at approximately seventy-five thousand dollars annually, roughly two-thirds of which are appropriated by the city council with the balance raised privately.

The museum's existing collection consists of some nine hundred paintings and sculpture plus a scattering of prints and drawings. The quality is generally high, but the collection is extremely uneven in its representation of major twentieth-century movements; that is, there are strong holdings in such areas as American abstract expressionism, German expressionism, and Italian futurism, but virtually no examples at all of cubism, photo-realism, surrealism, neoplasticism, constructivism, or color-field painting.

You have asked your staff for their individual recommendations as to what the chief focus of the policy statement should be. Their responses follow. Choose the one (or, if more than one, not more than three that can be harmoniously combined) that you will use as the basis for this document.

1. This collection has tremendous gaps. If we have the slightest pretense to being a place where people can learn about the art of our time, then the

This text appeared as an appendix in Neil G. Kotler and Philip Kotler, *Museum Strategy and Marketing: Designing Missions, Building Audiences, Generating Revenue and Resources.* Copyright Jossey-Bass, Inc., 1998. Reprinted by permission of Jossey-Bass, Inc., a subsidiary of John Wiley & Sons, Inc.

highest priority must be given to filling those gaps. As things stand, we're giving our visitors a completely distorted picture. Let's concentrate on cubist painting first—that's the most critical lack—and go on from there. As a long-range goal, it's essential that we represent the full spectrum of twentieth-century art.

2. If this museum is popular for anything, it's our docent program. And the docents have told us time and again how badly they need paintings and sculpture that lend themselves to vivid explanation. We are, after all, an educational institution and it seems to me that our frontline educators— the people who must face the public every day in the galleries—are the ones who best know what kind of raw material they need in order to build an effective presentation.

3. We must never forget that museums are the last surviving heirs of the great royal and ecclesiastical patrons of the Renaissance. If art is to retain its vigor, then the young and deserving artist will always need a helping hand at an early stage of his or her career. What better use could we make of our limited acquisition funds than to nurture the roots of creativity by concentrating our purchases on the work of emerging artists?

4. It seems to me that we should simply hold out for the very finest objects that we can possibly afford. I'd rather accumulate our acquisition funds for ten years and buy a single masterpiece of the highest aesthetic quality for $750,000—or more, if we could put our cash into a money market fund— than fritter it away every year on things that may never amount to anything. The Louvre has its *Mona Lisa*. Why should we not aspire to have ours?

5. To me the most salient thing is that we're entering a period of great social and economic turbulence. I think we must seek to acquire works of art that have strong, positive (or even, if you will, edifying) qualities, works that can speak affirmatively to a public sorely in need of uplift. Art no longer deserves to be a central concern of society when it abandons its moral role. Then it becomes merely decoration or self-indulgence. If this museum cannot be a strong force for good, what would justify its continued existence?

6. To me, an art museum is first and foremost a history museum, a museum of art history. Central to our collecting should be objects that reflect significant moments in the development of contemporary art. You may object that such objects often lack the finish of later work—something that seems to dazzle the public—or even appear crude or ungainly. No matter— our duty is to preserve that first moment of inspiration, innovation, or invention so that future generations can read the unsullied record.

7. Since it's the city council that votes to give us most of our acquisition funds, it seems to me that they ought be consulted. I wouldn't expect them to tell us exactly what to buy, but it makes good sense to get some kind of indication of what they'd like to see us collect. They're not exactly a bunch of dummies, though we sometimes treat them that way. We can't afford to get so lost in our precious, aesthetic fog that we start forgetting that basic truth about he who pays the piper calling the tune.

8. If the museum is to attract more support, it must first itself be attractive. Those four empty sculpture niches in front of the building have become a public joke. There was even a cartoon about them last week. Ever since I've been here, we've been hoping that "something would turn up" to fill them. Nothing ever does, and something else always takes priority. We should now be using our acquisition money to commission a good sculptor to fill those niches. Then we can go on to other things, but let's get our own house in order first.

9. From any century, only a handful of artists will prove worthy of remembrance. If we are to carry out our obligation to future generations, then it's critical that we identify the great artists of our period and concentrate our collecting activities around them. The rest will sooner or later be largely forgotten, and—if our funds are short—then we have to be tough minded enough to be the ones to forget them sooner.

10. Given such a skimpy budget, it's clear that the only way we can continue building the collection over the near term will be through gifts. That should be our chief effort—to identify those works of art in the hands of potential donors that we can reasonably anticipate to be given one day. To duplicate those with purchases would simply be a waste. Once we know, then we'll have a better idea of how to work around them in what we buy. The big thing for now is not to rush until we know what the future promises.

11. Most of our recent acquisitions lack any flair. That's a problem. What we really need to buy now are things that can attract some attention, things that may have a glamorous background (a Marilyn Monroe or Patty Hearst collection provenance, for example) or a rousing story to tell. Without enough money to buy great things, at least we can buy things that would get some media coverage. That way we can build a following. I've never understood why someone from our public affairs office doesn't sit on the acquisitions committee.

12. We have two choices: merely to be a mirror of the times (and thus the slaves of fashion) or to take leadership and—through our purchases—

put our endorsement on the art that is theoretically and ideologically correct for this particular time. By that I mean advanced art that is purged of biography, personality, anecdote, or anything extrinsic to the means of its making. The latter is the only responsible way to go, and it doesn't require expensive "brand-name" artists to do it. We can do just as well with young people who follow the proper critical imperatives.

13. It's largely the taxpayers of this city who pay for our acquisitions. Why don't we ask them what they'd like to see us acquire? We are—in every sense—a public institution, and the public is entitled to have a say. We should set up a citizens' advisory council—and include some of the people who never come here because there's never been anything here that they wanted to see.

14. Realistically, seventy-five thousand dollars a year is not going to buy much quality in the way of painting and sculpture. But just think of what we could do if we decided to beef up our print department and also began to collect photography—in my view the most exciting development in contemporary art. Also (crass as this may sound) it's something of a bargain. We have an obligation to make the best possible use of our resources, and this would be the wisest and most prudent way to go.

15. Now is a good time to come to grips with our obligation to local artists. If we aren't going to see to it that examples of their work are properly preserved and assure them that their careers are worthy of study, then who ever will? Certainly not the New York or Chicago museums. Their prices would fit our budget admirably, and we'd be in position to buy their very top works. As a community-based museum, I don't see how we can avoid such an obligation.

16. Until we can break past a level of seventy-five thousand dollars, we're really out of the art market and that will increasingly be the case with every passing year. I would urge that we suspend collecting in any conventional sense and turn our energies toward the greater study of our collection. With the funds available, we should be able to buy the kind of documentation—preparatory sketches, scrapbooks, manuscripts, and the like—that would make us a center for scholarship in those fields where we're strongest. A museum, after all, isn't just things—it's also information about things.

17. To me, how we buy is just as important as what we buy. If this city is ever to have an active art scene—an absolute essential if this museum is to flourish—then it will need a stronger group of art dealers than it has today. If we don't patronize the local galleries, who will? What we should be doing

is making our wants known and letting them do the leg work of tracking things down. Buying art is something with more than one dimension, and it's high time we became sensitive to the wider implications of what we do.

18. The question of acquisitions is inseparable from the general budgetary constraints that the museum will face in the next few years. I think particularly of our shrinking funds for conservation and security. Surely, there must be fine works of art available that are too bulky for pilfering and could appropriately be shown behind heavy plexiglass or otherwise made of damage-resistant materials. Stuff like that could even save us money on handicap compliance. Someone has to remember that the true cost of any object is not just the purchase price—it also includes the ongoing expenses of safeguarding and preserving it.

19. We all know that women and minority artists are seriously underrepresented in this collection. The least we can do is to use our acquisition funds to try to correct this imbalance. No loss of quality need be involved, and if the museum can't go about its collecting business in a fair, just, and socially constructive way, then it simply doesn't deserve continued public support.

20. It's time to face the facts: we will never have the resources to be a miniature museum of modern art with representative examples of every contemporary style. Given our budget, we could only fill the gaps—cubism, for example—with second-rate material or worse. What we can and should do is to build on what we have already and acquire further examples in those fields where we're strongest. It's the only way we'll ever build a national reputation. It's like that military maxim: To try to be strong everywhere is to be weak everywhere.

21. What's been forgotten is that there's scarcely an important work in this collection that was important when we bought it. In the old days, curators just went to the great cities of the world and gambled on what looked new and fresh and exciting. Sure, there were some mistakes and they clutter up our storage, but we would never have gotten our Pollocks or Beckmanns or futurist things if we waited until art history had stamped them as important. We should keep that up: guts, instinct, and the willingness to make some mistakes. Buy broad, buy big, and let the masterpieces fall as they will.

THE MUSEUM
AS PALACE

16

Courtly Ghosts and Aristocratic Artifacts

At the court of Louis XIV, those who occupied the highest ranks—the king himself, the princes of the blood, the great dukes, and just below them the counts—were forbidden by custom to engage in any meaningfully productive work. What the court is best remembered for is its extravagant idleness. Its members derived their status from who they were, not from what they accomplished. Indeed, that they had no need to accomplish anything was one measure of their relative worth. By contrast, the more numerous members of the lower nobility frequently earned their titles through their public usefulness, as appointed officials or practicing professionals. Being more useful, they were thus lower ranked.

Consider the similarities to the art museum today. A hierarchy exists in which, at one extreme, unique works of art—useless for anything but disinterested contemplation and, by reason of their uniqueness, almost invariably costly—are positioned at the museum's summit, as if by divine and unquestionable right. At the other extreme, just barely noble enough to be admitted but too utilitarian ever to attain any higher rank, the decorative

The original version of this text was presented at the symposium "Ideals and Ideology: The Art Museum from 1851 to 2001" at the Museum of Fine Arts, Boston, in April 1998. This substantially revised version was subsequently published in *Museum News* (November–December 1998). Reprinted, with permission, from *Museum News* (November–December 1998). Copyright 1998, the American Association of Museums. All rights reserved.

arts and their other useful companions stand in the shoes of the lower no-
bility. Crafts, theatrical designs, illustrations, cartoons, and multiples of
every kind, like the great dukes and the counts, occupy a middle ground.

It scarcely seems surprising that the art museum has often been compared
to a palace, a palace still haunted by a particular vision of how, once upon
a time, society was ideally organized from the top downward.

In his catalog essay for *A Grand Design: The Art of the Victoria and Albert Mu-
seum,* Michael Conforti points out that between the years 1905 and 1910,
America's two flagship art museums—the Museum of Fine Arts in Boston
and the Metropolitan Museum of Art in New York—turned away from the
primarily educational focus with which they each had been established in
1870. Although acting independently of one another, and impelled by what
appear, at least superficially, to have been somewhat different motives, they
both determined that they would thereafter emphasize the aesthetic rather
than the instructional aspects of the works of art that they chose to acquire
and/or display.

Among the consequences of that change—albeit, in all likelihood, an un-
intended one—was the establishment of a symbiotic relationship between
this country's social elite and its major art museums. One aspect of that re-
lationship is widely understood: the extraordinary level of patronage that
members of that elite have provided and continue to provide to those mu-
seums. Less recognized is what those museums have provided to their elite
patrons in return. By the very manner in which they deal with works of art,
those museums have provided a metaphorical model for a particular or-
dering of society, in which what is rare and beautiful is given a position far
superior to what is merely useful or common, as if that were the most natu-
ral, indeed inevitable, of choices.

Two distinct measures can be applied to the categories of objects that mu-
seums of art customarily collect: a scale of aesthetic purity and a scale of
commodity value. How an object is ranked for aesthetic purity depends
on the degree to which that object is free of any utility beyond its capacity
to produce an aesthetic response. Harking back to its earliest delineations
in the eighteenth century, such an aesthetic response can be described as
one that is valued as an end in itself, not because it fulfills some other pur-
pose. Defined otherwise, the benefit to be derived from such a response is
understood to lie in the experience itself, not in the expectation of some
future benefit or practical advantage. Categories of museum objects suit-
able only for disinterested contemplation are assigned to the top of this

scale. Objects with increasing degrees of utility for purposes other than con-templation occupy progressively lower places. Wholly utilitarian objects, perceived to lack any aesthetic value, generally fall outside the art museum's ambit altogether.

As Martha Woodmansee has observed (*The Author, Art, and the Market: Rereading the History of Aesthetics,* 1994), most of those who work regularly with the arts have become, over the past century and more, so steeped in this aesthetic emphasis that they cannot readily imagine that works of art were once valued not for what they looked like but for what they could do—inspire, instruct, incite, and inform. When Archibald MacLeish urged so ringingly in his 1926 *Ars Poetica* that "A poem should not mean / But be," he was not affirming some long-held position but preaching what was then an only recently revolutionary creed. To our early-twenty-first-century ears, Alfred Barr's assertion that what is central to the art museum's work is "the conscientious, continuous, resolute distinction of quality from medi-ocrity" sounds like a commonplace. To the mid-nineteenth-century founders of art museums who envisioned them as places of public im-provement, moral uplift, and educational advancement, Barr's words would have sounded like gibberish.

The notion of "commodity value," by contrast, would have been wholly familiar to those first museum founders. What might perplex them is the extent to which that has become central to an institution they had conceived as primarily instructional. "Commodity value" simply means the value that arises out of the interplay of supply and demand. In its postinstructional incarnation, the art museum has been especially attuned to the supply side of that equation—the less duplication there is within any category of art, the more the art museum tends to value objects of that category. Thus, on the scale of commodity value, unique works of art outrank works of art pro-duced in multiple copies, and among the latter, those reproduced in lim-ited numbers outrank those produced in unlimited copies. Only a few cate-gories of objects capable of reproduction in unlimited numbers—posters, films, video, and decorative arts—fall within the art museum's province at all.

Closely aligned with this scarcity-multiplicity distinction is the manner in which a work of art has been created. Because it tends to be scarcer, the pure autograph work—made wholly by the artist's own hand—will gen-erally be assigned a higher value than works in which the artist played only a collaborative or supervisory role. Anything created by hand, however—

by anybody's hand, even a studio assistant's—will generally be valued above what is produced by machine, which even if momentarily unique can be repeated indefinitely.

Before examining how the art museum has intertwined these two measures—aesthetic purity and commodity value—to create a hierarchy of worthiness, we might usefully revisit that moment early in the twentieth century when the original educational missions of the MFA and the Met were superseded by the decisions of those two institutions to pursue other goals. By a nice coincidence, the public gesture that most forcefully signaled their changes of direction was in both cases the same. It was the expulsion from their main galleries of the large plaster-cast collections that they had worked so assiduously to assemble over many previous years.

In the case of the MFA, this decision appears to have been largely ideological and to have originated within the staff. The story is told in detail by Walter Muir Whitehill in his centennial history of the MFA. Ostensibly at issue was the collection of more than seven hundred architectural and sculptural casts that the MFA had accumulated during its first four decades. In the museum's original two-story building on Copley Square, these occupied more than half of its first-floor galleries. The battle was over what provision, if any, was to be made for these casts when the MFA moved to its new Huntington Avenue facility in 1909.

One question raised by the staff concerned the efficacy of these casts. How successfully did they represent the original objects from which they were taken? Even if they accurately reproduced the outward forms of those objects, did they also convey the same emotional force? Comparing the casts to the pianola—then a popular form of player piano—Matthew Stewart Prichard, an influential staff member, argued: "The exhibition halls of our Museum have the same right to be free of mechanical sculptures as the programmes of the Symphony Concerts, which set the standard of musical taste in Boston, have of exemption from mechanical music." Ideally, he said, every cast in a museum should be marked with a label saying THE ORIGINAL DOES NOT LOOK LIKE THIS.

The staff also posed a more fundamental question, related to the very nature of the art museum. Was it, like the museums of other disciplines, to be primarily educational? Or, as a museum of fine arts, was its mission to be primarily aesthetic, not didactic? Urging the latter position was another important staff member, Benjamin Ives Gilman, the museum's longtime secretary. Writing several years after the event, Gilman spelled out in

charmingly eloquent detail what he envisioned as distinctive about a museum of fine art and its collection. "A collection of science is gathered primarily in the interest of the real; a collection of art primarily in the interest of the ideal. The former is a panorama of fact, the latter a paradise of fancy. In the former we learn, in the latter we admire. A museum of science is in essence a school; a museum of art is in essence a temple. Minerva presides over the one, sacred to the reason; Apollo over the other, sacred to the imagination."

The sociologist Paul DiMaggio has closely studied Boston's major cultural institutions. In his view, what was at stake in this quarrel over the casts was something far more consequential than the MFA's future direction. He has described it as one of the culminating episodes in the long process that began in the mid–nineteenth century through which the forms of "high culture" in the United States—initially concert music, opera, and the visual arts—were set apart from popular culture and enshrined in a separate and distinct cluster of philanthropic institutions of which the MFA was typical. Driving this process was "an aesthetic ideology that distinguished sharply between the nobility of art and the vulgarity of mere entertainment."

For the United States, a whole-hearted embrace of that ideology was to have momentous repercussions in terms of both how its cultural institutions have been structured and how their audiences have evolved. As DiMaggio summarizes it, "The distinction between true art, distributed by not-for-profit corporations managed by artistic professionals and governed closely by prosperous and influential trustees, and popular entertainment, sponsored by entrepreneurs and distributed via the market to whomever would buy it, had taken a form that has persisted to the present. So, too, had the social distinctions that would differentiate the publics for high and popular culture."

In DiMaggio's analysis, the problem with the casts was that they fell on the vulgar side of this growing divide. As mere reproductions, as "impure" works of art, they had to be purged. Whatever the reason, the casts were about to become history. In the MFA's spacious new building, they were banished from the exhibition galleries. Some dropped out of public view altogether, others were relegated to open study collections. By World War II, even those seem largely to have disappeared.

At the Met, the expulsion of the cast collection followed a different scenario and was not quite so precipitous. The Met's collection of architectural and sculptural casts was triple the size of the MFA's. With more than

two thousand objects, it was perhaps second in size only to Berlin's. Assembled almost entirely between 1883 and 1895 and at great expense, the collection was astonishing in its range and richness. Among the architectural casts were full-size sections of the Parthenon and the Temple of Vespasian. At less than full size were scale models of the Pantheon, the Hypostyle Hall at Karnak, and the Cathedral of Notre-Dame.

Equally outstanding were the sculptural casts. In a single gallery, a student of the Renaissance could directly compare Donatello's great equestrian sculpture from Padua with Verrocchio's slightly later work in that genre from Venice. In a suite of adjoining galleries, visitors could study almost all of Michelangelo's known sculptures through carefully made replicas. To be able to see—or, in the case of art students, to be able to sketch—in relatively rapid succession the reclining figures from the Medici tombs in Florence, the *Bound Slaves* from the Louvre, and the *Moses* from the Church of San Pietro in Vincoli in Rome was an opportunity transcending anything that the Grand Tour could possibly provide.

Unlike the MFA, the impetus for change at the Met seems to have originated primarily with the board of trustees rather than the staff. Moreover, the change envisioned by the board only indirectly involved any ideological question of what weight was henceforth to be given to the museum's educational aspect. The board's primary interest was in changing what the Met would collect. The several histories of the Met are all in accord in ascribing this change primarily to the period from 1904 to 1913, when J. P. Morgan served as the board's president. "With Morgan's assumption of the presidency," writes Calvin Tompkins in *Merchants and Masterpieces*, "the concept of the museum underwent a fundamental change. No longer would the Metropolitan defer to European institutions, or limit itself to the utilitarian and educational ideals of the South Kensington Museum. Casts, reproductions, and second-rate works of art might still retain some usefulness for artisans and students, but the emphasis had shifted unmistakably to the great and original masterpieces, the treasures that old Europe proved only too willing, after all, to relinquish."

In a 1987 *New Yorker* article, Tompkins suggested that it was not Morgan alone but a whole new breed of trustees, whom Morgan had brought onto the board, who powered this change: prominent philanthropists such as George F. Baker and Edward S. Harkness, but also such major art collectors and future museum founders as Henry Walters and Henry Clay Frick. Referring to the plaster casts, Tompkins says, "By 1905 . . . [they] had al-

ready begun to seem an embarrassment . . . Europe was proving more than ready . . . to part with the aesthetic spoils of monarchism, and Morgan's eye was fixed on acquisitions of the highest quality and importance."

Nancy Einreinhofer, following a similar line, notes that the boards of trustees of the MFA and the Met in their early days were "composed of a mix of old families, the landed gentry, and professional men (*The American Art Museum: Elitism and Democracy,* 1997). They were not necessarily people of great wealth but were men with a strong interest in art who were willing to contribute their time and talents to the museum." Einreinhofer argues that the trustees who came to dominate the Met and other art museums in the early years of this century were different. They *did* have great wealth and, moreover, they held it in far more liquid forms and were far readier to spend it on ostentatious display. Acquiring art was, for many, a part of that display. In *Civilizing Rituals,* art historian Carol Duncan describes how they approached it: "Once they decided to rival the palaces and country houses of European nobility, they went at it with the same single-mindedness . . . with which they [had] amassed their fortunes. They bought the best art, retained the best architects, and employed the best art experts that money could buy."

Possibly, Morgan and the other collectors among this new generation of trustees simply took it as a given that the Met's collection should properly resemble those that they were simultaneously assembling for themselves. Or, they might have calculated that building the Met's collection in such an opulent way could ultimately enhance the prestige of their own. In any event, they appear to have applied the same multiple standards to the museum's new acquisitions that they had hitherto applied to their own. What an object looked like was, of course, important. But so too was a firm attribution to a highly regarded artist, preferably one who might be considered a genius. So too was an impressive provenance, preferably one studded with aristocratic names. Finally, it was important that the acquired object be something of which nobody else might have a duplicate. To the extent that their quest for status was a driving force behind the formation of these collections, this preference for unique objects was consistent with that quest. By excluding all others from the possibility of ownership, uniqueness could confer a measure of status. Was the problem with the Met's plaster cast of Michelangelo's *Pieta* that it lacked formal beauty or that an even better version carved from marble was to be seen in Saint Peter's? Or was it that such a plaster cast was outside the newly defined bounds of

acceptable collecting? It was an infinitely reproducible object, of which any-body—indeed, everybody—could own a copy.

In its annual report for 1905, acknowledging that in the past it had some-times accepted the gift of objects "hardly worthy of permanent display," the Met said it would henceforth seek instead "the masterpieces of different countries and times." Roger Fry, briefly recruited from England to assist in that search, said his instructions were to find "exceptional and spectacu-lar pieces" for the museum. Henry James visited the Met during this pe-riod, and Tompkins amusingly quotes his reaction as set down in *The Ameri-can Scene* of 1907. "There was," James wrote, "money in the air, ever so much money . . . [a]nd the money was to be for all the most exquisite things. . . . The Museum, in short, was going to be great."

Not everybody agreed that the limitless acquisition of exquisite things was the path to museological greatness. Across the Hudson River at the Newark Museum, John Cotton Dana—perhaps this country's greatest ad-vocate of the museum as a community-based educational institution—watched disdainfully. In his 1917 pamphlet *The New Museum*, he wrote: "The old style museums are founded on the assumption . . . that the presence in a community of rare and expensive objects . . . gives that community not only a certain prestige in the world, but also a certain mental éclat . . . a certain open-sesame to the world of refinement. . . . Acting under it, com-munities are still taxing themselves to get, and are asking private bene-factors to get for them, marble palaces filled with these so-called emblems of culture, rare and costly and wonder-working objects." Arguing that mu-seums should not be "store-houses" but "work-shops," Dana proposed a modest alternative to this endless agglomeration of precious objects. "A scrap of printed cotton, accompanied by proper texts, pictures, charts and suitably related objects, can throw more light on the subject of textiles for ninety-nine out of one hundred visitors than can long rows of examples of the finest 'museum specimens' of old and rare fabrics."

The Met sailed on, undeterred. As increasing numbers of the most exquisite things accumulated, the gallery space and curatorial attention available for the cast collection steadily diminished. By the early 1930s the architectural casts were largely gone. The sculptural casts lost their last ded-icated gallery in 1938. Except for their brief resurrection during World War II, when some of the Met's more valuable collections were evacuated for safekeeping, the casts have been almost entirely off public view at the Met for nearly sixty years.

Returning, then, to the scales of aesthetic purity and commodity value: What remains to be shown is how these measures intersect to form a hierarchy among those categories, a hierarchy reflected in the different amounts and kinds of gallery space, acquisitions budget, staff salaries, and even prestige generally associated with each such category. It is not the same hierarchy that prevailed when the worthiness of museum objects was being judged by their capacity to contribute to such Ruskinian goals as—in Debora Silverman's phrase—"collective moral uplift and social humanization."

At the bottom of this new hierarchy—sometimes confined to separate and usually smaller museums of their own, sometimes segregated in small departments within a larger museum—are categories of objects that suffer from a double disability, such as the decorative arts. Instead of being useless—which would place them at the top of the scale of aesthetic purity—they are useful. Instead of being unique—which would place them at the top of the scale of commodity value—they can exist in unlimited copies. Depending upon whether these are for use in the home or workplace, for recreation, or as apparel, the categories in which these objects are grouped may carry such designations as industrial, costume, or graphic design.

At the intermediate level of this hierarchy are two otherwise very different classes of objects that are only singly disabled: craft objects and multiples. Craft objects may be highly regarded on the grounds that they are unique and created entirely by a particular artisan's hand. They are nonetheless barred from the topmost rank because, by definition, they suffer from the flaw of usefulness. Stamped with a similar flaw are such useful categories of art as theatrical designs, book and magazine illustrations, and cartoons.

Objects in the other intermediate class—works of art produced in a limited number of copies and grouped into such categories as tapestries, fine-art prints, photographs, and sculptures made in limited editions—are disabled from reaching the top for precisely the opposite reason. Although they may fully satisfy the criterion of uselessness, these objects, by definition, are never unique.

Finally, positioned at the museum's pinnacle—and frequently at the top of its grand marble staircase as well—we encounter those rarified works of fine art that score highest on both the aesthetic purity and the commodity value scales: autograph, handmade paintings and personally carved sculptures that are by far the most celebrated of all the objects that an art museum collects and displays, last in usefulness and first in costliness.

And here we come to something of a marvel. If we stare intently at this

seemingly odd hierarchy, in which prestige increases precisely as utility and widespread availability decline, it suddenly seems not so odd after all. Recalling the comparison of the museum to a palace, we can begin to glimpse something both familiar and unexpected: the social structure of an aristocratic or princely European court—Versailles—or the imitative version of that structure sought by this country's newly arisen leisure class in the decades following the Civil War.

The theme of rank—this notion that it is only natural for some things to be inherently worthier of respect than others—permeates the art museum. It continues and extends DiMaggio's description of that earlier, nineteenth-century process of stratification by which high culture was separated from popular culture. Not only are the washed different from the unwashed, but even among the washed, some are more washed than others. Not only are categories of art ranked for their aesthetic purity and commodity value, but within each such category objects are further subranked for their aesthetic quality.

Here the aristocratic parallel is reinforced. As used in the phrase "a lady or gentleman of quality," the term "quality" may, according to the *Oxford English Dictionary,* refer to "an individual of noble birth or high social rank." Returning to Alfred Barr's description of the art museum's central task as distinguishing "quality from mediocrity," the question irresistibly occurs as to whether members of the *Social Register*'s advisory board or even the editors of *Burke's Peerage* might not with equal justification describe their work in almost identical terms: the conscientious, continuous, resolute distinction of quality from mediocrity.

Are not the subtle, subliminal, and intricately interlocked messages that issue from the palace-museum very like those that the *Social Register* still broadcasts? Precedence is the normal and natural order of the world. Uselessness, like idleness, is an essential aspect of distinction. Costliness, like wealth, is another. A good provenance, like a good pedigree, is always an enhancement. Quality, whether in art or people, will always be apparent to the discerning eye. In the appropriate setting, such traditional and self-indulgent rituals as discrimination and exclusion may still be performed with impunity.

At the end of the insistently egalitarian and leveling twentieth century, such messages must certainly provide comfort to those members of the social elite who, in turn, provide the art museums with their patronage. Some nagging questions remain, though. To what extent do those messages also

reach the members of a larger public beyond that elite circle, and how are they likely to interpret them? Do some find them persuasive? Or, more critically from an art museum's perspective, might some find those messages repellent? When art museums are charged with "elitism," might this constant, subliminal reiteration of rank and hierarchy provide some legitimate basis for that charge? For those of us who still believe in the art museum as an educational institution, a far more critical look is needed to see just what it has been teaching over these past eight decades or so. We might be surprised.

Reduced to Art

At an early-1980s annual meeting of the AAM, one of the general session speakers was the minister of antiquities from a West African nation. His topic was the role of museums in the illicit international trade in stolen cultural property. Midway through his talk he told an anecdote about a tribal ceremonial carving that had been wrongfully removed from his country. The object eventually was located in an American art museum where—the minister's tone, at that point, turning to one of palpable disgust—"it had been reduced to nothing more than a work of art." Not said, but certainly implied, was that this reduction to "nothing more than a work of art" had stripped this carving of all the things that had made it valuable to the tribe from which it was taken.

How did the assembled museum representatives respond to the minister's words? With appreciative laughter, yes, but also—at least in the case of those many of us who were in attendance on behalf of art museums—with some nervous laughter as well. The very notion that being included in an art museum's collection could be a form of degradation goes wholly against the thinking that customarily dominates such institutions. In that view—common not only to most of those who work in art museums but also to their visitors, and to many contemporary artists, critics, and col-

This text was delivered as a lecture at the University of Richmond (Richmond, Virginia), September 1996.

lectors as well—to be perceived as a work of art is at the furthest possible extreme from degradation. To be perceived as a work of fine art, and most especially to be perceived as a work of *fine* art, is the acme of stuffhood, the most supreme status to which an artifact might aspire.

The reasons that so many of us (though no means all) place so exalted a value on the fine-art category of objects are by no means self-evident. Not only is it a curious practice, but several of its implications—some obvious; a few less so—are more curious still. Not every society has developed such a practice; even within our own the practice is relatively recent. Even today, the practice is still not characteristic of our society as a whole but tends to be concentrated among its better educated and/or more affluent members. A cluster of public institutions, especially the art museum as it has evolved over the past century, have played an important or even central role in fostering the tangle of interlocked understandings by which, in the view of those who participate in those understandings, one kind of object—the work of fine art—is elevated to a position of superiority over virtually every other artifact of human fabrication.

In 1890 the French painter Maurice Denis wrote, "Remember that a painting—before it is a battle horse, a nude woman, or some anecdote—is essentially a flat surface covered with colors assembled in a certain order." Let me ask you to conjure up for yourselves three flat surfaces, more or less identical in size, each "covered with colors assembled in a certain order."[1] To make them more contemporary, let's have them depict—instead of a battle horse, a nude woman, or some anecdote—a bombed-out Croatian church, half a cantaloupe, and Charlie Chaplin. I propose that many of us have become so thoroughly accustomed to thinking about art in a particular way that, implausible as it may seem to others, it strikes us as perfectly natural to think that a knowledgeable person could form a well-considered opinion as to which of these was the best work of art and which one was the worst by simply standing there and looking at them intently, with no further information about their authorship, history, or subject matter. In everyday language, we refer to this knowledgeable person's confrontation with these paintings as an "aesthetic encounter," the conclusions reached concerning their relative merit as an "aesthetic judgment," and whatever it is that makes one of these paintings aesthetically superior to the others as its "aesthetic quality."

What seems so remarkable about this aesthetic judgment—at least in its idealized version—is the singularity of the consideration upon which it is

based—how do these paintings look in comparison with one another?—
and the entirety with which every other kind of consideration has been ex-
cluded. This idealized aesthetic judgment is utterly exclusive. It excludes
any consideration of whether one of these paintings might depict its subject
matter with greater accuracy and/or technical facility than do the others;
what kinds of problems—artistic or otherwise—these several paintings may
have been intended to solve and/or their relative success or failure in doing
so; what meaning or even feeling any of these paintings might express—re-
gardless of the artist's intention—about Croatia, about churches, about can-
taloupes, or about Charlie Chaplin, not to mention the viewer's opinions
or feelings toward those same subjects. It excludes any consideration as to
whether one or another of those subjects might be more or less deserving
of being depicted than the others. It excludes finally any consideration of
the fitness of these paintings for any purpose other than being looked at—
their critical reception, their potential market value, the history of their
ownership, the circumstances of their production, or the quality of mate-
rials used in that production. In its idealized form, the aesthetic encounter
involves nothing more or less than a highly concentrated effort to ascer-
tain what we can call the "intrinsic perceptual value" of the object under
scrutiny. This is asserted to be a value independent of the viewer, the artist,
the subject, or the context. To ensure the purity of that aesthetic inquiry,
no other consideration can be taken into account.

We are so steeped in looking at works of fine art in this way that—as Pro-
fessor Martha Woodmansee of Case Western has pointed out—we can
readily imagine that it has always been current.[2] That simply is not the case.
Before the eighteenth century, works of fine art were considered in other
ways entirely. The aestheticism that so prevails in the art community today
is a relatively recent phenomenon, attributable to a profound change in at-
titudes toward art that occurred during the closing years of the eighteenth
century and which, in the two hundred years since, has come to dominate
the understanding of the fine arts both in this country and in many other
parts of the world.

Since the eighteenth century, aestheticism has included a cluster of linked
ideas at its core. Foremost is the notion that the true aesthetic experience
must be a disinterested one, an end in itself and not instrumental toward
the fulfillment of some further purpose. Put otherwise, the pleasure to be
derived from the aesthetic experience does not lie in the expectation of
some future benefit or practical advantage; it is in the experience itself.

Thus an object that might be of potential utility to the viewer—a beauti-fully crafted chair, for example—must, in terms of its aesthetic potential, be ranked below an object that might have no utility to the viewer at all, such as a painting of that self-same chair. This emphasis on nonutility finds public recognition in the widely used phrase, "art for art's sake." Art is for art's sake when all other sakes have been excluded.

A second idea, central to most if not every version of aestheticism, is that the intrinsic perceptual value of a work of fine art is determined by char-acteristics that are timeless and universal. It is on this underpinning that we have built this country's great encyclopedic art museums, in which objects created by dozens of different cultures in eras ranging across fifty centuries can all be shown in adjacent galleries, on the premise that, as works of art, they all share something in common; for the practiced eye, an aesthetic unity can be discovered beneath their ostensible diversity. It was on just this premise that the West African tribal carving could be "reduced" to a work of art.

At the opposite pole from transcendent qualities of timelessness and uni-versality lies style. Style is particular to a time or place or artist or school of artists. It is distinctive and characteristic. It has little more substance, if any, than fashion. To the untutored eye, style may be everything. The well-trained eye of the connoisseur must, by contrast, be able to see beyond the merely stylish and disentangle style from substance. It must have the capa-bility to pierce clear through to a work of art's visual core, where its in-trinsic perceptual value can ultimately be judged. By what rules might one perform such a daunting task? Alas, none. As the late and greatly revered Meyer Schapiro once cautioned, "the best in art can hardly be discerned through rules; it must be discovered in a sustained experience of serious looking and judging."[3]

Still another characteristic idea at the core of aestheticism is that the ideal aesthetic response, to be consistent with its self-sufficiency, ought also be autonomous; it should be fenced off from the getting and spending of every-day life. From the aestheticized point of view, all we can rightfully expect from a work of art is that it be a work of art—not that it be relevant to some other concern. No matter how unimportant any other concern may be, works of art belong to a different—and some would argue, higher—realm. Here is that supreme English aesthete, Clive Bell, writing on the eve of World War I: "Why should artists bother about the fate of humanity? If art does not justify itself, aesthetic rapture does. . . . Rapture suffices. The

artist has no more call to look forward than [does] the lover in the arms of his mistress. There are moments in life that are ends to which the whole history of humanity would not be an extravagant means; of such are the moments of aesthetic ecstacy."[4]

Two further quotations—both courtesy of Woodmansee—might be helpful to an understanding of aestheticism's eighteenth-century origins. The first is from the writings of the little-known German author Karl Philipp Moritz. What is remarkable is its date: 1785, or five years before the publication of Immanuel Kant's *Critique of Aesthetic Judgment,* which has frequently been taken to be aestheticism's jumping-off point. Moritz wrote: "In contemplating a beautiful object . . . I roll the purpose back into the object itself—I regard it as something that finds *completion* not in me but *in itself* and thus constitutes a whole in itself and gives me pleasure *for its own sake.* . . . Thus the beautiful object yields a higher and more distinct pleasure than the merely useful object."[5] Six years later, in what must certainly be one of the boldest statements ever of the aesthetic position, the far-better-known Friedrich Schiller writes, not about the visual arts but about poetry: "The first, essential condition for the perfection of a poem is that it possess an absolute intrinsic value that is entirely independent of the powers of comprehension of its readers."[6]

In twentieth-century America, Archibald MacLeish crafted a particularly graceful statement of the aesthetic position in his 1926 poem, *Ars Poetica.* Likening the ideal poem to a beautifully formed three-dimensional object that the reader might hold in his or her hand to savor its shape, heft, and patina, the poem concludes with these lines:

> A poem should be equal to:
> Not true
>
> For all the history of grief
> An empty doorway and a maple leaf
>
> For love
> The leaning grasses and two lights above the sea—
>
> A poem should not mean
> But be[7]

Why has the aesthetic viewpoint taken so deep a hold in the United States? My own sense is that, surprising as the idea may initially seem, there is a fundamental connection between aestheticism and the foundation stone of

our democratic system of government, the Constitution. What makes our national constitution so distinctive—and in the view of some, so deficient—is its emphasis on process over substance. In terms of life's basic necessities—shelter, sustenance, health care, education, or personal security—it guarantees nothing to anyone. What it offers instead is a framework of governance through which the citizenry's elected representatives are empowered to address those basic needs and decide how to deal with them. It also requires that whatever such decisions those representatives do make must be broadly applicable and that certain individual rights—particularly those that involve liberty or property—are not thereby to be infringed. With only a few exceptions, the separate constitutions of each of the fifty states are similar in their emphasis on process over substance.

In essence, then, we live in a country that—by choice—lacks any constitutionally mandated public ideology. This has important implications for the ways that federal or state governments may, directly or indirectly, provide support to the arts. Consider the opposite case, that of the former Soviet Union. For most of that country's history, the ruling cultural authorities made clear that they would only support art that directly furthered the government's larger and overarching social goals. In practice, that meant art in which the content was clear and broadly understandable, that took a positive point of view toward the Soviet Union and its allies, and that was free of cosmopolitan taint or bourgeois self-indulgence. The cultural authorities most emphatically would not support art that was created for art's sake alone. Such art was consistently condemned for its formalism and denounced as "antipeople" and decadent.

The difference in the United States is immense. When Congress established the National Endowment for the Arts in 1965, it was clear from the beginning that the endowment would, at every point forward, be faced with applications requesting far more funds than it would ever have available to grant. Choices would have to be made. Frequently those would have to be hard choices between worthy applicants. On what basis could a government agency like the NEA permissibly decide which applications to fund and which to reject? Could it follow the Soviet Union's example and use its grant-making authority to further larger governmental purposes? Might it award grants to artists whose work expressed support for the war in Vietnam and reject the applications of those whose works of art expressed opposition to the war? Ditto for government-sanctioned strip mining, or offshore drilling? Ditto for every other government effort of the day?

The answer, of course, was a resounding no. That is precisely the kind of activity that the First Amendment to the United States Constitution forbids. Works of art may, for constitutional purposes, be considered as a form of speech. Not in dispensing money through grants, any more than in collecting money through taxes, may the powers of the federal government—the ultimate 800-pound gorilla—be used selectively to favor one kind of speech (speech that the government likes) over another kind of speech (speech that the government does not like). Similar constitutional prohibitions would have ruled out other schemes for distributing grants based, for example, on the racial or religious characteristics of the applicants or on their political affiliation.

In the end, what Congress was left with—and what Congress adopted as a principle of choice—was a governmentally blessed version of aestheticism. In making its funding decisions, the NEA was to be guided by artistic excellence. Thus was born the NEA's sometimes controversial but ultimately inevitable system of peer review. Artistic excellence was, in turn, to be judged by panels composed of those who had, to echo Schapiro's words, "a sustained experience of serious looking and judging." In virtually every argument concerning the NEA during the thirty years since its inception, those questioning the propriety of an NEA grant have pointed to what they consider objectionable subject matter of the art in question. Those defending the NEA, as well as the agency itself, have responded with the aesthetic argument of intrinsic artistic quality.

The NEA is only one example of the federal government's involvement with the arts. The government also funds half a dozen art museums within the Smithsonian, provides direct and indirect support to other museums throughout the country, and furnishes scholarship funds and guaranteed loans to students who attend schools of art or who study studio art in regular institutions of higher education. On those not infrequent occasions when members of Congress, the press, or the public attack decisions about the expenditure of federal funds in an art-related context, aestheticism will almost invariably be raised as a defense. During my twenty-one years as deputy director of the Hirshhorn Museum, our occasional encounters with hostile members of the public generally followed a course very similar to the NEA's.

Although this privileging of aesthetic excellence may sometimes be a useful strategy to publicly funded museums, it has also involved a considerable cost by sharply deepening the divide that separates the fine arts from the

general public. Two consequences follow. First, only a small (and possibly still shrinking) portion of the public finds either pleasure or relevance in the ongoing production of the fine arts. Second, fine artists themselves have become progressively marginalized in terms of their impact on the social, political, and economic life of the larger society.

Decades of effort to diversify art museum audiences have shown little result. By all available evidence, in Europe and the United States those audiences still and stubbornly tend to be composed predominantly of highly educated visitors. A recent study of attendance conducted jointly at the Smithsonian's Freer Gallery of Art and Arthur M. Sackler Gallery—physically adjacent museums, both devoted primarily to the display of Asian art—suggests just how marked this tendency remains.[8] Between October 1994 and September 1995, 51 percent of the visitors to those museums age twenty-five or older had completed at least one university degree above the bachelor level. That was more than seven times the rate at which such degree holders are represented in the general population. Adding another 32 percent of visitors with at least a bachelor's degree, 83 percent of mature visitors—five out of every six—were college graduates. For the country as a whole, the figure was 20 percent, or one out of five. To many, oriental art may be an esoteric subject, but if we take recent art museum attendance as a whole, the numbers were still telling. Those with a bachelor's degree or higher constituted 42 percent of their attendance.

What does this discrepancy in attendance have to do with aestheticism? In the case of painting, the French sociologist Pierre Bourdieu speculates that the fine arts began to lose their more general audience at the point when Academic art, which had encouraged and prized history painting, with its often familiar narratives and human drama, above all other types, began to be supplanted by a new kind of art that was primarily focused self-referentially upon itself; he marks the rise of impressionism in the 1860s and 1870s as the turning point.[9] Unlike Academic art, which was relatively accessible to anybody who had received a general education, this new painting required a correspondingly new set of skills for its proper appreciation. In a series of books and articles written during some thirty years, Bourdieu argues that these newly required skills—these new aesthetic ways of looking at things—were neither inborn nor natural. Nor were they equally distributed among the public. Rather, he argues, they were skills developed and transmitted through means that were largely peculiar to society's more privileged classes. Taking his argument further, Bourdieu contends that one

of the principal roles of the art museum—and, indeed, of many other cultural institutions—is to contribute to what he calls the "consecration of the social order," through which can be replicated anew in each generation a sense of distinction between those fortunate few who are perceived to be naturally cultivated and those very many others—regarded by some as "barbarians"—who are perceived to lack any capacity for such cultivation.

Without necessarily accepting Bourdieu's argument in full, we can nonetheless say that art of all kinds—not just contemporary art—is being shown today in art museums in ways that demand this new, aesthetic way of seeing in order to be appreciated. For visitors who have not been trained in this skill—who, indeed, may not accept the notion that a painting, like a poem, should not "mean" but "be"—the display of art in this manner can transform the once-inclusive and welcoming art museum into its very opposite: an exclusive and intimidating institution. In a series of focus-group studies conducted with nonvisitors to art museums in the late 1980s, some participants went so far as to explain why they do not visit in terms of shame. Said one, in a typical answer: "I'm embarrassed because I don't know what the stuff means. My overall feeling about the museum is . . . people are there because they know what they are looking at and I don't. . . . I know there is something meaningful there, but I just can't figure out what it is."[10]

The mirror image of the alienated public is the marginalized artist. As recently as the nineteenth century, such creative giants as Victor Hugo and Giuseppe Verdi could play heroic roles in shaping their national histories. Gustave Courbet was involved with the Paris Commune in 1870 and ultimately had to leave France for his purported role in toppling the memorial to Napoleon's Grand Army in the Place Vendome. Today, few artists play prominent roles in public life—either as individual participants, working visibly within or beyond the political system, or through their creative output. In neither painting nor sculpture is more than a handful of work being produced that addresses major issues of our time. To the extent that artists are dealing with these issues at all, they are far more likely to be doing so through video, billboards, installation pieces, or other nontraditional media. One could probably count on the fingers of a single hand the number of artists whose death might make the front page of *USA Today*. Having relinquished its involvement with larger concerns and substituted art itself as its subject, the fine art of today has become a thing apart, and so has the world of the artists who create it.

Beyond this deepened rift between the fine arts and society in general, the widespread adoption of the aesthetic position—at least as it manifests itself in art museums—has had some subtler implications as well. Here we must pause to consider a second value that—along with the aesthetic value—plays a major role in determining the kind of art that museums choose to collect and display. And that is commodity value, determined by the interplay of supply and demand. The compelling logic suggests that aesthetic and commodity values may be independent variables, but the blunt fact is that the less there is of something, the more an art museum tends to value it. A unique work is valued above one made in a limited number of copies; one made in a limited number of copies is valued above one made in an unlimited number. Also relevant to commodity value is the manner in which an object has been produced. Because it is essentially unique, the object from the hand of the artist is preferred over one that the artist played only an incidental part in creating. But any object created at least in part by hand is preferred over one that is wholly produced by machine.

We observed earlier that one of the hallmarks of the aesthetic experience was its disinterestedness—that it was not a step toward the fulfillment of some other purpose but an end in itself. As a corollary, the potential aesthetic value of any object must thereby be in direct ratio to its uselessness, at least for any purpose beyond aesthetic contemplation. When we combine both of these values that art museums take into account—aesthetic value and commodity value—a hierarchy emerges among museum-grade artifacts that is very different from that which prevailed under the Academicism that preceded the development of modern art. Academicism's hierarchy was based on subject matter. History painting was considered more elevated than portrait or landscape painting; and those three types were accorded greater dignity than still life or genre painting. To return to our earlier examples, the painting of the burned-out Croation church would have ranked in dignity above the portrait of Charlie Chaplin, and both would have outranked the half of a cantaloupe. Within the art museum community today, a very different hierarchy prevails.

At the bottom are such machine-made multiples as tableware and housewares. Regardless of their aesthetic merit, without the redeeming quality of either uselessness or scarcity, these objects have only passing interest. Craft objects attract more interest. Although useful (a minus), they are at least handmade and unique (a plus). Limited-edition multiples are their mirror image. Although not as scarce as unique objects (a minus), they at least

are useless (a plus). At the top reign such unique objects as paintings and hand-carved sculpture (plus-plus in both their uselessness and scarcity).

Whimsical as it may seem when described in terms of uselessness and uniqueness, this hierarchy frequently serves as the basis upon which art museums are organized and/or in which the pecking order among a community's museums is established. Within a single museum, it will not be at all unusual to find that the painting and sculpture department, for example, has access to more and better-situated gallery space, a larger staff, and a bigger budget than do the print, decorative arts, and design departments. To the extent that museum directors are drawn from curatorial ranks, it is only rarely that a costume or design curator will be promoted to such a position, but painting curators are so promoted routinely. Likewise, the prestige of an art museum may depend upon what it collects. A craft museum might be regarded as more prestigious than a costume museum but not so prestigious as one that collects and displays original paintings and sculpture.

Two coincidences seem remarkable. One is between this hierarchy of the arts and the parallel hierarchy that might be found in a royal court of the eighteenth century—a hierarchy in which those who did the least and required the most occupied the topmost tier, and those who did the most and required the least were at the bottom. The second coincidence has to do with the timing of when this hierarchy of the arts began to emerge. As Carol Duncan has pointed out, it was the burgeoning of aesthetic theory in the late eighteenth century that initially stimulated the establishment and growth of art museums. The art museum "is a corollary to the philosophical invention of the aesthetic . . . powers of art objects: if art objects are most properly used when contemplated as art then the museum is the most proper setting for them, since it makes them useless for any other purpose."[11]

Is it merely a coincidence that the art museum began its ascent in Western consciousness during the very years when the aristocratic court—which it so oddly resembles—was beginning its long decline? Or is it possible that one of the most salient characteristics of the aristocratic court—as a hierarchy in which the prestige accorded to an individual depended upon that person's rank within the system—was subtly replicated within the art museum? That the museum's hierarchy was composed of objects of different kinds rather than nobles of different ranks might be beside the point; the message was the same: There is a natural ordering to things. At the bottom are the many who must work. Only through their usefulness can they even

hope to secure any place in the hierarchy at all. At the top are those whose idleness gives them value, whom we associate with the luxury of costly things, whose value derives from who they are, not from what they can do.

Writing about works of art in general, sociologist Vera L. Zolberg notes that they "have long been luxury commodities, valued for their rarity, association with nobility, foreign cachet, and romantic genius. These attributes, extrinsic to the works' aesthetic substance, have been said to create an aura, contact with which, through ownership or appreciation, provides symbolic legitimation for high social status. The extra-aesthetic character of art is no new discovery, having been variously analyzed since at least Veblen by Marxian and non-Marxian thinkers alike."[12]

Is it not possible that this status-conferring power of art is not, as Zolberg states it, "extrinsic to [its] aesthetic substance," but rather that it is deeply—even inextricably—intertwined with its aesthetic substance? Implicit in the aesthetic attitude—and deeply embedded in the experience of visiting the art museums of this country in which that attitude is dominant—is not merely the notion of hierarchy but the notion of a very particular hierarchy as the natural order of things.

Because art museums have become one of our most important occasions for public architecture, and because they are thought by many to be institutions that embody some of society's highest aspirations, it has become commonplace in recent years to speak of them as successors in some sense to the great churches and cathedrals of earlier centuries. Artists and museums alike have become implicated in this imagery. Artists—consistent with their pursuit of the timeless universal—aspire to achieve transcendence. Critics scour their work for signs of spirituality. Museums are seen by some as the sites of a secular religion; others see them as "temples of contemplation." In his 1977 social history of American art museum, for example, Nathaniel Burt refers to them as "Churches of the Eye."[13] Not content with the religious imagery swirling around museums, Burt supplemented it with a comparison of his own. He titled his book *Palaces for the People.*

Burt's account, true to its title, focuses on the art museum as a leveling institution, where rich and poor alike can enjoy access to remarkable objects that once were reserved for the pleasure of a select few. Absent from his account is any sense of how ironic it might be to describe such museums as "palaces." The very notion of a palace is shot through with hierarchal and antileveling associations. A palace was not merely an opulent or luxurious

residence; a palace was where a king or prince lived and held court. As Norbert Elias pointed out in *The Court Society,* no noble below the rank of prince was even permitted to use the word "palace" to designate his dwelling place.[14] The kings of old may long be dead, but in the museum-palace of today their successor—the unique, handmade, utterly useless work of art prized only for its intrinsic perceptual value—sits firmly on the throne. The message, to whatever degree subliminal, remains the same. Idleness is valued above labor, the unique is valued above the common, and what is unrepeatable and costly is valued above what might be made available to all at a modest cost. To those who do think of the art museum as a leveling institution, that may indeed seem like a strange message. To those who think of it more broadly—who think that the art museum, like other museums and, indeed, like all the other institutions of the humanities, should help us to think about what it means to be a human being living on this earth—it is also a remarkably constricted message.

Might things be otherwise for art museums? Must there be so deep a disconnect between the rarified domain of the fine arts and that larger world that so many of us are puzzling to understand? American museums are so deeply immersed in this aesthetic approach that it is scarcely conceivable that they could suddenly reestablish themselves on some wholly other basis. Nor has anybody been able to suggest what basis that might be. Aestheticism has given many of us—and can continue to provide—experiences that we would be reluctant to part with, moments of extraordinary wonder and the most profound pleasure. Further, the arguments based on artistic quality, for which aestheticism provides a framework, have helped museums defend themselves against interference from governmental and other sources. What does seem a practical expectation, which we might be witnessing in embryo, is some tempering of aestheticism. Sought in its stead is a greater recognition that aestheticism is an option and not an imperative, that it is simply one way, but not the only legitimate way, to approach works of visual art.

Where might we see signs of such a change? Some museums have mounted exhibitions that emphasized the social, cultural, and historical contexts in which works of art were produced, rather than their traditionally formal aesthetic properties. For museum visitors nurtured on aestheticism, such exhibitions may come as something of a shock. Writing in the *Chronicle of Higher Education,* Professor Alan Wallach of the College of William and Mary described the audience response to one such instance, the 1994 ex-

hibition of Thomas Cole's paintings that he and William Truettner of the National Museum of American Arts had organized to be shown in Washington, D.C., Hartford, and Brooklyn.[15] In the exhibition, Wallach and Truettner had sought to show that Cole's paintings specifically embodied the artist's pessimistic response to certain events of his time. The negative reaction of one visitor was typical. "I think it's problematic to impose the spirit of the age on paintings; it discounts the importance of understanding the artist as a creative genius who somehow transcends the spirit of his or her age." Wallach ruefully concluded, it may take "years of patient labor" to reorient an art museum audience so deeply steeped in such notions, but he seemed to have confidence that it might be done.

At other times, critics may take the lead. One such instance—concerning classical music rather than fine art—involved a performance at New York's Lincoln Center of two works for chorus and orchestra by Sergei Prokofiev. Both were written during the bloody Stalinist purges of the late 1930s, and both straight-facedly celebrated the liberties graciously bestowed upon the citizens of the Soviet Union by the author of those very purges, Joseph Stalin. Discussing their inclusion in the Lincoln Center Festival, festival director John Rockwell explained that it was because "they have abstract musical worth—formalist integrity, if you will."

Writing in the *New York Times,* Berkeley musicologist Richard Taruskin took issue with "abstract musical worth" as a legitimate basis on which to present these works.[16] What was most significant about them, he said, was not their "abstract musical worth" but the context from which they came: the immoral conditions under which—and the cynicism with which—Prokofiev had composed them. To elevate formal aesthetic values over other humanitarian concerns was, Taruskin charged, an act of "moral indifference." So blind an adherence to aestheticism was not only debasing and degrading; it might, he concluded, also help to explain "the tremendous decline in the prestige of classical music—and of high art in general."

Sometimes, wise voices may speak to us from out of the past. In the case of the museum community, one such voice was that of Ananda K. Coomaraswamy, the first curator of the great Indian collection at Boston's MFA. In opposition to the notion that there could be an art for art's sake, Coomaraswamy insisted that art, by definition, could not be an end in itself, but rather was simply the by-product of "the making well, or properly arranging, of anything whatever that needs to be made or arranged."[17] The critical word in Coomaraswamy's formulation is "needs." Things only need

to be made or arranged if they will have some meaning or serve some purpose. Objects not intended to meet any worthwhile need are nothing more than ornaments. Objects intended to meet a worthwhile need ought be judged by their effectiveness in meeting that need, not by the visual form in which they happen to have been fabricated. To emphasize the visual form of these objects above their "content or true intention" is to turn things on their head. Consistent with that position, Coomaraswamy contended that art museums should not collect or display works of contemporary art that had been created for no better purpose than to satisfy what he called the artist's vain ambition to see his or her work on display in such a museum.[18]

Finally, artists themselves may take the lead in seeking to moderate the dominance of the aesthetic attitude. Among those prominent in this regard has been the German-born American conceptual artist Hans Haacke. "The gospel of art for art's sake," Haacke says, "isolates art and postulates its self-sufficiency, as if art had or followed rules which are impervious to the social environment. Adherents of the doctrine believe that art does not and should not reflect the squabbles of the day. Obviously they are mistaken in their assumption that products of consciousness can be created in isolation."[19]

In recent years, the anti-aesthetic position has found its most forceful expression in politically activist art addressing such front-burner public issues as the environment, AIDS, homelessness, violence against women, segregation, and racism. In keeping with its subject matter, this art is often confrontational; in keeping with its anti-aesthetic stance, it may frequently be shrill. Often it will have been created by collaborative groups rather than individual practitioners; some examples are the Guerilla Girls, Gran Fury, and Group Materials. This art is intended to reach a broader public than those who ordinarily visit museums or art galleries. To reach them, it will often be disseminated through billboards, bus advertisements, and other media rather than at more customary venues. Art historian Nina Felshin describes politically activist art as being shaped by the "real world" in distinction to the "art world."[20] Notwithstanding her claim that such art "exploded" in the 1990s and is still "thriving," there seems sadly little to indicate that it has affected the direction of public events in any substantial measure. What it has done is to expand greatly the range of means by which artists might engage themselves with a wider spectrum of the public than the narrow band to which they now appeal.

Such a tempering of aestheticism might have several important and positive consequences. For artists—freed from the tyranny of practicing art for

art's sake as virtually the exclusive path to recognition by the museum establishment—it would open broad new opportunities to approach their art in other ways. To the extent that some might be prepared suspend their pursuit of the timeless and universal and choose instead to address here-and-now issues, the public discourse could be immeasurably enriched. At the very least, artists might provide memorable images through which those issues might be reformulated and brought to public attention in visually compelling ways.

Where is it written that we might never again have paintings that speak to an entire nation, like Delacroix's *Liberty Leading the People*, Goya's *Third of May*, or even Picasso's *Guernica*? And why must the small body of history painting that is created today be so consistently soured by irony? On a less grand scale, why might we not encourage artists also to use their skills to comment on the smaller dramas of everyday life or the passing political scene? Why should we not be able to look forward with pleasure to another Hogarth or Daumier? And so on, across the board. With the monolith of aestheticism pushed even slightly from dead center, art could grow a far richer and more varied garden than we currently enjoy. More important still, we might begin to reconnect what has become so sadly and radically disconnected: the visual arts and the world of everything else.

Likewise, the art-viewing public could be greatly enriched—it could probably be greatly enlarged as well—if it were enabled to expand the range of ways in which it can respond to art. The issue is not one of suppressing the aesthetic response, but of supplementing it. As the reactions to Wallach and Truettner's Thomas Cole exhibition suggested, the public has been so thoroughly beaten with the aesthetic stick that it scarcely dares to react to works of art in what may be richer and perhaps more deeply felt ways. Well-bred visitors rarely display any horror, lust, envy, or open amusement at the things they see in art museums, regardless of how horrifying, lust-inducing, luxurious, or funny those things may be. What they respond with is polite appreciation. Whether or not art museums are solely to blame for such an attenuated response, they are clearly in the best position to address it, and they should.

Such a tempering of aestheticism might have one last consequence as well. If another speaker should ever stand before an AAM meeting to describe how an object spirited from his country had found its way to a museum, where it was stripped of its deeper meanings and "reduced to nothing more than a work of art," perhaps—mingled with the laughter, nervous

or otherwise—there will also be some greater and more genuine sense of just what he meant. Becoming a work of art may not always be the highest and best thing that can happen to an object.

NOTES

1. Reprinted in Linda Nochlin, *Impressionism and Post-Impressionism 1874–1904: Sources and Documents* (Englewood Cliffs, N.J.: Prentice Hall, 1966), 187.

2. Martha Woodmansee, *The Author, Art, and the Market: Rereading the History of Aesthetics* (New York: Columbia University Press, 1994). In his admiring introduction to this volume, Arthur C. Danto makes the point that the rise of aestheticism "was not a new chapter in an ongoing story but a whole new story misread as a new chapter."

3. Meyer Schapiro, *Modern Art: Nineteenth and Twentieth Centuries* (New York: George Braziller, 1978), 232.

4. From Bell's 1914 volume, *Art.* Quoted in D. W. Gotshalk, *Art and the Social Order* (Chicago: University of Chicago Press, 1947), 231.

5. Woodmansee, *Author, Art, and the Market,* 12.

6. *Ibid.,* 78.

7. Archibald MacLeish, *Poems 1924–1933* (Boston.: Houghton Mifflin, 1933), 122.

8. The figures that follow are drawn from *America Meets Asia,* a report based on the 1994–1995 Freer Gallery of Art and Arthur M. Sackler Gallery visitor study by Stacey Bielick, Andrew J. Pekarik, and Zahava D. Doering published as *Report 96-2A* of the Smithsonian's Institutional Studies Office, March 1996.

9. For a representative sampling of Bourdieu's work in this area, see Pierre Bourdieu, Alain Darbel, and Dominique Schnapper, *The Love of Art: European Art Museums and Their Public* (Stanford: Stanford University Press, 1990); Pierre Bourdieu, *Distinction: A Social Critique of the Judgment of Taste* (Cambridge: Harvard University Press, 1984); Pierre Bourdieu, *The Field of Cultural Production: Essays on Art and Literature* (New York: Columbia University Press, 1993).

10. *Insights: Museums, Visitors, Attitudes, Expectations: A Focus Group Experiment* (Los Angeles: Getty Center for Education in the Arts, 1991), 10.

11. Carol Duncan, *Civilizing Rituals: Inside Public Art Museums* (London: Routledge, 1995), 14.

12. Vera L. Zolberg, "Tensions of Mission in American Art Museums," in *Nonprofit Enterprise in the Arts: Studies in Mission and Constraint,* ed. Paul J. DiMaggio (New York: Oxford University Press, 1986), 185.

13. Nathaniel Burt, *Palaces for the People: A Social History of the American Art Museum* (Boston: Little, Brown, 1977), 416.

14. Norbert Elias, *The Court Society* (New York: Pantheon Books, 1983), 54.

15. Alan Wallach, "Museums and Resistance to History," *Chronicle of Higher Education,* September 21, 1994.

16. Richard Taruskin, "Stalin Lives, in the Concert Hall," *New York Times,* August 25, 1996, H26.

17. Ananda K. Coomaraswamy, "What Use Is Art Anyway," in *What Use Is Art Anyway? Six Broadcasts Sponsored by Boston Museum of Fine Arts, January and February 1937* (Providence: John Stevens, 1937), 1.

18. *Ibid.,* 4.

19. Hans Haacke, "Museums, Managers of Consciousness," in *Hans Haacke: Unfinished Business,* ed. Brian Wallis (New York: New Museum of Contemporary Art, 1986), 66.

20. Nina Felshin, ed., introduction to *But Is It Art? The Spirit of Art as Activism* (Seattle: Bay Press, 1995).

John Cotton Dana's New Museum

For museum workers of my generation, John Cotton Dana (1856–1929) was largely a legend. His last full-length biography was published in 1940. The little that most of us knew about his career came primarily from the chapter devoted to him in Edward P. Alexander's 1983 *Museum Masters: Their Museums and Their Influence*. The larger part of his writings—originally published in the most fugitive of forms—had disappeared from view. The only thing readily extant was the edited reprint of *The New Museum* included in the special Dana issue of *The Museologist* that Barbara H. Butler edited for the Mid-Atlantic Association of Museums in 1988. Even the last few living links to Dana had dissolved. Gone from the scene were such senior colleagues as Dorothy Dudley and Dorothy Miller, both at the Museum of Modern Art, who had apprenticed under Dana in the groundbreaking museum studies program he initiated at the Newark Museum in 1925. But with the publication of *The New Museum: Writings by John Cotton Dana* in 1999, both Dana and his work have been restored to us.

This was written as the introduction to *The New Museum: Selected Writings by John Cotton Dana* (Newark and Washington, D.C.: The Newark Museum and the American Association of Museums, 1999). Reprinted with permission. Copyright 1999, the American Association of Museums and The Newark Museum. All rights reserved.

As perhaps befitted his New England Puritan ancestry and early legal training, Dana was hardheaded and eminently practical, little given to sentimentality and prepared to unleash his curmudgeonly and coruscating wit at any sign of pretense. His own turn-of-the-century description of himself was as "an agnostic . . . an egotist, a pessimist and an anarchist." That description notwithstanding, readers of *The New Museum* will find a certain sweet and distinct idealism repeatedly shining through his otherwise acerbic prose. There were two things in which Dana appeared to have a particular faith. One was in the capacity of museums in the United States to better themselves, to dispel the gloom into which he believed they had sunk through their slavish imitation of inappropriate European models. The other was in the power of beautifully wrought objects—as grand as works of art or as humble as pots and pans—to enrich the lives of individuals at every level of society.

With respect to the "betterment" of museums, Dana found a hopeful analogy in the institution to which he had devoted his earlier career: the public library. Writing in 1921, he recalled that forty years earlier, the management of libraries had been based on the proposition that "a library should first of all strive for size, completeness, and for the reverence of the unlettered and the respect of the learned." During the intervening decades, he had watched the library—indeed, he himself had played a pivotal role in its transformation—evolve from "a closed temple of 'wisdom undisturbed' to an open workshop of delight and learning." The proper measure of this newly evolved library was not what it owned but what it did, not the size or completeness of its collection but its capacity "to be of immediate practical aid to all of the community that supports it." Dana thought that museums should strive to emulate this model, "to be of direct and useful service to those who found and maintain them—the general public." For Dana, it was only a matter of time before the management of every museum would come to its common sense and realize that its most promising future lay not in mindlessly amassing ever more objects but in providing a "full and rich utility" to its community.

Dana's belief in the positive role that beautiful objects might play in everyday life contrasted dramatically with the enormous scorn he repeatedly directed toward the burgeoning, older-style art museums of New York, Philadelphia, and other metropolitan centers. Typical is his description of how the European-style art museum had been misguidedly replicated in the United States in the form of a public institution:

[When the] common people found that they had, through taxes, money held in common and at their own disposal through their elected servants, they decided to use some of it to buy museums for themselves. Unfortunately, no one was at hand to tell them that they would get no pleasure or profit out of the kinds of museums which kings, princes, and other masters of people and wealth had constructed; and so, being ruled by precedent or fashion, as were also their rich donors, their important citizen-trustees, and their architects, they voted for, or silently approved, spending public money for the old kinds of museums. They cared more to be in the fashion than they did to get something useful and enjoyable.

In condemning those museums—together with the older European works of art that they principally displayed—Dana offered several arguments. First, he said, it was pointless to devote a museum entirely to the display of objects that had no connection to the lives of most of its potential visitors. Second, the belief that these works of art might nevertheless exert some beneficial influence—to think that "museum pieces need only to be seen to produce in those who see them a certain elevation of soul, a definite impulse to better living, and a beautiful and helpful broadening of the mind"— was a delusion. Finally, to display only such works to the exclusion of everything else was more than simply pointless, it was actually pernicious. It inevitably suggested to the public that only things that were old, rare, costly, and mostly of foreign origin were capable of providing visual delight. And that, in turn, could only undermine the public's understanding of how much satisfying design and beauty might be inherent in the everyday objects produced in their own time and country and frequently available at modest prices.

In Dana's view, the true work of the museum as a service institution was in enriching the quality of its visitors' lives, not in accumulating masterpieces for its own greater glory. One way to do that was by helping its visitors cultivate their own individual sensibilities in such a way that beautiful objects could provide them with pleasure and serve as the source of a satisfying lifelong interest. The old art museum, with its emphasis on certifiably important objects that virtually none of its visitors could ever hope to connect with, did not offer such cultivation. The new museum that Dana envisioned would do precisely that. "In art matters," he wrote, "it is more important to be sensitive than to be knowing; it is better worthwhile to feel that a thing is right for you and to get pleasure with the feeling than it is to know who made it and when, where it was made and under what condi-

tions, who has owned it, who now owns it, what he paid for it, and what great critics have said of it."

This missionary sense—that the museum has both the capacity and the obligation to be a life-enhancing institution—is the hallmark of all of Dana's writings. Sometimes, as in *The New Museum,* he described the museum's role in positive terms. Its "one and obvious task," he wrote, is "adding to the happiness, wisdom and comfort of members of the community." At other times he defined it through negation, specifying what the museum was not and ought not to be. He rejected as baseless conventions an entire host of then-current notions about museums: what he called the "old doctrine that a museum, like beauty, is its own excuse for being" and the belief that the museum ought to serve principally as a storehouse to safeguard humankind's common heritage and as a place in which curators can educate and even (his word) "entertain" themselves. Above all, he rejected the idea that simply to collect objects was to create a museum. Objects were easy to get, but objects alone were not a museum. They "merely form a 'collection.'" The worth of a museum, he repeatedly said, was in its use.

Dana's prescience was awesome. He articulated as nobody previously had done the informal nature of learning in museums. He foresaw the need of museums, schools, and libraries to collaborate. He emphasized—long before marketing concepts became current—the importance of connecting program decisions to the needs and interests of the museum's community. "Learn what aid the community needs," he said, and "fit the museum to those needs." He speculated on the extent to which a museum might be an enterprise that could be better managed as a business. He explored the possibility of branch museums and other forms of outreach. He understood how advertising and public relations might be used to further institutional goals.

In some instances, Dana's ideas came to fruition only years later and in the hands of others. At the Museum of Modern Art (which opened just four months after his death in 1929), Dana's notion of showing well-designed and readily available objects of everyday utility achieved its fullest realization in the series of *Good Design* exhibitions that Edgar Kaufmann Jr. mounted in the early 1950s in cooperation with Chicago's Merchandise Mart. Dana's belief that a museum should be community based rather than discipline based was ultimately to find its most complete expression in the Anacostia Neighborhood Museum that the Smithsonian Institution opened in 1967. When that museum's founding director, John R. Kinard, described

it as encompassing "the life of the people of the neighborhood—people who are vitally concerned about who they are, where they came from, what they have accomplished, their values and their most pressing needs," one could almost hear Dana speaking through him.

Some of Dana's other ideas are only now starting to be realized. Of those, perhaps the most startling was his anticipation of a basic truth that the museum community has only begun to grasp some seven decades after his death: that there must be some demonstrable relationship between the support that a museum receives from its community and the value that the museum is able to return to the community in exchange. In 1920 Dana wrote:

> All public institutions (and museums are not exceptions to this rule) should give returns for their cost; and those returns should be in good degree positive, definite, visible, measurable. The goodness of a museum is not in direct ratio to the cost of its building and the upkeep thereof, or to the rarity, auction value, or money cost of its collections. A museum is good only insofar as it is of use. . . . Common sense demands that a publicly supported institution do something for its supporters and that some part at least of what it does be capable of clear description and downright valuation.

Dana was rarely explicit about the kinds of values he envisioned the museum returning to the community—if pressed, he might have responded that those values were, in every case, something to be negotiated between a specific museum and its particular community. They would probably have all fallen within the boundaries cited earlier from *The New Museum:* They must somehow add to the community's happiness, wisdom, and comfort. About the final configuration of such a museum, Dana was specific: No such final configuration was possible: "A finished museum is a corpse, and so is a finished collection. In common with all other institutions, a museum to be of any value must grow; and it must do more than that—it must change its objects, their manner of presentment, and its method of management that it may meet the ever changing needs of a changing order of society."

If Dana's writings had been more widely available in the years after his death, might the history of this country's museums have been different? Conceivably, museums might still have come out where they are today—with their focus shifting from collections care to visitor services—but perhaps they could have done so sooner and with less anguish. Only now, with Dana's writings in hand, can we realize how much we miss him, how badly we need to hear his views. No serious conversation about museums may ever again be possible without his participation.

THE MUSEUM
IN THE PUBLIC SPHERE

19

The Museum and the Public

For the sake of simplicity in addressing the topic of "The Museum and The Public," I will be using those two big words—"museum" and "public"—as if each had behind it some single, monolithic, sharply defined reality. Neither, of course, does. Museums are almost infinite in their variety and occupy a field with fuzzy edges. The public is not singular but plural, in no way sharply bounded but perceived and defined differently from one observer to the next. Likewise, from time to time I may employ that always slippery pronoun "we" in a way that seems too encompassing. Feel free to disassociate yourself from any such use. In general, "we" will be intended to refer to a majority—or at least plurality—of the people who spend substantial time thinking, talking, or writing about the museum and its situation.

I will propose that the relationship between the museum and the public must be understood as a revolution in process, a revolution in the most fundamental sense of that term. At the museum's birth—some two hundred years ago in Europe and only a little more than one hundred years ago in America—its position vis-à-vis the public was one of superiority. Com-

This text was originally presented at a public lecture in April 1997, at Teachers College, Columbia University, under the auspices of that college's Program in Arts Administration and as part of its Artists, Scholars, and Executives in Residence Program. It subsequently appeared in *Museum Management and Curatorship*, vol. 16, no. 3 (1997). Reprinted from *Museum Management and Curatorship*, vol. 16, no. 3, pages 257–271, copyright 1997, with permission from Elsevier Science.

monly used spatial metaphors made this relationship clear: The museum was established to "raise" the level of public understanding, to "elevate" the spirits of its visitors, and to refine and "uplift" the common taste. There was no ambiguity in this. Museums were created and maintained by the high for the low, by the couth for the uncouth, by the washed for the unwashed, by those who knew for those who didn't but needed to know and who would come to learn. The museum was established to "do"; what was to be "done" was the public. The museum was a place of inculcation. At some point— probably not more than forty to fifty years into the twenty-first century— the relative positions of the museum and the public will have revolved a full 180 degrees. In their emerging new relationship—already to be glimpsed in a myriad of ways—it will be the public, not the museum, that occupies the superior position. The museum's role will have been transformed from one of mastery to one of service. Toward what ends that service is to be performed, for whom it is to be rendered, and how, and when—those are all determinations that will be made by the museum's newly ascendant master, the public.

What follows is in three parts. First, I would like to look briefly at the museum as it was in its earliest days, and particularly at the ways it was thought to relate to the public. Then I will turn to consideration of the museum of the near future, which we can begin to discern as emerging from the worn and hollowed-out husk of that old museum. Finally, I will look back at some of the factors that account for the loss of the museum's initially superior position and then examine some phenomena that seem to me symptomatic of the ongoing metamorphosis through which the public is succeeding to the museum's formerly commanding position. My basic contention is that we—and again readers are free to disassociate themselves from that "we"—are engaged in a process of adaptive reuse. What we have inherited was once a grand and imposing structure. With most of its ideological foundations long since rotted away, that structure can no longer function in all the ways its builders intended. Few of us, though, are prepared to tear it down or even just to walk away and leave it to collapse. It still provides value and, properly adapted, it could provide far greater value still. Although this work of adapting the museum to better serve the public's needs is far from successfully accomplished, the museum community shows heartening signs that it is well under way.

To begin, then, with some beginnings. The Museum of Fine Arts in Boston was established in 1870. In arguing for its establishment, Charles

Callahan Perkins—destined to serve as one of its first trustees—was explicit in describing what such an institution might offer to the public at large: "There exists a modicum of capacity for improvement in all men, which can be greatly developed by familiarity with such acknowledged masterpieces as are found in all great collections of works of art. Their humblest function is to give enjoyment to all classes; their highest, to elevate men by purifying the taste and acting upon the moral nature."

Beyond the capacity to elevate the taste and purify the morals of its visitors, the museum was also envisioned by its founders as providing a wholesome alternative to the seamier forms of diversion that might otherwise tempt the working-class inhabitants of those burgeoning nineteenth-century cities where the earliest museums were established. The original program for the Metropolitan Museum of Art—also founded in 1870—proposed that the new institution not only cultivate a "pure taste in all matters connected with the arts" but also provide the people of New York City with a "means for innocent and refined enjoyment." As for uplift, William Cullen Bryant said that the new museum would provide "entertainment of an . . . improving character." Discussing the advantages of adding evening hours for the public at London's South Kensington Museum (subsequently to be renamed the Victoria & Albert Museum) Sir Henry Cole, the museum's superintendent, projected the following scene:

> The working man comes to this Museum from his one or two dimly lighted, cheerless dwelling rooms, in his fustian jacket [fuschen: an inexpensive cloth combining cotton and flax] with his shirt collar a little trimmed up, accompanied by his threes, and fours, and fives of little fustian jackets, a wife, in her best bonnet, and a baby, of course, under her shawl. The looks of surprise and pleasure of the whole party when they first observe the brilliant lighting inside the Museum show what a new, acceptable, and wholesome excitement this evening entertainment affords to all of them. Perhaps the evening opening of Public Museums may furnish a powerful antidote to the gin palace.

On another occasion, Sir Henry suggested that keeping the South Kensington Museum open on Sundays as well as evenings might be a way, in his phrase, of "defeating Satan." As it was in New York and London, so too in Paris: The conversion of the Louvre from a palace to a museum in the years immediately following the French Revolution was multiple in its purposes. It was intended to provide a facility for training artists who would subsequently employ their talents on behalf of the state. It was also intended

to symbolize the newborn freedom of the people, in which access to what had once been exclusive to the aristocracy and clergy would now be universal for every citizen. Such access, as George Heard Hamilton has written, "was not solely for aesthetic pleasure, but for the inculcation of political and social virtue. Though Napoleon's imperial ambition eroded the earlier artistic morality, there remained a strong belief that acquaintance with great art improves the morals as it does the taste of the individual and thus contributes to the general welfare of society."

Founded on a somewhat different premise from the art museum was the natural-history museum. There the goal was not so much to inculcate virtue as to locate the place that its Western and predominantly Caucasian visitors occupied in the terrestrial order of things. And that place, beyond any doubt, was at the top of things, certainly above the dinosaurs—sometimes portrayed as bird-brained losers—seashells, tigers, and swordfish, but also above the little red, brown, and yellow people who appeared in dioramas or scale models with their quaint but primitive hunting weapons, clothing, shelter, and cookpots. In an evolutionary twist, the societies that these people inhabited were not presented as self-sustaining and functional responses to the particular circumstances in which their members lived. These societies were depicted, rather, as passing through one of advanced society's earlier stages of development, as living examples of civilization's long-gone past. Consider the following extract from the British Museum's *Handbook to the Ethnographic Collections,* all the more shocking because it was first published within our own century, in 1910, and republished almost within our lifetimes—mine, anyway—in 1925. It reads:

> The mind of primitive man is wayward, and seldom capable of continuous attention. His thoughts are not quickly collected, so that he is bewildered in an emergency; and he is so much the creature of habit that unfamiliar influences such as those which white men introduce into his country disturb his mental balance. His powers of discrimination and analysis are undeveloped, so that distinctions which to us are fundamental, need not be obvious to him. Thus he does not distinguish between similarity and identity, between names and things, between the events that occur in dreams and real events, between the sequence of ideas in his mind and of things in the outer world to which they correspond. His ideas are grouped by chance impressions, and his conclusions often based on superficial analogies which have no weight with us.

Key to understanding the art and natural-history museums in their earliest manifestations is that they were both celebratory: The art museum cele-

brated "acknowledged masterpieces"; the natural-history museum cele-
brated Western humankind's place in nature. No less celebratory in its
founding days was the history museum. In its European version what it
tended to celebrate was military victory. Almost invariably, it was founded
and maintained by the state. At the extreme end of the scale was the Gallery
of Battles opened by Louis-Philippe at Versailles in 1837. Some 400 feet
(122 meters) long, it is hung with huge canvases depicting the glory of French
arms. With each new war—win or lose—new paintings were to be added.

In the United States, history museums evolved somewhat differently. Al-
though also celebratory, they were initially private in their inception, tended
to grow out of local historical societies, were frequently located in historic
houses, and were as much concerned with civic virtue as with military valor.
Civic virtue, in turn, was largely defined by success in politics, the profes-
sions, or business. The subject matter ultimately celebrated in most of these
museums (at least in the East; a somewhat different tradition developed in
such populist Midwestern states as Wisconsin and Minnesota) was the com-
munity's first families. Those who principally supported these museums,
served on their boards, worked in them, or even directed them were often
none other than the descendants of those same first families. The stories
that these museums told were invariably success stories. The greatest suc-
cess story of all, and the model for many others, was that of George Wash-
ington. Campaigning in the mid-1850s for the establishment of Mount Ver-
non as a historic-house museum, South Carolina's Ann Pamela Cunningham
called for it to be a "shrine" where "the mothers of the land and their inno-
cent children might make their offering in the cause of [the] greatness,
goodness, and prosperity of their country."

Let us turn to the museum of the near future. Will it too be celebratory?
Perhaps, or perhaps not. What will be important and what will be differ-
ent are not so much what particular stance the museum may take but how
the decision to take that stance is to be made. In that museum, it will be
primarily the public, and not those inside the museum, who will make those
decisions. And what, in turn, can those museum insiders be expected to
bring to the table? The answer, I think, is their astonishing technical ex-
pertise. As I wrote in another context, "Museum workers are fundamen-
tally technicians. They have developed and passed along to their succes-
sors systematic ways in which to deal with the objects (and with information
about those objects) that their museums collect and make accessible to the
public. Through training and experience they have developed a high level

of expertise as to how those objects ought properly be collected, preserved, restored, classified, catalogued, studied, displayed, interpreted, stored, transported, and safeguarded."

The museum of the near future, as thus envisioned, will in itself be an ideologically neutral organization. It will in essence be one of a range of organizations—instruments, really—available to the supporting community to be used in pursuit of its communal goals. As an intricate and potentially powerful instrument of communication, it will make available to the community, and for the community's purposes, its profound expertise at telling stories, eliciting emotion, triggering memories, stirring imagination, and prompting discovery—its expertise in stimulating all those object-based responses.

And how might the community choose to use the museum? In as many ways, certainly, as different communities at different times might have different needs. We know already that the museum has proven itself to be a remarkably flexible instrument. The history museum, for example, has shown that beyond being celebratory, it can also—as Professor Joyce Appleby of UCLA has pointed out—be compensatory, and that beyond praising history's winners, be they military, political, professional, or economic, it can also seek to soothe the pain—or at least recognize, memorialize, and try to understand the losses—of history's victims. Our repertory of museum types has expanded enormously in just the past two decades. Consider, for example, the Famine Museum that opened in Strokestown, Ireland, in 1994, or the U.S. Holocaust Memorial Museum in Washington, D.C., or the Yad Vashem Memorial in Jerusalem. In much the same way that Maya Lin's Vietnam Memorial differs from the celebratory war memorials of earlier conflicts, these new museums are places of memory, places for inward and sober reflection. Likewise, the art museum and the natural-history museum have cloned off variants of themselves, which can serve a multiplicity of public purposes.

How was this revolution set into motion? How was the museum so unceremoniously dethroned from the sovereign position in which it was first established? One factor, certainly, was money. As the report submitted to the White House in February 1997 by the President's Committee on the Arts and Humanities made clear, the dependence of the America's museums on government for their support exceeds that of other arts institutions by a ratio of almost four to one. In the case of museums, just under 30 percent of their 1995 income was from governmental sources; for the other groups

surveyed, nonprofit theater was the highest at 6.5 percent, and symphony orchestras and opera companies were each at 6 percent. So disproportionately great a dependence on governmental support requires that museums, far more than other cultural organizations, keep themselves at all times finely tuned as to how they are being perceived, not merely by their visitors and potential visitors but also by the larger, tax-paying public upon whose goodwill and at least tacit approval they have made themselves so dependent. In those bygone days when museums were supported largely by the contributions of their well-to-do trustees, a touch of royal arrogance might not have been wholly unexpected. With so radical a shift in their sources of support—only 22.8 percent of their support was received through private contributions in 1995, when every other group surveyed by the president's committee received between 30 and 40 percent—whatever arrogance the museum may have once displayed toward the public has long since been converted to deference.

In accounting for the public's growing ascendancy, money figures in a second way as well. Given the recurring fear that levels of governmental support might fall victim to budget balancing, museums have become ever more intense in their pursuit of earned income, whether through increased admissions revenue and/or the net proceeds from such auxiliary activities as on-site and off-site gift shops, mail-order catalogs, restaurants, facilities rentals, and foreign travel tours. Consider this irony: Sir Henry Cole originally envisioned the museum as a wholesome alternative to the gin mill, but given the innumerable social events for which museums rent themselves out these days, it is by no means clear that the museum itself has not *become* the gin mill. In its pursuit of earned income, the museum has inevitably—kicking and screaming, certainly, but nonetheless inevitably— put itself in a marketing mode. In planning special exhibitions, and in creating the special merchandise it hopes to sell in conjunction with such exhibitions, the degree to which these will appeal to the public is necessarily taken seriously into account.

The American Museum of Natural History's exhibition *Endangered! Exploring a World at Risk* is a case in point. According to the *New York Times* (March 13, 1997), the American Museum spent an estimated two hundred to three hundred thousand dollars to publicize the exhibition. Asked whether he thought such an expenditure for a single, five-and-a-half month exhibition was unusual, New York City's commissioner of cultural affairs Schuyler C. Chapin said, "I think the American Museum is increasingly

moving in a new, more visible direction, using the tools of modern marketing in a precise way. And I think the museum is trying to bring in a larger family audience." Among the special gift shop items that the family audience could buy were a fifty-five-cent pencil with the exhibition's logo, a seventy-five-hundred-dollar chessboard made of Cambrian slate with gold and silver chess pieces in the forms of endangered species, exhibition-relevant plush toys, and a CD-ROM, *The Encyclopedia of Endangered Species*. By yet another metamorphosis, museum visitors, once the people to be "done," have been transformed into customers. And as customers—like those legendary people who pay the piper—they can with increasing frequency call the tune. Money, or the need for it, does not wholly account for the loss of the museum's former superiority. Contributing to that loss as well has been a general and ongoing decline in the respect generally accorded to institutions of every sort, from the presidency of the United States down to the local day-care center. Museums, although relatively untouched by scandals and touched only modestly by mismanagement, are in no way exempt from this loss of public trust. As University of Chicago historian Neal Harris observed in 1986, the "museum's voice is no longer seen as transcendent. Rather it is implicated in the distribution of wealth, power, knowledge and taste shaped by the larger social order."

With the loss of the museum's transcendent voice, the public's confidence in the museum as a disinterested, neutral, and objective agency has also been lost, or at least tarnished. In a dozen different contexts, identity and interest groups of every kind insist that the mainstream museum is neither empowered nor qualified to speak on their behalf. Increasingly, such groups are creating their own museums from which to speak in their own voices and address what they consider to be their own issues. In recent years, Native Americans, Asian Americans, and African Americans have been particularly active in the establishment of specialized museums. The Mashantucket Pequot Museum and Research Center on the Pequots' tribal reservation in Connecticut, with its 316,000 square feet (29,000 square meters), is among the largest museums in New England. The expanded Museum of African American History in Detroit has quadrupled its former space. It displays materials relating to slavery, a topic—compensatory, not celebratory—that is scarcely touched in any depth at most mainstream history museums. In Los Angeles, the Japanese American National Museum tells the story of the wartime detention centers in which innocent American citizens were held and treated as prisoners.

Consistent with this distrust of the museum's objectivity has come a growing recognition that the museum, in and of itself, is a morally neutral entity. The nineteenth-century view was different. As Carol Duncan describes the situation that prevailed in Europe, "public art museums were regarded as evidence of political virtue, indicative of a government which provided the right things for its people. . . . [E]ducated opinion understood that art museums could demonstrate the goodness of a state or show the civic-mindedness of its leading citizens." In the United States, of course, it was the latter part of Duncan's formulation that applied: The museum stood as tangible evidence of the civic-mindedness of the community's leading citizens. In the century since, we have come to understand that museums can be used just as easily for malevolent purposes as for benevolent ones, that the same technical skills that might be called upon to create a museum of tolerance could as easily be employed to create one of intolerance, and that the museum is simply an instrument. What really matters is in whose hands it is held and for what purposes it is intended to be used. Just as we recognize today that "art" is simply a noun and not a value judgment—those judgments come through such qualifying adjectives as sublime, terrible, interesting, disgusting, charming, and dull—so too is "museum" simply a noun. Whatever positive values it acquires must come through the appropriate qualifying adjectives.

Beyond these factors—beyond money, loss of public confidence, and the recognition that they are not inherently virtuous organizations—perhaps the greatest single factor contributing to the loss of the museum's once-superior position has been the bankruptcy of the underlying ideologies upon which it was founded. Where this can most clearly be seen is in the case of the art museum. No sooner had their founders begun to establish such museums in the United States than the link between art and moral uplift began to unravel. New ways of painting began to take hold, with painting intended to be looked at for its own sake and not because it depicted some character-forming scene from history, mythology, or the prevailing religious tradition. In time, new ways of looking at older paintings would also take hold. Instead of appreciating paintings for their moral probity or elevating sentiment, visitors were encouraged to value them only in terms of such formal elements as line, color, composition, and painterly skill. And what of the argument that the link between art and morality need not necessarily be broken? That line, color, and composition—even in their most abstract manifestations—might still be the stuff of moral uplift? "We know in our

hearts," writes Robert Hughes, "that the idea that people are morally en-nobled by contact with works of art is a pious fiction. The Rothko on the wall does not turn its lucky owner into Bambi." And what of Sir Robert Peel's observation to Parliament in 1832 when, in discussing London's pro-posed new National Gallery, he suggested that in times of political turmoil "the exacerbation of angry and unsocial feelings might be much softened" by exposure to works of fine art. Nobody believes that any longer, either.

In the case of the natural-history museum, the ideology that went bank-rupt was that which placed Western Caucasians at the pinnacle of creation. Being required to share that pinnacle with the former diorama and scale-model people was humbling enough. Much worse, though, was the dis-covery that far from having transcended the rest of the natural world, the people on the pinnacle, the whole lot of them, Caucasians and diorama-folk alike, were locked into a profound interdependence with that world, and that for better or for worse their futures were inextricably intertwined. Over the past several decades the center of interest for the natural-history museum, and that of many zoological parks as well, has shifted from tax-onomy to ecological and environmental issues. To the extent that the natural-history museum has defined, as its principal purpose, an increase in public awareness and activism with respect to those issues, it appears today to be far more focused as an institution than either the art or the history museum.

For the history museum—founded primarily on a "great man" and a cele-bratory approach to its subject matter—it was not so much the case that its underlying ideology was repudiated as that such an approach simply became just one, and by no means the dominant one, out of a great many different ways to do history. Whereas a historic house in New York City had once meant something on the order of the Morris-Jumel Mansion or Edgar Allan Poe's Cottage in the Bronx, it just as easily today can mean those three circa-1863 buildings that make up the Lower East Side Tenement Museum on Or-chard Street. History museums that focused on political leaders were apt to take for their subject such tried, true, and golden oldies as Jefferson or Lincoln, but today we can find history museums operating in the thicket of everyday contemporary life. Consider, for example, the Wing Luke Asian Museum in Seattle, which is named for and celebrates the life of Seattle's first elected city councilman of Chinese descent, or, a hemisphere away, the newly established museum on Robben Island where Nelson Mandela and other leaders of the African National Congress were held as prisoners.

The Smithsonian Institution announced in February 1997 that it would

assist in the establishment of a National Museum of Industrial History in Bethlehem, Pennsylvania. The museum would occupy a massive, abandoned steel mill that still stands on the 160-acre (64-hectare) site. How very different is that new museum from the earlier museums we associate with steel-making: the Morgan Library and Frick Collection in New York, or the Carnegie in Pittsburgh. That its frame can be enlarged to include not merely those who financed the making of steel or captained its great companies, but also those whose labor actually produced the steel, is symptomatic of how very far the history museum has evolved from its original approach.

Another example: When the Whitney Museum mounted an exhibition about the landscape architect and urban planner Frederick Law Olmstead in 1972, it was cast in the conventional hagiographic mode. Olmstead was portrayed as a heroic figure, who triumphed over whoever or whatever might have frustrated the full flowering of his talents. From a New York perspective, his greatest triumph, of course, had to be the creation of its beloved Central Park. Unmentioned, beyond vague references to "some shanties" that had to be moved and some "squatters" to be sent on their way, was the fact that there was a small town—Seneca Village, comprising poor African American and Irish American communities located toward the western edge of the park near Eighty-sixth Street—that had to be destroyed to make way for Olmstead's new construction. In January 1997 the New-York Historical Society opened the exhibition *Before Central Park: The Life and Death of Seneca Village*. In a manner more compensatory than celebratory, it tells the story of this lost community and its all-but-forgotten citizens. Included as part of the exhibition is a study center where visitors can consult files pertaining to those inhabitants of Seneca Village who can still be identified and explore the possibility of finding some family relationship. In that connection, the New-York Historical Society also presents several workshops on genealogical research; such an example might seem to suggest that the museum of the near future, which will conceive itself wholly in terms of its ability to serve the public, might be even nearer than first appeared.

Not quite, though. These are still only isolated examples, and a great deal of hard work remains to be done. In all fairness, one might ask why so much work should be undertaken at all. If the original premises upon which the museum was founded no longer appear valid, why are we struggling so hard to wrestle it onto some other foundation? Why not just let it go? Let me suggest two answers. The first has to do with the all-but-unique power of objects.

Although the museum as we know it has been with us for some two hun-

dred years, we are only in the foothills of learning about the ways in which the museum's visitors respond to the objects it shows. Some things we already know: that the response to a real, three-dimensional object, be it a moon rock, George Washington's false teeth, or an original painting by Rembrandt, is entirely different from our response to a photograph, video image, or verbal description of that some object. Whether this response is attributable to some Benjaminian "aura" or to the power of association—the moon rock, as tangible proof that there really is a moon, is more than just a rock; it is a souvenir of a truly grand adventure; and it makes a claim to be "true" in a way that words or pictures can never be—the fact remains that authentic objects displayed in a museumlike setting can trigger powerful cognitive and affective responses. In an effort to sort such responses into some sensible pattern, the touring exhibition that marked the Smithsonian Institution's 150th anniversary in 1996 was divided into three sections, *Remembering, Discovering,* and *Imagining.* Even those categories barely scratch the surface.

What we are learning about visitor response has come as something of a surprise. That museums serve an educational function has long been a basic rubric of the field. It has also been long been supposed that the way they serve that function is through exhibitions, in which the curator, by the artful arrangement of objects and placement of labels, spells out a lesson in such a way that the visitor, having carefully visited the exhibition, will have learned some or all of the lesson that the curator was trying to teach. In a paper published in 1996, Zahava Doering, who directs the Office of Institutional Studies at the Smithsonian, argued that this might not be the case at all. Rather than communicating new information, she says, the primary impact of visiting a museum exhibition is to confirm, reinforce, and extend the visitor's existing beliefs. The "most satisfying exhibition[s] for visitors," she says, "are those that resonate with their experience and provide new information in ways that confirm and enrich their [own] view of the world."

A parallel conclusion was drawn by Russel J. Ohta of Arizona State University West, who studied visitor responses to the admittedly controversial exhibition *Old Glory: The American Flag in Contemporary Art* when it was shown in Phoenix in 1996. Although each of the visitors he studied experienced "rich moments filled with deep personal meaning," none of those meanings resembled each other. The meaning in each case was forged from the visitor's own personal identity. What they primarily experienced was neither about art nor about the flag, he concluded, it was primarily about them-

selves. "In essence," he writes, "the exhibition became a looking glass for visitors. They experienced what they were capable of experiencing. They experienced who they were." He concluded by quoting David Pilbeam's dictum that, in looking at things, we tend not see them as they are but as we are. This research suggests that, among the services a museum is able to offer to its community is this capacity to provide the individual visitor with an important degree of personal self-affirmation. Although some religious organizations may perform a similar function, it is difficult to identify many other secular institutions that can play so communally valuable a role for an adult population. It is also difficult to identify many other secular institutions that play such a conservative role. As Doering points out, the museum, when understood in this mode of providing individual self-affirmation, functions far more strongly as an instrument for social stability than as any kind of a lever for radical change. To what extent might just such an insight serve to justify the continued funding of museums by government at its current, or even a higher, level?

A second answer as to why museums might justify all the effort required for their readaption might be based on what is a relatively new concept for museums: They have a vital role to play in building what a Baltimore-based consulting organization, the Museum Group, calls "healthy human communities." A related idea has been advocated for some time now by Elaine Heumann Gurian, a member of the group and well known for her work over many years at the Boston Children's Museum, the Smithsonian, and the Holocaust Museum. During the winter of 1996–1997, Gurian proposed that the AAM expand its official statement of principles—which seeks to encapsulate the educational, stewardship, and public-service roles that museums play, and to do so within a framework of diversity—to include the notion that one of the museum's core functions was to be "a place of safety." In an increasingly atomized and even hostile environment, she argued, the museum ought to emphasize the fact that it has traditionally been and still remains one of the few public spaces in which people of every background can gather together for peaceful exchange in a secure surrounding. In that mode, the museum might be understood as a contemporary descendent of such earlier public gathering places as the Roman bath, the medieval cathedral, and the New England village green. Although the AAM's leadership was not prepared to adopt Gurian's proposal, it did engender considerable discussion and, as they say on Wall Street, it certainly remains in play.

During a spring 1997 meeting at the North Carolina Museum of Art,

Raleigh architect-artist Thomas Sayre expressed a similar idea. Discussing the various ways that public space might be conceptualized, two of his examples seemed particularly relevant to the museum: one to the museum that once was, the other to the museum of the near future. The example relevant to the museum that once was, the Museum of Inculcation, was this: "Public space as the display of 'civic virtue.' This is a space which has traditionally had the large equestrian statue proclaiming a host of attitudes and emotions about seminal events in the culture. [The p]otency of this kind of public space comes from the extent to which the public agrees or 'buys into' the civic virtues, themselves. Nowadays, this kind of space is losing its potency. We don't agree so readily on what is civic virtue."

In contrast to that, Sayre proposed another kind of public space, one that seems in its way only a slight variant on Gurian's notion of the museum as a place of safety and is also akin to Duncan Cameron's vision of a quarter century ago, that the museum, in addition to what it already was, ought properly to be a site for community confrontation, interchange, and debate. Sayre's description: "Public space [as] a confluence of voices, as [a] forum for exchange. This admittedly utopian vision sees public space as a place where our multi-cultural society orchestrates its many voices into a dynamic whole. It is a place where the melting pot melts. Its function is something like fluid dynamics."

To be a place for personal self-affirmation, to contribute importantly to the health of human communities, to be a place where the melting pot melts: All in all, and combined with what we already think to be of value about the museum, those seem reasonably powerful arguments to justify this ongoing effort to build the museum of the near future.

At this point, let me describe a few of the phenomena occurring in and around museums, phenomena that in some instances seem to resonate with one another and seem to me symptomatic of this changing relationship between the museum and the public. One involves a toning down of that omniscient and impersonal voice in which the museum of yesteryear was accustomed to address its public. This change is particularly evident in natural-history museums. Consider the renovated Dinosaur Halls at the American Museum of Natural History. In contrast with the scientifically authoritarian tone of the museum's old galleries, humility is now the order of the day. The labels make clear that the book on dinosaurs is far from closed. "So far," the labels seem to say, "this is what we think we know and this is why we think so; but we're just people and we've been wrong before, and

we may well be proven wrong again. Moreover, there are some things—like what color the dinosaurs were—that we may just never find out." At the Think Tank building at the National Zoo in Washington, D.C., the public can watch and interact with scientists who are studying animal intelligence. The methodologies are all experimental. Asked by members of the public why one approach is being used rather than another, the scientists openly acknowledge the experimental nature of their work. That, they say, is how science is. At the Field Museum of Natural History in Chicago, Michael Spock made it a practice to include in each exhibit hall photographs of the curators and preparators who had been responsible for its installation. It is important, he believes, for the public to understand that its interaction with the indubitably authentic specimens on view is in no way inevitable but has been shaped and mediated by real human beings, with all the possibilities for error and/or bias that any such human undertaking might entail.

Also symptomatic of change are several recent instances in which museums have reformulated their missions entirely in an effort to connect more directly with their visitors and potential visitors. Two recent examples are the Strong Museum in Rochester, New York, and the Glenbow Museum in Calgary, Alberta. Established just two years apart in the mid-1960s, both museums were created by the gifts of very large private collections, in the case of the Glenbow some 1.2 million objects. Both were provided with substantial funds to underwrite their operations, by a very considerable private bequest in the case of the Strong and by public funding from the Province of Alberta in the case of the Glenbow, and both were left relatively free to develop their own missions. They both also found it necessary, some twenty to twenty-five years after first opening their doors, to rethink what they were doing. In its original conception the Strong, which concentrates on the history of the northeastern United States, chose the year 1940 as the end date for its collecting and interpretive activities. With the passage of time, the museum came to recognize that its ties to the community were becoming progressively weaker. Attendance was in decline, public interest appeared scant, and nobody below the age of fifty could any longer make much of a connection with the museum's cut-off date of 1940. The Strong Museum gathered its collective courage and did what very few museums have ever dared to do. It went to the community to ask if there was something else, something different from a museum concentrating on history up to 1940, that the community might find more useful. There was: The community wanted a museum oriented toward contemporary issues and family

visits, a museum where parents might take their children to learn important lessons not fully taught in school. Since 1992, the Strong has mounted exhibitions dealing with AIDS, the cold war, bereavement, racism, alcohol, and drugs. It is also working with the Children's Television Workshop on an exhibition that will be built around the characters from *Sesame Street.*

The Glenbow experienced what its director, Robert Janes, calls a "philosophic shift." Whereas the collection and its management had previously been at the core of its operations, that focus was shifted instead to public service and communication. "Museums," he writes, "exist to communicate and in the process provide answers to the question . . . What does it mean to be a human being? Although collections are the indispensable means to that end, they are not the end in themselves." Reflecting that shift of focus is the Glenbow's new statement of its mission. Unlike traditional mission statements, filled with such museum-specific verbs as "collect," "preserve," and "exhibit," the Glenbow's new statement is concentrates on the response of its visiting public: "to be a place where people find meaning and value, and delight in exploring the diversity of the human experience."

In contrast with these older museums making midcourse corrections in order to place greater emphasis on the public-service aspects of their operation, new museums are being established that provide this emphasis from the outset. At a symposium held in Washington, D.C., in September 1996 in celebration of the Smithsonian's 150th anniversary, Irene Hirano of the Japanese American National Museum in Los Angeles described how her own museum had been founded in 1985. Members of the local Japanese American community, she said, had become aware that the experience of the World War II detention camps in which they and their families had been incarcerated was slowly being forgotten. Sensing the need, in her phrase, to "give their history a home" and fearful that their story would never be properly told if the telling was left to others, the community itself determined to take on the responsibility to "ensure that [its] history and culture was documented." Of the various means by which this might have been done, a museum was the community's instrument of choice. At that same symposium, Maria de Lourdes Horta of the Museu Imperial in Brazil talked about the remarkable cluster of small history museums that are springing up in Brazil's rural countryside:

> Under the stress of development and the need to survive, communities are taking hold of the idea of a "museum," whatever that may be in their minds, and are starting to take the job in their own hands. This is the case of some projects developed

with the assistance of . . . educators and museologists in the south of Brazil. . . .
Working with teachers and children, the process involves . . . old people and field
workers, who start to dig into their past, looking for their roots, recovering self-
pride and a sense of belonging to a given group with a unique history. A museum
without walls, a true virtual museum, is being born in some of those communities
that look in wonder to their own process of self-discovery and recognition. . . . For
the moment, in my country, [museums] are being used in a new way, as tools for
self-expression, self-recognition and representation, as spaces of power negotiation
among social forces, as strategies for empowering people so [that] they are more
capable to decide their own destiny.

The art museum is changing too, if not as dramatically. One of the factors
driving its change is simply the unavailability to new museums of the "Old
Master" art—or even not-so-old-master art—that was once collected by
the great urban museums such as those in Boston, New York, Cleveland,
Philadelphia, and Chicago. Most of that art is already in museum collec-
tions. With the explosion in art prices over the last two decades, what is
not already in museum collections is prohibitively expensive. Concurrently,
increasingly restrictive ethical codes and the worldwide spread of export
controls have made it virtually impossible for these new museums to col-
lect the once-so-cheerfully plundered art of other cultures. Nor is it likely
that many will inherit important private collections. The era of heroic col-
lecting may well be on the wane. Accordingly, these new museums have had
to learn to do more with less. And many of them have done so with re-
markable ingenuity. Of necessity, their energies are directed at public pro-
gramming rather than collection care. That, in turn, has required that their
focus be more outward than inward.

 In the southwestern corner of Virginia, the William King Regional Art
Center in Abingdon lacks a single work of art that a major New York City
museum would consider fit to hang in its galleries, but it provides a broad
range of community and school programming that would, pound for
pound, knock the socks off anything to be found in New York City. Closer
to home, the James A. Michener Museum of Art in Doylestown, Pennsyl-
vania—a museum that limits its program to Bucks County—seamlessly
supplements its rather slender collection of Bucks County paintings with
masterfully designed displays about the writers and other creative indi-
viduals who have been associated with the county, including individuals such
as S. J. Perelman, playwrights Kauffman and Hart, writer Jean Toomer, and
lyricist Oscar Hammerstein. In so doing, it has evolved from what was

originally a museum of visual art into a novel form: a museum of human creativity. Often for the new art museum, the strength of its imagination and not the strength of its collection may be its only hope for distinction.

Also influencing how the museum and the public interact, or at least on how they may be perceived to interact, is an idea implicit in postmodernism. It is the proposition that no text is completed except through the act of "reading" it, and that every text, accordingly, has as many versions— all equally correct—as it has readers. Translated into museum terms, that would suggest that the objects displayed in the museum do not have any fixed or inherent meaning but that "meaning making," or the process by which those objects acquire meaning for individual members of the public, will in each case involve the specific memories, expertise, viewpoint, assumptions, and connections that the particular individual brings. It may be noted that this notion has considerable resonance with some of the visitor research considered earlier. Indeed, adherents of this meaning-making paradigm claim that it is unduly restrictive to conceive of the museum's relationship to the public purely in terms of its educational potential. Lois Silverman of Indiana University argued, "Hindered by [their] historical focus on a nearly exclusively educational mission, other potentialities of museums lie seriously underutilized in exhibitions and institutions alike. Museums in a new age can become places that actively support and facilitate a range of human experiences with artifacts and collections—social, spiritual, imaginal, therapeutic, aesthetic, and more."

Among the interesting implications that Silverman draws from the meaning-making model is that a museum visit made in company, whether that be the company of partners, family, or friends, is likely to produce a richer harvest of meanings than a visit made by an individual alone. "Often," she writes, "visitors learn new things through the past experience and knowledge of their companions. Thus . . . people create content and meaning in museums through the filter of their interpersonal relationships." Again, some resonance may be sensed between this and the experience of the Strong Museum, where the community expressed its interest in having a museum that encouraged family visits. From this postmodernist perspective, the relationship of the museum to its visiting public in one sense seems clear. They are partners in giving a meaningful voice to objects that, according to a previous generation of museum practitioners, were once said to speak for themselves.

One final symptom of change: at a Smithsonian-wide exchange of ideas

held in Washington, D.C., in March 1997, Doering astonished some participants with her radical suggestion that museum visitor studies might become more useful to museums if they focused, at least in part, on whether the visitor's expectations with respect to a display had been satisfied rather than on whether the expectations of the display's curator had been met. Underlying this suggestion was a recognition of the disconnect between what curators have traditionally expected of the display medium—that visitors will learn the lesson the curator has set out to teach—and the emerging reality that visitors may inevitably bring their own agendas to the museum and that, from their point of view, the satisfaction of those agendas constitutes the essence of a successful museum visit. As she noted in the abstract for her session: "The visitor paradigm most commonly found among museum staff today is the 'baby bird' model, which sees the visitor as a relatively undeveloped appetite needing our wise and learned feeding. The staff expects to provide these visitors with motivation and with learning experiences. The actual range of visitor expectations is more sophisticated, more complex, and more challenging than most of us suspect."

Is not that precise shift of focus, subordinating a concentration on the museum's expectations of the public to a concentration on the public's expectation of the museum, at the very center of the revolution under consideration? I would submit that it is.

Finally, then, when that revolution has run its course and when the museum of the near future is firmly established, what might we expect it to be like? In the glorious phrase that Northrup Frye once used to describe the potentialities of an open society, there will be a "reservoir of possibilities." From that very rich reservoir, it will be the public—voting with its feet, voting with its credit cards, and acting through its elected representatives—that will determine which of those many possibilities and in what combinations best meet its needs and wants. No longer the passive body of the museum's first conception, doomed to be raised, elevated, refined, and uplifted, in short, to be "done"—the public will have succeeded to active control of this quite remarkable and uniquely powerful instrument. The museum will still do, but this time it will be the public, in all its plurality, that determines what it does. By then, perhaps, that might not even seem like such a revolutionary idea.

20

The American Legal Response to the Problem of Holocaust Art

During World War II, paintings, sculptures, and other forms of cultural property estimated to number in the millions were stolen, expropriated, looted, hidden, or otherwise displaced from their customary locations. More than a half century later, many have yet to be returned to their original owners. Meanwhile, some of these displaced works have ostensibly been acquired by other individuals and/or institutions—frequently acting in the best of faith—who now believe that in all fairness they should be entitled to keep them. As the courts of the United States are increasingly faced with such instances, they find themselves forced to deal with legal doctrines never contemplated to be applicable in such an extreme context, to contend with factual complexities all but obscured by the inevitable fog of war and, above all, to balance the mutually compelling but often conflicting claims of justice and fairness. Many dilemmas—ranging from the applica-

The initial text of this talk was presented as the Jane Ruby Humanities Lecture at Wheaton College in Norton, Massachusetts, in December 1998. Subsequent versions were presented during the Brown University Commencement Weekend in May 1999 and at the Institute of Art and Law Annual Lecture at the National Gallery in London in October 1999. The final printed text was prepared for and appeared in *Art Antiquity and Law,* vol. 4, issue 4 (December 1999). The author wishes to thank Ms Emily Pocock, Institute of Art and Law, for her assistance in preparing this article for publication. Published here with the kind permission of Kluwer Law International.

bility of statutes of limitation to the disposition "heirless" art—remain to be resolved.

THE BENEFIT OF HINDSIGHT

To begin with an anecdote: Shortly after the Hirshhorn Museum and Sculpture Garden in Washington, D.C., opened to the public in 1974—I was then the museum's deputy director—we received a letter from a man in New York together with a black-and-white photograph that showed a small, white marble sculpture standing on a coffee table. The sculpture looked very like a 1915 carved marble torso by Alexander Archipenko in the museum's collection. In his letter, the man claimed that they were in fact the same. He said that the photograph had been taken just before the war in his family's Paris apartment, that the sculpture had been left behind when the family was forced to flee from France, and that the Nazis had ransacked the apartment and taken the piece. He asked that we now send it back to him at the return address shown on his letter.

In checking the Hirshhorn's internal records, nothing initially turned up either to support or refute his claim. The Archipenko sculpture had originally come to the museum as a gift from its founding donor, Joseph H. Hirshhorn. Mr. Hirshhorn, in turn, had bought it from a well-known gallery in London in 1958. That gallery, in its turn, had acquired the piece in 1957 at a Sotheby's auction sale, also in London. Beyond that, all we knew was that it had passed through the hands of yet another art gallery with a Lichtenstein address at some still earlier date.

The Hirshhorn is part of the Smithsonian Institution, and the sculpture was in some sense U.S. government property—not lightly to be disposed of. We wrote back promptly, but with appropriate caution. Before we could consider his claim, we would need some further information. Exactly to whom in his family did the sculpture originally belong? Was there any kind of documentation—a bill of sale, a catalog, an insurance policy, an inventory—to support this claim of ownership? How was that owner's possession of the sculpture terminated? If, as the writer claimed, the piece had been taken by the Nazis after the date of the photograph, did he have any evidence to that effect? And, finally, what was his relationship to the original owner? If he was an heir, was he the only such heir of his degree or were there other surviving heirs of a similar or greater degree who might have

claims equal to or better than his own? We never heard from the man again. Several years later, we did manage—with the aid of the artist's family—to track down the carving's earlier provenance. It was fine. From the mid-1920s straight through into the 1950s, it had been in a single private collection in England and never in a French collection at all.

For years afterward, though, we continued to wonder. Had this been a mistaken but nonetheless innocent claim? Archipenko had, in fact, repeated this carving several times, and our correspondent might readily have mistaken our version for a similar one that really did belong to his family. Or, and it was not such a pretty thought, had he simply found an old photograph of an Archipenko sculpture—perhaps one taken in Paris and before the war, perhaps not—and sent it to the museum on the off chance that he might squeeze out some kind of settlement? Of virtually no reality in 1974, though, was the possibility that so small and fragile a work of art could have slipped out of the chaos of wartime Europe, made its way into and through the international art market, and ended up in our galleries. Nobody was even thinking in that way then.

A CHANGE OF ATTITUDE

If that letter had come this year instead, the response would almost certainly have been different. What we understand today, far more thoroughly than we did a quarter century ago, is the extent to which—intertwined with the unspeakable destruction that they inflicted on individuals, families, and communities—the Nazis also committed crimes against property and also the extent to which some part of that property was spirited out of Germany to make its way into the seemingly legitimate art trade. Inseparable from the Nazis' master plan of domination was the wholesale plunder of personal property of every kind: gold, jewelry, household furnishings, and works of fine art. At the war's end, in the American zone of occupation alone, United States Army troops located some fourteen hundred mines, storehouses, and other depositories to which more than 15 million items of cultural property had been transported by the Germans for safekeeping. More than 3 million of those turned out to have been stolen from other countries to which they were eventually returned by the American government.

Since the mid-1990s, there has been a growing sense within the United States that—helpless as we may ever be to relieve the human distress of those years—perhaps something positive might still be done toward rectifying or at least seeking to ameliorate the property losses that occurred in that period. An avalanche of books and newspaper and magazine articles have addressed that issue. Beyond those, in the late 1990s, Congress has held several hearings concerning restitution for various categories of Nazi-stolen property, including bank deposits, insurance proceeds, and works of art.[1] In February 1998 Congress passed the Holocaust Victims Redress Act. In December 1998, the U.S. Department of State, in cooperation with the U.S. Holocaust Memorial Museum, held an international conference in Washington, D C., to explore what additional steps might be taken to provide further relief for the last surviving victims of the Holocaust and/or their heirs. Another executive branch effort to deal with this issue was initiated in the early months of 1999 with the White House's activation of the Presidential Advisory Commission on Holocaust Assets in the United States. Among the commission's several consultants, one deals exclusively with museums and works of art.

The question is frequently asked, Why only now, and not before? One answer, proposed recently by a State Department spokesperson, is that the cold war was responsible for the delay. Restoring plundered objects to their rightful owners, he said, is the customary follow-up to any conflict. In the case of World War II, the intervention of forty years of cold war simply delayed that process until the latter contest could itself be resolved. Others have suggested that the records necessary to track down the ownership of certain dislocated objects were not readily available before the fall of communism in Eastern Europe and the opening of many previously sealed archives. Still others have felt that these questions of lost property were—in the overall scheme of things—properly secondary ones, appropriately postponed until some of the anguish over so many millions of lost lives, over so much suffering, had first been given some opportunity to heal.

Whatever the reason, questions about the possible recovery of property lost during the Nazi era have now come—and come most forcefully—to the surface. For individuals and institutions within the United States who collect works of art, two of those questions are particularly consequential. First, to what extent may they have innocently acquired works of art that were stolen from Jewish or other victims during the Nazi era? And second,

if they have in fact acquired any such works of art, how do their rights to retain these works balance against the rights of the original owners or their heirs to get those works back?

A HISTORY OF WORLD WAR II CONFISCATIONS

Some of the works of art that eventually reached the United States were originally separated from their owners by plunder—or, as the plunderers preferred to call it, "confiscation." The German plunder of Europe was not a single, monolithic operation. It was initially carried on by a variety of organizational units, sometimes acting in cooperation with one another but more often in competition. Some—such as those within the military or operating out of the Foreign Ministry—were acting under the direct orders of the German government. Others were created by individual Nazi leaders from Adolf Hitler downward, each pursuing his own private agenda. Hitler's personal project was a monumental, multipavilioned museum he proposed to construct in the Austrian provincial capital of Linz, his childhood home. Its collection was to consist of great masterpieces of European art from every period. These were to be obtained by purchase, barter, or outright theft. In 1939 the distinguished director of the Dresden Museum was put in charge of acquisitions. Although he began slowly—in the first year he collected only 465 paintings for the museum—by the end of 1944 more than 8,000 works of art had been gathered and were being stored for the still-to-be-built museum at Hitler's headquarters in Munich. Meanwhile, in freshly conquered Poland, Heinrich Himmler's dreaded SS squads fought over the control of confiscated art with the Special Commissioner for the Protection of Monuments and Art Objects, an official personally appointed by the Nazis' number-two leader, Hermann Göring.

Government-Sponsored Confiscations

What was ultimately to become the largest and arguably the most powerful of these various irregular units was the *Einsatzstab Reichsleiter Rosenberg* (ERR)—the Special Action Unit of Reich Leader Rosenberg—which was established by the Nazi Party in June 1940. Under the titular leadership of Alfred Rosenberg, the party's chief idealogue, the ERR was initially responsible for battling "Judaism and Freemasonry" by seizing archives, li-

braries, and works of art in the occupied countries. Coming eventually under Göring's control, the ERR was used for a number of projects, perhaps most notorious of them being the "furniture program," under which the homes of French, Dutch, and Belgian Jews who had either been sent to concentration camps or fled the country were systematically emptied of their contents.[2] Household goods, utensils, and clothing were sent back to Germany for the use of bombed-out German families. Works of art, fine carpets, and other items of value were picked over for possible retention by the Nazi leadership or else for sale or barter, either within the occupied zone or in Switzerland. In Paris alone, the contents of more than seventy thousand homes were taken. In the Netherlands, where the furniture program was expanded to include Christians as well as Jews, twenty-nine thousand homes were emptied.

In Paris, much of the art confiscated by the ERR was stored in the Musée du Jeu de Paume, the former royal tennis court (now part of the Louvre). There, one of the more bizarre episodes of World War II was periodically reenacted. From time to time, officers of the ERR would install the choicest of these stolen works in the Jeu de Paume just as if they were mounting an exhibition in a commercial art gallery. Göring—who was independently wealthy and had first begun amassing a serious art collection in the 1930s—would then be invited to visit and review these, selecting those he wanted to keep for his own collection and others that he thought might be valuable for barter. Over the course of some twenty visits, he chose more than one thousand works to be shipped back to Germany. Technically, Göring was to "buy" these at a price to be set by an appraiser in his own employ. In fact, he never paid for any.

Among the works of art confiscated by the ERR, a considerable number—the kinds of art, for example, that the Nazis had denounced in their *Degenerate Art (Entartete Kunst)* exhibition of 1937—were problematic for retention.[3] The fiercer or more extreme examples of German expressionism fell outside the boundaries of what it was politically correct for good Germans to collect. Large patches of twentieth-century art, especially abstract paintings, as well as all works of any century by Jewish artists, were also taboo. Even French impressionist paintings were in bad odor, possibly for no better reason than that they were French. In the wake of the *Degenerate Art* exhibition, the Nazis had realized that much of this unacceptable art could readily be sold outside of Germany to raise money for their war effort or, as in later years with the art seized by the ERR, could be used as

barter to obtain more acceptable kinds of art. Once smuggled into Switzer-land—commonly through the diplomatic pouch—these works could slip effortlessly into the mainstream of commerce. In considering how displaced works of art may have made their way to the United States, this barter route is among the most likely.

Private Looting

A second route through which dislocated works of art eventually came into the United States was through looting—almost inevitably a companion to war. Looting was most widespread in the final days of the war, when any last semblance of order had broken down. Sometimes art that had already been stolen once was stolen again. In 1943 the Germans had taken control of the highly regarded Adolphe Schloss collection of some 333 paintings, including a substantial number of works by seventeenth-century Dutch and Flemish masters.[4] The choicest of these were in storage at Hitler's head-quarters in Munich, pending their installation in the great museum to be built in Linz. In 1945 a mob broke into the headquarters and carried off a large number of these. A similar fate befell a part of Göring's collection. In an effort to protect these art works from advancing Russian troops in April 1945, they were evacuated from his country home and loaded onto a train that was temporarily halted at a station in southern Bavaria. There, a crowd of peasants broke into the boxcars and carried off art treasures that he had rounded up from every corner of Europe over the preceding four years.

More looting was to follow the arrival of the victorious Allied troops that occupied Germany. In many instances, works of art looted by the members of these armies were taken back to their home countries and either kept as souvenirs or put up for sale. Of the dozen or so cases thus far initiated in American courts for the recovery of cultural property stolen during World War II, at least one-third have involved objects that were stolen by Ameri-can soldiers. Looted works of art—in this instance, initially looted by Soviet troops—were also involved in a recent criminal prosecution in New York.

In this latter case, the Bremen *Kunstverein* had sent a large group of Old Master and other drawings—reportedly more than one thousand—for safe-keeping to Karnzow Castle, north of Berlin. From there, they were stolen by Soviet troops who were billeted at the castle in 1945. Following an un-successful effort to sell them back in Russia, the drawings were confiscated by the Soviet police, who in turn deposited them in 1947 in various mu-

seums throughout the USSR, including the Azerbaijan National Museum in Baku. In 1993 some of these drawings were again stolen, this time from the museum in Baku. Smuggled into the United States, a dozen of them—including one by Dürer and another attributed to Rembrandt—turned up in New York City two years later, with an initial asking price of $12 million. Working with curators from Bremen who had been called in to authenticate the drawings, U.S. customs officials were eventually able to lure one of the principals behind this smuggling operation from Baku to New York, where she was arrested in early autumn 1997. In 1999 she was convicted on three charges of conspiring to sell stolen art. The drawings were to be returned to Bremen, not to Baku.

By far the most widely publicized episode of looting by the American army was the theft of a ninth-century Carolingian manuscript and nearly a dozen other precious medieval objects that belonged to the church of Saint Servatius in Quedlinburg. At the beginning of the war, these were first stored in the vault of a local bank, but in 1943 they were removed to a nearby cave to protect them against the threat of air strikes. From there, they were stolen by an American lieutenant assigned at the war's end with his armored field artillery unit to guard the cave. To remove them from Germany, he simply packed them in small boxes, labeled them as souvenirs, and sent them back home to Whitewright, Texas, through the military postal service. They resurfaced only in 1990 after his brother and sister, to whom he had left these treasures at his death some ten years earlier, tried to sell some of them in the international art market for several million dollars.[5]

Plunder and random looting alone cannot account for all of the dislocation of cultural property that occurred during those wartime years. Under German occupation, the major European capitals—and most especially Paris— had thriving art markets in which innumerable works of art and decorative objects continued to change hands. Buzzing around these was a swarm of private art dealers, middlemen, fixers, and runners, sometimes working on their own account and sometimes for one or another of the Nazi leaders. One postwar difficulty has been in distinguishing between what were genuinely voluntary transactions—was the exchange of a work of art for an exit visa, for example, the equivalent of a voluntary sale?—and what were not.

Consider the case of Count Jaromir Czernin of Austria, who owned one of the last Vermeer paintings in private hands. In 1940 Hitler authorized its purchase at a very high price for the proposed museum in Linz. After re-

ceiving the proceeds, the count sent a personal thank-you note that ended with "the wish that the Picture may, my Führer, always bring you joy." Immediately after the war, Count Czernin sued for the return of his painting on the grounds that the sale had been coerced. The court, with his thank-you note in evidence, decided otherwise. The painting—the only work by Vermeer in Austria—can be found today in the Kunsthistorisches Museum in Vienna. In an extraordinary document signed in London in January 1943, the United States and its Allies—recognizing that they would ultimately have to deal with many such ambiguous situations—reserved the right to declare invalid all transfers of property made in the war zone, regardless of whether those transfers were the result of "open looting or plunder, or of transactions apparently legal in form, even when they purport to be voluntarily effected."[6]

Finally, in the chaos of war, objects might simply be lost. To protect them against seizure, a collector might hide his most valuable paintings behind a false wall or bury the family silver in the garden, only to be carried off to die in a concentration camp before he could advise any heirs of the objects' whereabouts.

U.S. LAWS ON THE RECOVERY OF STOLEN ART

The legal complexities triggered by lawsuits that seek to recover stolen art stem from this: Almost never are such lawsuits between the original owner of such art and the thief who stole it. Those would be the easy cases. The original owner would recover the work. As first-year law students, we learned almost to chant, "He who takes what isn't his'n must give it back or go to prison." Far more typically, lawsuits for the recovery of stolen art are commenced long after the thief has disappeared from the scene and long after the stolen art work has slipped into the normal course of commerce, passing from one hand to another until it eventually winds up in the possession of a purchaser who may have no reasonable grounds to suspect that it once was stolen.

To make that situation concrete, imagine that somebody has hijacked the truck carrying a traveling exhibition of treasures from the Smithsonian. Most of the loot is quickly recovered, but among the items still missing are a Benin bronze head from the collection of the National Museum of African Art and a Sony TV monitor that was used in the exhibition. The thief is

never identified or caught. Ten years later—and quite by accident—the Benin bronze is discovered in the possession of an individual in Los Angeles who purchased it some seven years earlier in all good faith—without in fact really knowing what it was—from a perfectly reputable (and since deceased) San Francisco dealer in curios.

What if it was the TV monitor instead of the Benin bronze that had turned up some ten years later? Nobody would likely care. It would be an obsolete machine, probably without any resale value and long since satisfactorily replaced by a succession of newer models. Not so with a work of art. Like jewelry, fine furniture, and musical instruments, works of art belong to a small class of objects that may become more rather than less valuable with the passage of time. Moreover, they are unique—not fungible like the TV monitor. Nothing may truly serve as a satisfactory substitute. Promptly upon discovering its whereabouts, the Smithsonian firmly demands the return of the Benin bronze as its property. The individual in Los Angeles, delighted to find that he has inadvertently acquired something of considerable value, also promptly and just as firmly refuses. He claims it to be his property. With the contending parties unable to reach any compromise, a lawsuit follows.

Over the past several decades in the United States, we have developed a complex, distinctive, and delicately balanced body of law to resolve lawsuits of that kind—suits that a colleague of mine once characterized as a battle between two victims. One is the original owner, the victim of a theft. The other is the subsequent good-faith purchaser, inadvertently defrauded by his vendor's failure to provide him with good title to a work of art for which he has paid a full purchase price. In seeking to resolve these cases, courts have found themselves caught in a conflict between two deeply cherished but sometimes incompatible principles: justice and fairness.

Justice is embodied in the traditional common-law rule—also drummed into the memory of every first-year law student—that "you can't get good title from a thief." That rule of Anglo-American law is very different from the civil law rule prevailing in various European countries where, after the passage of a certain amount of time, you can sometimes get very good title from a thief. In the case of the Smithsonian's Benin bronze, we can imagine that, during the three years between the time of its original theft and the time it reached the San Francisco curio dealer, it passed through the hands of several individuals and/or merchants, each one perhaps just a bit more respectable than the one before. Notwithstanding how innocently

they may have been made, however, those intermediate transfers could not operate to extinguish—any more than the theft itself could extinguish—the Smithsonian's basic property rights in the bronze. You can't get good title from a thief, and it should follow logically that—in the name of justice—the Smithsonian should always be able to recover its stolen bronze wherever and whenever it might ultimately be found.[7]

But crosscutting the claims of justice—not necessarily in this case, but frequently—may be the conflicting claims of fairness. Fairness dictates that the subsequent purchaser of a stolen work of art—more specifically, a good-faith purchaser for value, like our individual in Los Angeles—should not remain indefinitely exposed to the risk of having to defend his right to that work against what may be increasingly stale or ancient claims. Fairness requires that there should ultimately come a time when, in his ownership of that work, he can enjoy what the law calls "repose." This fairness principle is embodied in statutes of limitations that can be traced back to English law of the early seventeenth century. These statutes are intended, first, to prod those who may have recognizable legal claims into asserting them in a timely manner and, second, to assure that such claims, once asserted, can be adjudicated fairly before—in the words of one commentator—"evidence has been lost, memories have faded, and witnesses have disappeared."[8]

Statutes of Limitations

Although some lay persons may be troubled by those occasional cases when a court deliberately withholds justice in the name of fairness, there is a well-developed legal rationale for doing so. As one New York court observed: "The statute of limitations is a statute of repose. At times it may bar the assertion of a just claim. Then its application causes hardship. The legislature has found that such occasional hardship is outweighed by the advantage of outlawing stale claims."[9] In harmony with that rationale is the conclusion of a New Jersey court, that the effect of these statutes of limitations is to give "security and stability to human affairs."[10]

The question that American courts have had to face is not whether statutes of limitations should apply to cases involving stolen art that may not arise—like that of the Benin bronze imagined here—until many years after the theft itself, but how such statutes are to be applied and, most especially, when the limitations period they prescribe should begin to run. In most legal contexts—negligence, for example, or breach of contract—the nor-

mally applicable rule is that the statute of limitations, generally from two to six years in duration, begins to run when the underlying cause of action accrues. In the case of stolen art, however, to start running the statute of limitations at the moment of the theft—a moment that may be many decades before the original owner can possibly discover the whereabouts of the stolen property—would be so manifestly unfair as to wholly undermine the very rationale, that of fairness, under which statutes of limitations were developed in the first place.

Evolving Interpretations of Statutes of Limitations

What has emerged instead in many American states is a "discovery" rule that attempts to strike a balance between justice and fairness. The California civil code was amended in 1983 to provide a three-year statute of limitations in the case of stolen art or artifacts that does not begin to run until the discovery of the stolen property's whereabouts.[11] Assuming that California law might be applicable here—the choice of law question is not entirely clear, but the law of the jurisdiction in which the Los Angeles individual putatively acquired the bronze would certainly be a reasonable choice—and further assuming that the Smithsonian acted promptly in asserting its claim, then it should be able to recover its stolen property. Conversely, if—once having discovered the whereabouts of that property—it was dilatory by more than three years in asserting its rights, then the Los Angeles defendant might prevail. You may not be able to get good title from a thief, but being able to block the original owner's claim by interposing a statute of limitations is certainly its functional equivalent.

Lest that seem too simple, some American states—New York is one—have muddied this seemingly clear tension between abstract conceptions of justice on the one hand and fairness on the other by the introduction of still a third factor—a factor that the courts refer to as "diligence."[12] Beyond considering merely the respective property rights of the parties, diligence also examines their behavior. How vigorously did the contending parties actually seek to safeguard their rights? Thus applied, diligence functions as a kind of moral makeweight that can tilt the decision in a controversy over stolen art one way or the other. In stolen-art cases, diligence is good and may be rewarded; lack of diligence is bad and may be penalized. Diligence, though, is not a fixed and single standard. Not only may its requirements differ from party to party—a museum may be expected to exercise a higher

degree of diligence than a private individual—but those requirements may also differ from one decade to another.

Assume for a moment that the Los Angeles purchaser bought the Benin bronze in New York instead of San Francisco. Under New York law, the question of whether the Smithsonian could recover this work might turn on the diligence it had exercised in trying to recover its property following the hijacking of the truck. Was the report filed with the police complete in listing the truck's contents? Had the theft been reported to Interpol and to one or more of the various registries where stolen art can be listed? Had it been widely publicized, or even advertised, in any ongoing way? How carefully had the Smithsonian monitored those auction houses where the stolen material might most likely turn up for resale? Although a failure of diligence might not in itself be wholly dispositive of the case, it could nevertheless be a critical factor under a doctrine called "laches" if the collector could also prove that he had been prejudiced (legally disadvantaged) by the Smithsonian's failure to be more vigorous in its pursuit of the stolen work.

Diligence cuts both ways, though. Thus far, we have characterized the Los Angeles purchaser as a "good-faith purchaser." Embodied within that shorthand legal phrase is the notion that, in purchasing the Benin bronze, he exercised a level of care appropriate to such a transaction. If the converse were true, however—if he had purchased the bronze either knowing or having reason to suspect that it was stolen—then, under still another doctrine called "equitable estoppel," a court might well find that he did not have the "clean hands" required of a party who would avail himself of a statute of limitations defense. The "clean hands" doctrine provides that the courts of equity will not assist those whose cause of action arises out of an illegal act. Thus, equity will only assist those who have "clean hands."[13]

What if the purchaser, instead of buying the bronze from a reputable curio dealer for a few hundred dollars, had acquired it for just a few dollars—all cash—from a furtive stranger he met in a back alley? Would he still be held a good-faith purchaser? Most likely not. What if he had simply accepted the curio dealer's assurance that the work might be legitimately acquired, without first checking, himself, whatever police or other records might be available? A good-faith purchaser? Probably so. Change the purchaser to a major urban museum instead of a private individual, though, and something more might be required to satisfy this diligence test.

Arguments with respect to diligence can be extraordinarily subtle. Several years ago the Republic of Turkey brought a lawsuit against the Metro-

politan Museum of Art, seeking to recover a large group of antiquities that the Met referred to as the "East Greek Treasure."[14] Turkey argued that: as a general rule, the longer a group of archaeologically excavated antiquities has been out of the ground, the greater will be its dispersal through the community of those who deal in such material; the Met had acquired the several hundred objects constituting the "East Greek Treasure" from only two dealers, and no other dealers worldwide were known to have had similar material for sale at that time; the Met must therefore have known that the material in question had been excavated only recently and that any such recent excavation would have been in contravention of the 1906 Turkish law that vests the ownership of all such buried material in the Turkish government; and, accordingly, the Met had ample reason to suspect that these objects were stolen and could not be considered a good-faith purchaser entitled to invoke the statute of limitations.

Whether that argument would have carried the day will never be known. The Met eventually abandoned its defense and returned the contested material to Turkey.

All lawsuits are inescapably costly, but suits for the recovery of stolen art are dauntingly so. Because the outcome of these cases may be so dependent on a close consideration of the underlying facts, they are rarely susceptible to any early decision on the basis of the law alone. Almost invariably they will require extensive depositions, interrogatories, and other pretrial proceedings that can rapidly run up their cost. Unless the value of the work of art at issue is great enough to justify it, even a successful lawsuit—considered strictly from an economic point of view—may be a losing proposition. But considered from the heart rather than the head, Holocaust survivors and their heirs may understandably feel that, no matter how costly, they have no alternative but to try to recover what may be their only remaining link to the life they once lived before the war. Nearly all of these cases are only superficially about property. Mostly, they have a deeper dimension.

THE LAW IN PRACTICE: HOLOCAUST VICTIMS IN THE COURTS

When we turn to the actual cases involving claims for the return of stolen art, those same questions that the Hirshhorn Museum raised back in the 1970s with respect to the Archipenko sculpture continue to be central. Can

the claimant prove the identity of the original owner? Can the claimant prove that the original owner's possession was terminated by a theft? And can the claimant—if different from the original owner—provide proof of being the rightful successor in ownership to that original owner? Several recent lawsuits suggest that the second of these questions—how the original possession was terminated?—may be the most critical.

Cases in U.S. Courts

The first case, settled in May 1998, involved a group of valuable sixteenth-century miniature paintings that originally belonged to the Library of the University of Kassel in Germany. During the war, these miniatures had been stored for safekeeping in a nearby mineshaft. They had apparently disappeared in 1945 while the mineshaft was under the protection of the occupying American troops. In 1989, by the sheerest of chances, a Boston museum official recognized three of the miniatures hanging in a rug merchant's shop in Brookline. The merchant had no idea what they were. He had simply bought them, along with several others, from an antiques dealer in 1974 for a total of two hundred dollars. Word of the miniatures' whereabouts eventually reached the University of Kassel, which first demanded and then sued for their return. In claiming that he, and not the university, was the rightful owner, the rug merchant argued, first, that he had acquired the miniatures in good faith and, second, that the university had no proof that its property was ever stolen. That defense crumbled entirely when a private investigator, hired by the university, was able to track down an American civilian employee associated with the military who had actually worked in that mineshaft. The latter, an elderly man living in Connecticut, not only admitted to stealing the miniatures but also said that he had sold them for one hundred dollars to the very same antiques dealer from whom the rug merchant had subsequently purchased them for two hundred dollars. Following a very quick settlement, the miniatures were turned over to the German Consulate in Boston for delivery to the university.

The second case, settled in August 1998, is not nearly so neat and a good deal uglier. The story can best be told in chronological order. It begins with the Dutch-German banker Friedrich (or Fritz) Gutmann, his wife, Louise, and their large and well-known collection of Renaissance objets d'art, Old Master paintings, and a handful of more modern works. In 1939, living in Holland and fearful that war might break out, the Gutmanns sent a num-

ber of paintings to an art dealer in Paris with the intent that these either be sold or put into safekeeping—they left no record as to which. Among these works was a landscape by Degas. In 1943 Gutmann and his wife were arrested and interned at the Theresienstadt concentration camp. The Nazis were eager to take over the Old Master paintings that the Gutmanns still owned, and they tried to make him sign a document that would transfer ownership of these to Germany. Gutmann refused and was found beaten to death in April 1944. Several months later, Louise was transferred to Auschwitz-Birkenau and died in the gas chambers there.

Two Gutmann children survived the war, and in 1945 they began a worldwide search—a search that continues to this day in the hands of the Gutmann grandchildren —for the family's dispersed art collection. Unbeknownst to them, however, the Degas landscape had turned up in the United States in 1951 in the hands of Emile Wolf, a New York collector. Wolf made no secret of the Degas. He lent the work at least twice, once to an exhibition at Finch College in 1965 and once to Harvard's Fogg Museum in 1968. In 1987 Daniel Searle, a wealthy Chicago collector acting on the advice of a curator at the Art Institute of Chicago, purchased the Degas for a price reportedly close to nine hundred thousand dollars. He too lent it out freely, most particularly to an exhibition of Degas landscapes that was shown in 1994 at the Met and the Houston Museum of Fine Arts. In 1995, while looking through a book published in connection with this exhibition, one of the Gutmann grandsons was finally able to locate the whereabouts of the long-missing Degas landscape that his grandparents had sent off to Paris some fifty-six years earlier.

The Gutmann heirs demanded the work back. Searle refused, and a lawsuit followed. Claiming to be a good-faith purchaser, Searle pointed out that a widely distributed catalog had been published for the 1968 exhibition at the Fogg. If the Gutmann family had been truly diligent in its search, it should have known on that basis where the work could be found. Accordingly, he argued, the statute of limitations should properly be found to have started to run in 1968 and had long since expired. More forcefully, Searle also argued that there was no proof that the work had not been sold in Paris after Gutmann had sent it there for sale in 1939. If, in fact, it had been sold, then the Gutmann heirs would have no claim.

To counter this second point, the Gutmann family was prepared to show that Emile Wolf had purchased it in 1951 from a Swiss collector, Hans Frankhauser. And Frankhauser, for his part, turned out to be the brother-

in-law of Hans Wendland, a Swiss-based German dealer who had allegedly helped the ERR sell off its confiscated plunder in Switzerland. In his remarkable book *The Lost Museum,* Hector Feliciano hypothesizes that—regardless of the intentions with which it was dispatched to Paris in 1939—the Gutmann Degas was never actually offered for sale by the dealer to whom it was sent but was placed instead in a warehouse for storage.[15] From that warehouse, Feliciano speculates, it was confiscated by the ERR sometime in 1942 or 1943 and shortly thereafter, presumably through the agency of Wendland, surreptitiously slipped out of Germany, through Switzerland, and into the stream of legitimate commerce. As a trial date approached, Searle's attorneys—seeking to establish a wholly different scenario—were meanwhile scouring Europe, trying to assemble documentary evidence to suggest that any connection that Wendland may have had with the Degas was irrelevant because the work had already been sold by the time it first came into his possession.

In the end, because of the almost total obscurity into which the facts about the Degas had fallen, the parties settled. Under a two-step agreement negotiated in August 1998, Searle and the Gutmann heirs first divided the ownership of the painting on a fifty-fifty basis. Searle then gave his half interest to the Art Institute of Chicago, which simultaneously bought the remaining half interest from the Gutmann heirs at a price determined by a fair-market-value appraisal. The institute agreed that the painting would be displayed to the public with a label that acknowledged its history and described the plunder and dispersal of the Gutmann collection. Both parties were left to pay their own legal fees, reportedly more than a million dollars for Searle and something less but still considerable for the Gutmann heirs. The heirs are continuing their search for some forty works that are still missing.

As those lawsuits were being settled, an unusual new one was just beginning. The plaintiffs were the heirs of the great prewar Paris art dealer Paul Rosenberg. The painting at issue was a Matisse *Odalisque* that had been in Rosenberg's prewar inventory and which, with the outbreak of hostilities, was included in a group of 162 works that he sent for safekeeping to a bank near Bordeaux. In September 1941 the ERR confiscated this entire group of works and sent them to the Jeu de Paume. In July 1942 the painting passed into the hands of Gustav Rochlitz—a German art dealer working in Paris—who took it in partial exchange for a French Renaissance painting that Göring wanted for his personal collection. In 1954 the painting surfaced in New York at the venerable and highly reputed firm of

Knoedler and Company. Knoedler sold it that year to Mr. and Mrs. Prentice Bloedel, major West Coast collectors. At their deaths in 1996 and 1991, Mr. and Mrs. Bloedel bequeathed their respective interests to the Seattle Art Museum, the defendant in this new lawsuit.

What made this case so unusual was that, from the very start, the Seattle Art Museum did not appear to be vigorously contesting the right of the Rosenberg heirs to recover the *Odalisque*. Rather than attempting to retain the painting, what the museum really appeared to be seeking was a legal vehicle through which it might pursue a claim against the Knoedler and Company. The Rosenberg heirs had no sooner filed their complaint against the museum than the museum in turn joined Knoedler as a party and demanded damages equal to the fair market value—according to one estimate, perhaps two million dollars or more—of the Matisse painting that it was being asked to surrender.

In June 1999—in something of a reversal in strategy—the museum announced that it had decided to return the painting to the Rosenberg heirs while continuing to press its claim against Knoedler. Concerned that Knoedler might now argue that there was no longer any basis on which it could be held liable for damages—that any loss suffered by the museum had been voluntarily incurred—the museum specifically tied its decision to the fact-findings in an investigatory report prepared for it by the Holocaust Art Restitution Project, a Washington, D.C.-based independent research organization that specialized in tracing the origins and ownership of valuable works of art that changed hands during World War II. In submitting these findings to the court, the museum asked that it ratify the decision to return the painting by ruling that the Rosenberg heirs did, in fact, have legal title.

Meanwhile, the museum continued to press its case against Knoedler, a case constructed with some ingenuity. Although the statute of limitations on the sale of a work of art normally begins to run at the time of the sale— 1954, in this case—a party acting in bad faith may not be able to avail itself of the statute. Knoedler, the museum claimed, acted in bad faith. Within its own library it had prewar exhibition catalogs indicating that the painting belonged to Paul Rosenberg. Moreover, that Rosenberg's paintings had been seized by the Nazis was common knowledge in the art trade. Knoedler, accordingly, either knew or should have known that it was selling to the Bloedels what was quite possibly a stolen painting. If the Rosenberg heirs had sued the Bloedels for its recovery, the Bloedels in turn might have sued Knoedler. As the result of an assignment by the Bloedel heirs of

whatever rights they inherited, the museum said that it now stood in the Bloedels' shoes and, therefore, it should have the same right. It should not be asked to relinquish so valuable a work of art without some financial compensation. In October 2000, Knoedler settled the case for an undisclosed amount of cash.

AN EVALUATION OF THE U.S. LEGAL FRAMEWORK

How satisfactory is this American legal framework as a means for dealing with these stolen art claims? That the Rosenberg heirs were at one point forced to bear the burden of paying legal fees in a dispute that continues to be essentially between the Seattle Art Museum and Knoedler certainly highlights one problem: the enormous costs that may be involved by such one-at-a-time lawsuits. The same can be said about the Gutmann case, where the combined legal fees of both parties were a multiple of what ultimately turned out to be the appraised fair market value of the contested Degas landscape. Among the factors driving these legal fees are the heavy burdens of proof that Holocaust survivors or their heirs face, both in showing their original, prewar ownership and in proving the circumstances under which their possession was terminated. Another problem concerns the applicability of statutes of limitations. Some observers—Congressman Jim Leach of Iowa is one—have expressed the view that these Holocaust art cases ought be treated as exceptions to more general legal rules and that the mere passage of time should never—solely in itself—be a bar to the recovery of Holocaust-stolen art.

A third and perhaps more perplexing problem arises when there is neither a survivor nor any surviving heirs to claim the stolen property. Consider for a moment the Archipenko sculpture in the Hirshhorn Museum's collection. Hypothesize that the sculpture was in fact taken by the Nazis from an apartment in Paris and, further, that there were no surviving heirs in the family from which it was taken. The perplexity is this: The American legal system is adversarial, not inquisitorial. It resolves actual controversies between opposing parties but, in the absence of such a controversy, it does not act on its own to investigate or correct what may be an injustice. And the consequence is this: If the Nazis were only partially successful in wiping out a Jewish family, there may be heirs remaining to reclaim family property seized during the war. If the Nazis, however, were entirely suc-

cessful in wiping out that same family, then there would be no survivors to make a claim. In such a case, the postwar possessors of the family's property—good-faith and bad-faith purchasers alike—might be wholly secure in their possession.

Proposals for Reform

Efforts have been initiated to reduce both the complexity and the expense of litigation and/or to find a more satisfactory approach to the problem of heirless art. Thus far, though, attempts to solve these problems through legislation have generated little support. If exceptions to the normal common-law rules regarding stolen property are to be authorized—and many legal commentators would argue that those rules, developed by examining many instances over many centuries, are far too delicately balanced to permit any major exceptions at all—what boundaries would limit such exceptions? Given America's deeply ingrained and constitutionally enshrined principle of equal protection under the law, it would be unthinkable that, for example, special rights might be extended to Jewish families whose property was confiscated under the ERR's "furniture program" in Holland but not to their Christian neighbors whose property was seized in an identical way. It may not even be thinkable under American law that such protection could be extended to the victims of the Nazis' ethnic cleansing in Europe but not to the victims of the Serbs' ethnic cleansing in Bosnia and Kosovo or to the victims of similar tragic events in Africa. Two recent legislative proposals, neither of them thus far successful, demonstrate these difficulties.

In June 1998, Congressman Charles Schumer of New York (now Senator Schumer) introduced H.R. 4138, the Stolen Artwork Restitution Act, which would have provided up to five million dollars in grants to organizations that maintained databases through which stolen works of art might be identified and located. Addressing the costliness of litigation, this bill also included language urging that disputes over stolen art be resolved by some alternative means. Another provision would have required a review of all works of art in the possession of the U.S. government to ensure that none had been stolen. A fourth provision was intended to raise the level of diligence that would be required for the purchaser of a stolen work of art to be deemed a good-faith purchaser. Presumably to overcome the "equal protection" problem, Congressman Schumer's bill would have provided identical treatment to all stolen art—whether confiscated by the Nazis in Bel-

gium or Holland in 1944 or stolen by a cat burglar prowling Beverly Hills this past summer. H.R. 4138 was referred to the House Judiciary Committee, where it expired for that session.

Far less temperate and more specifically targeted to Holocaust-era thefts was a bill introduced in the New York State Assembly in March 1997. Bill A10304 specifically limited its benefits to those it called "victims or survivors of the 'Nazi German Regime' of 1933 to 1945." Once the heirs of such a victim or a survivor initially claimed the prior ownership and loss of possession of a work of art, this bill would immediately—with no further evidentiary requirement—shift the burden of proof to the possessor. From that point forward, the only way its present possessor could continue to retain the work was by proving, through a preponderance of the evidence, legitimacy of ownership. Setting aside the similarity between this process and the way witches were once tried in Salem—guilty until proven otherwise—it was by no means certain that such a radical assault on traditional property rights could have withstood constitutional scrutiny. In any event, this bill also expired without any further action being taken.

Several nonlegislative approaches appear more promising, particularly a project undertaken by the New York–based Commission for Art Recovery, established by the World Jewish Congress in September 1997. The commission is compiling a series of databases, one of which is an ongoing compilation of prewar European ownership information gathered from insurance policies, inventories, exhibition catalogs, and other documentary sources. Some of these sources—particularly insurance policies with attached schedules of covered property—have only recently been discovered in previously little-known European archives. In one application, this database can furnish plaintiffs with evidence they need to help prove original ownership. In another, it can be readily cross-checked with other databases, including routinely computerized lists of works of art scheduled to be sold at auction, to identify any works that might justify further inquiry. Another such database includes works of art that Holocaust survivors or their heirs claim have been stolen, and it can be readily compared with lists of works scheduled for auction or held in public collections. Although the commission itself does not as a general rule pursue individual claims, it does have the capacity—whenever a match turns up from one list to another—to provide information to potential claimants who may then wish to pursue such claims on their own.

Still another effort to deal with Holocaust stolen art was announced in

June 1998 by the AAMD, an organization that in effect represents all of the major art museums across the United States. AAMD will require its members to review the provenance or ownership history of the works of art in their permanent collections to ascertain whether any were unlawfully confiscated during the Nazi era. It will also require that similar scrutiny be given to future gifts, bequests, purchases, and loans. When claims are asserted against a museum, it recommends—in parallel with Congressman Schumer's Stolen Artwork Restitution Act—that every effort be made to settle these by mediation rather than through the more costly route of litigation.

One particularly interesting aspect of AAMD's approach is its treatment of any heirless art that a member museum might find in its collection. In such cases, AAMD recommends that the museum retain the work but acknowledge its history on all relevant labels and in its publications. The writer Elie Wiesel has reportedly taken a similar position in the case of museum-held works of art that cannot be returned. The museum community is not wholly in agreement with that approach. Some argue that a museum's governing board should retain greater flexibility to determine how any particular heirless-art situation might best be resolved. At a minimum, its board members should have the latitude to consider other possible resolutions—including even resolutions that may be adverse to the museum's economic interests—without thereby breaching their fiduciary duty.

Outside the United States, the World Jewish Congress has taken a somewhat different approach. In the case of heirless art, it urges that Congress itself should be deemed to be a proxy or substitute for those who are no longer able to claim this art on their own. The Austrian government, for one, has recently accepted that position. In October 1996, some three thousand works of unclaimed heirless art, presumably confiscated from long-since-perished Jewish owners in Vienna and elsewhere, were auctioned off. The $10 million in proceeds were turned over to the World Jewish Congress for distribution to charitable organizations both within and outside Austria.[16] Unclear is whether the World Jewish Congress might eventually assert a similar position in the United States.

A PUBLIC DISAVOWAL OF EVIL

None of these approaches may ever provide more than the very roughest of justice. To clean up entirely even this tiniest corner of the Holocaust is light-

years beyond what we can ever hope to accomplish with any of our rules or systems. Nevertheless, an absolute and even passionate sense of necessity is driving many individuals to do whatever can be done. At a meeting in April 1998 addressing these issues, Professor Norman Daniels of Tufts University made the point that more than individual property rights are at stake in these Holocaust art cases. They also involve what he called a "public disavowal of evil"—a public refusal to allow anyone, innocently or otherwise, to derive an advantage from the evils inflicted on Europe by the Nazis. In a similar vein, Constance Lowenthal, who directs the Commission for Art Recovery, argued in a recent interview that the resolution of these cases has to involve something more than business as usual, that the normal legal rules applicable to such cases ought perhaps be relaxed because the "heinous nature" of the Nazi art thefts gives them "a unique moral dimension that cannot be ignored."

Yet other voices caution us against the temptation to stray too far from the well-worn legal path. The irony cannot be ignored that it was precisely through the abandonment of that path and the ensuing adoption of sweeping and all-encompassing solutions that many of the twentieth century's greatest sins were committed. Our only real choice may be to continue on our present path, awkward as it may be, proceeding conscientiously by one carefully wrought case at a time, but understanding all the while that these cases are merely the outward surface of something more profound. What is really at stake is more than just who owns one or another work of art.

Several commentators—Lynn H. Nicholas for one—have recently suggested as much. Nicholas is the leading scholar with respect to Holocaust-era art thefts. Her magisterial study, *The Rape of Europa,* continues to be the foundation for virtually all subsequent research in this field.[17] During a 1995 symposium at the Bard Graduate Center for Studies in the Decorative Arts, she suggested that these disputes about art are not simply about material things; they also have a psychological and emotional dimension that must be taken into account. "Behind the enumerations of paintings [and] archives," she said, "move the specters of lost families, lives, and cities; of destroyed memories and traditions which cannot be replaced; of patriotic passions and the terrible suffering of war."[18]

Another speaker at that symposium was the journalist and cultural writer Bernard Taper. Fifty years earlier he been stationed in Germany as an intelligence officer with the American military unit—the Monuments, Fine Arts, and Archives section—that was primarily responsible for returning

the millions of plundered works of art that the army had discovered at the beginning of the occupation. Looking back at the work he did in 1945, Taper said that he still felt proud. "Our efforts to try to tidy up . . . some small part of the epic mess that had been made, seemed to me to have been meaningful behavior, not merely as equity but also as ritual and symbol."[19]

Concerning the tension between the enormity of the wrongs to be righted and our limited capacity ever to right more than a fraction of them, a final observation—but perhaps the most poignant of all—comes to us across two millennia in the words of the first-century Palestinian sage Rabbi Tarphon, as those words were preserved in "The Sayings of the Fathers." "The day is short," Rabbi Tarphon is reported to have said, "and the work is great. . . . You are not required to complete the work, but neither are you free to desist from it."

NOTES

1. For example, House of Representatives Full Committee Hearing on House Resolution 3662, "U.S. Holocaust Assets Commission Act," June 4, 1998; House of Representatives Full Committee Hearing on the Restitution of Assets Seized by the Nazis, February 12, 1998; House of Representatives Full Committee Hearing on World War II Assets of Holocaust Victims, September 14, 1999; Senate Full Committee Hearing on the Swiss Banks and the 1946 Washington Accounts, July 22, 1998.

2. Lynn H. Nicholas, *The Rape of Europa* (New York: Alfred A. Knopf, 1994), 138–140.

3. S. Barron, ed., *Degenerate Art: The Fate of the Avant-Garde in Nazi Germany* (Los Angeles and New York: Los Angeles County Museum of Art and Harry N. Abrams, 1991).

4. Hector Feliciano, *The Lost Museum* (Basic Books, 1997), 95–104.

5. R. Redmond-Cooper, "Quedlinburg Indictment Comes Too Late," *Antiquity and Law* 3 (1998): 307.

6. The Declaration of London, 1943.

7. Except, as an ironist might want to point out, in Nigeria, from which it was stolen in the first place many years before it ever came to the Smithsonian.

8. "Developments in the Law—Statutes of Limitation," *Harvard Law Review* 63 (1950): 1177, 1185.

9. *Schmidt v. Merchants Dispatch Transp. Co.*, 270 N.Y. 287, 302, 200 N.E. 824, 827–828 (1938).

10. *Leake v. Bullock*, 104 N.J. Super. 309 313 250 A.2d 27, 29 (1969).

11. C. Shapreau, "California's Discovery Rule," *Art Antiquity and Law* 51 (1996).

12. See *DeWeerth v. Baldinger*, 836 F.2d 103, 108–109 (2d Cir. 1987) and 486 US at 110; see also *Guggenheim v. Lubbell*, 550 N.Y.S.2d 618, 619 (App. Div. 1990) and 569 N.E.2d

426 (N.Y. 1991), and *Autocephalous Greek Orthodox Church of Cyprus v. Goldberg & Feldman Fine Arts Inc.*, 917 F.2d 278 (7th Cir. 1990) and 112 S.Ct. 337 (1991).

13. See *Gascoigne v. Gascoigne* [1918], K.B. 223 at 226; *Carmen v. Fox Film Corp*, U.S.C.A. (2d Cir.) 1920 269 F.928; *New York Football Giants Inc. v. Los Angeles Chargers Football Club Inc.*, 291 F.2d 471 (5th Cir. 1961).

14. *Republic of Turkey v. Metropolitan Museum of Art*, 762 F.Supp.44, 45 (S.D.N.Y. 1990).

15. Feliciano, *Lost Museum*.

16. The Mauerbach Benefit Sale, Christie's, Vienna, October 29 and 30, 1996. See O. Rathkolb, "From Legacy of Shame to the Auction of Heirless Article in Vienna: Coming to Terms Austrian Style with Nazi Artistic War Booty," published at Bruno Kreisky Archives Foundation Web site at members.vienna.at/kreisky/naziartloot.

17. Nicholas, *Rape of Europa*.

18. Nicholas in *The Spoils of War*, ed. E. Simpson (Harry N. Abrams, 1997).

19. Taper in Simpson, *Spoils of War*.

Fair Use and the Visual Arts

<div style="text-align:center">

PLEASE LEAVE SOME ROOM FOR ROBIN HOOD

</div>

The essay that follows rests on two foundations. One is the conception of fair use that federal judge Pierre N. Leval has so eloquently articulated over recent years: Fair use is not an exception to copyright's overall objective but is, rather, wholly consistent with that objective. If copyright's initial purpose was, as Leval has argued, to be an incentive that would stimulate progress in the arts for the intellectual enrichment of the public, then what is basically required in order to determine whether any particular use is or is not a fair one is a two-pronged inquiry. First, is the use of a sort consistent with copyright's underlying purpose of stimulating further productive thought and public instruction?[1] Second, if so, does it then do so without unduly dampening copyright's incentive for creativity?

The other foundation on which this essay rests is the proposition that the realms of the verbal and the visual are so fundamentally different that the rules developed to govern fair use in the one realm—language-based rules developed primarily in the context of the printed word—are not neces-

The original version of this text was the basis for a presentation first delivered at an interdisciplinary conference on technology and intellectual property held at the Ohio State University College of Law in February 2000 and then delivered again in March 2000 at a symposium on images and ethics held at the Annenberg School of Communications, University of Pennsylvania. This slightly revised version subsequently appeared in 62 *Ohio State Law Journal* 835 (2001) and is reprinted with permission.

sarily the most productive rules by which to govern fair use in the other. The argument here is that the objective of copyright could better be achieved if the visual arts had their own distinct and separate fair-use regime. In such a regime, regard must be given not only to the ways in which the visual arts as a whole differ from their creative counterparts in other realms—especially from the domain of the printed word—but also to the ways in which the various genres within the visual arts differ from one another. Four such differences are considered below.

THE CASE FOR APPROPRIATION

In contrast to its relatively infrequent use in literature, appropriation played and continues to play an important role in many of the most significant visual art movements of the twentieth century. On a recent visit to the Hirshhorn Museum and Sculpture Garden, I was struck by how many objects were on view in which one artist made reference to the work of another. In the museum's special exhibition *Regarding Beauty,* the first six works of art that a visitor encountered—works by artists as diverse as Jannis Kounellis, Michelangelo Pistoletto, Yasumasa Morimura, and Cindy Sherman—all incorporated, in part or in whole, other works of art: casts of antique sculpture, a series of portraits from the Renaissance, and, in one instance, Manet's great painting *Olympia* in its entirety.[2]

On another floor, Nam June Paik's *Video Flag*—its seventy 13-inch (33-centimeter) monitors arranged in the familiar format of the American flag—was pulsing out a barrage of microsecond-long snippets culled from television newscasts, documentaries, commercials, and films. Elsewhere were Larry Rivers's witty reprises of Cezanne's *Cardplayers* and David's standing portrait of *Napoleon,* together with Gerhard Richter's sumptuous repainting of Titian's *Annunciation* and Andy Warhol's own idiosyncratic version of the *Mona Lisa.* Outside the museum, in shimmering stainless steel, stood Jeff Koon's 6-foot- (1.8-meter-) high *Kiepenkerl,* a work cast directly from a twentieth-century replica of a nineteenth-century bronze sculpture, depicting a local tenant farmer, that once stood in a square in Munster, Germany.

This is more than coincidence. As the California-based experimental music and art collective Negativland pointed out in a statement on fair use posted on its Web site, "Artists have always perceived the environment

around them as both inspiration to act and as raw material to mold and re-mold. However, this particular century has presented us with a new kind of . . . human environment. We are now all immersed in an ever-growing media environment—an environment as real and just as affecting as the natural one from which it sprang."[3]

In tandem with the emergence of this "ever-growing media environment" has been the emergence, not surprisingly, of a new legal environment as well. The environment by which artists were once surrounded was a freely usable one of landscapes, seascapes, and townscapes, of cottages and cows. This new environment—the one that artists today are seeking to mold and remold—consists to an ever-greater measure of media and other human creations in which intellectual property rights generally subsist. A contemporary artist who seeks to portray aspects of everyday life must, in the course of doing so, almost inescapably bump up against somebody else's copyrighted material.

Beyond this change in subject matter, the repertory of techniques available to contemporary artists has also expanded. One early-twentieth-century development was the emergence of collage, a technique that frequently makes use of previously printed materials. A corollary technique common to virtually all of the photographic arts is montage, which also may rely on preexisting films, photographs, or video. Artists who would avoid complications by limiting their appropriations to material in the public domain find that the public domain itself has shrunk and continues to shrink. American artist Cindy Sherman, for example, is not yet fifty years old. If the artists of some future generation should choose to build upon her art, as she has chosen to build upon the work of those before her, it could well be another hundred years or more before her work is safely in the public domain and those future artists are clearly at liberty to use it.

If our society is to continue to be enriched by the vigorous production and distribution of original works of visual art, then visual artists need a license to forage widely—far more widely than conventionally interpreted copyright law might permit—in gathering the raw materials out of which to compose their work. In *Campbell v. Acuff-Rose Music,* the U.S. Supreme Court unanimously ruled that rap group 2 Live Crew's 1989 version of Roy Orbison's 1964 hit song "Oh Pretty Woman" could be characterized as a parody and that, accordingly—under a judicially crafted exception to the copyright law—it did not constitute an infringement of the original. In the end, 2 Live Crew's in-your-face rap music proved so outrageous that the Su-

preme Court could not escape its parodic element. Although *Campbell v. Acuff-Rose Music* might be read as a promising step in that direction, it is also a case that should be read with great caution.[4]

That the deadpan and often elusive ironies of postmodernist visual art are also parodies may not be quite so clear. *Rogers v. Koons*, a case in which the court never really "got" what the artist intended, seems a case in point.[5] Even had the Koons case been decided otherwise, it would still have left visual artists with a remarkably narrow fair-use opening through which they would have had to wiggle. And parody is by no means the only mode by which one work of art may refer to another in order to achieve a desired artistic effect.

The American literary critic R. P. Blackmur once observed that poetry had the capacity to add to our "stock of available reality."[6] Works of visual art share that same capacity. When the copyright law is used—as it was in *Koons*—not merely to award damages but actually to suppress a work of art, then its effect is to diminish the stock of reality available to those who might one day have come into contact with that work. Or worse, as Louise Harmon has pointed out, the loss to the public in such an instance may go far beyond just that one particular work of art. "Other artworks," she wrote, "may never reach maturation; some may never be conceived. There is much to mourn in Jeff Koons's defeat. Little unseen deaths inside you, inside me."[7]

In terms of the public's enrichment, the benefits to be expected from permitting visual artists to work at their imaginative fullest would seem to far outweigh any resulting disincentives to creativity. Visual artists, above all, need a fair-use rule that is both flexible enough and spacious enough to permit them a considerable degree of appropriation. To the extent that they might abuse such a privilege, remedies less drastic than to deprive the public of their work might better be established elsewhere than under the Copyright Law.

PERMITTING IMAGES TO CIRCULATE FREELY

For the visual arts to achieve their maximum vigor, artists require not only the freedom to work at their imaginative fullest but also the support provided by an "art world" of collectors, curators, critics, and others. Such an art world cannot function properly, however, without the relatively unimpeded circulation within it of images of contemporary art in such forms as

slides, transparencies, and printed illustrations. Of the several sensory do-
minions we inhabit, that of the visual is arguably the most complex—both
in the richness of the elements it comprises and in the simultaneity with
which those elements may be apprehended. At any moment, our visual field
can encompass hundreds or even thousands of these elements, each of a dis-
tinctive color, contour, and texture. In terms of color alone, the appear-
ance of any single element may change from moment to moment, de-
pending upon the distance from which it is seen, the light by which it is
illuminated, and the proximity it has to one or more other elements. If Es-
kimos truly do have thirty words for snow, that number pales by compari
son to the vocabulary that would be required—a million words or more—
to name all the distinct colors among which the human eye can purportedly
differentiate. The computer does even better: A twenty-four-bit monitor
has the capacity to produce more than 16 million different colors.

Regard must be given here to those differences between the realms of the
verbal and the visual. That words can be adequately defined by other words
is what makes a dictionary possible. By that same token, most verbal com-
positions—a novel, a play, even a narrative poem—can be effectively sum-
marized or even paraphrased. A reviewer might write a perfectly intelli-
gible review of a new novel or play without ever actually quoting a single
line of text.

Images generally cannot be adequately defined, though, either by words
or by other images. Likewise, works of visual art—because they partake of
the simultaneity and infinite complexity of the visual realm—cannot be ade-
quately summarized or paraphrased. Nor can they be accurately described.
Imagine trying to provide an adequate verbal account of Botticelli's *Primavera*
or Rembrandt's *Night Watch*.[8] Unlike the literary critic, an art critic would
find it virtually impossible to write an intelligible review of a new painting
without providing the reader with some pictorial notion of what the paint-
ing itself looked like. Not even quotations can help. Works of visual art, un-
like literary ones, are generally incapable of yielding up some small detail
that, like a quotable extract, might give a better sense of the whole.

If works of contemporary visual art are to be discussed, analyzed, de-
bated, compared, championed, criticized, or demonized or are otherwise
to serve as the center of any serious discourse, then images of those
works—images of them in full, not just details—must be available to cir-
culate among those who participate in that discourse and who ultimately
provide a support system for the creators of those works.

Just as it might be sound copyright policy to provide contemporary visual artists greater latitude than other creative practitioners as to what they may incorporate into their own work, it may also be sound policy to limit the ability of such artists to use copyright to impede the free circulation of images of that work within the cultural and commercial marketplaces. It is also important that artists (or, as may be more frequently the case in actual practice, the surviving spouses or other heirs of artists) not be able to use copyright in wholly arbitrary ways as a means to stifle and/or control the views expressed by others with respect to their work. To put too great an emphasis on the exclusionary aspects of copyright is to undermine its fundamental public-service objective.

Section 107 of the Copyright Law provides that, in determining whether certain uses for purposes such as criticism, comment, news reporting, teaching, scholarship, or research might be "fair uses" and consequently noninfringing, the factors to be considered in any particular case shall include "(1) the purpose and character of the use, including whether such use is of a commercial nature or is for nonprofit educational purposes; (2) the nature of the copyrighted work; (3) the amount and substantiality of the portion used in relation to the copyrighted work as a whole; and (4) the effect of the use upon the potential market for or value of the copyrighted work."[9]

Arguably, then, in determining the fairness or unfairness of producing and distributing photographic and/or printed copies of a work of art for educational purposes or for comment and criticism, little or no weight should be given to the third of section 107's four fair-use factors—the amount and substantiality of the portion used in relation to the copyrighted work as a whole.[10] Because visual images cannot be summarized, paraphrased, described, or even quoted, it follows that uses intended for the purposes of education, criticism, and comment must—if they are to engender the meaningful discourse essential to ongoing well-being of the visual arts—necessarily include some greater "amount and substantiality" of the copyrighted original than might be the case for some other kind of use or in some other area of creativity. Instead, added weight must go to factor one—the purpose and character of such a use.[11] Thus approached, a use that is truly aimed at encouraging a broader and/or more discriminating appreciation of a work of visual art should (absent some fatal problem under factor four) per se qualify as a fair use. Factor three, then, might only regain some greater weight when the purpose of the use did not pertain to education, criticism, or comment.

IMPACT OF DIFFERENT BUSINESS MODELS

The extent to which strong copyright protection is warranted for a work of visual art may depend upon the business model by which it is distributed to the public and the medium in which it was originally created. Works of visual art are distributed to the public through a broader variety of business models than are the products of other creative domains. Consider the spectra along which these might be arrayed. At one extreme is the model employed by Thomas Kincade, the California painter of sentimental landscapes and rain-glittering city scenes whom the *New York Times* recently described as this country's most commercially successful artist.[12] Kincade reportedly does not sell his original paintings at all. What he sells instead are prints made from these. Distributed by a captive network of more than two hundred galleries (the "Signature Galleries"), these prints are offered in a dazzling variety of formats: Studio Proofs, Gallery Proofs, Renaissance Editions, versions touched up with a little paint by a studio assistant, or versions touched up with quite a bit more paint by the artist himself. Prices can range from $35 for a small, framed gift card to $10,000 or more for a large, hand-touched paper print mounted on canvas. Some editions are "limited," but those limits can run up to several thousand for each size of each image. For fiscal year 1999, Kincade's publisher—the New York Stock Exchange–listed Media Arts Group—reported net revenues of $126 million. Assuming that half the retail sales proceeds were retained by the galleries, that would suggest that the volume of Kincade sales to the public is around $250 million annually.

At Kincade's end of the spectrum, then, we have the work of art as the source of a valuable image. At the other end of the spectrum, though—in total contrast—is the work of art as a precious object. The most familiar example of the type of artwork is the hand-painted canvas that an artist has personally created in a single copy, to be sold for a price that will probably constitute the entire income ever to be realized from its production. Consider the work of the contemporary British figurative painter Lucian Freud, who has reportedly sold several of his most recent paintings for upward of $2 million each.

Let us suppose, first, that each of these artists retains copyright to his work and, second, that an art museum—the Philadelphia Museum of Art, for example—without the authorization of either Kincade or Freud, pro-

duces and offers for sale in its on-site museum shop a set of full-color post-cards of paintings by both these artists. Assuming that this use meets the threshold test of section 107—the museum can successfully argue that its distribution and sale of postcards is at bottom educational—and also assuming that the third fair-use factor is not to be given any weight, how confidently can we proceed to apply the fourth fair-use factor, the one that addresses the effect of this use on the market?

In the case of Kincade, the fourth factor makes an excellent fit. Kincade's business model is essentially that of a book publisher who, without ever attempting to sell the underlying manuscript itself, simultaneously offers deluxe, clothbound, and paperbound editions of the text. Under those circumstances, the unauthorized Kincade postcard might compete directly with those small, framed, thirty-five-dollar gift cards. To attempt to defend such a use as fair under section 107 might very well founder over this fourth factor, potentially having an effect on the market for or value of the copy-righted work. To permit the manufacture and distribution of such a post-cards could only—in Judge Leval's analysis—diminish the artist's incentives for creativity, without providing the public any substantial benefit beyond that which it already enjoys.

The case of the Freudian postcards is different. Freud's business model—a very traditional model for painters—is to sell his original paintings and to suppress whatever urge he may otherwise feel to traffic in printed copies of these. The fourth factor of section 107 scarcely fits his situation at all. Assuming in the first place that the paintings depicted on the postcards were for sale—they might not be; they might be in the hands of museums that never deaccession works of art from their collections—it would still be ludicrous to contend that these postcards might adversely affect the artist's market, that a potential purchaser of one of his paintings might be tempted to acquire a postcard as a substitute.

Alternately, although such an unauthorized postcard might be competitive with an authorized small-scale printed version of the painting—in which case its manufacture and distribution might be palpably unfair—what if no such authorized small-scale version is ever to be anticipated? *Campbell v. Acuff-Rose Music,* the 2 Live Crew case, suggests that an unauthorized derivative work may constitute a fair use when there is little likelihood of a similar version ever appearing with the copyright owner's authorization. If these postcards and other small-scale printed versions are unauthorized works, it might be arguable, again in Levallian terms, that the museum's

production and distribution of those unauthorized Freudian postcards is, on balance, enriching to the public without diminishing the artist's incentive for continued creativity in any substantial way.[13]

Between these Kincadian and Freudian extremes are a host of other business models, each with its own following among visual artists. In every instance, how and to what extent the section 107 factors can be applied to even so seemingly simple a copy as a picture postcard will depend on very specific facts and circumstances. Picture postcards, in turn, are only the tip of the complexity. Offered within every museum shop, beside those postcards, are a host of other art-derived products, some of such hefty and indisputable educational value as scholarly catalogs and some of such tangential or even dubious educational value as coffee cups and T-shirts. Notwithstanding the fantasies of those who hope that copyright law might be smoothed out to an easy, uniform application, each of these many uses might require a separate determination—on the basis of all of its particular facts and circumstances—to ascertain whether or not it was a fair one.

Further complicating the application of the fourth fair-use factors in section 107, the range of materials and techniques employed to create original works of visual art and copies of those works is far broader than that in other creative domains. Notwithstanding the variety of forms they may take, literary works are invariably embodied in language. Determining whether and to what degree any particular text may be a copy of some other—even when the language of the original has been changed through translation—may be little more, at least conceptually, than a case of comparing apples with apples. Within the visual arts, comparisons can rapidly escalate to the level of apples and oranges.

Until late in the nineteenth century, the visual fine arts largely consisted of painting (in a variety of media and on a variety of surfaces), sculpture (cast metal and carved wood or stone), printmaking, and drawing. In the past century, that list expanded to include collage, constructed sculpture, sculpture cast or otherwise fabricated in glass, plastic, and ceramic, conceptual art, fabric art, earth art, and, perhaps most important, the still-expanding range of photography-based fine art forms including still photography, motion pictures, and video art, as well as the now-emerging Internet art. Also expanded has been the range of materials and techniques by which these original works of fine art may be copied, sometimes in their original medium, sometimes in other media altogether.

Returning to our hypothetical on-site museum store—the one that spe-

cializes in unauthorized copies—the least perplexing cases for fair-use purposes might be those in which an original work of art was copied so exactly in terms both of its medium and its appearance as to be virtually indistinguishable from the original. That might be the case with a minimalist sculpture by Donald Judd or Carl Andre, a black-and-white photograph by Robert Mapplethorpe, or a work of digitalized video art by Bruce Nauman. In those instances, the fourth fair-use factor of section 107 again appears to make an easy fit. Setting aside their lack of appeal to that handful of collectors with the means to pay a premium price for a real Judd, Andre, Mapplethorpe, or Nauman original, the production and distribution of these copies might readily be enjoined on competitive grounds—to use Levallian terms, they are wholly duplicative rather than in any sense transformative.[14] Here the balance tips toward protection. For the public, no gain; for the artists, some pain.

Not so obvious might be the outcome when the copy is in a different medium: a small, black-and-white photograph of a monumental and brilliantly colored kinetic sculpture, or a videotape of the works hung in a painting exhibition. Consider the case of the sculpture. It would by no means be clear how the "amount and substantiality" of the portion used in the photograph would weigh in relation to the monumental sculpture as a whole. As for the fourth fair-use factor, its application to the museum-made photograph might, in turn, depend on whether the sculptor was seeking to exploit a market in such a derivative. At a policy level, this photographic copy—more transformative, less duplicative—might be understood as providing the public with a benefit beyond that furnished by the original without unduly penalizing the copyright owner in the course of doing so. Thus understood, such a use might, on balance, qualify as a fair one.

Again, as was the case of with the different business models, generalities may be misleading. The determination of whether any particular unauthorized copy does or does not qualify as a fair use requires a careful examination of all the facts and circumstances surrounding both the original and that copy.

WHAT IS A REPRODUCTION?

Particularly applicable to works of visual art is Susan Sontag's dictum that "art is not only about something; it is something."[15] It is here that the situa-

tion of the visual arts diverges most radically from that of the literary ones. With the possible exception of lyric poetry, literary works are primarily *about* something. Not so works of visual art. They're about, but they also *are*.

That distinction has not always been recognized. In the second of his *Bridgeman Art Library* opinions, for example, Judge Lewis A. Kaplan observed that photographic "transparencies stand in the same relation to the original works of art as a photocopy stands to a page of typescript."[16] Notwithstanding whatever accuracy that analogy might have had in the particularly narrow context in which he invoked it—the question before Judge Kaplan concerned the degree of originality involved in making photographs of paintings—beyond that context, the analogy he offered is wholly misleading. A transparency or other photograph of a work of art most emphatically does not bear the same relation to such work as does a photocopy to a page of typescript. The photocopy is literally a reproduction. It includes virtually everything of importance about the typescript except perhaps the watermark, weight, weave, and finish of the paper on which it was originally typed. In terms of the information it conveys about the text, it can readily be considered complete.

By contrast, the transparency of the painting is anything but complete. A confection of celluloid and colored dyes, it may capture the painting's informational content—in essence, what it's about—but in no way does it reflect what the painting is: a tangible object with a physical scale and presence, a canvas support or other surface encrusted and/or stained with a distinctively applied coat of paint in a range of pigment-based colors that in the depth of their hues and their subtle interplay far exceed anything that a camera could possibly record. That the various paper products commonly generated from such transparencies—catalog and book illustrations, postcards, posters, and various-size prints suitable for framing—are so frequently referred to as "reproductions" seems an unfortunately imprecise and misleading usage. If Judge Kaplan's photocopy is truly what counts as a reproduction of the typescript from which it was made, then the only thing that should comparably count as a reproduction of a six-square-foot (half a square meter) heavily impastoed abstract expressionist canvas would be another such six-foot-square canvas—a full-scale and just-as-heavily impastoed copy of the original. The transparency and its progeny are not reproductions. A more accurate term for them might be "photoreductions."

Here again, the third of section 107's fair-use factors comes into play. The degree to which these photoreductions omit substantial parts of what a

painting "is" may arguably have implications in applying this third factor. In dealing with such a photoreduction, what is the "portion used" that is to be compared in "amount and substantiality" with the copyrighted work as a whole? In the case of our Freudian postcards, might we not appropriately think of such a postcard as little more than a thin, pale reflection of the larger and more imposing original? Might we not even analogize such a postcard to the quotation of a brief passage excerpted from a longer text?

Such an interpretation would provide a further degree of fair-use protection to many of the photoreduction-based images in which museums shops traditionally deal. As a possible improvement on Judge Kaplan's photocopier analogy, consider this: A photograph has the same relation to an original painting that the literal translation of a palindrome might have to the palindrome itself. *Madame, je suis Adam* may certainly catch the literal sense of "Madame, I'm Adam." Just as certainly, though, what it has lost in translation is everything that made the original a palindrome—and also that made it interesting—in the first place.

Fair use has so integral a connection to the maintenance of a robust visual creativity in our society that we can ill afford even to limit its application— much less to lose it completely. Of the several threats it faces, consider these two. One would be any effort to simplify its application, to formulate some one-size-fits-all rule that might be incorporated into software and that could claim to provide prompt, clear, and reliable answers as to which proposed uses were or were not fair ones. For better or worse, fair use in the visual realm—with its reliance on particular facts and circumstances—may never be a neat or tidy affair.

The other threat, perhaps equally dangerous and particularly damaging in the case of artists, might be the restriction of access to copyrighted materials in cyberspace. Fair use is quintessentially a "don't ask" practice. First comes the use; the discussion of whether or not the use was a fair use follows—if and when the original copyright owner objects. A use authorized in advance is only an authorized use, not a fair one. When the authors of the U.S. Patent and Trademark Office's 1995 white paper speculated in an ominous footnote that fair use might be an "anachronism with no role to play" in the age of electronic commerce, they presumably meant that fair use was a potential stumbling block.[17] Fair use is far too fact-specific to make an easy fit with a seamlessly functioning, self-regulating, and encryption-guarded system in which all of the aspects of a copyright negotiation—the

scope and terms of a proposed use, the fee to be paid, and perhaps even the payment itself—might be wholly integrated into one smooth process.

Whatever the advantages of such a system in commercial convenience, the threat to creative freedom could be considerable. If visual artists are to enrich our society by "molding and remolding" the environment in which we live, they require unfettered access to all aspects of that environment—including however much thereof may happen to consist of materials copyrighted by others—so that they can do their work, and so that we may have its ultimate benefit. In its way, fair use is the "Robin Hood provision" of copyright. Within limits, it permits the artist—not infrequently envisioned anyway as a sort of rogue—to poach on the content-rich so long as excessive harm isn't done and so long as something with a value beyond that of the original is thereby made available to everybody else. Even now, as the lush and enchanted forest of cyberspace springs up all about us, room—some place for play, some proper clearing in the woods—still needs to be left for Robin Hood.

NOTES

1. Judge Leval refers to uses that meet this first test—uses that introduce additional creative elements rather than simply duplicate the original copyrighted material- as "transformative" uses. Judge Leval was first appointed to the District Court for the Southern District of New York in 1977 and subsequently elevated to the U.S. Court of Appeals for the Second Circuit in 1993. His views on fair use—which have proven highly influential—are set forth in an extensive series of opinions, speeches, and law review articles. See Pierre N. Leval, "Toward a Fair Use Standard," *Harvard Law Review* 103 (1990): 1105.

2. *Regarding Beauty: A View of the Twentieth Century* was a group exhibition organized by the Hirshorn Museum and Sculpture Garden in Washington, D.C., from October 7, 1999, through January 17, 2000. It was subsequently shown at the Haus der Kunst in Munich from February 11 through April 30, 2000.

3. The Negativland Web site—a remarkably feisty source of anticopyright sentiment—can be found at http://www.negativland.com.

4. *Campbell v. Acuff-Rose Music, Inc.,* 510 U.S. 569 (1994). Further details concerning this case (and samples from the two musical versions) can be found at the copyright Web site, http://www.bencdict.com/audio/crew/crew.htm.

5. The work of art at issue in *Rogers v. Koons,* 960 F.2d 301 (2d Cir., 1992) was a sculpture entitled *String of Puppies* that the well-known New York artist Jeff Koons had based

directly (and without authority) on an image by the relatively lesser-known California photographer Art Rogers. Rogers sued for copyright infringement. Koons's defense was that his sculpture was essentially satiric or parodic in nature and, accordingly, was immune from any charge of infringement as a form of fair use. In rejecting that claim and finding for Rogers, the Court noted that parody can only function as such when the work subject to parody was already familiar to the audience for the parodic version and found that such was not the case in this instant situation.

6. James D. Bloom, *The Stock of Available Reality: R. P. Blackmur and John Berryman* (1984).

7. Louise Harmon, "Law, Art and the Killing Jar," *Iowa Law Review* 79 (1994): 367, 412.

8. Sandro Botticelli (1445–1510), *Primavera* (ca. 1477–1478), Uffizi Gallery, Florence, and Rembrandt van Rijn (1606–1669), *The Militia Company of Captain Frans Banning Cocq ("Night Watch,"*1642), Rijksmuseum, Amsterdam.

9. 17 U.S.C. Sec. 107 (1994).

10. Sec. 107 (3).

11. Sec. 107 (1).

12. See the article describing Kincade, his working methods, marketing strategy, philosophy and audience, by Tessa DeCarlo, "Landscapes by the Carload: Art or Kitsch?" *New York Times,* November 7, 1999, Arts and Leisure section.

13. In other words, it is arguable that such a use might tend to be of benefit to the public without unduly discouraging the artist from further production.

14. Leval, n. 1 *supra.,* concerning concept of "transformative."

15. Susan Sontag, "On Style," *Against Interpretation* 39 (1969).

16. *Bridgeman Art Library, Ltd. v. Corel Corp.,* 25 F. Supp. 2d 421 (S.D.N.Y. 1998), on *reconsideration,* 36 F. Supp. 2d 191 (S.D.N.Y. 1999). The principal question in the *Bridgeman* case was whether meticulously prepared color transparencies of two-dimensional works of art that were themselves in the public domain contained a sufficient degree of originality to entitle such transparencies to independent copyright protection. The Court held that they did not.

17. *Intellectual Property and the National Information Infrastructure: The Report of the Working Group on Intellectual Property Rights* ("White Paper"), U.S. Information Infrastructure Task Force, Working Group on Intellectual Property Rights, Bruce A. Lehman, chair (Washington, D.C.: U.S. Patent and Trademark Office, 1995).

2 2

Cloning and Copyright

In September 1996, at a symposium celebrating the Smithsonian Institution's 150th anniversary, Bran Ferren, the senior vice president for creative technology in the Disney Corporation's research and development division, asked participants of a Smithsonian symposium to imagine themselves in the following fantastical situation.[1]

It's the mid-1950s. You have just learned that you have a serious—probably even fatal—heart problem. But the doctor tells you not to worry, that your life can be prolonged by a new technology. "We are," says the doctor, "going to saw your chest open. We are going to put in a computer." (Here Ferren paused to remind his audience that in the 1950s the only computer that anybody knew about was a bulky, several-ton mainframe that occupied its own large and specially air-conditioned workspace.) "We are going to put in a stethoscope and listen to your heart. We are going to put in a cattle prod, so if it stops, we will give it a little 'zotz' and get it going again. We have to power this, and because it is hard to get connectors through the skin, we will probably put a little nuclear power plant in your heart, a little plutonium, but you should live a long, healthy life."

The seemingly impossible combination of devices about which Ferren was talking was, of course, the pacemaker. Through miniaturization and the

This text was delivered at a symposium on art and the law held in April 2000 at the Benjamin N. Cardozo School of Law, Yeshiva University.

economies attributable to mass production, technologies that were once cutting edge and exotic have today become commonplace and widely affordable. And that was his point: how unforeseen—perhaps even, for most people, how unforeseeable—were the developments, even in existing technologies, that would occur within only the next four or five decades. What additional wonders might yet spring from wholly new technologies was beyond unforeseeable. It was unimaginable.

In this instance, I want to touch on two subjects on which new technologies—foreseeable ones, already in development—may have an enormous impact on art and the law: cloning and copyright.

The cover of the April–May 2000 issue of the Library of Congress magazine *Civilization* carried this headline: "How to Clone at Home." The story inside told how—in the field of plant biotechnology—the expense to set up a home-based, do-it-yourself laboratory had steadily plummeted to the point that "the cost in required materials and equipment is [now] next to nothing." The chairman of Edvotek—a company that sells biotechnology-related educational supplies—was quoted as saying that an adequately equipped home lab could be set up for less than thirty-five hundred dollars.

As this technology continues to develop—from reproducing and/or modifying existing genes to producing new and wholly novel genes and/or combinations of genes—and to become more readily accessible, how long will it be before the first visual artist begins to explore its use as a medium of artistic expression? And, if so, with what consequences under intellectual property law? Could the artist's work in such a medium receive the relatively lengthy protection of copyright if it were claimed to be a living, self-replicating sculpture, or would protection be limited to the shorter period of a patent? What about mutations? Would those constitute derivative works? What kind of moral rights, if any, might ultimately attach? Would an owner's failure to water or fertilize such a living work be a violation of that moral right?

Those questions, though, are simple compared to those that might arise at the next level of complexity—cloning animals. That technology is still in its earliest phase.[2] If animal cloning—not limited to genetic duplication, but moving on to genetic enhancement as well—should follow the same path as other technologies, in two or three generations it too might well be as publicly accessible as plant cloning has become today.

And if plant cloning is a temptation, consider what it might be like for artists if they could express themselves by designing their own living crea-

tures; if every artist could be his or her own Dr. Frankenstein. Think of what an extraordinary tangle of legal issues that might generate.

Given the danger that an artist could accidentally flood the planet with self-replicating creatures who might in time compete with humans for food and space, ought we permit this at all? Alternately, if we do, how would such creatures be classified? If we consider them to be human, then civil and human rights issues will need to be resolved. If we consider them instead to be animals, issues of animal rights may come into play.[3] Even if we were to create some new category into which such creatures might be classified, a host of intellectual property questions (and personal property ones too) would still have to be addressed.

All that, though, is only prelude. What I really want to address here is the possibility (and, by the end of the twenty-first century, perhaps the reality) of cloning objects, the possibility of creating duplicate, triplicate, and up-to-infinity-cate copies of original objects that in every detail—molecule for molecule, atom for atom—replicate those original objects exactly.

The field of investigation that gives rise to this startling possibility is called "nanotechnology." Of the several definitions now in circulation, the simplest might be that it is mechanical engineering at the atomic level—it contemplates the extraordinarily precise assembly of objects one atom at a time. Although the great American physicist Richard Feynman is generally credited with having first suggested that such a process might be possible in 1959, the founding theoretical work in the field was done by K. Eric Drexler at MIT and first published in his book *Engines of Creation* in 1986. Since then, nanotechnology—initially greeted with considerable skepticism and/or as little more than the stuff of science fiction—has slowly worked its way from a fringe science freak show toward an increasingly respectable place within mainstream scientific and industrial research.

In 1996 two scientists at Rice University in Houston shared the Nobel Prize for chemistry for their work with "buckyballs." Named after Buckminster Fuller, these were arrangements of sixty or more carbon atoms that resembled soccer balls. That work, in turn, has led to the creation at Rice's Center for Nanoscale Science and Technology of "buckytubes"—a pattern of carbon atoms that can be formed into fibers said to be one hundred times as strong as steel at less than one-sixth the weight of steel. As if to demonstrate the rapidity with which a technology can move from the exotic to the commonplace, buckytubes can now be ordered through Rice's Web site.[4]

For fiscal year 2000, the federal budget for nanotechnology research was

$123 million. In his budget proposal for fiscal year 2001, President Clinton—launching what the White House called the National Nanotechnology Initiative—proposed that this be increased to $227 million. Interestingly, approximately 10 percent of that total was to be used to study nanotechnotogy's impact on society from "legal, ethical, social, economic, and workforce preparation perspectives."

My own fascination with this technology and its possible application to works of art can be traced to a meeting of the Texas Association of Museums where, in the middle of an otherwise sober presentation about nanotechnology, Hal Ham—director of the Conner Museum at Texas A&M, and with his tongue only partly in cheek—suddenly tossed out the exhilarating proposition that, through such a technology, artistic masterpieces might be replicated in infinite quantities and with absolute fidelity. If we wished, there could someday be a *Mona Lisa* in every museum in Texas or, even better, a *Mona Lisa* in every home in America.[5]

Three years later, this notion of a perfect three-dimensional replica still seems to me not only puzzling but wonderfully provocative. Consider the Elgin Marbles. What consequences might follow from the fabrication of their nanotech duplicate? With two identical sets of marbles, what would be the legal situation? Would one be entitled to the privileged treatment that the law accords to a work of art, with the other entitled to be treated as no more than a humble manufactured artifact? With how much confidence could we talk about the original's "aura"—so sadly lacking from the other—when we really couldn't tell which is which? Legal treatment aside, might we use the replica to solve the long-standing dispute between Greece and the United Kingdom? Or would each party insist that it must have the real "original"—Greece for patrimonial reasons and Britain because that's what its bargain called for.

To take a dispute much closer to home, consider the legal wrangle over the "Willamette Meteorite," now installed in the American Museum of Natural History's Rose Center for Earth and Space. Having landed in Alaska at some unknown date, the meteorite was dragged south by a glacier and eventually came to rest in Oregon's Willamette Valley. In due course, it came to play a role in the religious observances of a local tribe of Native Americans, the Clackamas. In 1857 the Clackamas tribe relinquished its land in the valley to the U.S. government and was settled on a reservation elsewhere. The land around the meteorite subsequently passed to the Oregon Iron and Steel Company. In 1902 an enterprising trespasser severed the

meteorite and hauled it off to become a sideshow attraction. The Oregon Iron and Steel Company successfully sued the trespasser/showman for its return in 1905, and the American Museum of Natural History then purchased the meteorite the following year.

In 1999 the Clackamas tribe (now represented by the Confederated Tribes of the Grand Ronde Community of Oregon)—acting under NAGPRA, the Native American Graves and Repatriation Act—filed a claim with the museum demanding the return of the meteorite as a "sacred" object—an object required for the practice of its religion. The museum not only denied this claim but—taking the offensive—went to federal court in February 2000 to seek a declaratory judgment that the claim itself lacked any merit. Among the arguments raised by the museum was that the meteorite (at least during the time when it figured in the Klackamas observances) was not an "object" at all but an integral feature of the landscape, that the Klackamas had never in any event (as required for recovery under NAGPRA) "owned or controlled" the meteorite, and that the Klackamas cannot overcome the museum's showing that the method by which it had acquired the meteorite in 1906—an arm's length purchase for value from a vendor previously declared to have good title—gave it an actual "right" of possession.

Could cloning resolve this dispute? My guess is not. Most likely, the Klackamas tribe—consistent with its religious beliefs—would insist that only one of the two resulting and identical objects was truly imbued with the traditional sacred power, and that was the one it had to have. Likewise, the scientific staff of the museum—consistent with its own particular (and strangely parallel) belief system—would likely insist with equal stubbornness that only one of those two objects had really come from outer space, and that was the one that it, in turn, had to have.

What the situations of the Elgin Marbles and the Willamette Meteorite seem to suggest is that perhaps—to a greater degree than we generally acknowledge—it is not only the visual and/or physical aspects of objects that make them important to us but also (and perhaps even more so) their particular histories. Is it those histories—rather than any fact of uniqueness—that imbues objects with their purported "aura"? Certainly, by so palpably connecting us to our own cultural and personal roots, these objects—beyond their aesthetic or scientific interest—can play powerful roles in helping us to locate ourselves in the present. As John Merryman has quoted from John Steinbeck's *The Grapes of Wrath* in this regard: "How will we know it's us without our past?"

Turning now to copyright, let me begin with the proposition that copyright is only one of two basic means by which the owner and/or possessor of cultural property can exercise control over its use; the other is by controlling access to the property itself.

Traditionally, the great advantage of copyright has been that it permits the copyright holder to distribute the copyrighted work to a broad audience without having to negotiate the terms of a separate arrangement with each user. In the United States, though, the effect of copyright has been a matter of balance. As virtually every commentator in the field has noted, the constitutional provision that authorizes the grant of copyright makes clear that its underlying purpose is ultimately a public one: "to promote the progress of [the] useful arts." The Constitution, accordingly, also provides that copyright can be granted only for a limited time. Works of authorship granted copyright must sooner or later fall into the public domain, freely available for use by all.

Also embodied in our copyright law are the concepts of *fair use* and *first sale*. Under section 107, fair use permits uses for such purposes as criticism, comment, news reporting, teaching, scholarship, or research without any need for the copyright proprietor's approval. Under section 109(a), the first-sale doctrine provides that the purchaser of a copyrighted work—a book, for example—is then free (without any need for the copyright proprietor's approval) to resell that book, or to lend it to friends, to lease it, even to destroy it—in short, to do anything but copy it.

For many of us, these three limitations on the otherwise monopolistic reach of copyright—public domain, fair use, and first sale—are more than simply technicalities. They speak directly to the reason that copyright appears in the Constitution at all: It is integral to the scheme of self-government that the Constitution was intended to establish. For self-government to work, one of its essential components must be an informed citizenry, a citizenry able to keep itself continuously and contemporaneously informed by the free flow of information and ideas. Copyright, by encouraging the creation and dissemination of fresh ideas, novel insights, free commentary, and informed criticism is, in its turn, among the mechanisms intended to ensure that such a citizenry does become and remain informed. As scarcely need be added, such a process-centered view of copyright is light-years removed from those author-centered European approaches that treat copyright as a natural right of creative individuals, rather than as an incentive intended to enrich the communal discourse.

In contrast to copyright, to limit other people's use of a work by controlling access to that work has traditionally been practical only when the work to be controlled exists in very few copies—ideally, one. Consider a late-nineteenth-century painting in a museum collection. Notwithstanding that the museum may never have had a copyright in the work at all and/or that the painting has long since passed into the public domain, simply by monitoring the activities permitted on its premise—by forbidding visitors to bring in commercial-grade photography equipment and lights—the museum can exercise as tight a control over reproductions of that work of art as it might if it actually held a still-valid copyright. A combination of criminal law against breaking and entering, tort law providing protection against trespass, and contract law permitting the museum to limit the scope of any permitted uses obviate the need for copyright or any other law pertinent to the painting itself.

What now looms before us is an unprecedented "cake-and-eat-it" situation, in which a copyright holder may be able to have the ability to distribute a work to a broad audience while at the same time keeping the tight control that has traditionally been possible only when the work was unique. Three factors are contributing to this development: a new environment, a new technology, and a new law. The new environment is the digital one, with its capacity to convert texts, images, and sound into digital data and to distribute that data around the world. The new technology is encryption, the electronic equivalent of a strongroom inside which digital data can be safeguarded from any previously unauthorized use. And the new law is the Digital Millennium Copyright Act (DMCA), passed by the Congress in 1998 to implement U.S. obligations under the 1996 WIPO Copyright Treaty. Among its provisions, the DMCA criminalizes both the circumvention of encryption and the manufacture and distribution of equipment that might be used for that purpose. Under the DMCA, circumvention is the equivalent of breaking and entering.

What this combination does, in effect, is to destroy the traditional balance between copyright proprietors and potential users. Copyrighted material, once encrypted, can remain encrypted forever—thus killing off the notion of public domain. Once encrypted, it can also be walled off from fair use. Notwithstanding that a prospective fair user could fairly use it if she could get access to it, the very effort to secure that access has itself been made a crime. And copyrighted material, once encrypted, can also be screened off from first sale because the owner need never sell it at all—

he can decide to lease it instead, and on whatever restrictive terms he chooses.

Consider, for example, how this might work in the case of a scholarly journal. In the predigital world, a library—having made a one-time payment—would thereafter be the owner of a hard-copy version that it could lend out to the public, keep on an open shelf for browsing and/or other reference, and—within certain limits—copy in facsimile form. After the work ultimately passed into the public domain, the library could then freely copy it, with no further limitation at all. Pending that time, library users in turn would nevertheless still be able to make fair use of its contents. Finally, at the end of time, the library might still have that original hard copy in its archives with its text, incorruptible, still reading identically as it had done on the first day.[6]

In what appears to be the coming electronic environment, things may be wholly different. Instead of being able to buy a copy and have it available indefinitely, the library may be forced to lease it instead and have it available only for so long as it continues to make its lease payments. Through encryption, the publisher may be able to impose separate charges for and/or otherwise control whether and to what extent the library's users may browse the journal, download and copy extracts, or call the text up on a screen. Whether or not the journal's text remains constant over time will be wholly in the hands of the publisher. If the publisher should go out of business, then back issues of the journal may simply cease to exist. And what the library will be left with at the end of time is not an archival copy but simply a pile of receipts.

For content providers, this ability to control access can provide them with all the exclusionary benefits of copyright, with none of its downside: public domain, fair use, first sale. For a publisher tightly enough in control of its materials, the expiration of copyright—even the extinguishment of copyright law itself—would be a nonevent.

For the rest of us, this is not even a zero-sum game. Our loss stands to be considerably greater than the content provider's gain. With the further diminution of public domain (already eroded by the Sonny Bono Copyright Term Extension Act) and the emasculation of fair use and first sale, we will also lose some part of the common body of discourse that we need to share if we are to govern ourselves wisely and responsibly.

Is this ongoing destabilization of our copyright law reversible? To what extent may it simply be a by-product of—or at least deeply intertwined

with—the larger movement toward the globalization of trade, a movement certainly reflected in the U.S. decision in 1989 to become a signatory to the Berne Copyright Convention? To what extent might there be some potential coalition that could successfully be mobilized to bring political pressure to restore the traditional balance between content providers and users? Perhaps most important of all, might the constitutional roots from which our copyright law springs provide some legal basis through which we might hope to reinvigorate public domain, fair use and first sale?

Given what's at risk, those all seem questions that a rising generation of copyright lawyers might fruitfully choose to address.

NOTES

1. Smithsonian Institution's 150th anniversary symposium, Washington, D.C., September 1996.

2. An ongoing experiment at Texas A&M to create a genetic duplicate of an aging mutt named Missy—the work is being financed by Missy's "wealthy owners"—can be followed through monthly progress reports posted on the experiment's dedicated Web site: http://missyplicity.com.

3. Concerning the strength of such animal-rights claims, see Steven Wise's recent *Rattling the Cage: Toward Legal Rights for Animals* (Boulder: Perseus Publishing, 1999), in which the author argues that certain animals at least—chimpanzees and others—ought be granted a legal "personhood" that would be the basis of at least limited rights.

4. The tubes can be ordered at http//cnst.rice.edu at the price of $1,000 per gram.

5. With regard to the potential application of nanotechnology to previously unique works of art, Bill Spence—president of *NanoTechnology* magazine—has argued that "the ability to manipulate atoms individually . . . will cause the possession of artifacts to become irrelevant. As long as digital schema for an artifact is maintained the artifact itself is superfluous. The entire collections of all the world's museums and galleries could be reduced to digital storage and reproduced at any location on demand." Two outlandish thoughts occur in this connection. First, a contemporary Leonardo—digital camera in hand—might well choose to portray his sitter in a medium that would be infinitely reproducible. Leonardo da Vinci had no such choice. The state of the art being what it was, the best he could manage was to smear some pigments on a flat surface and create a unique object. Now, with the potential advent of nanotechnology, we at long last have the possibility to overcome that technical limitation and to distribute Leonardo's work in multiple, exact copies to a far wider audience. Is that not a good thing? Second, rather than treating this previous inability to make infinitely reproducible works of fine art as a technical shortcoming that it would be desirable to overcome, art mu-

seums (and private collectors as well) have tended instead to treat unique works of art as fetishes, even to the point of celebrating their uniqueness as a virtue rather than deploring it as a technical failure. To what extent might this response be linked to some lurking desire for exclusivity? To be the possessor of a unique object is, by definition, to exclude everybody else from such a possibility. To own an infinitely reproducible copy of anything would, by contrast, confer no more distinction than to own a copy of an ordinary book or compact disk.

6. By contrast, a Web site may be constantly changed. For many converts to e-publishing, this ability to change a text—and often more than once—following its first distribution is one of its most positive attributes, not a negative.

Fair Use and Museum Use

Notwithstanding occasional threats from the estates of a number of Euro-
pean artists, several artists' rights organizations headquartered in Paris or
New York City, and a scattering of others, remarkably few actions for
copyright infringement have ever been brought against museums in the
United States that collect and/or display works of contemporary visual art
and that prepare and distribute reproductions of that art in a wide variety
of formats.

Two reasons may be adduced for this. First, it can fairly be claimed that
most works of contemporary visual art that have passed out of the artist's
ownership are in the public domain as a result of having been published
without notice. That was certainly the case for works so published that orig-
inated in the United States, and arguably also the case for works so pub-
lished that originated elsewhere. Second, even in those instances where a
work of visual art is protected by a copyright, only rarely will that copy-
right have been registered with the Copyright Office in Washington, D.C.,
thus negating any possible award of statutory damages or attorney fees and
relegating the copyright owner to a series of remedies far too insubstantial
to justify the considerable expenses to be anticipated in bringing an action
for infringement.

This text was published in *Visual Resources,* vol. 7 (1997). Copyright, Overseas Publishers Associa-
tion (OPA) N.V.; permission granted by Taylor & Francis Ltd.

Given those impediments, there has been little need for museums that deal with contemporary art to rely upon or even to consider closely the extent to which fair use might provide them with a successful defense against a claim of copyright infringement. In the last decade or so, however, those impediments have begun to dissolve, and in time they well may disappear altogether. Under the Berne Convention Implementation Act of 1988, works of art published on or after March 1, 1989, no longer require notice in order to be accorded copyright protection. Thus, with every passing year, an ever-larger proportion of the works of art with which these museums regularly deal is covered by copyright and will continue in that coverage for many years to come. Beyond that, with the GATT-generated Uruguay Round Agreements Act of 1994 now in effect, tens or even hundreds of thousands of works of contemporary art originating outside the United States have been dramatically removed from the public domain and restored to copyright protection for periods that may endure to dates as distant as 2064. Many observers believe that it is only a matter of time before the formal requirements linking statutory damages and legal fees to registration will be repealed by one or another copyright reform act. In this emerging situation, museums that deal with works of contemporary art will need to consider far more closely which uses of such works may be deemed to be fair and which uses may be deemed to be infringing.

Immediately evident is that not every possible use that a museum might make of a work of art will be deemed to be fair. Intuition suggests, rather, that such uses will array themselves along a spectrum anchored at one end by examples that may be considered indisputably "fair" (illustrations printed in a scholarly text) and at the other end by examples that may appear to be clearly "unfair" (the preparation and distribution of a same-size, same-medium, three-dimensional reproduction of an editioned sculpture, of which the living artist still retains copies that she is contemporaneously attempting to sell). To sort out the vast range of possible museum uses along this spectrum—publications of other kinds, slides, transparencies, postcards, posters, notecards, address books, sheet reproductions, calendars, films, T-shirts, jigsaw puzzles, coffee mugs, video disks, Internet Web sites, CD-ROMs—some interesting questions will need to be addressed.

Given that most museums are fundamentally educational in purpose, it ought to be reasonable to assume that many of the uses they make of works of art will meet the threshold test of section 107 of the Copyright Law (that they are for a purpose such as criticism, comment, teaching, scholarship,

or research). Proceeding beyond that to consider the fairness of such uses, some of the questions pertinent to the four factors that section 107 sets out as guidelines might be as follows.

Regarding factor one: "The purpose and character of the use, including whether such use is of a commercial nature or is for nonprofit educational purposes." In determining the "purpose and character" of a museum's reproductive use, how relevant is the number of reproductions that it distributes? In the past, at least one of the New York–based artists' rights organizations has argued that quantity *is* relevant—that the use of a work of art to illustrate a scholarly exhibition catalog produced in an edition of one thousand might be conceded a fair use, but the same use in an identical exhibition catalog produced in an edition of one hundred thousand was not. What was apparently being argued here was that this second use would be of a "commercial nature," thus allegedly reversing what might otherwise have been an "educational" and promuseum finding under factor one. Whatever force such an argument may once have had must surely have been undercut by the Supreme Court's decision in *Campbell v. Acuff-Rose.* If the purely commercial distribution of 2 Live Crew's parody of Roy Orbison's "Oh Pretty Woman" was not deemed too commercial to be a fair use, then the sale of a hundred thousand Matisse catalogs ought to present a court with no worse a case. In the fair-use context, the fact that a particular use has an undeniably commercial aspect may no longer be so damning as once was thought.

Regarding factor two: "The nature of the copyrighted work." This factor has traditionally been understood as requiring a distinction to be made between a primarily "creative" work (a novel, for example), which may be accorded greater copyright protection, and a primarily "factual" one (for instance, a set of instructions), which may be considered less eligible for such protection. So understood, this factor would almost always weigh against museums on the grounds that a museum's very interest in a particular work of art is compelling evidence of that work's creative content. Must this factor, though, be so narrowly construed? Might not factor two also be interpreted to mean that the nature of the copyrighted work is to be considered in relation to the nature of the allegedly infringing use? So interpreted, factor two would allow a court to distinguish between the preparation and distribution of an 8-by-10-inch (20-by-25-centimeter) black-and-white photographic copy of a large, colorful painting by Henri Matisse and the preparation and distribution of an 8-by-10-inch photo-

graphic copy of an original 8-by-10-inch black-and-white photograph by Robert Mapplethorpe. To the extent that common-sense determinations of fair use are to be preferred over highly technical ones, such an interpretation of factor two might prove to be an appealing one.

Regarding factor three: "The amount and substantiality of the portion used in relation to the copyrighted work as a whole." Here is perhaps the most intriguing question of all. In dealing with the reproduction of a work of visual art, what is the "portion used" that is to be compared in "amount and substantiality" with "the copyrighted work as a whole"? Consider a 4-by-6-inch (10-by-15-centimeter) printed black-and-white postcard that depicts in its entirety an 8-by-12-foot (244-by-366-centimeter) heavily impastoed and vibrantly colorful painting on stretched canvas. Does such a postcard really "use" all of the painting, or does the omission from the postcard of the painting's scale, canvas support, paint surface, and color mean that what it is using is something considerably less than all? Might we not think of such a postcard as little more than a thin, pale summary or condensation of the larger and more imposing original? Might we not even analogize such a postcard to the quotation of a brief passage excerpted from a longer text? If so, how different would the case be if the postcard were printed in color? What if the postcard were painted rather than printed? What if the painting had not been so large, but postcard-size to begin with? Is the case of the postcard never, sometimes, or always the same as that of a full-scale replica painted on a canvas support?

Assume, though, for argument's sake that this "quotation" argument is not persuasive and that the postcard must be treated as a potentially infringing derivative work because the whole of the painting has been "used." Such an adverse finding on factor three would still not necessarily be conclusive. Although some may argue that the reproduction of a copyrighted work in its entirety precludes a finding of fair use per se, there are cases (*Sega Enterprises, Ltd. v. Accolade, Inc.; Universal City Studios, Inc. v. Sony Corp. of America*) in which that was found not to be so. Regardless of how it is approached, this question of how factor three applies to works of visual art remains fundamental and fascinating. What a great irony it would be if art museums—which normally refuse to make postcards of details from a work of art, on the grounds that to do so would be a serious misrepresentation of the artist's intent—were to be instructed by the law that the production and sale of postcards limited to the details of a work of art was a benign and protected fair use while the production and distribution of post-

cards that depicted that same work in a way that was closer to the artist's original intent would be an actionable infringement! Whom would that serve, and how?

Regarding factor four: "The effect of the use upon the potential market for or value of the copyrighted work." Imagine here that the copyrighted work is a painting held in a museum's permanent collection. In the case of a unique object already owned by a museum, how is factor four to be applied? This seems to be one of those instances in which a body of law that evolved around infinitely reproducible classes of things (books, films, software programs) capable of distribution to a mass market has little or no fit with an object that exists as a singleton and that may not be for sale. There is neither any market nor any market value for a work of art (like the *Mona Lisa*) that a museum has no present intention to sell, which is why such works are generally described as "priceless."

Should factor four be applied instead to what might actually be for sale— derivative works (or the right to make such derivative works) prepared from a not-for-sale original? There is certainly some authority for that. Another look at *Campbell v. Acuff-Rose,* however, suggests that such an application of factor four might require a further inquiry as to whether and to what extent the copyright owner was actually exploiting or could reasonably be expected to exploit the market for the kind of derivative work claimed to be an infringement. Translated into museum terms, the question of whether a museum-produced postcard of a copyrighted painting from its collection infringes the artist's retained copyright might then turn in part on a factual inquiry as to whether the artist has customarily exploited or could likely be expected to exploit the market for such a postcard. The question is not the large theoretical one, "Might the artist ever?" but the smaller "Is the artist likely?"

How museums might fare under this factor-by-factor analysis would depend upon the relative weight accorded to each factor. To the extent the first and fourth factors are given the greatest weight, museums might be expected to do well. Factors two and three might be more problematic. Rather than entwining themselves so deeply in such an analysis, those seeking to secure museums the broadest possible right to deal with copyrighted works of art might find it wiser to take a different tack. Much could be gained by adopting (and urging more courts to adopt) the approach to fair use explored by federal Judge Pierre N. Leval, an approach that treats fair use not as an exception to copyright's overall objective but rather as being

wholly consistent with that objective. If copyright is designed, as Leval views it, "to stimulate activity and progress in the arts for the intellectual enrichment of the public," then what is basically required in order to determine whether any particular use is a fair one is not some narrow consideration of the copyright owner's monopolistic property rights but rather a more expansive inquiry into what public purposes are served, and at what cost, by the specific use under scrutiny. The fundamental question, as formulated by Leval, ought to be as to whether that particular use is "of a character that serves the copyright objective of stimulating productive thought and public instruction without excessively diminishing the incentives for creativity." Such a use would be a fair use.

For a particular use to satisfy the first part of Leval's formulation, it must also be what he terms "transformative." It must "employ the quoted matter in a different manner or for a different purpose than the original. A quotation of copyrighted material that merely repackages or republishes the original is unlikely to pass the test." Is that not exactly what a museum-produced postcard of an original painting does? It neither repackages nor republishes the original, as might a full-scale painted replica. To the contrary, as the end product of several intervening technologies (principally photography and printing) it constitutes a transformed, albeit greatly diluted, version of the original in a new form that can be broadly distributed at a modest price— something impossible with the unique original, which can only be seen in one place at any one time—while in no way affecting the market for the work from which it quotes. The only circumstances in which the production and distribution of such a postcard might diminish any "incentives for creativity" would be if the artist's expectation of creating a derivative version for the postcard market had been among the factors that impelled the original creation of the underlying work. If so, then just as in traditional fair-use analysis, factor four would come into play to make the use competitive and potentially unfair.

Thus approached, a very large part of what museums have customarily produced and distributed would appear to fall well within the safe haven of fair use. Only two exceptions seem readily apparent. One would be those objects (coffee mugs, desk sets, perhaps even T-shirts) whose stimulative/instructional aspect appears to be so minimal that their production and distribution might arguably be said to fail to serve the objective of copyright. Museums ought not to risk the danger of making adverse law in the defense of such trivial uses. The other exception would be those products

(the same-size, three-dimensional sculpture reproduction or the copy photograph of Mapplethorpe's original photograph) that might actually compete with the copyright owner's own production—the very situation contemplated by factor four.

Left largely unimpaired by this approach would be the right of museums to make fundamentally educational use of copyrighted contemporary art materials that they own and/or display and to do so without fear that they will thereby be found to be infringers under the Copyright Law of the United States. Whether such uses might nevertheless be found infringing in other jurisdictions (to which museums might export catalogs and other materials) is beyond the scope of what is considered here.

24

Not Money, Control

Copyright is only secondarily about money. Primarily, it's about control. For most museums, copyright questions may occasionally be important, but rarely are they critical. For museums that collect contemporary art, however, copyright issues—and most especially those that concern fair use— may directly affect their very ability to carry out their work.

Consider the impact of fair use in the following situation. Your museum plans a publication that will illustrate one hundred works from its collection, each accompanied by a brief scholarly text. Among these is _Grande Gaufre Rouge,_ the larger of two colorful oil paintings in the collection, by a recently deceased Belgian artist. Her son has inherited their copyrights, copyrights that (whatever their previous status) are now fully enforceable in the United States as a result of 1994's so-called GATT amendments to the copyright law.

Because you may later decide to distribute your publication outside the United States (where fair use will not apply), you write to the son, describing the publication, requesting permission to reproduce _Grande Gaufre Rouge,_ and inquiring about a reproduction fee. He responds that he will waive any fee but wants to review the text, which you send. After an interval you hear further: The text does not adequately acknowledge his mother's

importance, and permission to reproduce *Grande Gaufre Rouge* will not be granted unless several significant changes are made. Or alternately, he responds that the text is fine but demands that *Grande Gaufre Rouge* appear both on your publication's dust jacket and as its frontispiece. Or that permission will be granted only if the second of his late mother's paintings is also included. Or that permission will be granted only if you should purchase still another of her paintings (a selection of which he has available for sale).

Fair use is what stands between these scenarios and the practical realities of day-to-day museum practice. Nothing in the Copyright Law requires copyright owners to exercise their monopoly power in any fair or reasonable manner. In the case of certain educational and kindred uses, however—the uses that museums routinely make in carrying out their public-service function—fair use can be interposed as insulation against the arbitrary exercise of power, provided, always, that the copyright owner will not suffer any significant adverse economic impact as a consequence. Absent the protective shield of fair use, museums that collect works of contemporary art without being able also to acquire (whether by transfer or license) the underlying reproduction rights to those works may be wholly vulnerable to whatever conditions—reasonable or otherwise—the owners of those rights may seek to impose.

Although it is applicable throughout the realm of copyright, fair use has a particular importance for the visual arts (and perhaps for music as well). Unlike written texts, works of visual art cannot be paraphrased. Nor, unlike a play or novel, can they be summarized. Beyond a gallery talk, the ability of a museum to initiate or maintain any meaningful discourse about the works in its collection depends upon its ability to reproduce those works, and to do so in color and in full. Whether such reproductions appear as illustrations in its publications, as slides shown in its auditorium, or as digitized images in its collections management system, the situation is the same. Absent fair use, those holding copyright may have the power to block such uses.

Considering how vital fair use is to the implementation of their public programs, it was not surprising that a number of contemporary art museums took so wary a view of the recently proposed Conference on Fair Use (CONFU) guidelines on educational use for digital images. At one level, they were concerned that these seemed a poor bargain. Rights that these guidelines ostensibly granted to users were, in the main, no more than the same fair-use rights that those users already enjoyed. In exchange, users

were asked to undertake obligations that might ultimately prove extremely burdensome. At a deeper level, though, some of their unease over the CONFU process came from the recognition that it was part of a larger and more ominous agenda: an effort to reshape America's basic copyright law in order to make it more compatible with the anticipated operating requirements of the National Information Infrastructure (NII). What those museums feared was that the very notion of fair use might well become a victim to that effort.

Such fear was by no means groundless. As suggested by a footnote in the 1995 white paper on intellectual property and the NII, fair use—traditionally raised as an affirmative defense following a copyright owner's claim of infringement—may be "an anachronism with no role to play in the context of the NII." In a smoothly functioning electronic environment of automated transactions, the kind of situation-specific, after-the-fact, and one-at-a-time distinctions that fair use determinations generally require of a federal court might well be seen as a throwback to some primitive precomputer age, a glitch out of yesteryear, an obstacle to be removed.

Ironically, given that copyright holders may ultimately have (or perhaps already have) the technical capacity to place a powerful electronic "lock" on copyrighted materials in cyberspace—a lock that may be opened only when payment has been received in advance or permission to copy is otherwise granted—it may in any case become virtually impossible, simply as a practical matter, to make any fair use (an unauthorized use that is nevertheless legally permissible) of such materials. Those who believe there to be a strong link between fair use and the First Amendment's guarantee of free expression may well argue that the exclusion of fair use from cyberspace would be the functional equivalent of also excluding from cyberspace the constitutionally protected criticism and comment with which fair use has traditionally been associated.

For museums that collect contemporary art, fair use is far too important to let it be treated like a legal leper, ripe for expulsion from the brave new world of cyberspace. Its contemplated elimination there can only serve to weaken its application in other contexts. Rather than the relatively passive wariness evidenced by those museums in the CONFU process, they ought to be working vigorously to ensure that fair use not only continues to play a role in cyberspace but also that it be positioned to play that role in as strong and expansive a way as possible. Powerful arguments are available that fair use—more than simply an affirmative defense or an "excep-

tion" to copyright (as the authors of the white paper tend to treat it)—is in fact an integral extension of copyright and intended to achieve the same publicly beneficial purposes as the rest of our copyright law. Viewed from that perspective, fair use can be seen virtually as an independent right in itself. It is toward defining, defending, and strengthening that right that museums of contemporary art should be strenuously working. Again, fair use is too important to the fulfillment of their public service obligations to let it be so casually snatched away.